THE BIG SHOW

Charles M. Conlon's
Golden Age Baseball Photographs

The BIGS

*Charles M. Conlon's
Golden Age
Baseball Photographs*

From the Archives of *Sporting News*

By **NEAL McCABE** *and* **CONSTANCE McCABE**
Foreword by **ROGER KAHN**

Abrams, New York

HOW

Editor: Laura Dozier
Design: Rogers Eckersley Design
Art Director: Michelle Ishay-Cohen
Production Manager: Anet Sirna-Bruder

For more information on Charles M. Conlon or to purchase high-quality prints
of his work, please visit TheConlonCollection.com

Library of Congress Cataloging-in-Publication Data

McCabe, Neal.
 The big show : Charles M. Conlon's golden age baseball photographs / by
Neal McCabe & Constance McCabe.
 p. cm.
 ISBN 978-1-4197-0069-9
 1. Baseball—United States—Pictorial works. 2. Baseball players—United
States—Pictorial works. 3. Conlon, Charles Martin, 1868-1945. I. McCabe,
Constance. II. Title.
 GV863.A1M2 2011
 796.357—dc22

 2011007948

Printed and bound in Hong Kong, China
10 9 8 7 6 5 4 3 2 1

Abrams books are available at special discounts when purchased in quantity
for premiums and promotions as well as fundraising or educational use.
Special editions can also be created to specification. For details, contact
specialsales@abramsbooks.com or the address below.

ABRAMS
THE ART OF BOOKS SINCE 1949

115 West 18th Street
New York, NY 10011
www.abramsbooks.com

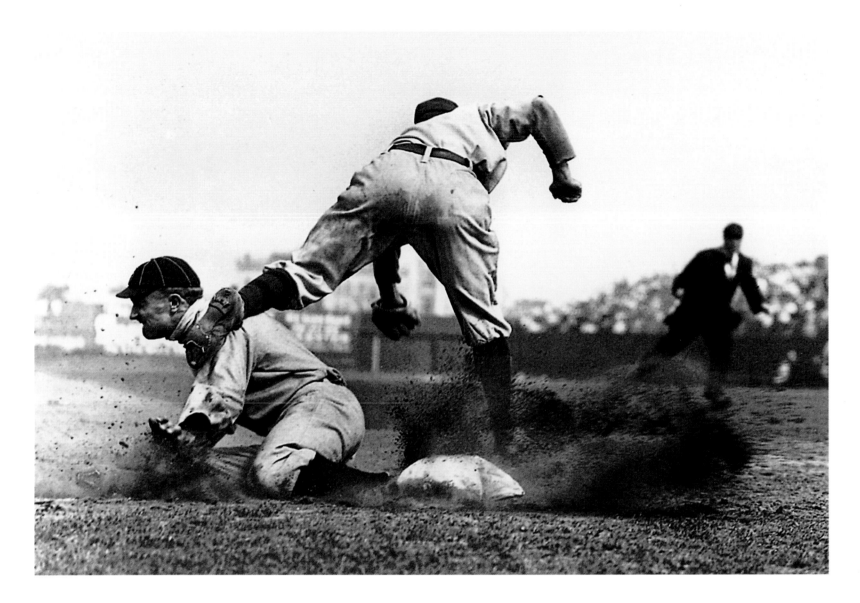

TY COBB *Detroit Tigers*
July 23, 1910

Dirty uniforms

worn by some players

on the diamond are an eye-sore

and a disgrace to the game.

It would seem, from the appearance

frequently presented by uniforms this season,

that the laundries had quit working.

Nothing so disgusts an amusement seeker

as untidiness.

The cinemas cater to the fastidious

by dolling up their attendants

and embellishing their theaters

with decorations.

Evidently some club owners

have not yet learned

the lesson of cleanliness.

It is time they had

a clean-up week.

THE *SPORTING NEWS*
June 25, 1931

Yesterday afternoon as I went for the mail the drugstore was filled with Villagers listening to the Radio—baseball.—Washington. My heart nearly stood still when I was informed that it was the last half of the 11th inning—tie.—And then came the twelfth. The suspense. I've been rooting for Washington for years. Just a feeling.—Yes, years, and here was Johnson in the box in the final tie after having lost two games for the team and all the U.S.A. rooting for him. Johnson called in to win this final game—Gosh! talk about breathless moments—Washington wins!

. . . I was wondering would a crowd of Americans ever stand before a picture of real value with a fraction of the enthusiasm spent on baseball.

ALFRED STIEGLITZ TO SHERWOOD ANDERSON
October 11, 1924

CONTENTS

The Game on Film

BY ROGER KAHN

Oscar time.

We are gathered here to salute the great Charles M. Conlon and to select the four greatest baseball photographs of all time. Impartiality reigns. The envelopes have been sealed. (I stuffed them myself.) Now let's see what they have to tell us.

First, Conlon's 1910 action shot of Ty Cobb sliding into third—and into a third baseman named Jimmy Austin—at Hilltop Park in New York. Austin, a native of Wales, played several seasons for the Highlanders, the primordial Yankees, before being exiled to the St. Louis Browns. Cobb's teeth are clenched. He is all intensity. That was the man. Working on the field, Conlon caught the slide, the dust, and Cobb's grimace. Spiked, Jimmy Austin could not handle the catcher's throw, and Cobb got up and raced home. There was nothing unusual in Cobb racing home or spiking an infielder, but Conlon's portrait of Cobb in ferocious action is unique.

Second, we have a somber moment captured on June 13, 1948, by the late Nat Fein, once a colleague of mine at the New York *Herald Tribune*. Unlike Conlon, Fein was not a baseball specialist, and he attributed some of the success of this picture to luck. Taken from the rear, it shows a bent and ailing Babe Ruth, in full uniform, number three on his back, bidding a final farewell to Yankee Stadium. "I shot the Babe from behind," Fein told me, "because all the photographers'

spots up front were taken." Whatever the reason, the frailty of Ruth as a cancer victim here defines poignancy. Signed copies of Fein's photograph, originally captioned "Three Is Out," have sold on the Internet for as much as $16,000.

Third, on September 29, 1954, in the first game of the World Series, Willie Mays, the Giants' wunderkind, ran down a 450-foot drive, clubbed by Vic Wertz of the Cleveland Indians. Using a specially developed 70 millimeter SLR sequence camera, Frank Hurley of the *New York Daily News* caught this memorable play, freezing the action in the instant before the ball disappeared into Willie's glove. That sequence camera was originally developed to photograph missile launches, which seems appropriate. The ball Wertz hit was a missile, until it vanished in the magic glove of Willie Mays, described by Vin Scully as "the place where triples go to die."

The fourth? Bear with me. We'll get to it presently. But let us now consider the gallery contained in this book. In sum, it is just about the finest collection of baseball photographs that I have seen. All of the best baseball photographs—from Fein's Babe Ruth, to Conlon's Ty Cobb, to the many other images in this book—not only record a moment in baseball history but also reveal something significant about the players, giving us a rare glimpse of the people they were. In essence they speak to the nature of mankind.

9

Conlon is most successful with his portraits. There—as with fine painters—he takes us beyond physical features, and illuminates something of the inner man. I knew of most of the men pictured here, without knowing how they looked. Take Flint Rhem, a hard-throwing pitcher from the Carolinas. As John Lardner put it, "Rhem was a right-handed pitcher, but a switch drinker, He could raise a glass with either hand." Conlon's Rhem looks out at us with boyish innocence and apparent sobriety.

I met Rogers Hornsby, probably the greatest right-handed batter in National League history when he was managing the Cincinnati Reds. Hard as nails, the prototypical tough Texan. Conlon caught him in a dugout wearing civilian clothes, including a vest and a necktie. Out of uniform The Rajah looked (almost) approachable.

Many know Lou Gehrig from the sentimental movie *Pride of the Yankees*, in which Gehrig was portrayed by long, lean Gary Cooper. Gehrig was tall all right, but lean does not describe him. Larrupin' Lou was a thick-bodied muscle man. That comes through in Conlon's portrait of Gehrig at the bat. (Cooper was naturally right-handed and his performance suffered when the script called for him to step up to the plate and swing—as Gehrig did—left-handed).

Joe DiMaggio still had a hungry look in 1937, his sopho-more season, when Conlon photographed him . . . But by 1941 DiMaggio was baseball royalty. Conlon's later portrait conveys disdain and perhaps even a hint of the paranoia that was not DiMaggio's most attractive quality,

Conlon's strongest point, and one critical to portrait photography, was getting the subject to relax so that he did not seem to be doing what he was actually doing: posing for a picture. And that brings us to Oscar Number Four . . .

Jackie Robinson had edgy relations both with the media and the Dodger front office. One of his defenses was to insist that he didn't care what anyone, outside of his immediate family, said about him. Bigotry and resentment always lurked near this heroic black pioneer. In the spring of 1971 I drove with my family to visit Jackie at his home on Cascade Road in Stamford, Connecticut. Jack was wonderful with kids, and we had a warm and relaxed afternoon. My son Gordon, then fifteen, brought along his SLR, a Pentax Spotmatic, and Jack said sure, take all the pictures you want.

Robinson knew I had been traveling and meeting with his old Brooklyn teammates; in that relaxed setting he dropped his guard and asked, "Did the fellers say anything about me?" I was prepared. I'd brought a few pages of typescript on Preacher Roe, a gifted left-handed pitcher who lived near the border of Missouri and Arkansas. Roe told me that in the winter following Robinson's rookie season, he had gone to a party where someone said, "Well, Preach, now that you're playing ball with them, I guess you'll be marryin' with 'em next."

Preacher responded, "When I hear a remark like that, I consider the source. Well, I just considered my teammates and I just considered you, and you can go plumb to hell."

Jackie Robinson was a handsome man. Now his face lit in a glorious smile, and Gordon caught this joyous moment on film. Rachel Robinson has said many times since that Gordon's picture is her favorite of all the photos of Jackie in his later years. Al Silverman, editing *Sport Magazine*, liked the picture so much he bought magazine rights and sent Gordon a check for $25.

I think Charles Conlon would have liked the story and the picture. His own work often has that same natural quality. I imagine he would have said to Gordon, "Good going, kid.

"Except next time don't settle for $25.

"Hold out for $30."

* * *

Author's note: In the current volume, the referenced photo of Flint Rhem appears on page 58; Rogers Hornsby on pages 54–55; Lou Gehrig on page 29; and Joe DiMaggio on page 111 and page 171. Gordon Kahn's picture of Jackie Robinson is reproduced in all editions of *The Boys of Summer*, except the one published in Japan. A poor call by my Asian friends, but at least Gordon was spared having to pay Japanese income tax.

CHARLES M. CONLON

Devoid of All Flim-Flam

In recent years, it has become fashionable for photographers to produce faux-intense, faux-brooding, faux-artistic portraits of baseball players. Beads of sprayed-on perspiration gleam on streaks of carefully applied grime. The acquiescent athlete plays his role, glaring menacingly at the camera. His hair is painstakingly disheveled (or shaved clean to the scalp), his three-day growth of beard meticulously trimmed. Garish lighting adds manufactured drama to the image.

But these photographs are entirely devoid of real drama. Such contrived portraits reveal nothing. At worst, they are kitsch. They are certainly not art—although one cannot help but sense the presence of an art director hovering just outside the frame. One can almost hear the photographer's cell phone ringing, his agent on the line wondering when the check for the photo shoot will arrive. Baseball photography, like baseball itself, is showbiz.

Charles M. Conlon lived in a different world. If a ballplayer scowled at him, there was an implicit threat: "You're annoying me, mister. Take your camera and go away . . . or else." When his lighting is dramatic, it only means that the sun had perched behind the grandstand roof. In Conlon's pictures, the dirt and sweat are real. If a player is unshaven,

it probably means that he had been out all night. And if a Conlon portrait is dramatic, it often means that his subject was a seriously disturbed individual. Baseball photography, like baseball itself, was real, and today's photographers—try as they might, using every modern artifice at their disposal—cannot re-create the quiet power and eerie authenticity of a Conlon photograph.

Born in Albany, New York, in 1868, Charles M. "Charley" Conlon was an ordinary working man—a newspaper printer and proofreader whose hobby was photography. One day in 1904, the editor of his newspaper casually asked him if he'd like to take a few pictures of baseball players. Charley offered to give it a try and took his camera out to the Polo Grounds, home of the New York Giants. This seemingly inauspicious event marked the beginning of one of the most remarkable careers in the history of photography. By the time he put down his camera in 1942, Conlon had taken some thirty thousand photographs, including many of the most beautiful and famous baseball images of the twentieth century: His sensational shot of Ty Cobb sliding into third base is without a doubt the most-reproduced baseball photograph ever. But during all that time, he never quit his day job, and he never worried about receiving recognition for his work. His photo-

"Well Al it will seem funny to be up there in the big show when I never was really in a big city before.

But I guess I seen enough of life not to be scared of the high buildings eh Al?"

JACK KEEFE, PITCHER, TO HIS PAL, AL BLANCHARD
(from Ring Lardner's *You Know Me Al*) *September 6, 1912*

graphs were reprinted constantly in newspapers, magazines, and books, but were rarely associated with his name—and thus, despite his extraordinary achievement, Conlon remained practically anonymous throughout his lifetime and in the years following his death in 1945.

This forgotten man was finally rescued from his undeserved obscurity when *Baseball's Golden Age: The Photographs of Charles M. Conlon* was published in 1993. The pictures in that book were selected from the more than eight thousand surviving original negatives in the Conlon Collection of the *Sporting News*, but early on in the editorial process it became obvious that there would have to be a second volume, because there were simply far more marvelous photographs than could possibly fit in a single book of reasonable size. In some cases—particularly with the more obscure players—it became clear that the captions didn't do justice to the pictures, many of which are among Conlon's most beautiful images. A great photograph grabs the reader's attention in an instant, but a weak caption can only detract from its power, and the disappointed reader will soon lose interest. On the other hand, a good caption will send the reader's eyes back to the photograph, and something hitherto hidden will be suddenly revealed. More

research was necessary to produce satisfactory captions, which meant that some quite wonderful photographs had to be set aside for the sequel. Furthermore, even as the first book was being sent to the printers, forgotten Conlon negatives were still being discovered in the archives of the *Sporting News*, where they had been filed under the names of the individual players. Splendid images of people like Babe Ruth and Joe DiMaggio kept turning up long after the publication of *Baseball's Golden Age*. This situation was exasperating, but it also meant that the sequel had a lineup of heavy hitters sitting on the bench, patiently waiting to get back in the game.

The picture of Frank Snyder on page 60 is a perfect example of the embarrassment of riches—and some of the special problems—presented by the photographs of Charles M. Conlon. As soon as I saw a contact print from the original glass negative twenty years ago, I knew that this was a classic American portrait—one of the best images Conlon ever made—yet I had no choice but to leave it out of *Baseball's Golden Age*. Snyder played for sixteen seasons, starred in several World Series, and was a coach for many years, but a brief, mundane description of his baseball career could never explain his frightening, almost homicidal stare—nor

could it possibly account for the deep, disturbing scar on his right cheek. When I first saw Conlon's photograph of the incredibly obscure Art Veltman (page 144), I was touched and puzzled: "Why is this poor kid about to burst into tears?" Veltman's meager baseball record suggested that it wouldn't be worth the trouble to find out, but Conlon's heartbreaking portrait left me no choice but to discover as much as I could about this young man's life. Then there was Jackie Hayes (page 145). His name meant nothing to me, but I definitely wanted to meet the goofy gentleman in Conlon's photo. Kent Greenfield's dreary pitching career has never sparked anyone's interest, yet I was troubled by the hint of anguish I detected in the face of the man in Conlon's photograph (page 62). I knew I had to find out who he was, but I also knew that I'd never find him in a baseball book. It turned out that he'd been in a book of poetry all along.

"The significance of a baseball player's life is usually measured by his statistics in the record book—wins and losses, hits and strikeouts, runs and errors, and so on, ad infinitum. When we rely solely on such cold, unforgiving standards, we can only conclude that the lives of some of the people in this book were nearly meaningless. But Charles M. Conlon never thought so."

It took me a long time to track down these forgotten men, but the results of my investigations consistently verified the truth of a remark made by Bill Brandt, a twentieth-century British photographer: "I think a good portrait ought to tell something of the subject's past and suggest something of his future." By this definition, Conlon's best portraits are astonishing—and they tell us far more than any history book ever could.

The significance of a baseball player's life is usually measured by his statistics in the record book—wins and losses, hits and strikeouts, runs and errors, and so on, ad infinitum. When we rely solely on such cold, unforgiving standards, we can only conclude that the lives of some of the people in this book were nearly meaningless. But Charles M. Conlon never thought so; they were all major leaguers, and he treated them all with the same respect. Players like Sterling Stryker and Johnny Riddle, Buzz McWeeny and Pinky Pittenger, Gabbo Gabler and Pid Purdy are barely footnotes in the history of baseball, but Conlon's photographs tell a different story, in which these men somehow become larger than life. Some were tragic figures, some were clowns, but all of them made it to the big show back when baseball was the only game in town—and more than a few of them will haunt the reader's dreams. They will now live on, but only because Charles M. Conlon took their pictures.

Nearly two decades after the publication of *Baseball's Golden Age*, Conlon's profile has risen significantly—certainly among baseball collectors—but he still has not achieved the status or recognition his work deserves. His name is, as yet, nowhere to be seen in the voluminous

literature of photography, and the reason is all too obvious: Conlon was not motivated by the self-aggrandizing, even delusional impulses necessary to be taken seriously by any self-respecting photo historian. Unlike the "great" documentary photographers, Conlon was not attempting to change the world, expose its ills, or improve the lot of the downtrodden, nor was he realizing some overarching artistic or ethnographic vision. Instead, he somehow managed to squander four decades doggedly documenting the peculiar world of major league baseball. He could not have found a more trivial pursuit.

Judging by the frequency with which they appear in histories of photography, only two baseball photographs have been deemed to be "great": Lewis W. Hine's memorable picture of tenement kids playing baseball in an alley, and Nickolas Muray's gorgeous studio portrait of Babe Ruth. Hine, a muckraking documentary photographer, and Muray, a celebrity photographer, both achieved prominence in their lifetimes, and these photographs are permanently enshrined in the prestigious collection of the George Eastman House, thus certifying their unquestioned status as works of art. But are these two images—as familiar as they have become—inherently more beautiful or worthy of interest than the thousands of striking baseball photographs taken by their unrecognized contemporary, Charles M. Conlon? The answer, obviously, is no—but Charley just didn't know the rules of the game: He failed to produce the requisite pretentious photographic manifesto, failed to flatter the right critics, and was actually imprudent enough to declare, "I take photographs simply because I enjoy taking them." It was only his hobby, after all.

Could it be that this humble newspaper proofreader was also an artist? Can conscientious historians of photography continue to ignore his remarkable body of work—only because this anonymous outsider lacked any grand motivation to produce it?

The history of photography has been virtually etched in stone by such eminent authorities as Alfred Stieglitz, Beaumont Newhall, and John Szarkowski, and no American photographer of Conlon's generation has ever been admitted to the ranks of "the great" without their imperious imprimatur. Subsequent historians have timidly followed their lead, and thus we find the same familiar pictures by the same famous photographers endlessly reprinted in book after book, much as the same baseball photographs reappear in baseball book after baseball book. If one studies their writings and looks at the photographs they admired, it becomes self-evident that if Newhall or Szarkowski had serendipitously stumbled upon a representative cache of vintage Conlon photos, these insightful critics would have appreciated their worth, and another name would have been added to the short list of great American documentary photographers.

Perhaps it is time for today's critics to take a look at some new photographs taken a long time ago. Perhaps it is time they tipped their caps to Charles M. Conlon. He has certainly earned a curtain call.

KID NICHOLS
1904 St. Louis Cardinals

Nichols first pitched professionally in 1887, at the age of seventeen: "Because of my size they referred to me as the batboy. That's where the nickname 'Kid' came from, and it was to stick to me throughout my life." His major-league career began in 1890 when he won twenty-seven games for the Boston Beaneaters. He won twenty or more games in each of his first ten big-league seasons, in seven of which he had thirty or more wins, but his phenomenal work on the mound didn't exempt him from less glamorous duties: "Pitching wasn't the only job pitchers had in the Nineties. The day after we had pitched a game it was our duty to stand at the gate, and afterwards to count the tickets. You never heard of anyone with chips in his elbow or a sore arm in my day. The biggest strain my arm ever underwent was at the Polo Grounds one afternoon when I counted 30,000 tickets."

In this photograph, Conlon has momentarily blocked the Kid's escape from the field after another long day at the Polo Grounds. A spectral crowd shadows Nichols as he obligingly demonstrates his famous no-windup delivery.

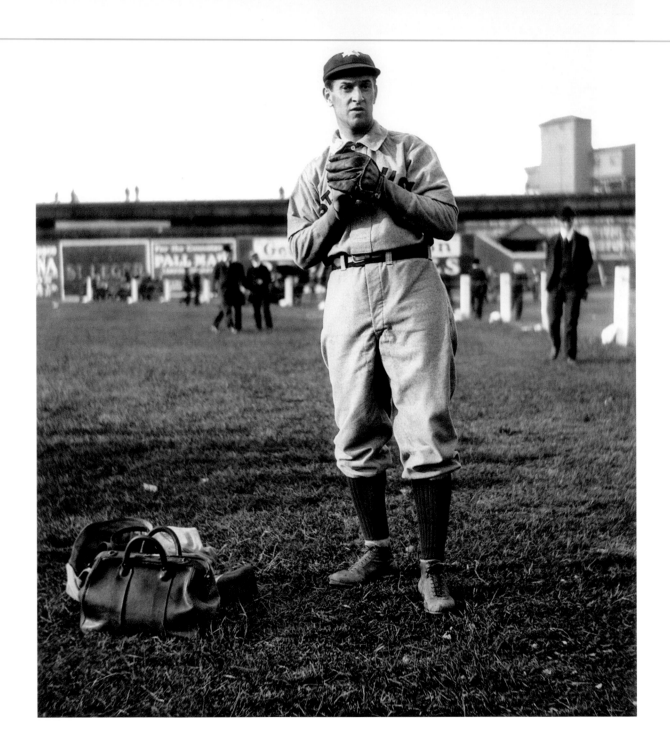

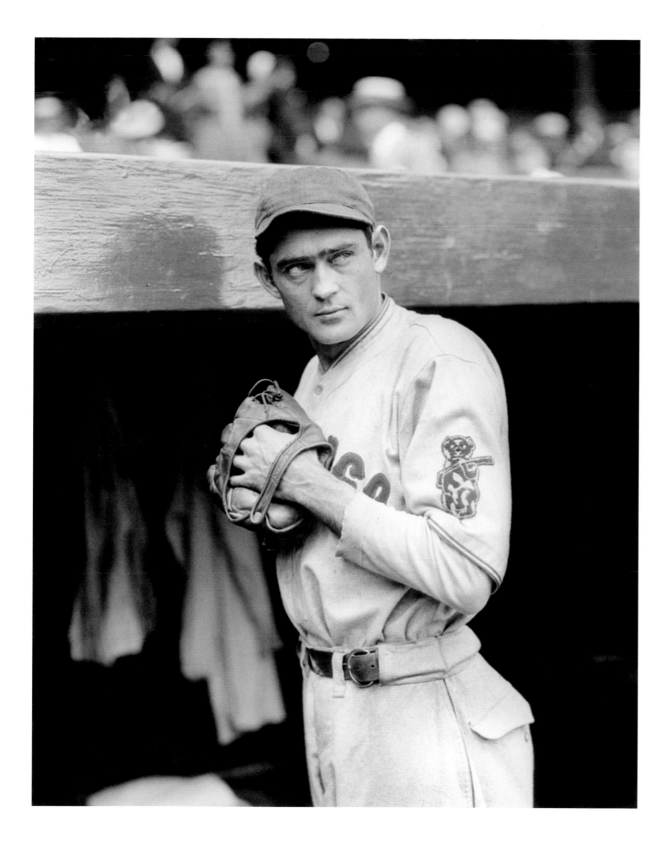

GUY BUSH
1929 Chicago Cubs

"Nobody apologized for nothin' in my day," declared Guy Bush. "Nobody *expected* nobody to apologize for nothin'. Once the bell rang you got mean and you stayed mean until it was over, if you wanted to get anywhere. You know what would happen if I loosened up somebody who was batting hell out of us? We wouldn't go over to the other guy's clubhouse to apologize. If we stuck our heads in there, there'd be 20–25 guys ready to smack us on the chops."

"I was one of the cockiest players in the game," said Bush. "And that ain't nothin' but confidence." But the Mississippi Mudcat didn't have much to brag about until 1929, his sixth season with the Cubs: "That was the first year I really started winning." He won eighteen games, and saved eight more as a reliever, leading the Cubs to the National League pennant. Bush was the only Chicago pitcher to win a game against the powerhouse Philadelphia Athletics in the 1929 World Series. He later called this victory his greatest thrill in baseball.

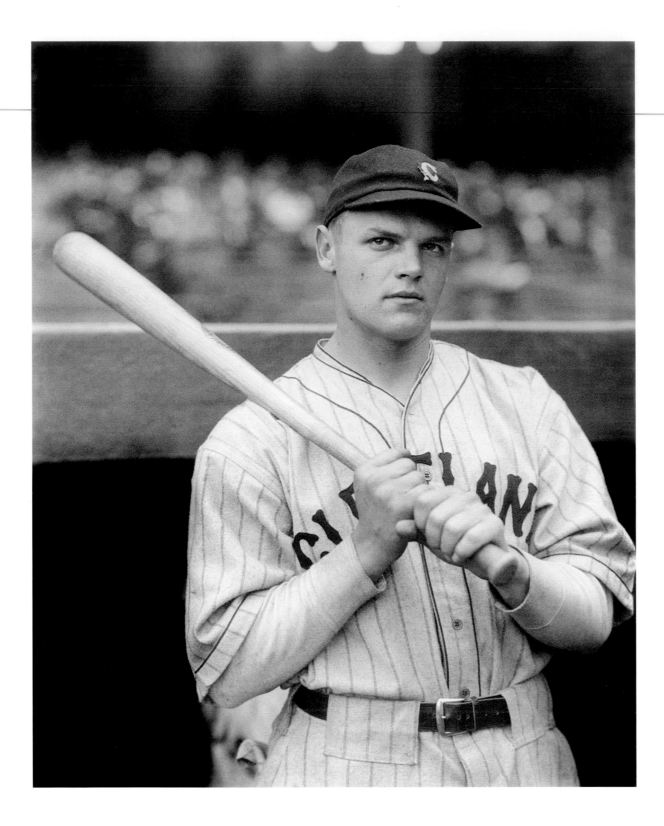

JOE VOSMIK
1932 Cleveland Indians

As Cleveland general manager Billy Evans watched a group of local sandlotters in 1928, he asked his wife: "Which one of the boys do you like?" Mrs. Evans replied: "The good-looking blond boy over there." Evans signed up the good-looking blond boy, who refused to accept a signing bonus: "All I want is a chance to play ball. I don't want any check." Evans quietly sent a $300 check to the boy's mother as a "gift," and by 1931, Joe Vosmik was starting in the Indians' outfield.

With only four days left in the 1935 season, Vosmik was leading the American League batting race by ten points. By the last day of the season, Buddy Myer of the Washington Senators had cut Vosmik's lead to just two points, but Joe gambled that he could win the batting title without starting either game of the Indians' season-ending doubleheader. When the shocking news reached Cleveland that Myer had just gone 4 for 5 in Washington's last game of the season, Vosmik belatedly put himself back in the lineup, but with only one hit in three at-bats, Joe lost the 1935 American League batting championship by a fraction of a point.

WALT CRUISE
1917 St. Louis Cardinals

Cruise hit just thirty home runs in his ten-year big-league career, but in 1917 his bat definitely earned this Conlon close-up. During a game in Boston on May 26, Walt "hit a ball into the right field bleachers, a distance of nearly 500 feet, the first time this feat has been accomplished at Braves Field," reported the *Sporting News*. Three years later, also at Braves Field, Cruise tripled and scored the only Braves run in the longest game by innings in major-league history: "That triple was the only hit I got out of nine times at bat that day. We were no tireder than we would have been for a regular game even though it lasted 26 innings. Of course, we kept thinking it would end, but every time somebody hit one hard it seemed to be right at a fielder."

But Walt's most memorable day came at Redland Field in 1922: "We got married at the ball park in Cincinnati," recalled his wife, Lillian. "It was a double header. Walt played in the first game and hit a home run. We got married between games and they let him sit with me in a grandstand during the second game."

ROGER BRESNAHAN
c. 1906 New York Giants

"If you haven't got a good catcher on your team, just throw it in the river," advised Roger Bresnahan. "God gave all those boys on the mound fine physiques and strong arms, but he didn't give many of them brains." This brainy Hall of Fame catcher invented shin guards, the "awkward contrivances" he introduced to Cincinnati on June 17, 1907: "It was the first time in the history of the local lot that such massive defensive implements have been used, either by friend or foe," noted a local writer, "and the populace gazed upon their impregnable front with some awe and much amusement." But these implements weren't much help to Bresnahan when he was struck by a pitch while batting on June 18: "Roger Bresnahan's shin pads might have done better service had he worn them strapped on his 'koko' when this inshoot from Andy Coakley's catapult laid him out." Bresnahan was hospitalized with a life-threatening head injury, but within two weeks he had transformed his near-death experience into a product-endorsement opportunity by appearing in ads for the "Reach Pneumatic Batter's Head Protector"—although practicable batting helmets were still decades in the future.

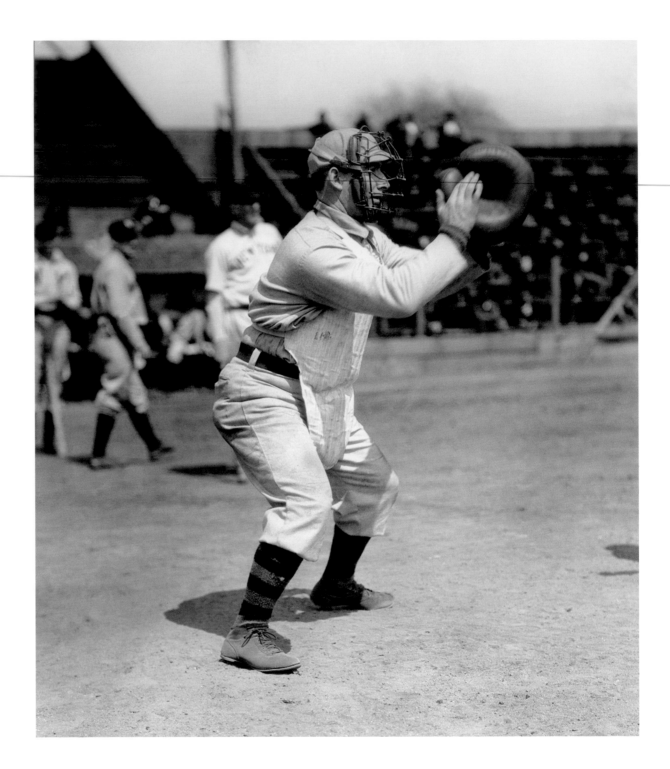

ANDY COAKLEY

c. 1923 Columbia University baseball coach

Coakley's pitching debut with the Philadelphia Athletics on September 17, 1902, was less than auspicious: "I'll never forget the day I broke in. I hit Bill Coughlin of Washington square in the kisser. The ball fractured his jaw and knocked out a lot of his teeth, and I had visions of being tried for manslaughter." In 1905, he knocked his own team's best pitcher out of the World Series: "It was September 1, and that was Straw Hat Busting Day in the major leagues. The custom died with the retirement of Babe Ruth. Rube Waddell was going around destroying straw hats. I had a pretty expensive skimmer which was in fine condition, and Waddell was waiting for me. As he ran for my hat, I backed up the aisle. He lunged. I struck him with my bag. He slipped and landed on his shoulder."

On June 18, 1907, when the game resumed after the unconscious Roger Bresnahan had been carried off the field, Coakley's next pitch broke Giant first baseman Dan McGann's right wrist. "I guess John McGraw thought I was going to kill his entire club," joked Andy.

This was one of a series of photographs Conlon took to illustrate a textbook titled *Fundamentals of Baseball* (1924) by one Charles Digby Wardlaw. Here Coakley demonstrates his "slow ball," or change-up, a pitch aptly described by Wardlaw in terms of deadly weaponry: "It may be likened to a ball shot from a smooth-bore musket as compared with a revolving bullet shot from a rifled firearm."

21

ARMANDO MARSANS

1917 St. Louis Browns

In the spring of 1911, Cincinnati Reds manager Clark Griffith offered a tryout to Cuban third baseman Rafael Almeida, who showed up with a young man named Armando Marsans: "This fellow was Almeida's valet, or interpreter, or a combination of both. He didn't have anything to say for himself. Well, I told Almeida to put on a uniform and when he came on the field, darned if his interpreter didn't have on a uniform, too. I wound up giving the interpreter a contract. They were interesting to watch. They had those Spanish customs. Whenever Almeida went to the plate, he doffed his cap and bowed low to the pitcher and the crowd. It wasn't a gag; he was sincere. We called him 'The Matador.' He wasn't much better than a sandlotter, but his interpreter, Marsans, was a pretty good ball player. And he turned out to be a fine big league outfielder."

Almeida and Marsans were among the first ten men inducted into the Cuban Baseball Hall of Fame in 1939, and the president of Cuba later presented Clark Griffith with a gold medal that read: "He was the first to give an opportunity to Cuban ballplayers in America's great national game."

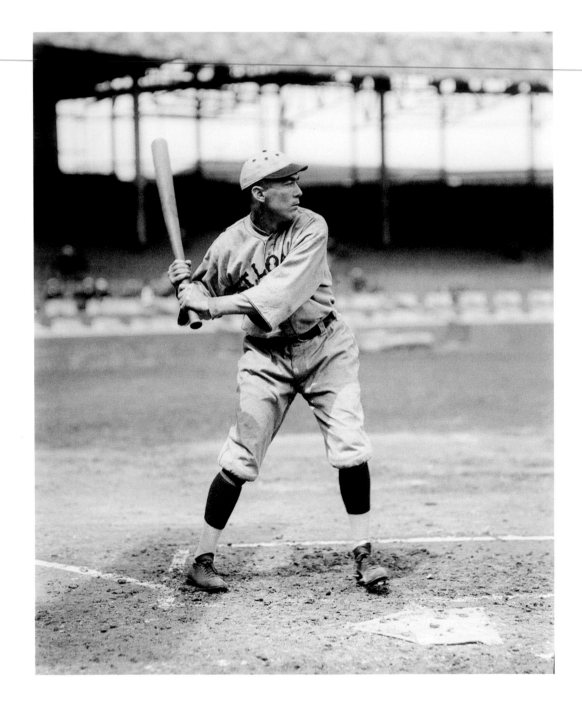

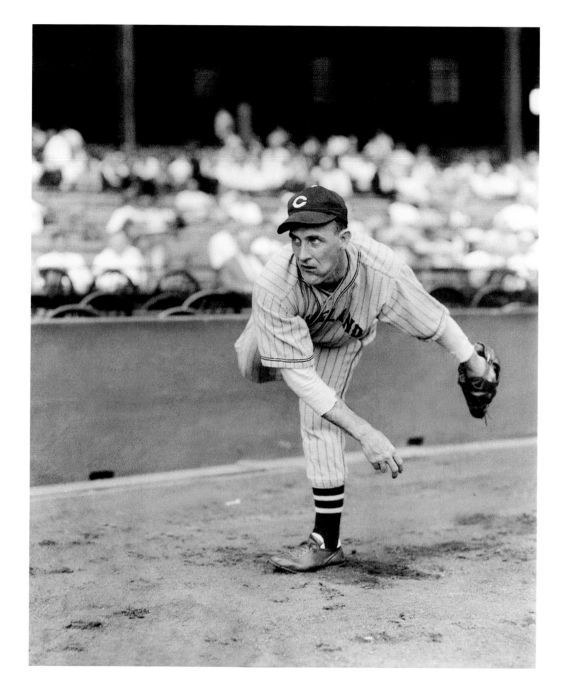

JOHNNY ALLEN
1937 Cleveland Indians

"I had to fight for everything I ever got out of life," said Johnny Allen. "Even as a kid, at the orphanage, it was a case of 'root, hog, or die.'" His aggressive attitude helped make him a winning pitcher for the Yankees, Indians, and Dodgers, but his hair-trigger temper made things tough for his teammates: "That guy thinks he should win every time he pitches," said Lou Gehrig, "and that if he loses it's a personal conspiracy against him." Johnny was also suspicious of the men in blue: "If the umpires let me alone, I'll be all right. Damn, I don't like them umpires." In 1937, the conspirators took their time: Allen won fifteen games in a row before finally losing on the last day of the season, whereupon he threatened to kill his third base-man for costing him the game.

Incredibly, Johnny Allen later became a minor-league umpire: "Maybe I just wanted to show them I could take it as well as I used to dish it out," he theorized.

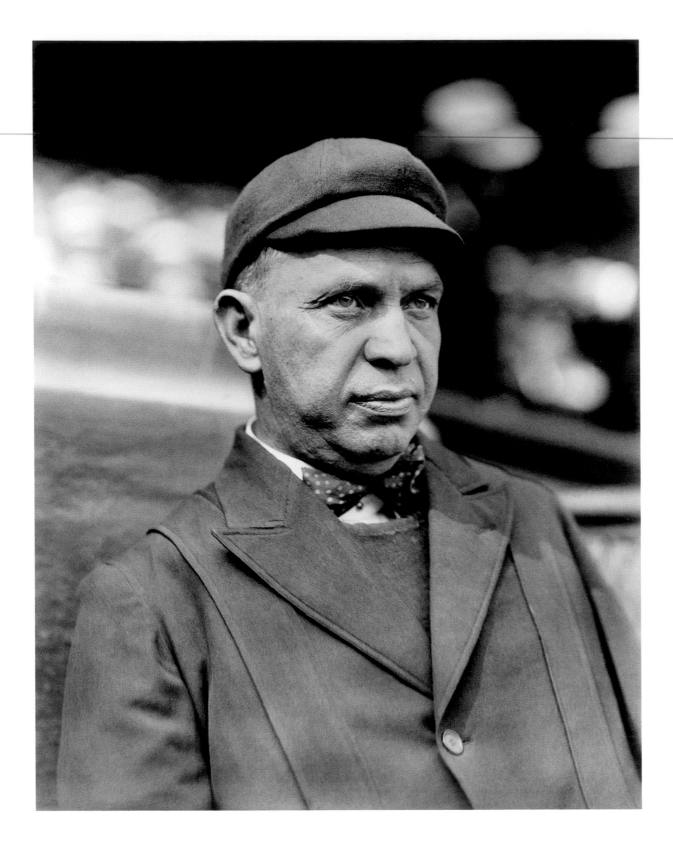

BILL KLEM
c. 1916 National League umpire

"Catfish! How I hated that word! I have a full lower lip, to be sure, but under no circumstances do I feel that I look like a catfish," asserted Bill Klem—although others begged to differ. Ballplayers were immediately ejected from the game if they called him "Catfish," but Bill couldn't eject everybody. One day in 1928, he halted a game three times because "a leather-lunged fan" persisted in shouting "Catfish." Four policemen were finally able to silence the offender, "but when a number of other fans learned the reason for the delay, they bombarded Klem with the term he abhors for the rest of the game," reported the *St. Louis Globe-Democrat*. Called the "Beau Brummel" of umpires by sportswriter Damon Runyon, the autocratic Klem umpired eighteen World Series in his thirty-six-year Hall of Fame career, and he was the oldest major-league umpire ever when he retired at the age of sixty-six in 1940.

"That guy did more for baseball than anybody who ever lived," said Jocko Conlan. "It was a privilege to be traincd by Bill."

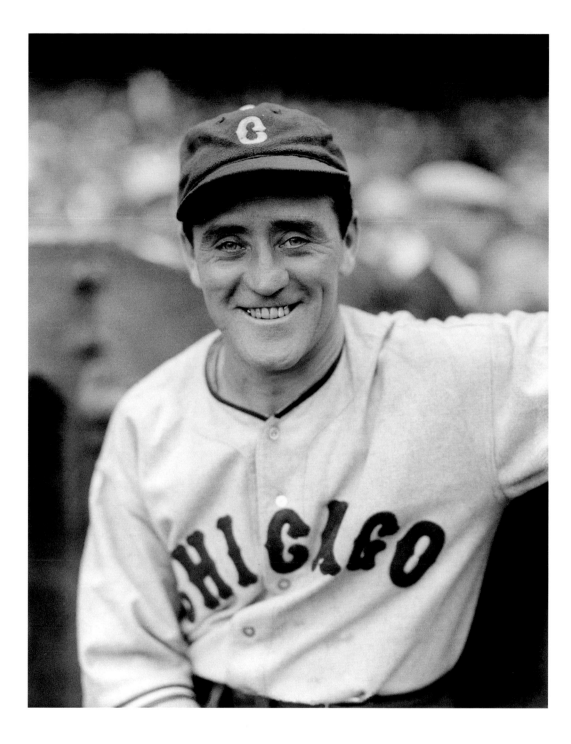

JOCKO CONLAN
1934 Chicago White Sox

"I was a pretty fresh ball player," admitted Jocko Conlan, but one day in July 1934, this jovial benchwarmer was called upon as an unlikely emergency replacement umpire. Jocko realized that he was going nowhere as an outfielder, so he made the bold decision to change careers: "Most players wouldn't have the guts to be an umpire," he contended. "They couldn't take the razzing." In 1941, Conlan returned to the majors as a National League umpire, and Dodgers manager Leo Durocher quickly became his nemesis: "He called me a name," recalled Jocko. "Then he called me everything. It was the closest I ever came to blowing my wig. I begged him. I said, 'Throw one punch at me. Please hit me, you pooch,' I said, 'so I can lick you.' But he just kept calling me names." Conlan, who ran a flower shop in the off-season, withstood the abuse until 1964.

"You are one man who could have umpired in the old days, single-handed," Bill Klem proudly told his protégé. In 1974, Jocko joined his mentor in the Hall of Fame.

GEORGE SISLER *1917 St. Louis Browns*

In 1951, Sisler published an instructional book called *Sisler on Baseball*, in which he offered this advice to young first basemen: "On every close play, stretch as far forward as you can, so that you will catch the ball as early as is humanly possible." But contemporaries observed that "Gorgeous" George's skills seemed almost inhuman: "George Sisler's grace is something to marvel at," wrote Nashville sportswriter R. E. McGill in 1925. "He moves out from first base like a small boat from the shore. He glides out as if he were a perfect mechanical toy moving on noiseless feet through intricate slots.

There is absolutely no wasted effort in Sisler's motions. There is sort of a phantom glide to his run, a soothing grace in his leap, and a catlike quality in his pounces and stretches for the ball."

Joe Kuhel, a major-league first baseman in the 1930s and 1940s, was entranced by Sisler's first-base wizardry as a boy growing up in Cleveland: "When the Browns came to town I never took my eyes off Sisler. I'd watch every move and play he made around first base, and then I'd try to imitate him on the neighborhood sandlot. He was the greatest defensive man around the bag I ever saw."

GEORGE McQUINN
1938 St. Louis Browns

"It has always come natural to me to play first base," said George McQuinn. "My brother bought me a first baseman's mitt when I was five years old. The first two months I wore it to bed with me." When he was twelve, he bought a George Sisler model glove, and he spent much of the 1930s in the New York Yankees farm system being groomed to take Lou Gehrig's place at first base. There was only one problem: Gehrig never missed a game. In 1938, McQuinn finally ended up with the lowly St. Louis Browns, but he was thrilled nonetheless: "It's grand to be in there every day working for a major league club. Yes, and it's good not to be having to wait for Lou Gehrig to break his leg."

In 1941, the *Sporting News* noted that McQuinn was "the closest thing to George Sisler the St. Louis fans have seen—well, since George Sisler." The George McQuinn "Claw" became the most popular first baseman's glove in organized baseball: "McQuinn gets a royalty from the sale of the mitts, and I do, too," said glove designer Harry Latina in 1942. "I got enough to buy myself a brand new Packard just from one year's royalties." President George H. W. Bush, first baseman for Yale in the late 1940s, kept his prized Claw in his desk in the Oval Office.

In 1947, McQuinn finally became the Yankees' starting first baseman, and in 1948, he opened his own sporting goods store, which he ran for the rest of his life.

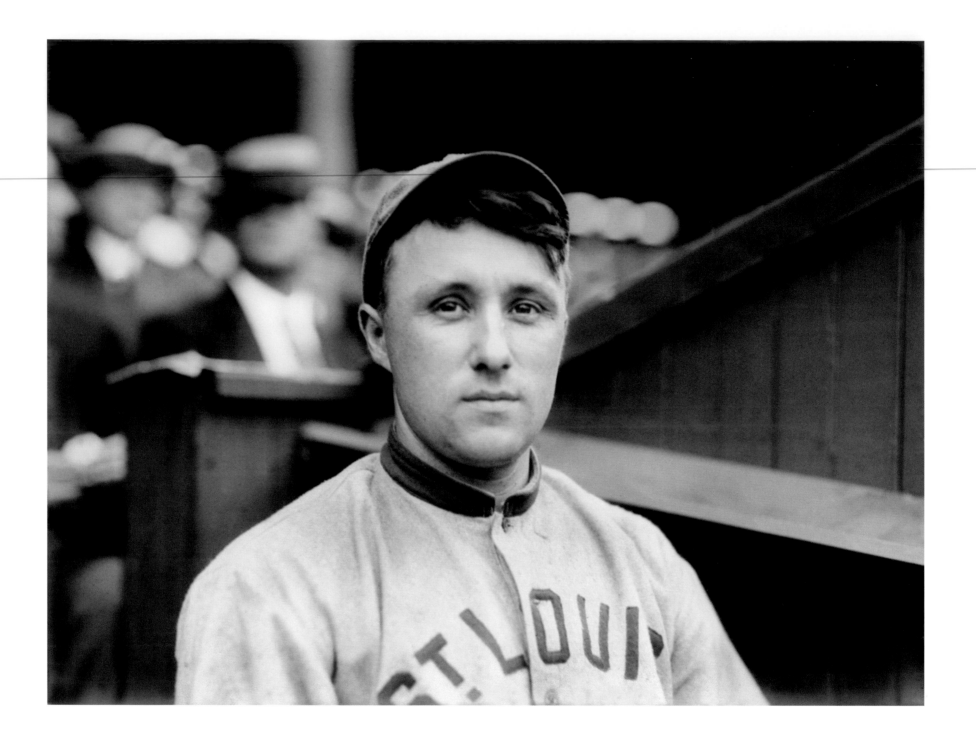

PAUL KRICHELL *1912 St. Louis Browns*

The highlight of this catcher's brief playing career was a joke that fizzled: "Ty Cobb was on first, and pitching for us was some punk out of the bullpen who could not keep Ty from stealing. As Cobb lit out for second, I saw there was no chance to head him off. So, with the game lost, I threw to third and hollered, 'Maybe we can get him there!' It was an attempt on my part to be funny. The next day there was a banner headline saying, 'Krichell Pulls Boner of Season.' That cured me from being funny. Nobody saw the joke except yours truly."

Paul Krichell was a mediocre catcher for a terrible team, but he later became the most famous scout in baseball history, signing scores of New York Yankees, including Hall of Famers Leo Durocher, Phil Rizzuto, and Whitey Ford.

LOU GEHRIG

1927 New York Yankees

Whenever the Yankees traveled between New York and Philadelphia, Paul Krichell tipped his hat as the train passed New Brunswick, New Jersey: "This is where I first saw Lou," he explained. "He was the *big* one—and he fell into my lap." One spring day in 1923, Krichell went to see Columbia play at Rutgers. "I was watching nobody in particular. I saw a big kid wallop the ball all over the place, and, riding back to New York, I was told by Andy Coakley, the Columbia coach, that the boy was a left-handed pitcher named Louie Gehrig. I went back that Saturday to Columbia and saw Gehrig powder the ball against Pennsylvania. That was the day he hit that famous home run to the steps of the library. That was all I had to see, and I'm glad I saw it first."

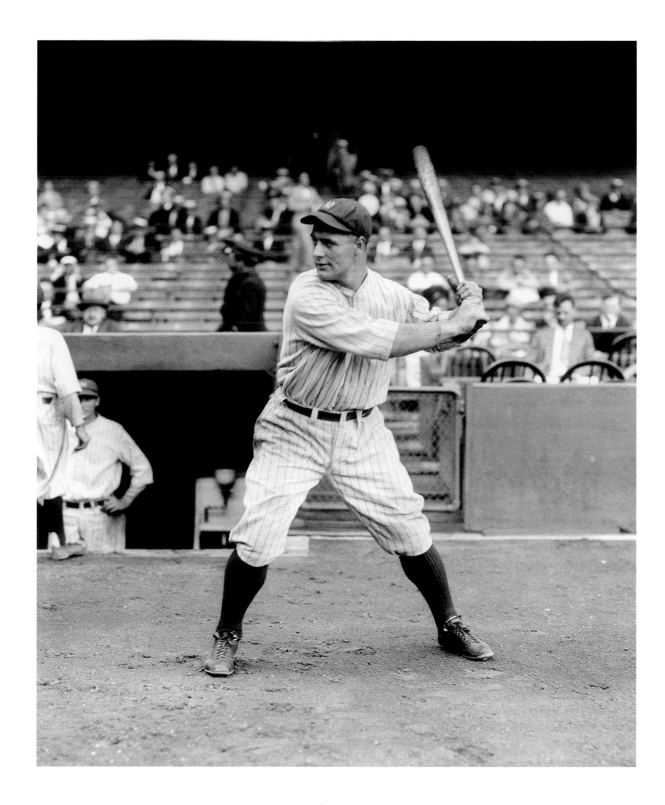

BOB CONNERY
1923 New York Yankees scout

In 1915, St. Louis Cardinals scout Bob Connery discovered an eighteen-year-old shortstop playing in Denison, Texas. "You like to play baseball, don't you, son?" inquired Connery. "I sure do, mister!" the young man exclaimed. "I want to be a big leaguer some day." The scout was impressed: "What I fancy about that kid is that he's full of fire and fight. His nickname is 'Pep,' and I tell you he's full of it." On Connery's recommendation, the Cardinals risked a cool $600 on Rogers Hornsby, who would become the greatest hitter in National League history. Moving to the Yankees as head scout in 1918, Connery helped sign many of the Yankee greats of the 1920s, including Earle Combs, Bob Meusel, and Tony Lazzeri. He also discovered Hall of Famer George Halas, who—although he didn't last long as the Yankees' right-fielder—later became a charter member of the National Football League as player, coach, owner, and "Papa Bear" of the Chicago Bears.

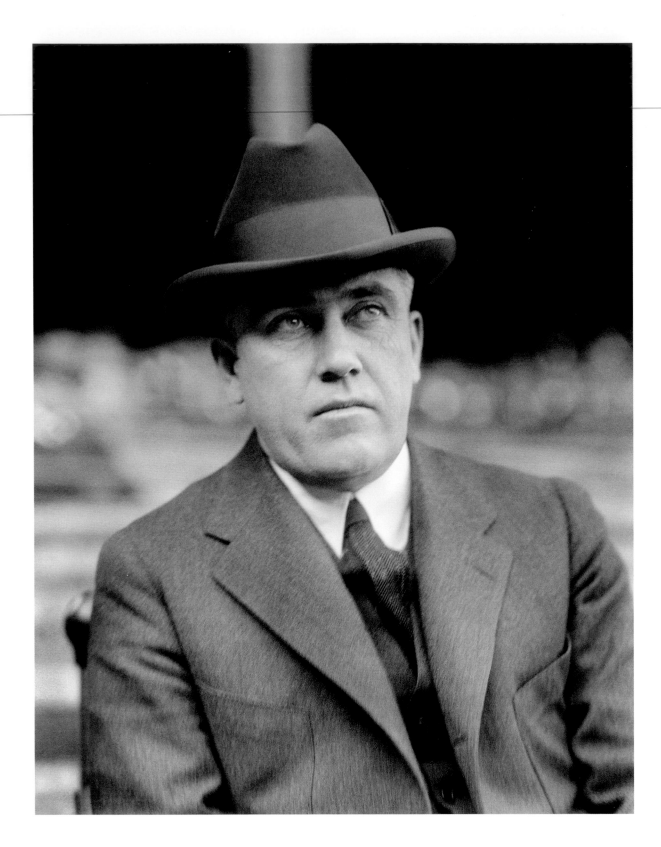

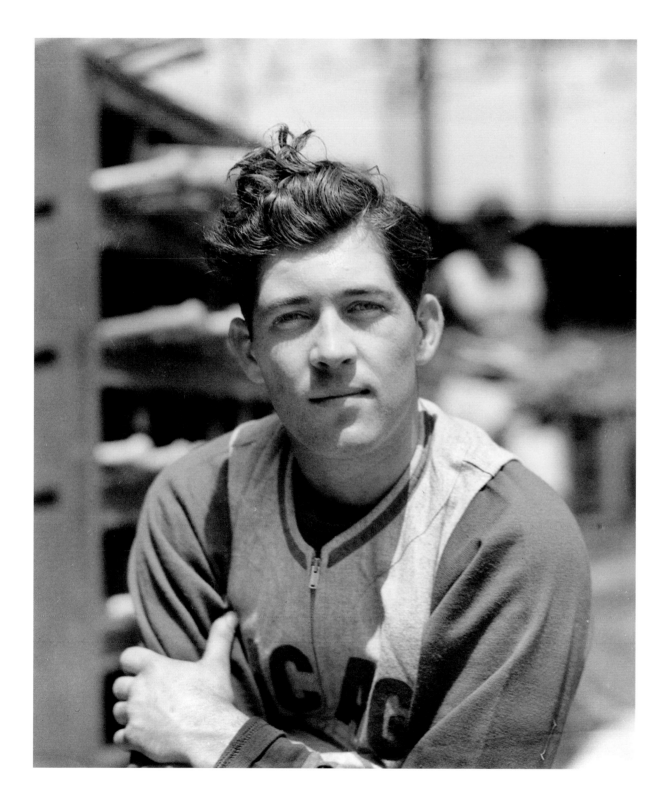

BOBBY MATTICK
1940 Chicago Cubs

In 1936, Bobby Mattick was playing in the Pacific Coast League when a foul ball fractured his skull above the right eye. His vision was permanently affected, rendering his major-league playing career unremarkable—but his subsequent major-league scouting career was brilliant. In 1950, Bobby spotted a promising fourteen-year-old from Oakland, California, who later became the first man to be voted Most Valuable Player in both the National and American Leagues—Frank Robinson. The impressive list of great players scouted or signed by Mattick includes Curt Flood, Vada Pinson, Rusty Staub, Don Baylor, Bobby Grich, and Gary Carter.

When he became manager of the Toronto Blue Jays in 1980, Mattick relaxed team rules regarding length of hair and mustaches: "I don't care if a guy's got hair down to his waist," Bobby declared, "as long as he can play ball."

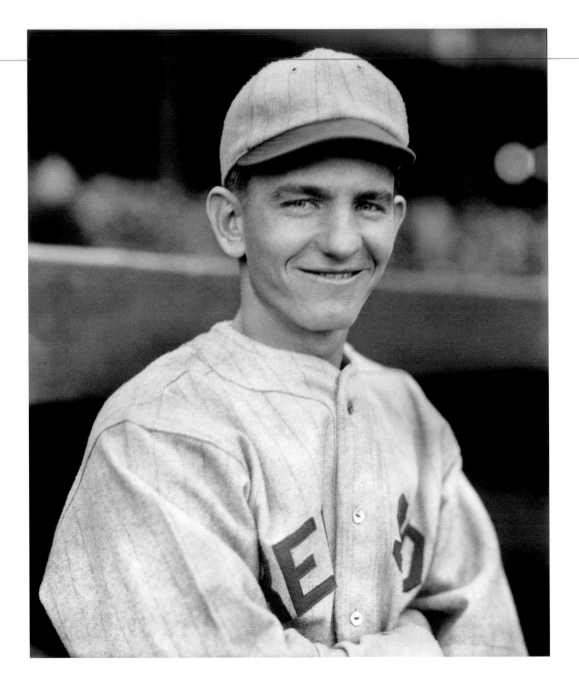

PEE WEE WANNINGER

1927 Boston Red Sox

On May 6, 1925, rookie Pee Wee Wanninger replaced Everett Scott as the New York Yankees' shortstop, ending Scott's all-time-record consecutive games streak at 1,307. On June 1, 1925, Wanninger was replaced in the lineup by pinch hitter Lou Gehrig, who thus began his own all-time-record consecutive games streak, which would last until 1939, finally totaling 2,130 games. Wanninger was soon replaced in the starting lineup by the far more promising Mark Koenig, and in 1926, Pee Wee played shortstop for St. Paul in the American Association.

In 1927, Pee Wee happily returned to the majors as the starting shortstop for the Boston Red Sox. He went 4 for 5 on Opening Day, but again, his job didn't last long: Buddy Myer was acquired in a trade from the Washington Senators on May 2, 1927, and Wanninger was back on the big-league bench for good. Washington owner Clark Griffith later called the Myer trade one of the worst he ever made, and in 1928, he had to give up five Senators—cumulatively worth an astonishing $80,000—to get Buddy back from Boston.

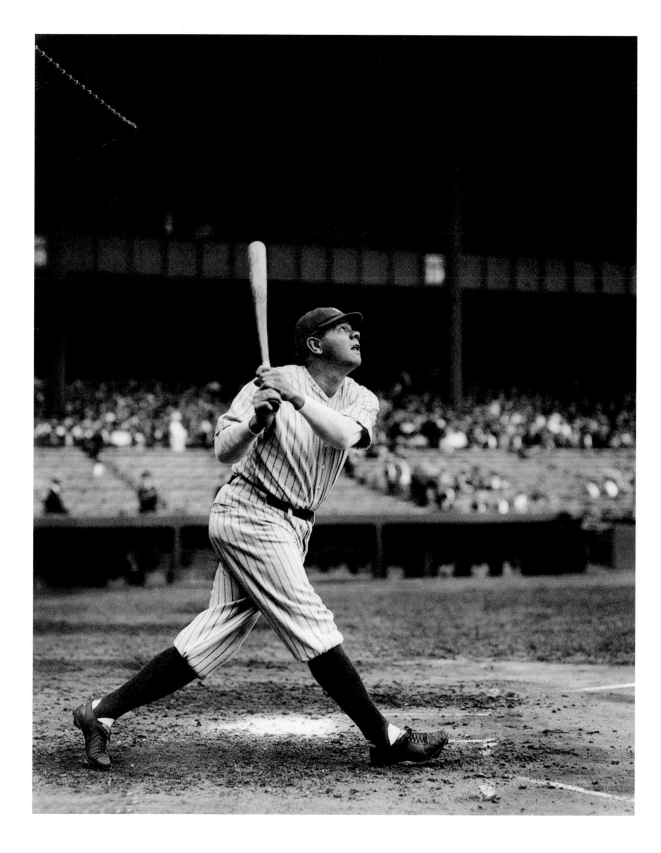

BABE RUTH
1925 New York Yankees

Sportswriter Ring Lardner deplored the changes Babe Ruth and the lively ball brought to the game of baseball: "Baseball hasn't meant much to me since the introduction of the TNT ball," he moaned. But his contemporary on the dead-ball beat, Damon Runyon, was completely won over by the new ball—and by the Babe: "You pay your money to see Babe Ruth knock home runs. Whereupon Babe knocks 'em—towering lifts over the walls, or sharp shots into the bleachers. Other men are hitting home runs this year. Other men have hit home runs in other years. But their home runs are infrequent, and you do not pay your money with the thought that they will hit home runs. They *may*. You feel that Ruth *will*. And Ruth *does*."

"Whether the ball is dead or lively, if you hit it right, it will go," explained Babe Ruth. In this picture he appears to have hit it right.

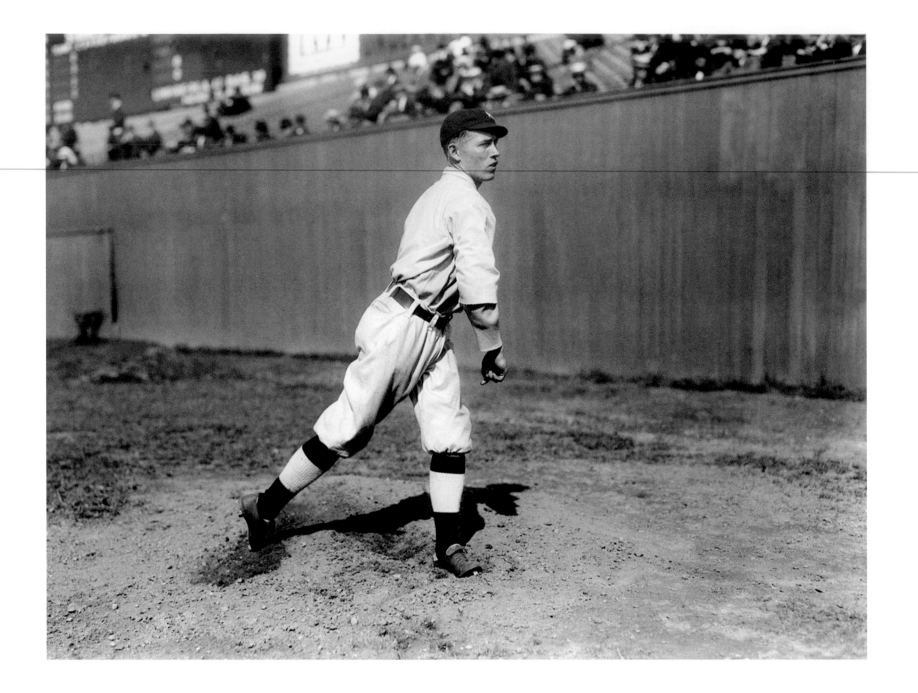

JACK WARHOP *c. 1914 New York Yankees*

On May 6, 1915, Babe Ruth hit his first major-league home run here at the Polo Grounds: "I'm glad that Babe hit his first home run off me," said pitcher Jack Warhop. "If I felt badly about it at the time, as most pitchers do, I certainly had every reason to take a more cheerful view in later years. He was going to hit 714 of them, so there is no disgrace in letting him have one." Warhop saw Babe Ruth for the last time in 1935: "He was closing his career with the Braves, and they brought me up to Boston for the twentieth anniversary of that homer. Babe knew who I was because they told him why I was there, and when I left he said, 'Kid, I'll see you again twenty years from now.' I'll never forget hearing him try to talk over the radio on that Day they had for him just before he died. When I remembered him in his prime and then heard what his voice sounded like, I knew he wasn't going to make it, and I just sat down in front of the radio and cried."

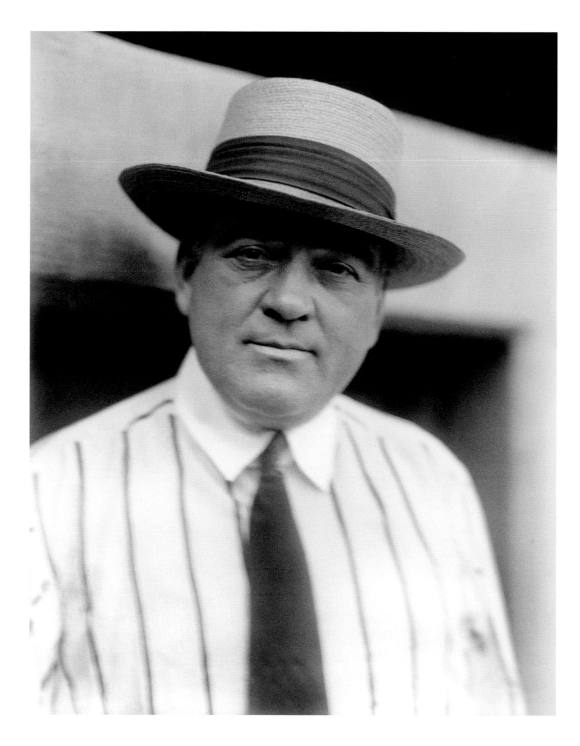

ED BARROW
1918 Boston Red Sox

NO UNIFORM FOR BARROW, headlined the *St. Louis Post-Dispatch* in 1918: "The Red Sox pilot appeared yesterday decked out in dark trousers, blue shirt and stiff collar. He directs the team from the bench in this attire."

The *Chicago Tribune* spotted this offbeat ensemble: "Manager Barrow of the Red Sox wears part uniform and part street clothes while on the job. He appears in a baseball shirt, street pants, tennis shoes, and a golf cap." In New York, Ed modeled a summer chapeau for Conlon.

In 1918, after much hesitation, this manager converted pitcher Babe Ruth into an outfielder. His reluctance seems ridiculous in retrospect, but Ruth had been one of the greatest pitchers in baseball history, and the move was still controversial a year later when anxious experts were still trying to convince Ed Barrow to convert the Babe *back* to a full-time pitcher: "Ruth's friends have all along felt that he was abandoning a position in which he was an undoubted star, to experiment in another position where it was not certain that he would shine so brilliantly, if at all—in other words, passing up a sure thing for a gamble," reported the *Boston Globe* in May 1919. "He will get into some games when he is not pitching, and Barrow will always have an ace in the hole when it comes to pinch hitting."

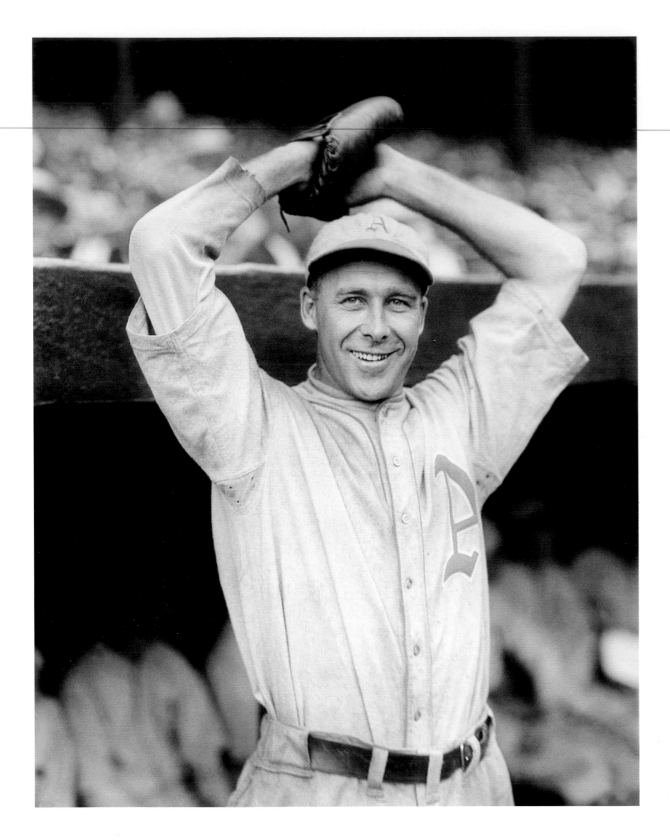

RUBE WALBERG
1929 Philadelphia Athletics

In 1948, the dying Babe Ruth came alive at the mention of this man's name: "Walberg! Walberg! What a cousin! Seventeen home runs I hit off him!" He served up more homers to Babe Ruth than any other pitcher in history, but even the beleaguered Rube Walberg stood in awe as they flew out of the park: "You could almost tell by the sound," he recalled, "but you always had to look around anyway."

HUB PRUETT
1922 St. Louis Browns

In 1922, Babe Ruth faced pitcher Hub Pruett in thirteen official at-bats . . . and struck out ten times: "All I did was swing at his motion," recalled Ruth. "He was an octopus pitcher, one of those guys who throws everything at you except the ball." Pruett's screwball was the reason for his uncanny success against Ruth, but Hub injured himself one day while throwing the pitch: "After I hurt the arm, pitching became drudgery. The arm would hurt so much I'd have to tie a pillow to it in order to get some sleep—but I never could have made it through medical school without my baseball earnings." Pruett pitched until he received his M.D. from St. Louis University in 1932, and the obstetrician/gynecologist got a chance to thank his benefactor in 1948: "I went up and introduced myself and said, 'Thanks, Babe, for putting me through medical school. If it hadn't been for you, nobody would ever have heard of me.' The Babe remembered me. He said, 'That's all right, kid, but I'm glad there weren't many more like you, or no one would have heard of *me*.'"

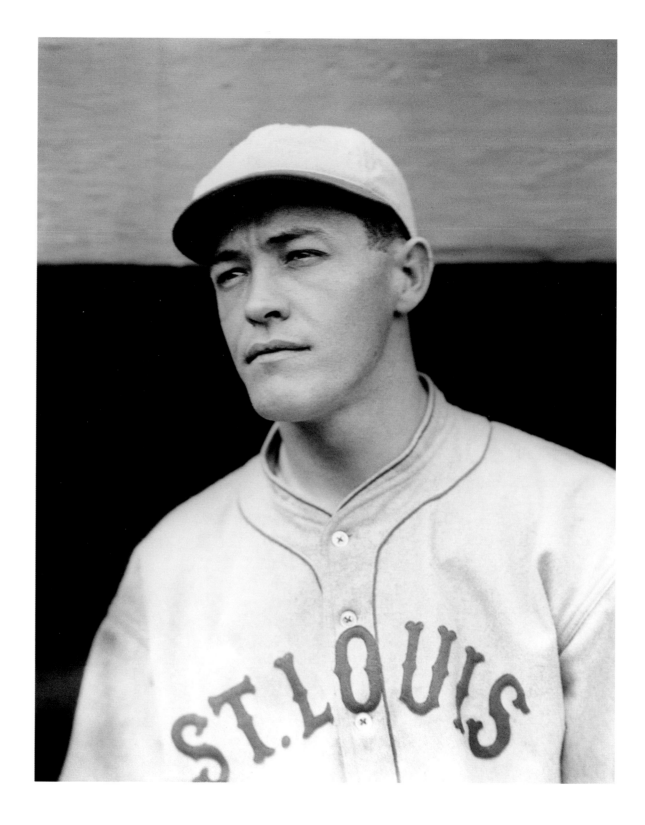

GUY BUSH
1935 Pittsburgh Pirates

"This slender and sinister slinger from the Mississippi swamps is the perfect Hollywood type for a showboat gambler with his piercing eyes, his sallow complexion, his sideburns and his plastered black hair," observed sportswriter Tommy Holmes in 1934.

On May 25, 1935, in Pittsburgh, Guy Bush surrendered Babe Ruth's last home run: "I meant to throw three fast balls by him and watch the crowd laugh while he swung. The first one I threw was just a tiny bit outside and he looked it over like it was a softball. He looked me right in the eye and I nodded 'yeah' to him, and threw another one right in the same spot. That big joker hit it clear out of the ball park. It was the longest homer I'd ever seen. I tipped my hat and hollered to him, 'Babe, now I've seen everything in baseball.' As he went around third he grinned at me and gave me the hand sign meaning 'to hell with you.' He was better than me. He was the best that ever lived."

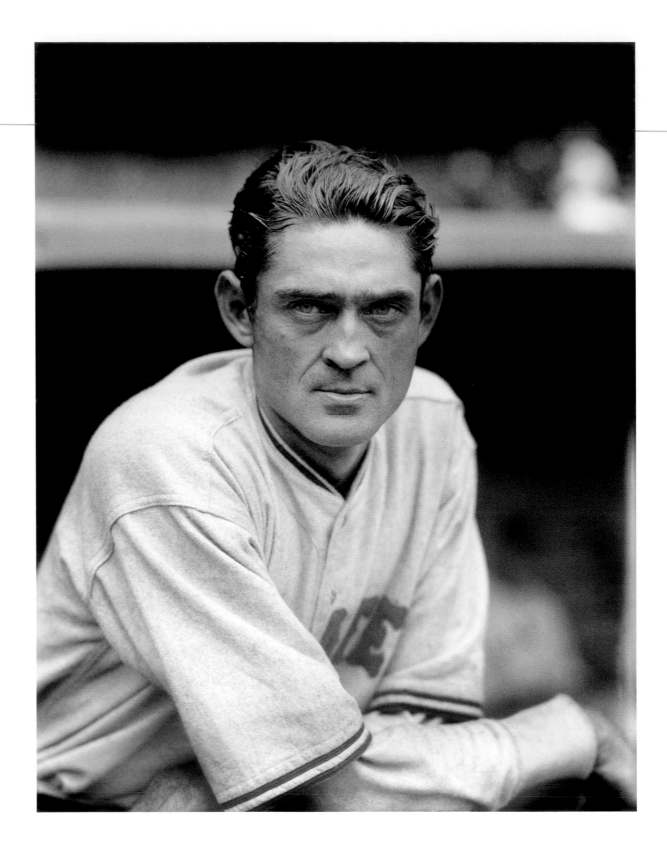

DUFFY LEWIS
1912 Boston Red Sox

On July 11, 1914, this outfielder became the only man ever to bat for Babe Ruth: "It didn't seem like anything big at the time, but over the years it became funnier and funnier, me pinch-hitting for the Babe. I got a hit, too." The next year, Lewis saw Ruth's first major-league home run. In 1935, he was a coach for the Boston Braves when he witnessed Ruth's last home run, and in 1954, he was the Milwaukee Braves' traveling secretary when Hank Aaron hit his first major-league home run: "Whether I saw it or not, I don't know. I might have been watching or I might have been busy doing something."

"Lewis could hit Walter Johnson in the middle of the night, blindfolded," recalled catcher Gabby Street. "I don't see how he got around on that speed but he did. He was the only one who really could do anything with Walter. 'Give him a duster, shake him up, drive him back,' I used to plead with him. But Walter would just shake his head. 'No,' he would say in that quiet way of his, 'if I've got to win ball games by those methods, I'd rather lose 'em.'"

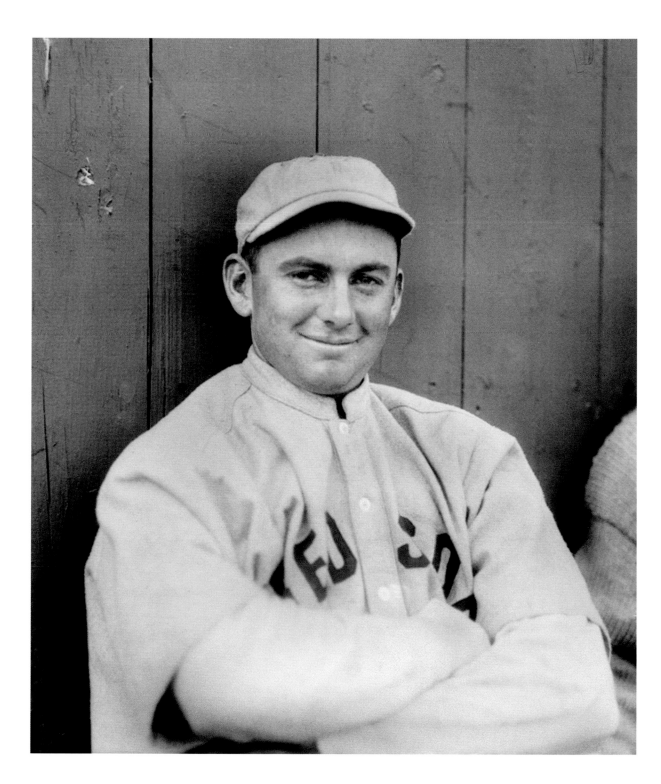

39

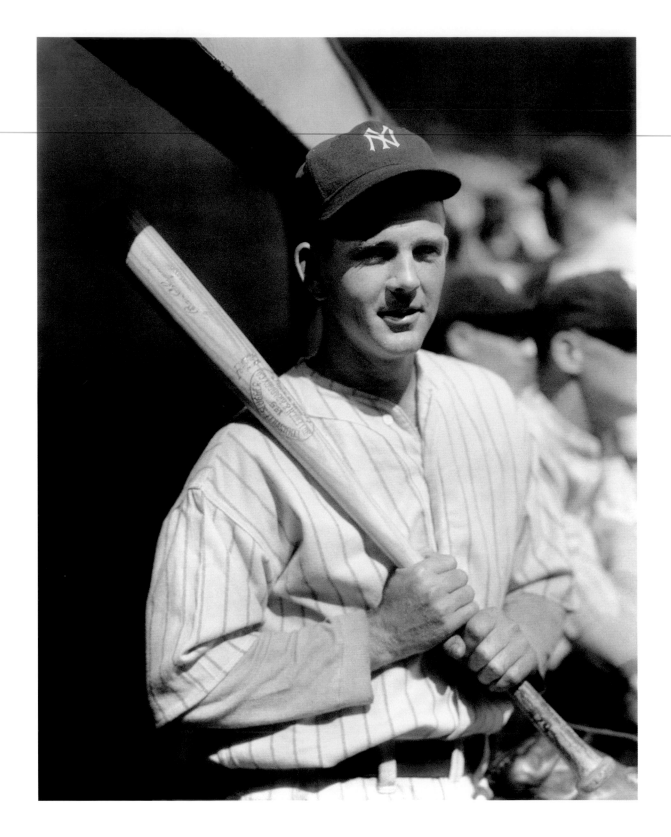

SAMMY BYRD
1932 New York Yankees

"Babe Ruth can hardly stoop, and when he runs after a fly ball he merely jogs," reported a Pittsburgh sportswriter during the 1932 World Series. In the last inning of the Series, Ruth's "ailing dogs" were finally replaced in right field by Sammy Byrd, the man who substituted for the gimpy Bambino so often that he became known as "Babe Ruth's Legs."

"I was Ruth's favorite golf partner," recalled Byrd, "and whenever we had an off day or a rainout, he and I would head for the nearest course." In 1934, Ruth offered this expert assessment of his partner: "That boy can hit a golf ball as well as any pro in the business. You just watch him." In 1936, at the age of twenty-nine, Sammy quit baseball to become a professional golfer, and he went on to win twenty-three tournaments in his career. His greatest thrill was winning the Victory Open at Chicago in 1943: "I was red hot and ran away and hid from the field—just some palookas named Ben Hogan, Byron Nelson and Craig Wood."

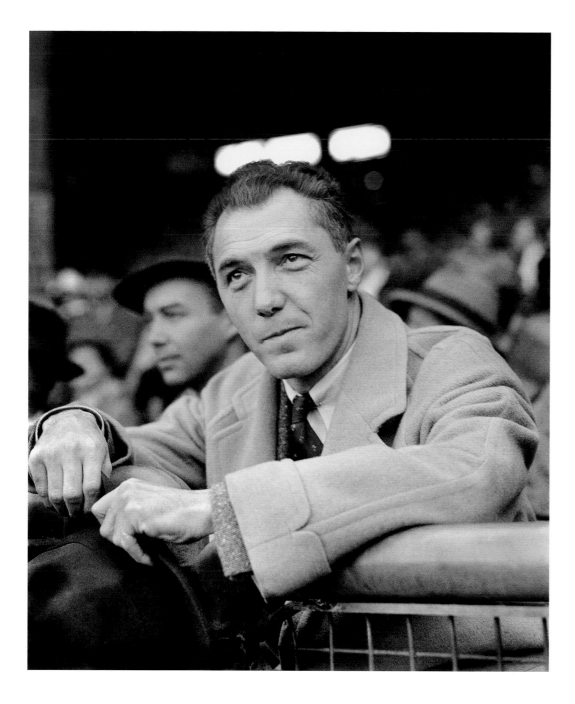

FORD FRICK
1938 National League president

"He is thinnish, and darkish, and very much alive," wrote Damon Runyon in 1934. "He has intelligence, and culture. If the somewhat moribund magnates of the National League let him alone, he will make a splendid executive. If they do not let him alone, Ford Frick can always go back to a very nice newspaper job." Frick was "Babe Ruth's Ghost," the man who wrote the words that appeared under Ruth's byline for much of the 1920s, including the text of *Babe Ruth's Own Book of Baseball* (1928), for which Charles M. Conlon anonymously supplied one-third of the photographs. Frick, one of the prime movers behind the establishment of the Baseball Hall of Fame at Cooperstown, was elected commissioner of baseball in 1951. In the latter position he became a somewhat moribund magnate himself, most memorably with his controversial decree that Ruth's all-time season record of sixty home runs in 1927 had not been superseded by the sixty-one home runs hit by Roger Maris in 1961.

BABE RUTH
1938 Brooklyn Dodgers

"Sure, I'd like to get back into baseball," said Babe Ruth in 1937. "I think I'd make a good manager. My habits are steady, my health is perfect. I know men, I know batters, and I know pitchers." In 1938, he returned to baseball as the Dodgers' first base coach: "It's good to have that fat old bum back, now ain't it?" said former teammate Tony Lazzeri. "Sure, I'd like to be a manager, but I guess I gotta wait awhile," said Ruth. But he soon came to the bitter realization that the Dodgers had no plans to make him their manager. He was merely a washed-up performer in a freak show, a fat old bum employed to flail away during batting practice, and at season's end, the humiliated Ruth retired from baseball forever.

"Nobody knows what kind of manager I would have made," said Ruth in 1946. "Today, I'm not sore at anybody, but I still think I should have had my chance. Speaker and Cobb had theirs, and I guess it was natural that I should expect a crack at managing some day. But I didn't, and that's that."

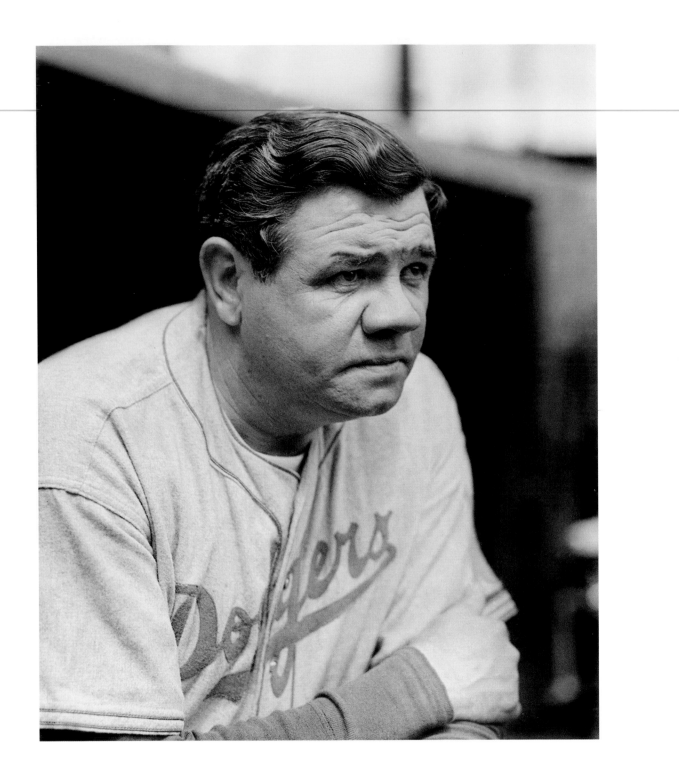

AMOS RUSIE
1922 Polo Grounds superintendent

This former Giant had fallen on hard times when Conlon took his picture, but Amos Rusie had once been the "Hoosier Thunderbolt," the fastest pitcher in baseball: "When I began in league ball the pitcher's box was only fifty feet from the plate, and the pitcher was allowed to take two steps. My catcher used a slab of lead in the palm of his hand, covered by a handkerchief and a sponge, along with his catcher's glove. I was told that the box was moved back to fifty-five feet, and then to sixty feet, largely on account of my speed." The intimidating Rusie was as wild as he was fast, striking out 208 batters in 1893, while walking 218—still the major-league record for bases on balls in a season. Apprehensive hitters were greatly relieved when Rusie sat out the entire 1896 season because of a salary dispute. After similar squabbles caused him to miss the 1899 and 1900 seasons, the Giants traded Rusie away in exchange for a promising college lad named Christy Mathewson.

In 1921, John McGraw hired the destitute Rusie as an assistant night watchman at the Polo Grounds, benevolently disguising the humble make-work job with an exalted title.

BOB FELLER
1937 Cleveland Indians

When sixty-three-year-old umpire Bill Klem first saw Bob Feller pitch in an exhibition game in the spring of 1937, the "Old Arbitrator" was flabbergasted: "Feller showed me stuff the like of which I've never seen in all my life. I expected to see plenty, but I never dreamed an 18-year-old kid could pitch like that. His curve was as fast as most pitchers' fast balls. There's nothing compared to Feller's pitching. You can't overdo that. It was one of the thrills of all time to see that boy deliver the ball that day."

Cy Young was also impressed by the youngster, although he admitted to a conflict of interest: "Bob Feller is the best pitcher I've seen among the modern boys. He was crude when he started because he had a hitch in his delivery, but he overcame that. I don't want to sound like I'm bragging about myself, but Feller wasn't as fast as Walter Johnson or myself."

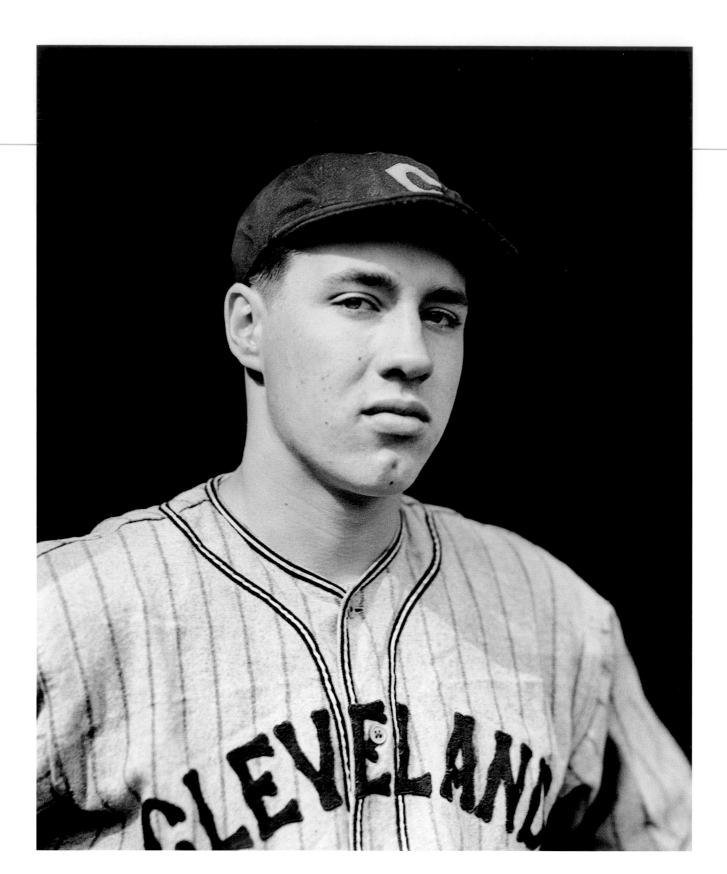

WALTER JOHNSON
1916 Washington Senators

In 1907, umpire Billy Evans was behind the plate for Johnson's first major-league game: "Walter had such blinding speed that he was the only pitcher I ever saw who made me instinctively shut my eyes. I tried hard to keep peering at the ball but I couldn't help myself. I umpired behind that man for nearly 20 years. During that time I must have called many balls on pitches that were a fraction of an inch inside. But he was willing to accept them as I called them. Not once in those many years did he as much as lift an eyebrow to question a single decision."

"He was the only player I ever knew who never complained of an ache or pain," recalled Washington trainer Mike Martin. "And only once in my time with the Senators do I recall Walter questioning a ball-and-strike decision. With the count 3 and 2 on the batter, the Big Train put the pitch right down the middle and umpire Tommy Connolly called it a ball. 'Goodness gracious,' said Walter, 'what was the matter with that ball?' Then he fanned the next batter to retire the side."

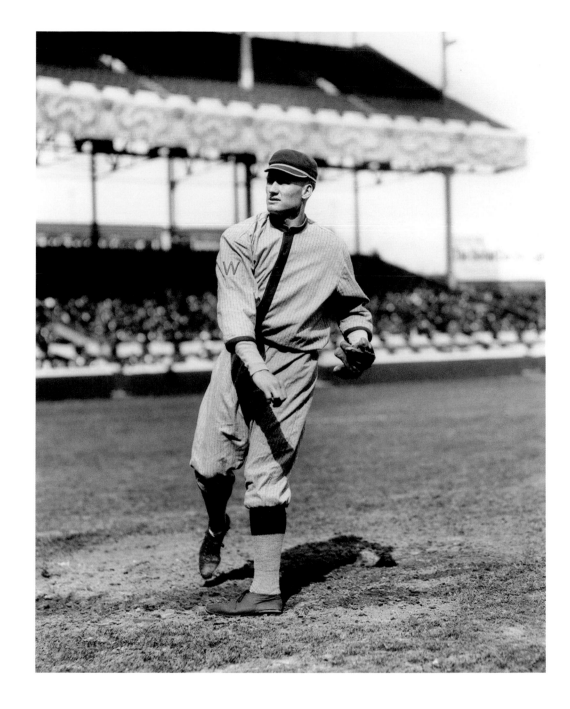

CY WILLIAMS

1923 Philadelphia Phillies

In 1908, Williams graduated with a degree in architecture from Notre Dame, where he played not for, but *with* Knute Rockne on the football team. When Cy's nineteen-year major league baseball career ended in 1930, the ex-outfielder became prominent in Wisconsin as a designer and builder of homes, banks, theaters, and hotels—a second career that lasted until his retirement in 1972 at the age of eighty-four.

"I can't ever remember seeing Williams hit to left unless it was by accident," recalled manager Bill McKechnie. In 1925, the *Philadelphia Inquirer* described the original "Williams shift": "Whenever Cy comes up, opposing teams shift their infield and outer works. Every fielder moves over to right field."

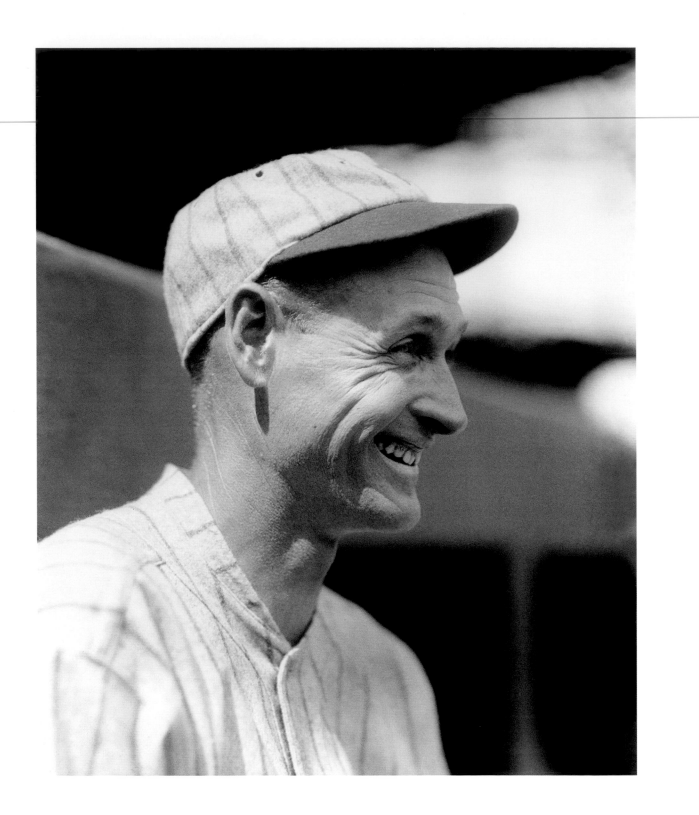

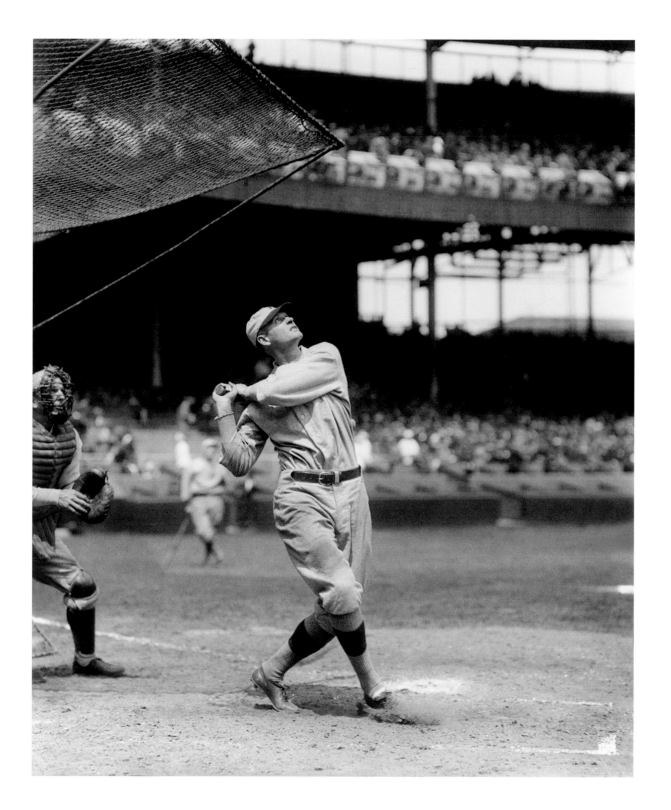

CY WILLIAMS
1924 Philadelphia Phillies

"I tried a thousand ways to hit that ball into left field, but I just couldn't make it go," Cy explained. "Maybe Lou Boudreau thought he was doing something new when he switched his whole infield over to the right for Ted Williams. Well, back in the days when I played, they used to do the same thing for me. It used to get my goat, too, and I imagine that's what happened to Ted. Why, when we used to play the Cubs, manager Fred Mitchell would move his shortstop Charlie Hollocher around past second and his center fielder clear into right field. I couldn't do much about it either. No matter how I tried, I just couldn't hit to left field."

But Cy *could* hit to right—especially here at his favorite ballpark, the cozy Polo Grounds. In 1926, he became the first National Leaguer to hit two hundred career home runs, and when he retired in 1930 he was second only to Babe Ruth in career homers—565 to 251.

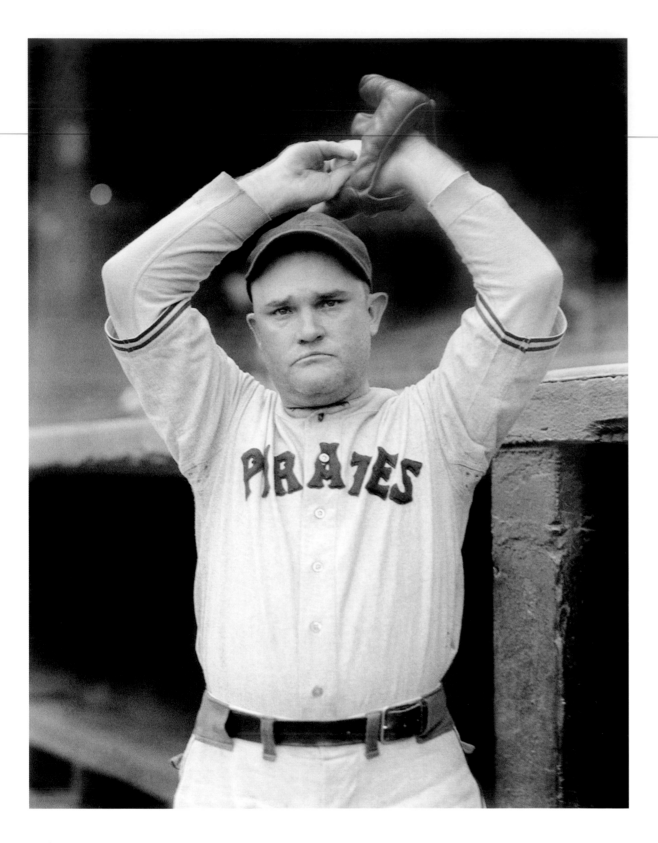

RED LUCAS
1936 Pittsburgh Pirates

"Nobody ever pinch-hit for Red—nobody," declared this pitcher. "What's the secret of my pinch-hitting? I know I'm going to hit the ball and I do. Perhaps the thing that helps me most is the fact that I came up as a kid playing nearly every position on the team, and hitting was the most important thing of all. I wasn't regarded as a pitcher. I didn't have time to acquire this present-day 'complex' of pitchers being unable to hit." In 1933, he broke Bob Fothergill's record for career pinch hits, and when he retired in 1938, Lucas had a total of 114 career pinch hits, a major-league record that would stand until 1965.

"He swings menacingly from the left side of the plate," reported the *St. Louis Post-Dispatch* in 1929. "In fact, he could hardly be as menacing as he looks, with his back half-turned to the opposing pitcher, his chin thrust outward toward the box, and his long bat swinging back and forth in long aggressive sweeps before the pitcher winds up. And frequently he carries out that impression with a clothesline smash over the infield."

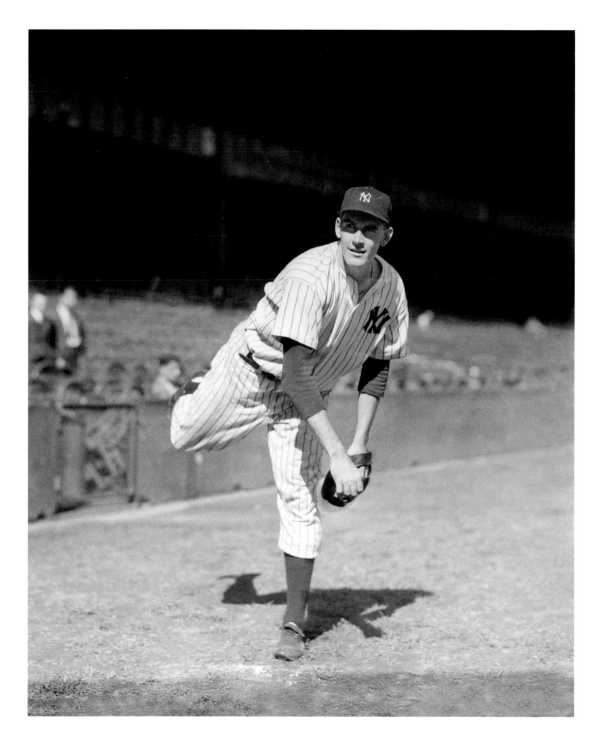

JOHNNY LINDELL
1942 New York Yankees

Lindell had a phenomenal 24-3 record with the Newark Bears in 1941, but he flopped with the Yanks in '42: "When I came up with the Yankees it was tough for a young pitcher to break in. I was called on so seldom I became rusty and my control went. They used me mostly as a pinch hitter." But Johnny became a wartime regular in 1943: "I break out in goose pimples every time I think of it. Just imagine—the right fielder of the Yankees—me, out there where Ruth used to play." He batted .500 in the 1947 World Series, but the outfielder still enjoyed practicing the pitcher's art: "I'd fool around with the knuckler while warming up on the sidelines before game time. I was throwing it every day, all the time I was with the Yankees. I remember a lot of guys giving me hell for throwing it to them, too. Nobody likes to catch knucklers." His big-league career seemed to have ended in 1950, but he made a surprising comeback as a knuckleballer in 1953, when, alas, with a 6-17 record and a sore arm, Johnny's luck finally wobbled away.

LEFTY O'DOUL

1930 Philadelphia Phillies

One day in 1929, Lefty O'Doul went 5 for 5: "That day, I was wearin' a green suit. Next day, I'm 3 for 4. Still wearin' my green suit. I can't keep wearing the same suit all the time, so I go out and buy myself a second green suit. Well, to make a long story short, I hit .398 that season and I got nothin' but green suits. Only eight men in history ever hit .400 or better. I'm next in line. I got the highest lifetime battin' average of any livin' ball player—.349. The three who were ahead of me—Hornsby, Cobb, and Jackson—all kicked the bucket. Yeah, I liked green suits."

O'Doul became an outfielder after hurting his pitching arm, and he always threw poorly—although not as poorly as actor Gary Cooper: "He threw the ball like an old woman tossing a hot biscuit," said Lefty, who had the unenviable task of coaching Cooper for his role as Lou Gehrig in *The Pride of the Yankees*.

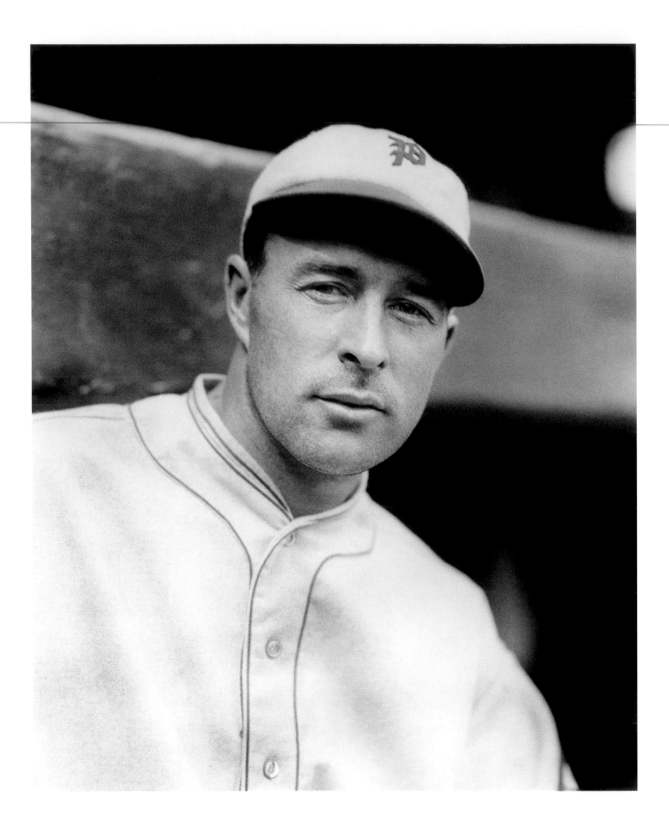

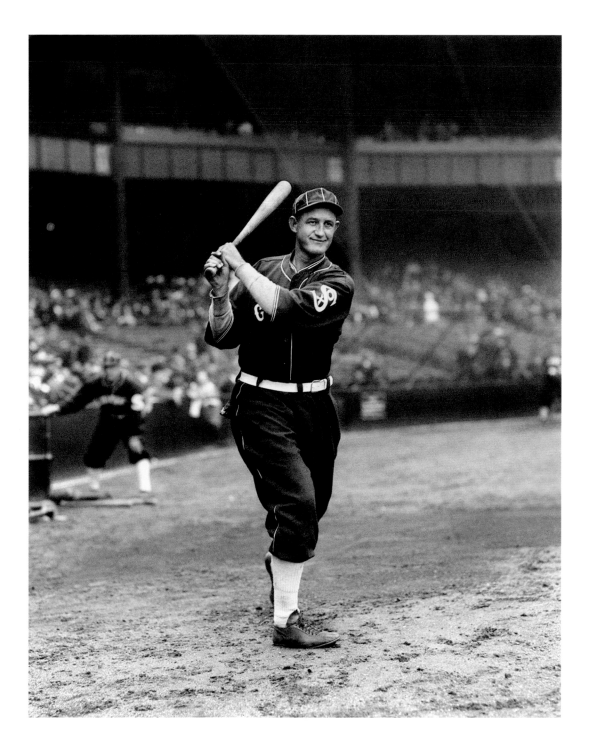

SMEAD JOLLEY
1930 Chicago White Sox

In the spring of 1930, this rookie hit a ball so hard it nearly killed a lineman working on a telephone pole beyond the center field flagpole: "The workman whirled about his perch," reported the *Chicago Tribune*, "but his life was saved by a safety strap." A lifetime .366 hitter in the minor leagues, Jolley would have made it into the Hall of Fame had it not been for one insurmountable roadblock: "He played the outfield like a kid chasing soap bubbles," recalled teammate Johnny Riddle. "He couldn't catch a fly ball if the franchise depended on it," said Washington coach Al Schacht. "Smead literally couldn't field," explained Red Sox manager Marty McManus. When Smead did catch a fly ball, he was often in a sitting position, and when he wasn't kicking the ball or letting it roll between his legs, he was throwing it into the stands. His atrocious fielding short-circuited his big-league career in 1933, exactly forty years before the American League introduced the designated hitter.

HAL SCHUMACHER
1932 New York Giants

When Schumacher received his psychology degree from St. Lawrence University in June 1933, every member of the Giants attended his graduation ceremony. He spent his entire thirteen-year career with the team, pitching in three World Series: "I had a big decision to make when I realized that my pitching days were over—the bat business or law school." Schumacher became vice president in charge of sales for Adirondack Bats: "The first endorsement I got from a major leaguer was Bobby Thomson's. Give college loyalty an assist on that. He and I both went to St. Lawrence upstate." In 1951, Thomson's "miracle homer" won the pennant for the Giants: "The next day every paper in the country had a picture of him kissing the bat. And there was our label for everybody to see."

In 1934, Hal hit six home runs to set the National League single-season record for pitchers: "If I had a chance to bat all over again, I'd use a thin handle bat with more whip in it than the bats I used. Maybe if I did I'd still hold that record."

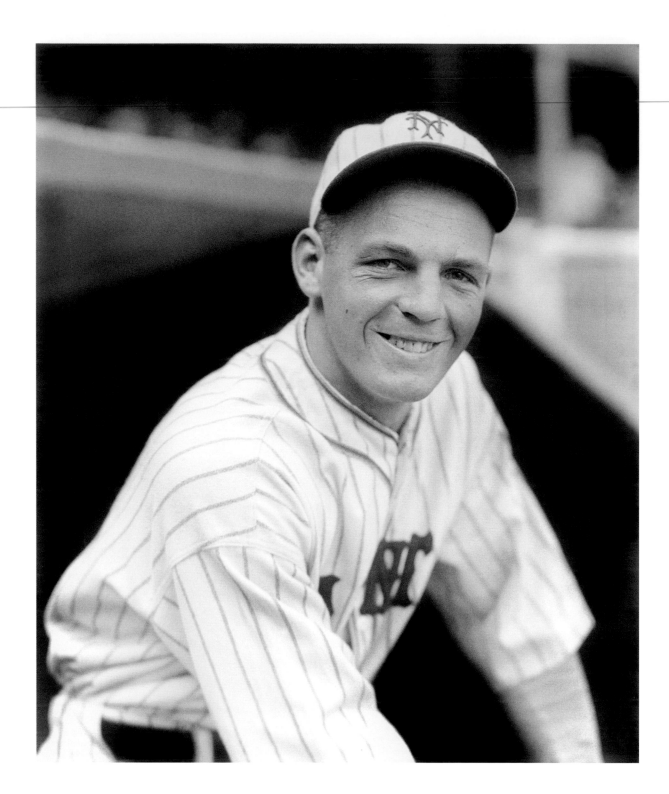

EDD ROUSH *1917 Cincinnati Reds*

"Everybody thinks Ruth swung the heaviest bat, but they're wrong," declared John Hillerich, president of the company that made Louisville Sluggers. "Ruth used 42-ounce bats, compared to Roush's 48-ounce bats. The Babe would order two or three 50-ounce bats each spring, but he used them only for exercise. Roush used 48-ounce bats consistently."

But Edd claimed that anyone could swing his bat: "How much strength is needed to swing three pounds of wood? All you had to do was throw that timber against the ball. The only time I ever won an argument from John McGraw was when I was a fresh rookie and he came into the dugout one day and picked up my bat. He hefted it

for a while, then turned to me and said, 'I don't want you to use this bat anymore. It's too heavy for you.' I blurted out, 'I can hit all right with it.' He turned on me and snarled, 'What league did you ever hit .300 in?' I shot right back, 'I hit .300 in every league I ever played in, and I'm going to hit .300 in this league, too, and with that bat you're holding.' He let me keep the bat and that's the last I heard of it."

Roush went on to lead the National League in batting twice: "I'd have won more batting championships, too, if that fellow Rogers Hornsby hadn't come along just as I was getting good. I would hit .352 and still finish second."

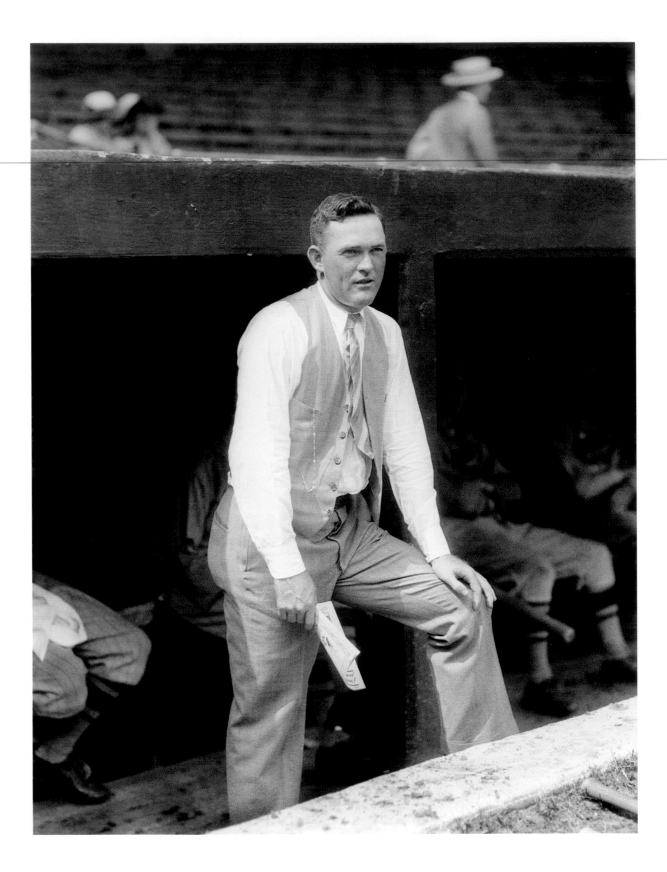

ROGERS HORNSBY
1926 St. Louis Cardinals

Second baseman Hornsby was a playing manager, but when the Cardinals arrived at the Polo Grounds on July 30, 1926, he was in street clothes, "a carbuncle having been carved out of his thigh," as the *Sporting News* delicately put it. His team dropped four out of five to the Giants, and the manager could sit on the bench no longer: "It got on his nerves. He was like an alley bull terrier suddenly put on a leash. And his team's results were more aggravating than his condition." When the team moved to Brooklyn on August 4, Hornsby put himself back in the lineup: "Six games were played with the Robins, and the Cardinals swept through every one of them. Hornsby is a great inspiration to the team. There is more confidence in the men when he is on the field, well or ailing. They think he is the 'best fellow they have worked for.' They know they are working for Hornsby. They know he is the boss. But they like it."

ROGERS HORNSBY
1934 St. Louis Browns

In 1926, Hornsby managed the Cardinals to the first St. Louis pennant since 1888, and then led them to a dramatic World Series victory, but after a bitter contract dispute he was traded away. By 1934, Hornsby was managing the sixth-place St. Louis Browns: "We have too many humptie-dumpties on this club," he complained. After five miserable seasons with the Browns in the 1930s, Hornsby made a disastrous, short-lived return as manager in 1952. "It's like a laboratory, a big league dugout," he told the press, but this new generation of Brownie humptie-dumpties had no desire to be subjected to Dr. Hornsby's experiments: "It's nice to get away from that man. It's like being let out of prison," said pitcher Lou Sleater, who had the good luck to be traded away by Hornsby. When Bill Veeck fired Hornsby in June 1952, the team presented the Browns' owner with a loving cup, but the hard-boiled Hornsby was unrepentant: "I wasn't a fellow running around with a lollipop in my hand and kissing them after they won a game or got a hit," he sneered.

ROLLIE HEMSLEY
1928 Pittsburgh Pirates

Hemsley was a talented All-Star catcher, but off the field he was the notorious "Rollicking Rollie," a violent, pugnacious alcoholic: "You know, a fellow can't be in his right mind when he's drinking the way I drank. I dare say that in my time I have had 2,000 fistfights. Hornsby made me catch a doubleheader with Detroit one hot Sunday afternoon when one eye was swollen shut and the other was closing fast. It was murder."

By April 1939, Hemsley was a tortured soul on a train ride straight to hell: "Why, the guy was right in my berth from midnight to 4 o'clock this morning," said Ossie Vitt, his horrified manager. "Half the time he was abusive and half the time he was crying. Oh! What a night! Rollie was kicking cuspidors from one end of the car to the other. Then he started lighting matches and throwing them into the unoccupied upper berths. I didn't close my eyes all night." But when the Indians' train arrived in Cleveland, Rollie was met by emissaries from a new organization called Alcoholics Anonymous: "I went with them. It was the most fortunate decision of my life. I just never realized that I needed help from others."

BUGS RAYMOND *1911 New York Giants*

"On the baseball field Raymond is a strong drawing card," observed one sportswriter. "The big, red-faced fellow is always cutting loose with some queer antics, and when he makes a base-hit, which is rarely, he never fails to dance a weird dance of his own invention." The colorful Raymond was a brilliant spitball pitcher, but he was also a hopeless alcoholic whose uncontrollable binges resulted in frequent suspensions, and in June 1911—two months after this photo was taken—Raymond's long-suffering manager John McGraw finally cast him adrift.

In September 1912, Raymond was beaten to death with a baseball bat during a melee at a semi-pro game in Chicago. He was thirty. "A season of success was followed by a career along the 'Great White Way' that spelled disaster," read one obituary, "and once in the web of Broadway's life, Raymond never got out, except to drift into a lower trend. Soon his eccentricities and escapades earned him the nickname of 'Bugs,' and it was never spoken in derision. Bugs was still loved by the fandom and players, and his waywardness brought sorrow to the Giants."

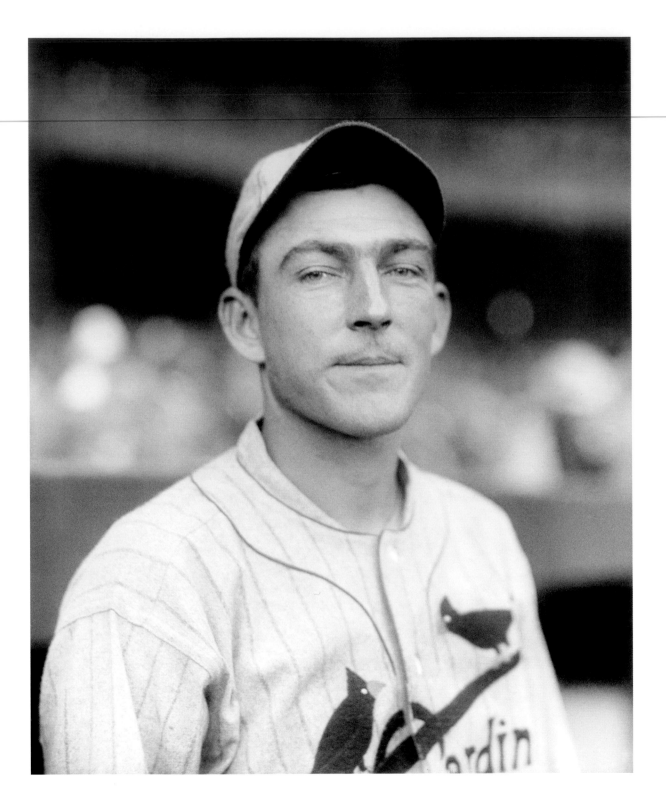

FLINT RHEM
1926 St. Louis Cardinals

Rhem, who earned an electrical engineering degree from Clemson in 1924, won twenty games in 1926. He gave up two tremendous home runs to Babe Ruth in Game Four of the 1926 World Series, but he still called that game "the biggest thrill I ever had in baseball." In 1927, Rhem was fined for drinking, though he claimed to have been protecting his teammate Grover Cleveland Alexander: "Everybody was trying to entertain him, and I knew he was trying to avoid too much entertainment. I took the stuff from him and drank it myself." In 1930, Rhem again drank under duress: "I was abducted by two thugs and taken to a lonely road house. The kidnappers told me I must not pitch against the Robins—and they had revolvers. But that wasn't the worst of it. They forced me to drink glass after glass of liquor." Decades later, Rhem revealed that he and Branch Rickey had cooked up this unlikely story because no one would have believed the real reason for his indisposition: "I was sicker than I have ever been in my life. It must have been some bad piece of meat I'd eaten the night before."

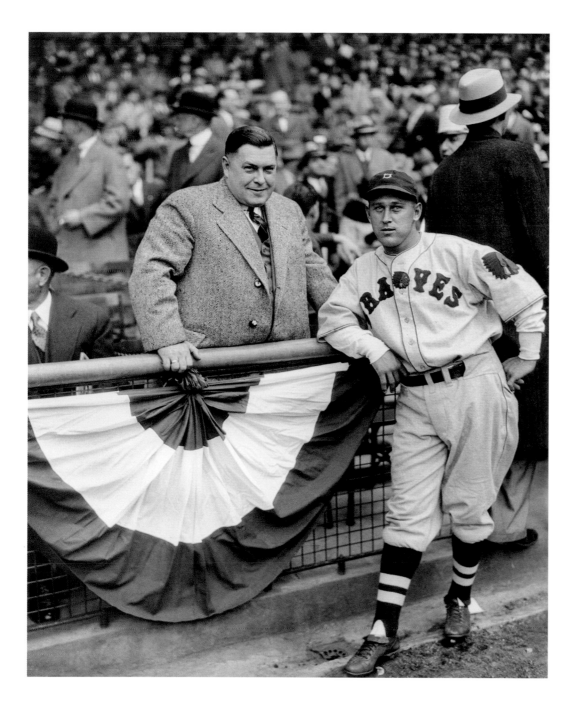

NEW JERSEY GOVERNOR HAROLD G. HOFFMAN (LEFT) AND BILLY URBANSKI (RIGHT)

1935 Boston Braves

Here two Garden State celebrities pose for Charles M. Conlon of Englewood, New Jersey. Hoffman, former sports editor of the *Perth Amboy Evening News*, was one of the few Republicans elected in the Democratic landslide of 1934, and there was even talk of the GOP presidential nomination in 1936, but he soon committed political suicide by trying to prove the innocence of Bruno Hauptmann, the convicted kidnapper and murderer of Charles Lindbergh Jr. After Hoffman's death in 1954, it came to light that he had sold political favors and embezzled money from the state of New Jersey: "Morality, in its ultimate determination, is a funny thing," he equivocated in a posthumous letter to his daughter.

Perth Amboy resident Urbanski, born in Linoleumville, New York, never went to high school, although he did graduate from a barber college on the Bowery. While playing shortstop for the Jersey City Skeeters, Billy was asked to shorten his last name to "Urban" so that it would fit more easily into the box scores, but he politely declined: "If I changed my name it might hurt my father's feelings."

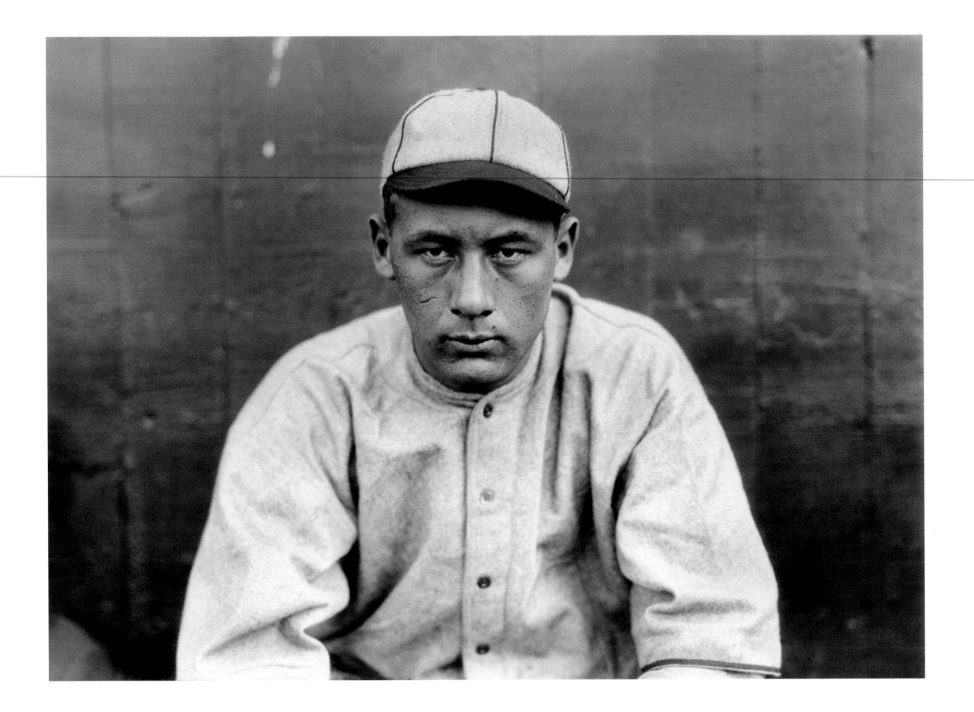

FRANK SNYDER *1914 St. Louis Cardinals*

This hard-drinking catcher from San Antonio, Texas, nicknamed "Pancho," was one mean hombre, not averse to punching out players or fighting with fans in the stands. "It is Snyder's nature. He can't help it," reported the *Sporting News* in 1915. "He doesn't fear anyone. He's ready for a fight and he's out there every day fighting to win the ball game." Off the field, Pancho carried a gun: "He comes from the country where they don't accept an apology. The answer always is a

bullet, and although there isn't a single notch on his revolver handle, he's always ready to carve a mark. That disposition is well known in the ranks of the Cardinals, too. Being a star, being such a wonderful catcher, one would think that every player on the team would be Frank's pal. They're not. It's just his nature. He isn't full of fun; he won't take a joke because he doesn't give one. He just wants to play ball; he wants to win, and baseball to him is a serious business."

RIP COLLINS
1924 Detroit Tigers

In 1929, when a teammate wondered why Collins looked so much older than his actual age of thirty-two, the pitcher explained: "You can't buck liquor and Broadway without getting marked up. When I was with the Yankees I hit all the high places. The bright lights weren't bright enough to me, so I made 'em brighter by looking at them through upturned glasses." But this Texan had been imbibing long before he hit Manhattan: "When I was six years old I could drain off a goblet of beer and smack my lips."

In the spring of 1920, while traveling in a car going thirty miles an hour, Collins shot a buzzard flying fifty feet overhead, and his amazed Yankee teammates dubbed the rookie "Two-Gun." By the end of the decade he had 135 guns in his collection. "Guns are like whisky and dynamite," he said. "There's no danger if you know how to handle them." Rip later joined law enforcement as a Texas Ranger: "I was always homesick for the wild country and the call of the coyotes. I was born a hundred years too late. I should have been a pioneer."

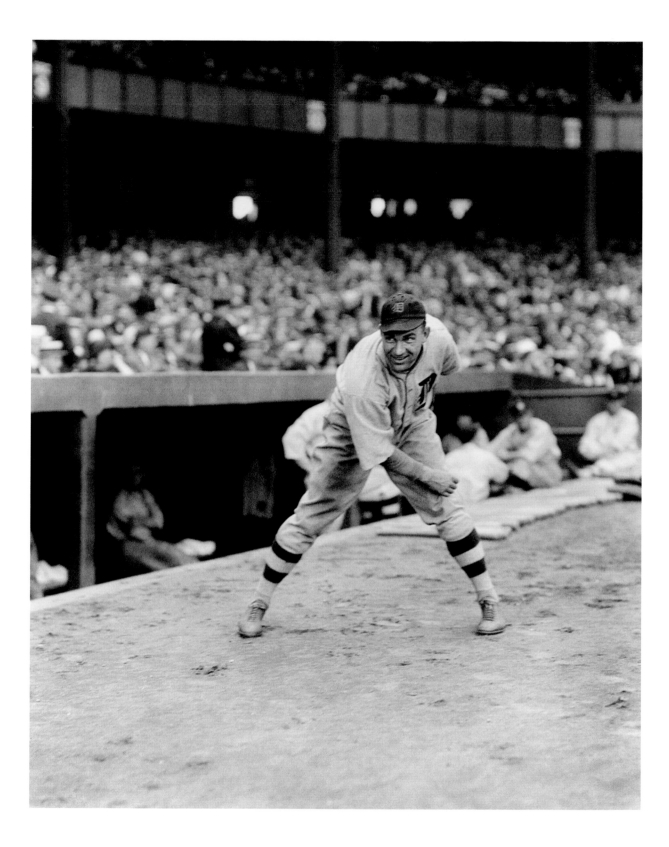

KENT GREENFIELD
1928 Boston Braves

Growing up in rural Guthrie, Kentucky, a bookish boy named Red learned to appreciate the beauty of nature by exploring the forest with his best friend, a gifted outdoorsman named Kent Greenfield: "He was born sadly out of phase. He should have been with Lewis and Clark opening the trail to the Pacific," wrote Red—better known as Robert Penn Warren, author of *All the King's Men* and the first U.S. Poet Laureate. Greenfield hated city life, and when his first big-league manager, John McGraw, ordered him not to exercise before games, the early rising pitcher began to drink in the mornings to pass the time—"until booze blew him off the mound," as Warren ruefully observed. Greenfield battled alcoholism for years, but finally found peace breeding his beloved bird dogs back in Guthrie. After Kent's death in 1978, Red memorialized their lifelong friendship in a moving valedictory poem titled "American Portrait: Old Style," which led off Warren's second Pulitzer Prize–winning book of poetry. Greenfield, he wrote, "seemed never to walk, but float / With a singular joy and silence."

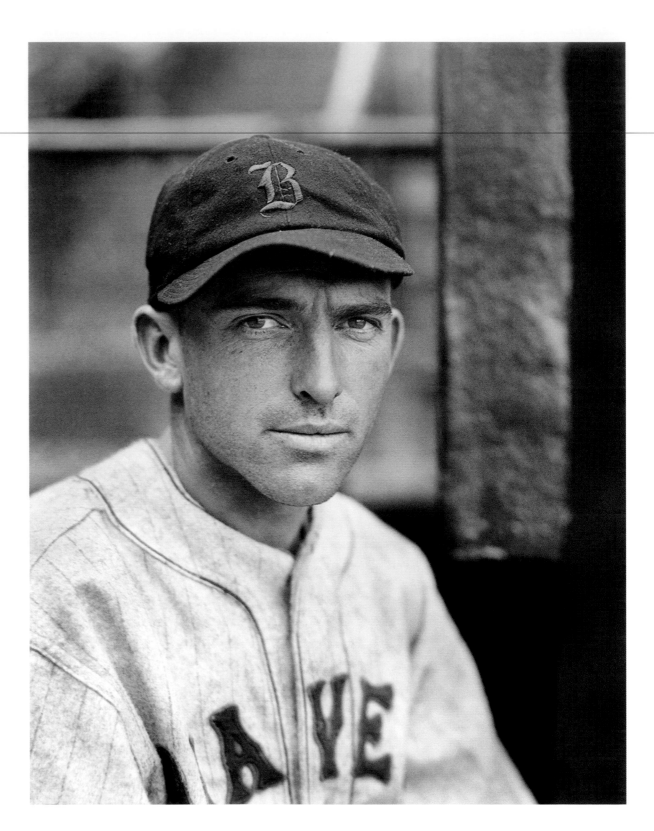

BUDDY GREMP
1940 Boston Bees

When twenty-one-year-old Buddy Gremp, "the newest of the Baby Bees," was called up to Boston in late August 1940, he was thrilled: "I thought it was a gag. In fact, I'm still so excited I hardly believe it's true." Coach George Kelly was pretty excited too: "There's one kid I won't have to tell much about first base play." Boston sportswriter Hy Hurwitz noted that Buddy was impressive off the field as well: "Gremp, a baby-faced lad, is distinguished off the field by the pork-pie hats he wears. He has several of the sharpest lids you ever laid peepers on." Unfortunately, a knee injury kept Buddy from fulfilling his enormous potential, and in 1942 he joined the navy, attending flight school with Ted Williams. The military was definitely a step up from the Boston Bees: "The food is great. It doesn't cost anything, you get seconds and all the milk you want, and there isn't any tipping." After the war, Gremp was stricken with polio and spent time in an iron lung, but he recovered fully, raised a family, and had a successful career as a livestock auctioneer in Modesto, California.

PHILADELPHIA ATHLETICS *March 1917, taking military instruction at Jacksonville, Florida*

American League president Ban Johnson, worried that America's entry into World War I would shut down the major leagues, offered a $500 prize to the team best drilled in military maneuvers, thus making ballplayers participants in the war effort. Detroit and Cleveland players contemptuously called the drills "a joke," and pitchers protested that carrying a rifle would hurt their arms. But orders were orders, and after five months of daily one-hour drills, final exams were held in August. The White Sox performed their maneuvers in regulation khaki uniforms, with real rifles, but they finished fourth. The Senators finished second—partly because infielder Eddie Foster, suffering from ptomaine poisoning, "fainted in the ranks."

And the winners were . . . the St. Louis Browns: "There was more snap and dash to the Browns' work, more 'pep' and ginger than in the drilling of the world's champions," reported the *St. Louis Globe-Democrat*. "There are no slackers or dodgers among the Browns. Every man has met his military obligations. And it is probable that the people of St. Louis will be just as proud of the Browns for winning the big drill as they would have been if they won the world's baseball championship. The majority of baseball fans did not think that the Browns could win anything." The *Sporting News* added: "They were penalized 0.5 for appearance, which may have been due to variety of sizes running from big Baby Doll Jacobson to diminutive Johnny Lavan. They couldn't help that."

The Athletics? They finished dead last.

LEW McCARTY
1918 New York Giants

"Lew has been a catcher all his baseball life," noted the *Brooklyn Daily Eagle* in 1916. "He is a baseball freak in that. At no stage of his career did he ever try or hope to be a pitcher." McCarty hit an inside-the-park home run in Game One of the 1917 World Series—or what *should* have been a home run, had he not been hobbled by the leg he had broken earlier that season. Lew had to settle for a long, limping triple, and thus lost out on a $50 Liberty Bond, the patriotic prize offered by singer Al Jolson for every home run hit in the Series.

In 1918, soldiers and sailors in uniform were admitted to the ballpark free on selected days: "The only assessment will be the ten cents which the Government exacts on every admission," reported the *New York American*. "There are no restrictions as to where they may sit." The sailors sitting behind McCarty have staked out the best seats in the house—the Polo Grounds press box.

HANK GOWDY

1911 Boston Rustlers

When they attended the 1914 World Series, Hank Gowdy's parents were hiding in plain sight: "You see, Horace likes to please us so well that when he knows we're watching, it makes him nervous for fear he'll make a mistake," his mother explained. "So we decided he shouldn't know of our being here. Before the Series he wrote and begged us not to come to the Series. We promised him we wouldn't for fear he'd be nervous. It was the first untruthful word we've told him since we told him of Santa Claus, I guess. My, I know if Mr. Connie Mack had known we were coming he wouldn't have hesitated a minute to have gone right straight and told Horace. He's what you call a 'home boy.' When he's at home he helps me with the dishes and everything." Gowdy's .545 batting average in the 1914 World Series led the Boston Braves as they demolished the Philadelphia A's in four games, and in 1917, this home boy became the first major-league player to enlist for military service in World War I. He served in combat with the Rainbow Division of the U.S. Army in France.

This Conlon photo appeared on the World Series hero's 1915 Cracker Jack baseball card.

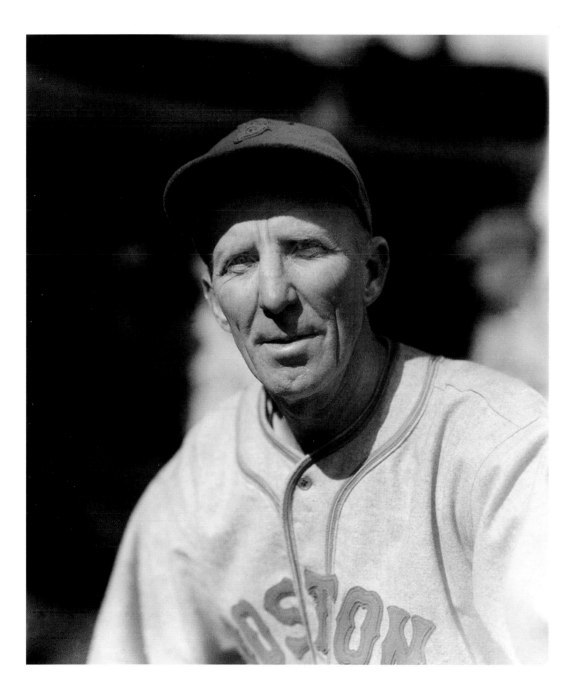

HANK GOWDY
1936 Boston Bees

"Members of the Braves call Hank Gowdy 'Old Glory,'" reported the *Sporting News* in 1935. "Hank has been a fixture with the Boston team so long that he seems to go with the lease," joked sportswriter Tom Swope in 1937— although Gowdy had spent a few years with the New York Giants, for whom he was the goat in the final game of the 1924 World Series when he missed a crucial foul pop fly after stumbling on his catcher's mask.

Hank Gowdy "does not wear shin guards, like the majority of big league catchers," reported the *Cincinnati Tribune* in 1916, "but his trousers are heavily padded in the knees, much on the order of football pants." But the older and wiser coach of the Cincinnati Reds chose to wear shin guards while pitching batting practice for his team during the 1940 World Series, and for additional protection he even erected "a little net in front of the mound," noted a bemused reporter for the *New York Herald Tribune*.

In 1943, Hank reenlisted in the army as a captain at the age of fifty-three, and the baseball diamond at Fort Benning, Georgia, was named "Gowdy Field" in his honor.

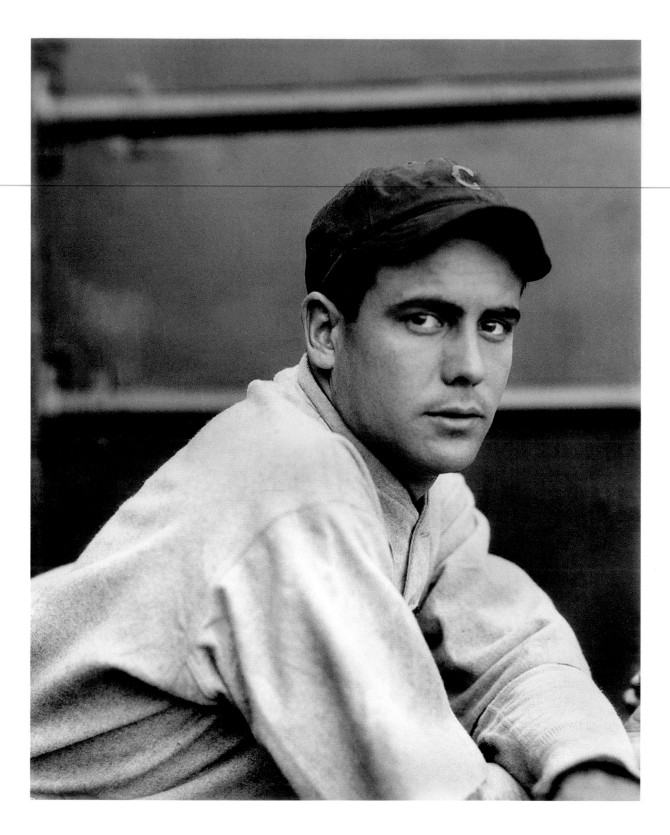

LUKE SEWELL

1925 Cleveland Indians

Luke's wife, Edna, was a volunteer with the Little Theater of Akron, Ohio, and she encouraged her handsome husband to become a thespian: "Clark Gable got his start in Akron, so I guess I will give the stage a little play, too," Luke reasoned. His acting career went nowhere, but Sewell did indeed follow in Gable's footsteps, although the movie star had never trodden the boards of the Rubber City—MGM press releases to the contrary. Gable had actually spent his time in Akron working at a tire factory, and Sewell would spend his off-seasons working for the Robbins Tire and Rubber Company of Akron, Ohio.

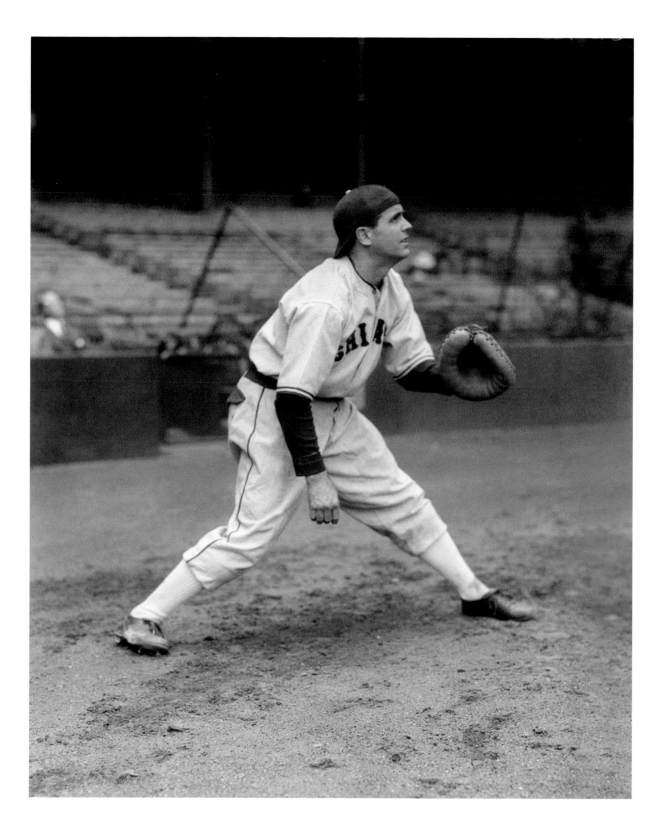

LUKE SEWELL
1935 Chicago White Sox

This photograph is the result of a happy accident, since it appears that Luke was preparing to assume the standard Conlon catching pose when someone cried: "Heads up!" In 1935, the normally weak-hitting Sewell batted a respectable .285, while his teammate Al Simmons batted an anemic .267. Mortified by this unfathomable turn of events, Simmons, a lifetime .334 hitter, groaned: "The league is upside-down when you're out-hitting me."

In 1935, shortly after his retirement as a player, Babe Ruth was asked to pick the best catchers in the major leagues: "I like Sewell first, and Hemsley next," he replied. "But what the hell! I'm just an old man now, and who cares what I think?"

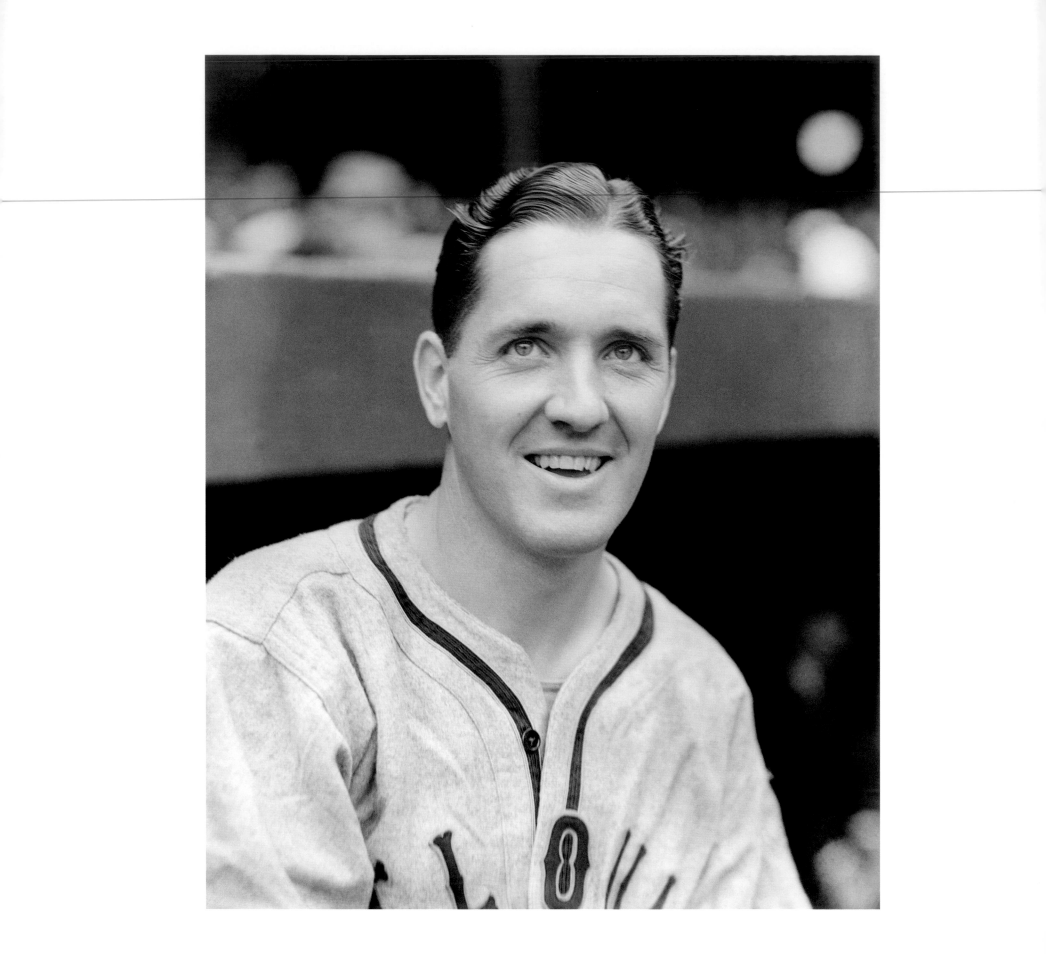

AL SPOHRER ⊙

1929 Boston Braves

When Al Spohrer challenged Chicago White Sox first baseman Art Shires to a boxing match, a Boston sportswriter noted ominously that "Spohrer's experience is nil, zero, nothing." On January 10, 1930, eighteen thousand fans packed the Boston Garden to watch Art "The Great" demolish Al "The Bald" in four rounds: "The sight of Spohrer getting banged around like a ping-pong ball certainly didn't come under the heading of clean, wholesome fun," chided the *Boston Herald*. "The fight came to a finish when Spohrer was wandering around the ring with a far-off, dreamy expression on his pan," smirked the *Boston Globe*. The disgusted commissioner of baseball ordered the ballplayers to hang up their boxing trunks: "Hereafter any person connected with any club in this organization who engages in professional boxing will be regarded by this office as having permanently retired from baseball. The two activities do not mix."

In 1935, the *New York Daily Mirror* asked Al Spohrer to pick an All-Ugly baseball team. Among his selections were pitcher Red Lucas, infielders Pepper Martin and Billy Urbanski, outfielder Joe Moore—and catcher Al Spohrer.

⊙ BILLY SULLIVAN, JR.

1938 St. Louis Browns

DIAMOND'S CLARK GABLE? asked the *Sporting News* when Charles M. Conlon submitted this photograph for its readers' consideration in December 1938. This catcher, Conlon's candidate of choice, finished third behind pitchers Wes Ferrell and Bill Lee in a subsequent readers' poll, but the old photographer refused to change his vote: "I still maintain that Billy Sullivan, that Irish lad with the laughing blue eyes, is the handsomest player in the majors."

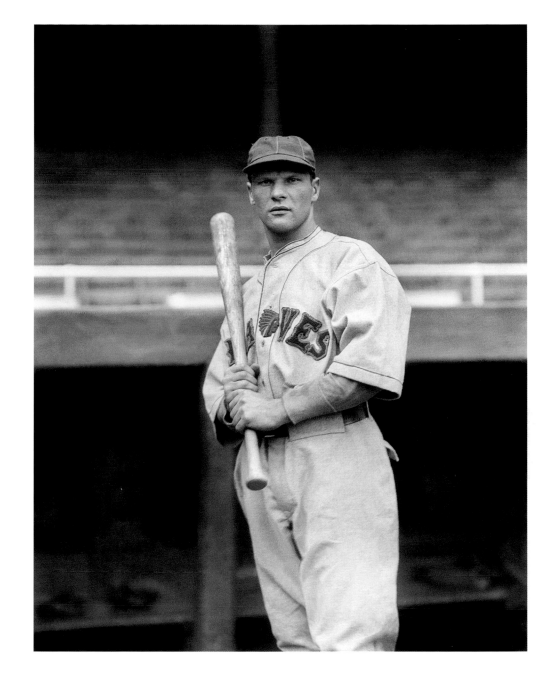

EDDIE COLLINS
1925 Chicago White Sox

"He was the greatest second baseman who ever lived," said his first manager, Connie Mack. His second manager, Pants Rowland, called him "the most valuable player to a ball club I ever saw. Eddie Collins was not spectacular, like Babe Ruth or Ty Cobb, but he was all ball player. He played in every game in my first three seasons as Sox manager. Eddie was inspirational. He made no false moves and had the uncanny ability of understanding and encouraging the players. Once I congratulated him for a fine play. He said, 'Thanks, Teach—but tell those things to the fellows who need it.' He was the salt of the earth!"

When Collins went up to bat he took the chewing gum out of his mouth and placed it on the peak of his cap. With two strikes against him, he put it back in his mouth. Eddie's system must have worked, because he had a lifetime batting average of .333, and in 1939 he was inducted into the Baseball Hall of Fame.

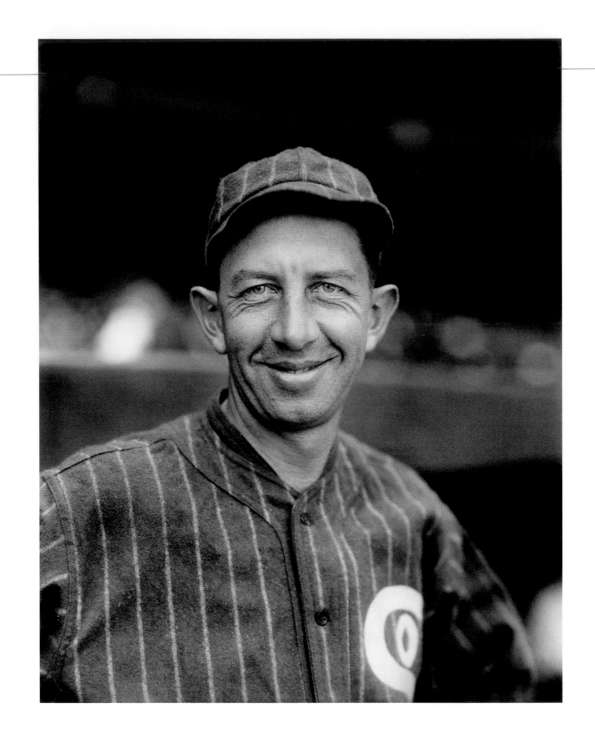

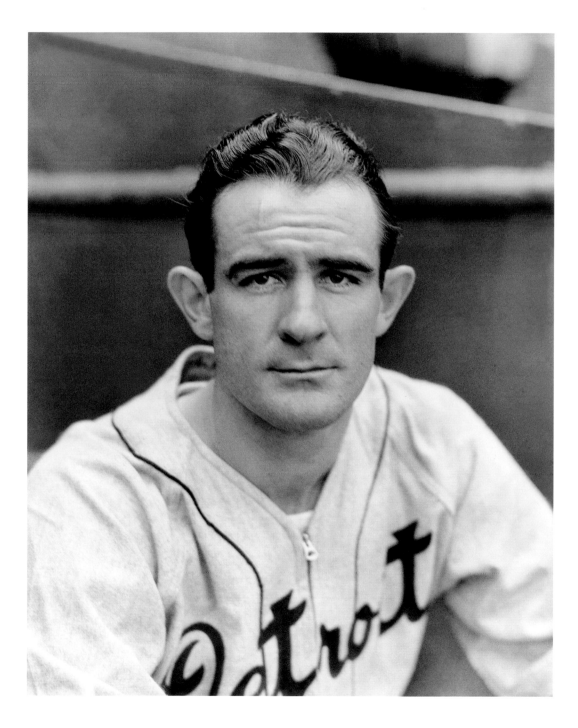

ELDEN AUKER
1938 Detroit Tigers

Auker separated his shoulder twice while playing halfback at Kansas State University, and his injuries forced him to adopt an unorthodox submarine pitching motion. During his first visit to Yankee Stadium as a rookie in 1933, the first batter he faced was none other than Babe Ruth, who hated "junk ball" pitchers more than anything. Auker's peculiar delivery made him junkier than most, and he proceeded to strike out the Bambino on four pitches. The Yankees' third base coach, Art Fletcher, shouted encouragement to the rookie: "Hey, Busher! You got the Bam real upset. He says he's been struck out plenty of times, but it's the first time he's ever been struck out by a damn girl!"

"The only reason I even keep you around is so that I won't have the biggest ears on the team," said Tigers manager Mickey Cochrane, who called Auker "Mule Ears."

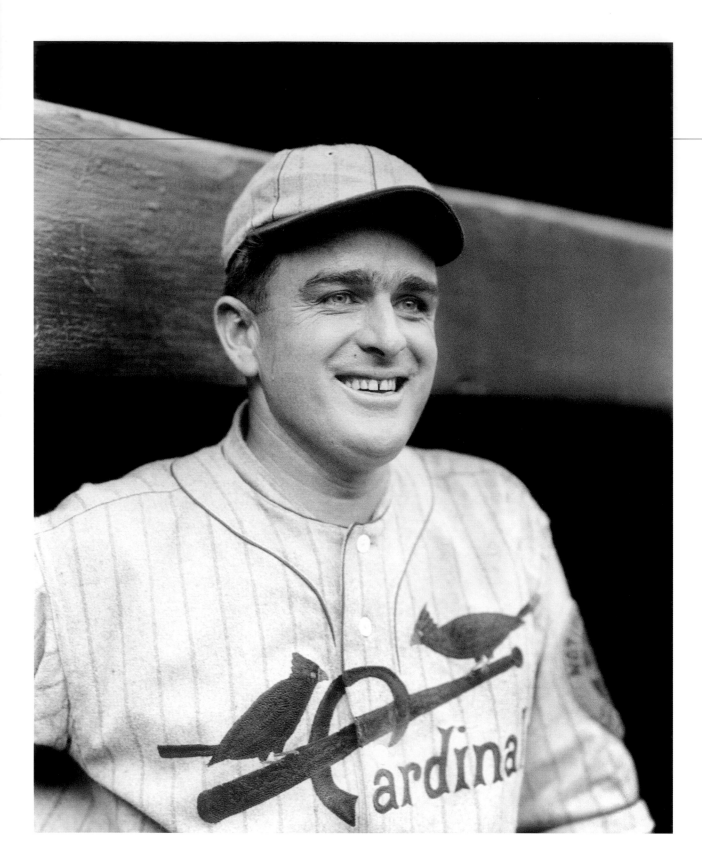

WALTER MAILS
1925 St. Louis Cardinals

Mails earned the nickname "Duster" while pitching against the Phillies in 1915: "It was very unfortunate. I hit all of their good hitters in the head," he recalled. "Get that bum out of there," screamed the Philadelphia manager. "He'll kill all my good hitters before the World Series starts. He is strictly a duster." Mails pitched a shutout for the Indians in the 1920 World Series, but his pugnacity led to his downfall: "Ty Cobb drove me out of the league. He started to call me rabbit ears. That means 'yellow,' you know. Pretty soon everyone in the league took up the call. I didn't have sense enough to ignore it. Trouble with me, I always wanted to fight. But fortunately I never allowed my temper to get the best of my discretion. I used to start plenty of fights, because I knew the other players would stop them. There wasn't a man in the whole sport that I could lick. That's why I am still a handsome man." Mails called himself "Walter the Great" and regretted that he hadn't played baseball in the age of television: "In my day, I'd have thrilled a million ladies with my pretty teeth. What a chance for showmanship!"

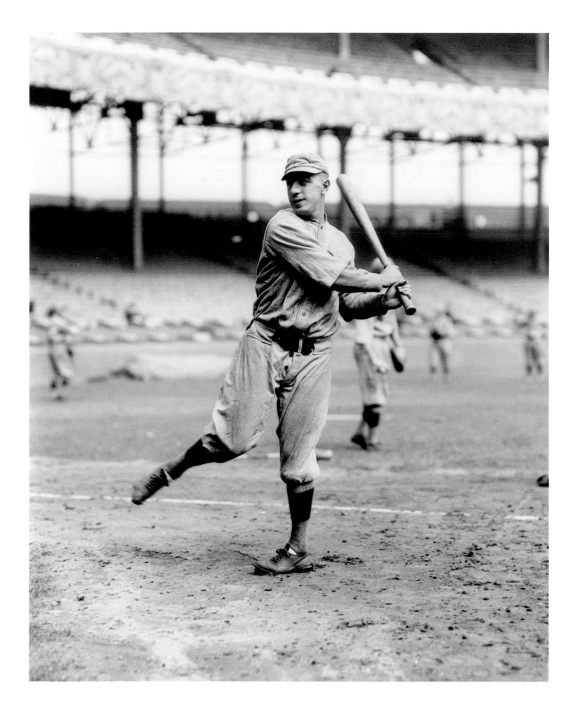

BRAGGO ROTII
1919 Boston Red Sox

"They leave it up to me every time," boasted Bobby Roth, who was dubbed "Braggo" by his teammates. This nickname was certainly not a term of endearment, as is made clear in this news report of his release by the Kansas City Blues of the American Association in 1923: "He was the exasperating grain of dust in the eye of whatever ball team he became associated with. With Kansas City he loafed, caring apparently only for his base hits. In the clubhouse he was fifty percent of almost every verbal or physical battle that cropped up. The Blues almost had a celebration when he was dropped. There were a lot of likeable points about Bobby, but he had the unhappy faculty of gaining enemies—apparently with cold deliberation. Like Carl Mays, he went through his major league career without making a single close friend among his teammates."

MIKE GONZALEZ
1926 Chicago Cubs

Described by sportswriter Red Smith as "Old Silvertooth, the Cuban with the smile like Cartier's window," Gonzalez was a big-league catcher for seventeen years, but his most lasting contribution to baseball was his immortal scouting report on a minor-league player: "Good field, no hit." Mike's fractured English delighted sportswriters, but it was a liability when he became the Cardinals' third base coach: "You go, she stay" or "He come, she go" were typical directions to perplexed base runners. After Stan Musial was thrown out at the plate late in the 1946 pennant race, he told Gonzalez: "I thought you said 'Go, go'—so I did." Gonzalez explained that he had said: "No, no." But there was no confusion when Enos Slaughter made his mad dash around the bases to score the winning run in the 1946 World Series: "I just had to run, that was all," said Enos immediately after the game. "Mike gave me the green light. He was watching the ball. He knew what could be expected. And I just dug in and tore for home. I had to make it."

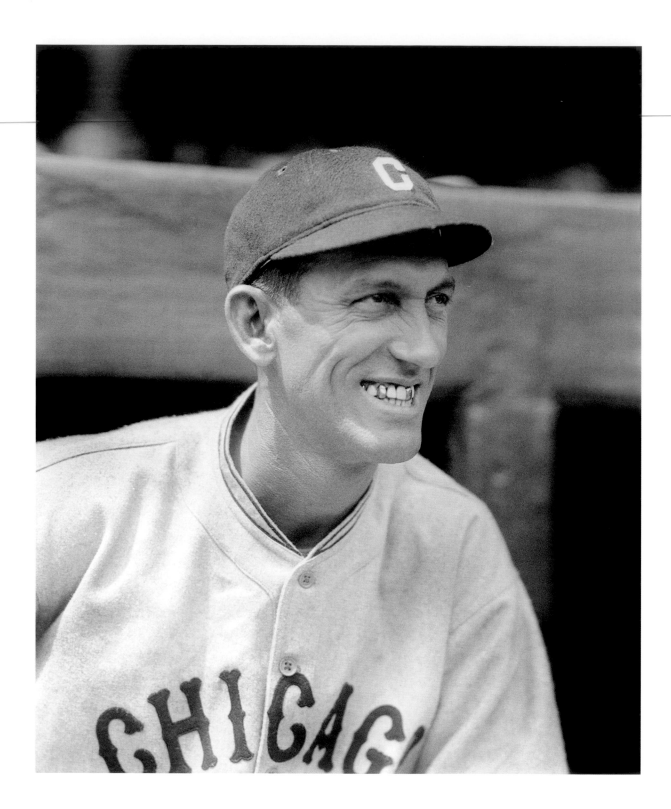

PANTS ROWLAND

1923 American League umpire

"A player never is thrown out of a game," declared umpire Pants Rowland. "The player removes himself by his own actions—and he knows it!" Described by one sportswriter as "the best dressed umpire who ever graced an American League diamond, not excepting even that glass of fashion, Mr. Billy Evans," Rowland spent his boyhood in Dubuque, Iowa, where he played for a local team called the Ninth Street Blues: "The Blues tried to live strictly up to their name. We wore blue blouses, blue caps, long black or blue stockings borrowed from our sisters, and in my case, my dad's blue trousers. To achieve the baseball effect, I folded them under the knee, restrained there by strong twine as a garter." Clarence Rowland earned his nickname after an especially wild ride around the bases: "The bases were of rock and when I hit the one at second base it skidded. This pressure snapped the twine. After I had turned third base I tripped the first of three times on the tumbling pants leg, but finally reached home safely. The umpire said, 'Pants, I didn't think you were going to make it!'"

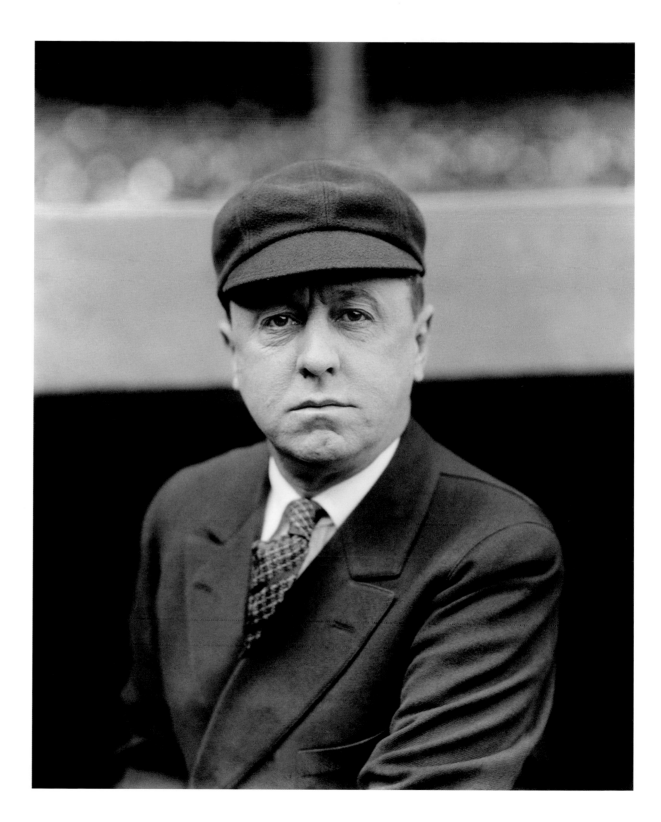

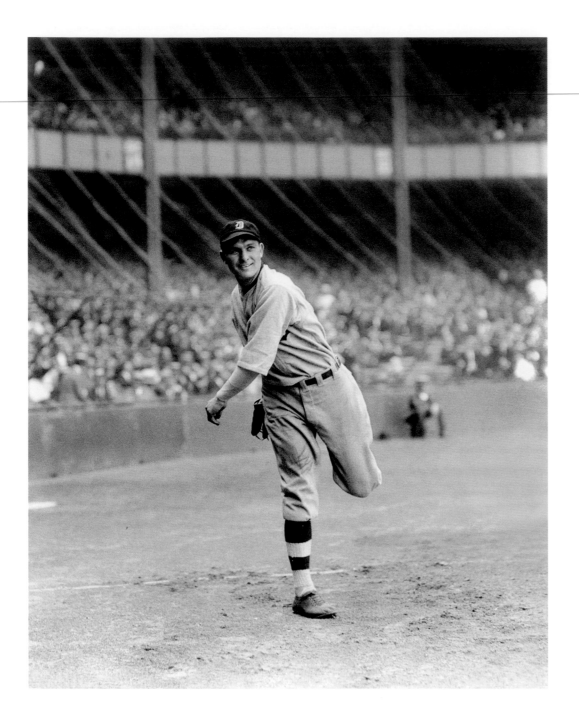

HEINIE MANUSH
1923 Detroit Tigers

This outfielder's first great thrill came when he beat out Babe Ruth for the American League batting championship on the last day of the 1926 season. His next big thrill came in 1933, when he played in his only World Series—even though he batted a humiliating .111 against the Giants. Manush played in his only All-Star Game in 1934: "Before the game started, Ruth, Foxx and some of those guys were givin' me a bad time about the World Series. I said, 'Listen, you buncha so-and-so's, you see that guy over there warmin' up? That's Carl Hubbell. That's the guy that beat us. You fellas are gonna have a chance to see what you can do with him today.' Charlie Gehringer led off with a base hit, and I walked. And that's when the fun started. Hubbell struck 'em all out—Ruth, Gehrig and Foxx. And I'm out there laughin' at 'em tryin' to hit Hubbell!"

In 1964, Manush was elected to the Baseball Hall of Fame: "Don't believe it that old ballplayers don't care whether they get in or stay out of the Hall of Fame," he said. "It's a perfect climax to the perfect way to live—playing baseball."

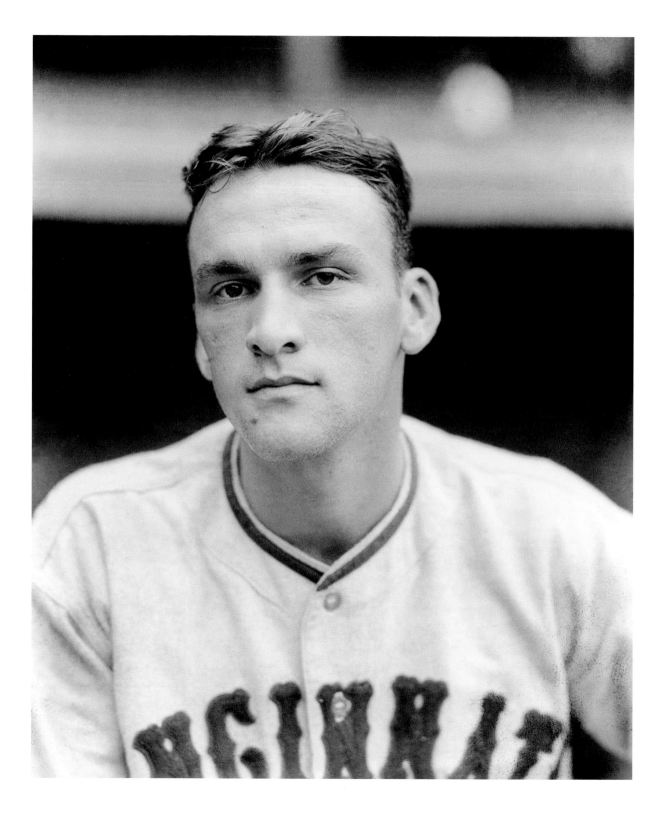

EDDIE MILLER
1937 Cincinnati Reds

"That fellow Miller isn't such a bad guy," conceded an uneasy teammate. "He's sort of nasty and abrupt around the batting cage, says things that get under your skin and always speaks his piece, but if you can keep your own lip buttoned at critical moments, you can get along with him." Though a brilliant shortstop, Eddie Miller was called a prima donna because he openly criticized the terrible teams he played for, and he was called a malingerer when he declined to appear in the 1947 All-Star Game—until it was revealed that he had been playing with a fractured elbow. A throwback to baseball's early days, Miller cut a huge hole in the palm of his glove to get a better feel for the ball, and he refused to interlace the fingers of his tattered glove: "Never could get used to having my fingers tied together. Never felt natural or free." His primitive means produced phenomenal results: "He's beautiful to watch," said Phillies pitcher Hugh Mulcahy. "He comes up with inhuman stops and throws."

STERLING STRYKER
1924 Boston Braves

"Sterling Stryker has let it be known that he has a grievance," reported the *Springfield* (Massachusetts) *Republican* in August 1924. "He says he doesn't want to play for Springfield, but that feeling will pass. He's the first ball player known to dislike the idea of making this his summer home. Looks like Stryker will have to play here or not at all." This World War I veteran had already gone AWOL in 1920, when New York Giants manager John McGraw sent him to Toledo: "I jumped the club, feeling I shouldn't have been demoted." In 1924, after enduring a 3-8 record with the Braves, and a demotion to Worcester of the Eastern League, Sterling decided not to play in Massachusetts at all. He returned to his home in New Jersey, where he would spend his retirement years at the racetrack working as a pari-mutuel clerk.

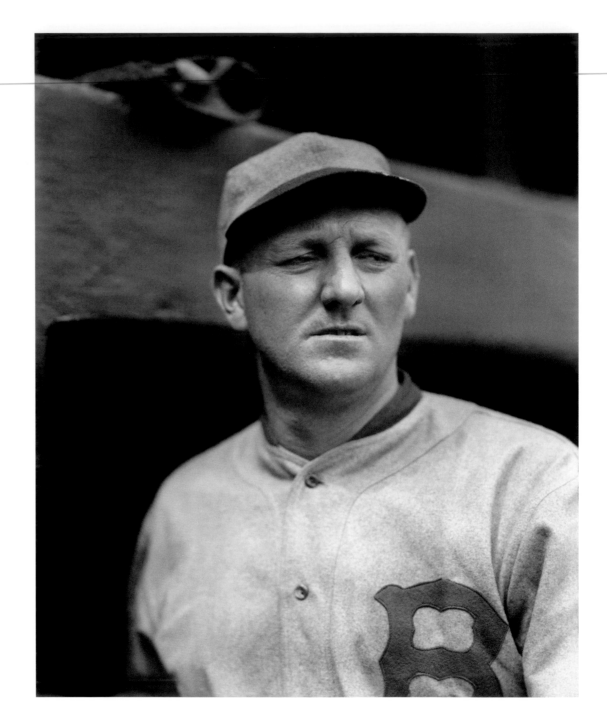

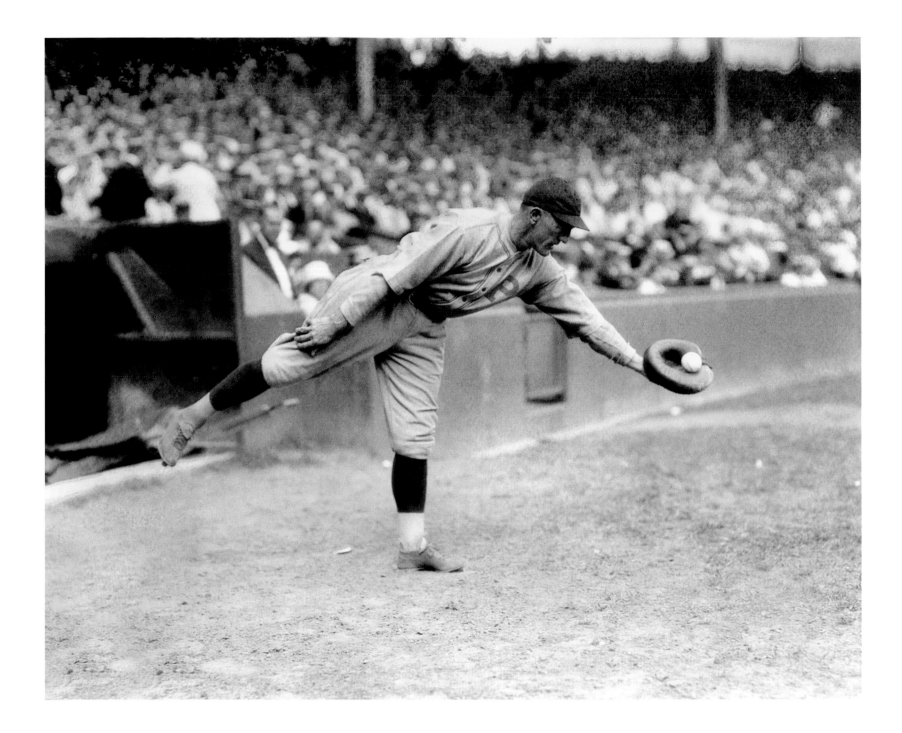

WALTER SCHMIDT *1921 Pittsburgh Pirates*

"Merit is not enough without a touch of the theatrical," wrote Walter Schmidt in 1921. "A player must not be merely good, he must be sensational, if he wants to qualify as a star. But some of us, unfortunately for ourselves, are lacking in the particular knack of attracting notice. We weren't born with the ability to pose and so we are labeled as plodders, while the fellows with the knack of doing things in a sensational way get all the glory and most of the money. I can still catch, I believe, as well as I ever could, but baseball is a show business and I guess I am not a good actor." The histrionically challenged Schmidt was a perceptive critic, however, as he demonstrated in this plodding pose for Conlon.

BUZZ McWEENY
1924 Chicago White Sox

McWeeny had two twenty-game-winning seasons while pitching in the Pacific Coast League, but he never had a winning season during his eight-year major-league career. By 1931, Buzz had been reduced to running a gas station in a Chicago suburb, but whenever his old teammates dropped by, he assured them that he didn't miss the big leagues at all: "I never could sleep on those trains," he explained. The sleep-deprived McWeeny posed drowsily for Conlon after a long, exhausting train ride to New York.

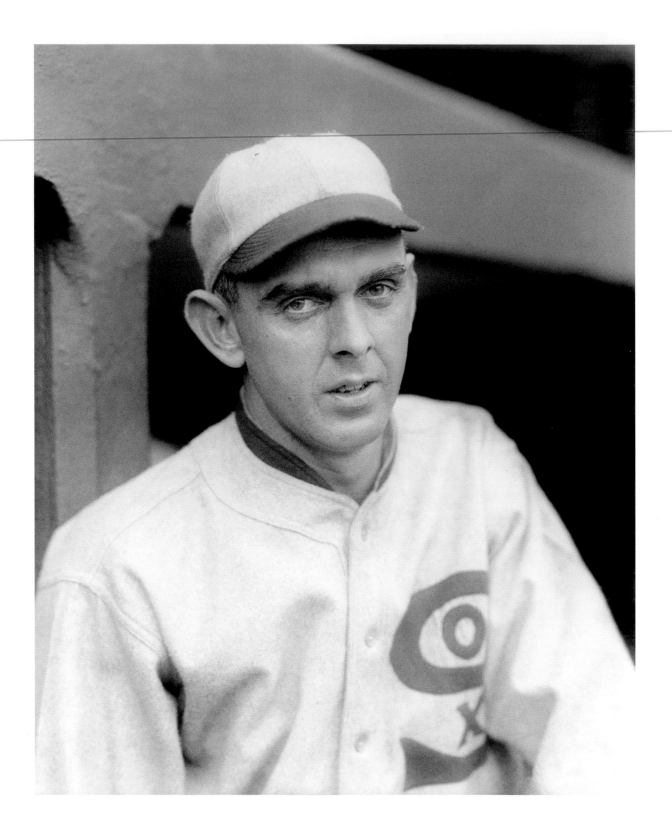

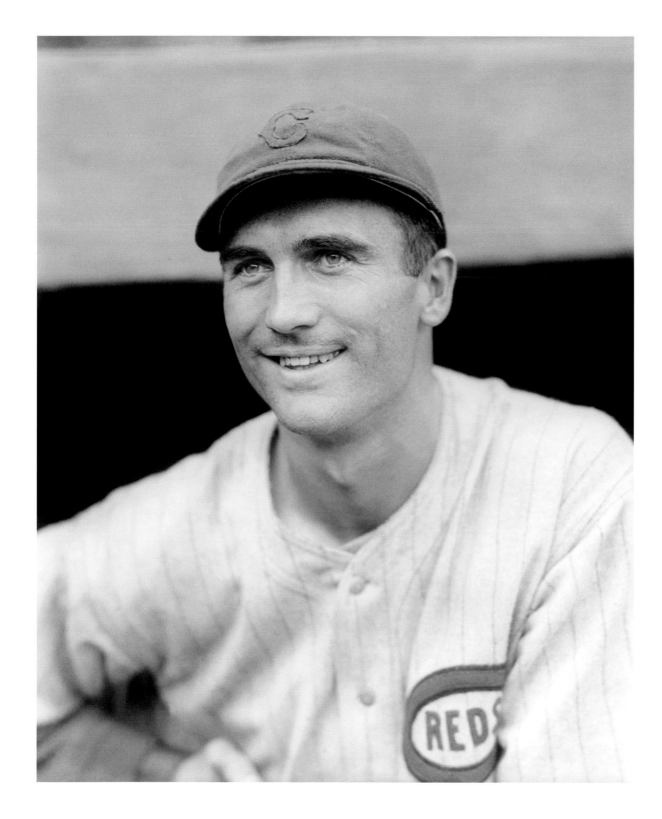

PINKY PITTENGER
1927 Cincinnati Reds

This light-hitting utility infielder played in the majors for seven years, but he never took his job very seriously: "I was just not aggressive enough in the big leagues," he admitted. "When I got there, I figured I had it made, and it didn't matter much to me whether I played or sat on the bench. It certainly wasn't the right attitude." In later years, Pinky found a more congenial career as a nightclub manager.

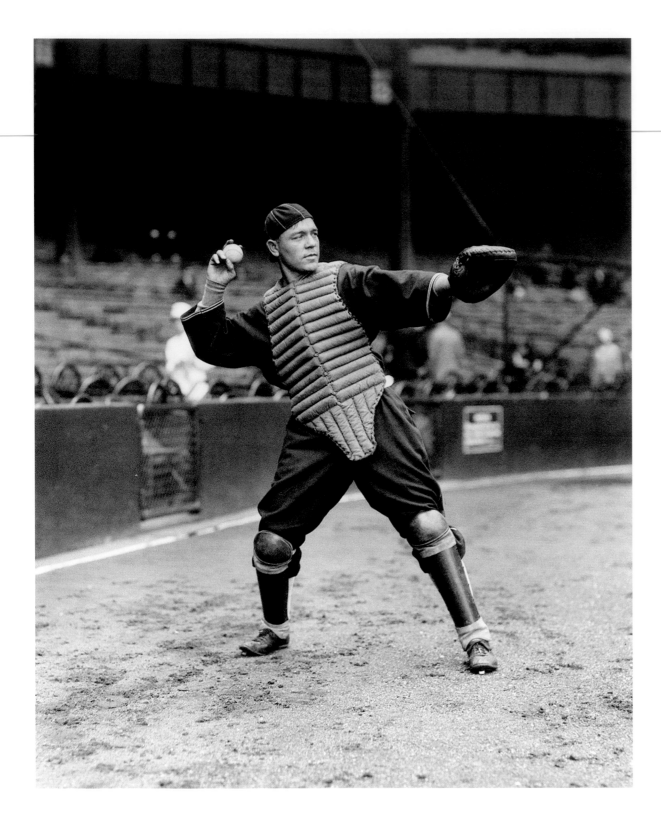

⊙ JOHNNY RIDDLE
1930 Chicago White Sox

A temporary replacement for the injured Moe Berg, Riddle visited Yankee Stadium only once during his brief and undistinguished major-league career. Twenty-seven years later, Riddle finally returned to the Bronx, this time as first base coach for the National League champion Milwaukee Braves, but again his stay was brief—and bittersweet: "My club finally wins the pennant and the World Series . . . and they fire me!"

FRANK CROSETTI ⊙
1938 New York Yankees

Crosetti played in his first World Series as a rookie shortstop in 1932. By the time he left the Yankees in 1968, he had collected a record twenty-three World Series shares as both player and third base coach. "I guess I was born under a kindly star," he reflected. Crosetti's dramatic home run in Game Two of the 1938 World Series against the Chicago Cubs forever haunted Hall of Fame pitcher Dizzy Dean, whose last hurrah was ruined by the blast: "I'll never forget that guy. Never. That home run of his . . . and me with my arm fallin' off." It was Crosetti's only World Series home run.

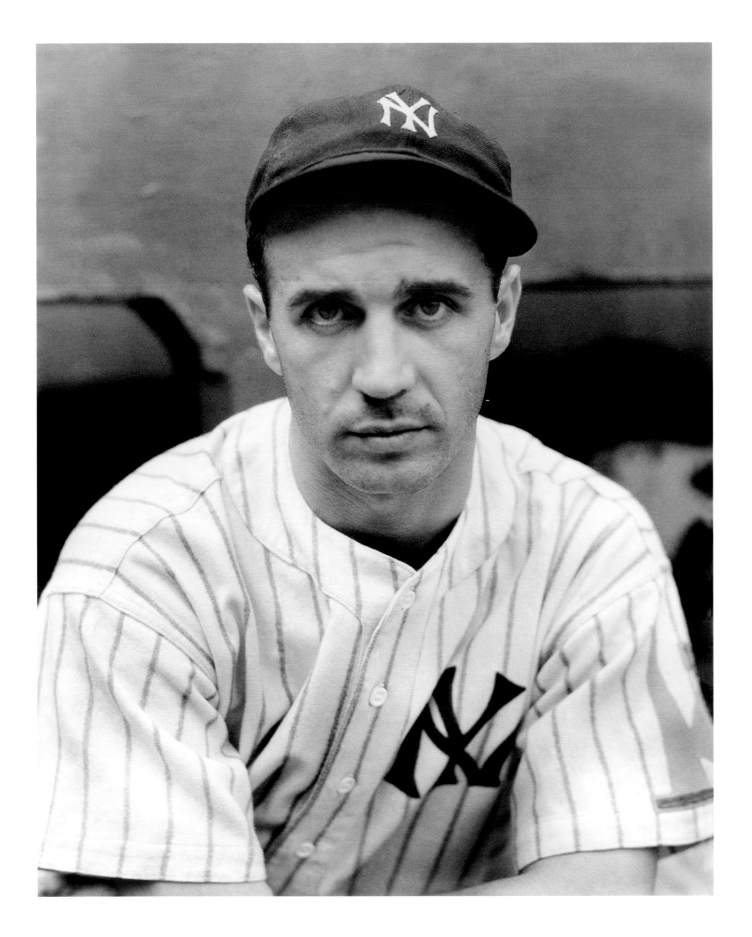

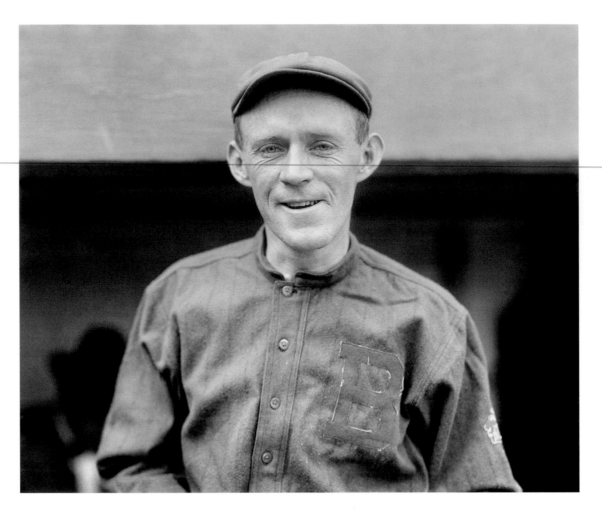

JOHNNY EVERS *1914 Boston Braves*

On September 23, 1908, Fred Merkle of the Giants left the field after his team scored the winning run—but the rookie base runner had inadvertently violated an obscure rule by failing to touch second base. Johnny Evers of the Cubs tagged second base, Merkle was called out on this absurd technicality, and the game was declared a tie. When the game was replayed on October 8, the league championship was on the line . . . and the Cubs won: "Johnny Evers talked a good and great umpire, Hank O'Day, into making the rottenest decision in the history of baseball and it cost John McGraw a pennant," wrote umpire Bill Klem in 1951. "It was the famous case of the 'Merkle Boner' and I am sick of reading for 42 years of what a great play Evers made. It was bad umpiring and gutless thinking at league headquarters." The guiltless Merkle was reviled, and the wily Evers became O'Day's nemesis.

O'Day had his revenge—or so it seemed at the time—when he replaced Evers as the Cubs' manager early in 1914. Evers joined the hapless Braves, who stayed mired in last place for the first three months of the season before making a stunning comeback to win the pennant. The World Series looked to be a hopeless mismatch, and O'Day was quick to predict that the A's would pull off an unprecedented Series sweep. "We are not the weaklings that 'dopesters' and others contend," responded second baseman Evers. "I believe the Athletics are destined to receive the biggest surprise of their lives"—whereupon the "Miracle Braves" swept the mighty A's. Evers batted .438 in the Series, picked up a Chalmers automobile as the league's outstanding player, and then really rubbed it in: "Hank O'Day's prediction before the series has worked out just as he said except for one small mistake," Johnny gloated. "He confused the names of the two teams."

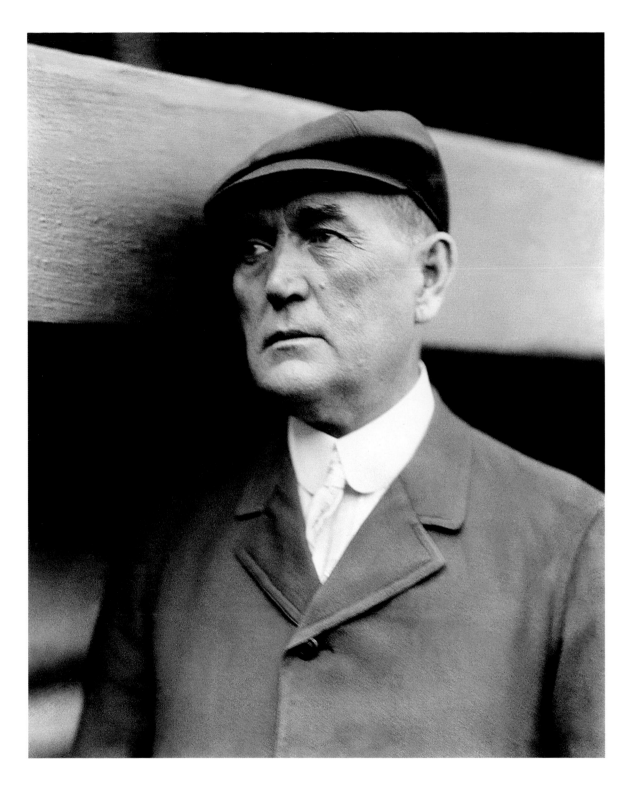

HANK O'DAY
1916 National League umpire

"I have nothing to say," said Hank O'Day to a writer for *Vanity Fair*. "I've said it all before. The papers have printed everything that I ever did, ever said, ever will do or ever will say; so I can't tell you anything." The umpire was similarly unforthcoming with everyone: "Hank O'Day wouldn't speak a civil word to anybody he had not known for 20 years," said umpire Bill Klem. "Hank O'Day is a hard bitten man, with little sympathy and humor in his make-up," reported the *Sporting News* in 1922. "The scorn of full thirty years' experience is in his glance when he turns it on some raving rebel who disputes his judgment," wrote the editor of the *Reach Guide* in 1920. "Umpiring does something to you," said umpire Silk O'Loughlin. "The abuse you get from the players, the insults from the crowds, and the awful things they write about you in the newspapers. Look at O'Day. One of the best umpires—maybe the best today—but he's sour."

"I liked to rile O'Day by lobbing the ball to first on a slow roller," recalled shortstop Honus Wagner. "Hank would fume, 'You coulda had him by 20 feet!' Sure I coulda, but it was fun seeing Hank boil."

BOB FOTHERGILL

1923 Detroit Tigers

Asked for his batting secret, this lifetime .325 hitter replied: "Secret? Hell, there ain't no secret to it. You just walk up there and hit the ball." Called "Rhino," "Fats," "Rotund Robert," and "Rob Roy the Tiger Fat Boy," among other unflattering names, this former football player was an immensely gifted athlete, untroubled by his tendency to put on weight: "Fat don't worry me none. Man, I'm as fast as ever. You notice I can still bump that apple, don't you?" He was also an acrobatic outfielder and base runner: "Fothergill has a head first slide that he learned on the diving board of the swimming pool at the Wardman Park Hotel, Washington," wrote Bud Shaver of the *Detroit News*. "It is somewhat similar to a swan dive, except that Robert does not duck his head. He arches his back in the prescribed manner and lands on his tummy. Fothergill doesn't go into a base upright if he can help it, for that would mean the elimination of his swan-diving slide, and such a thing would be unthinkable. Robert is too much the artiste to be thus callous to his public."

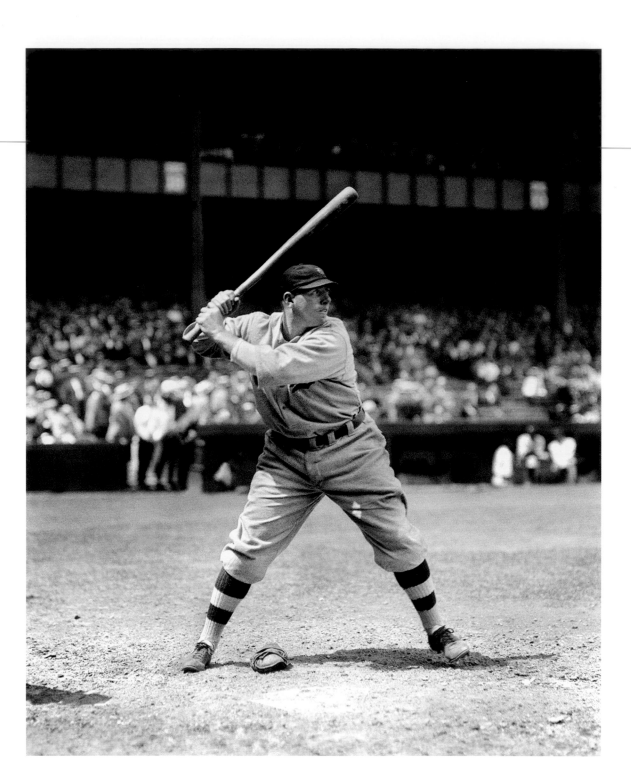

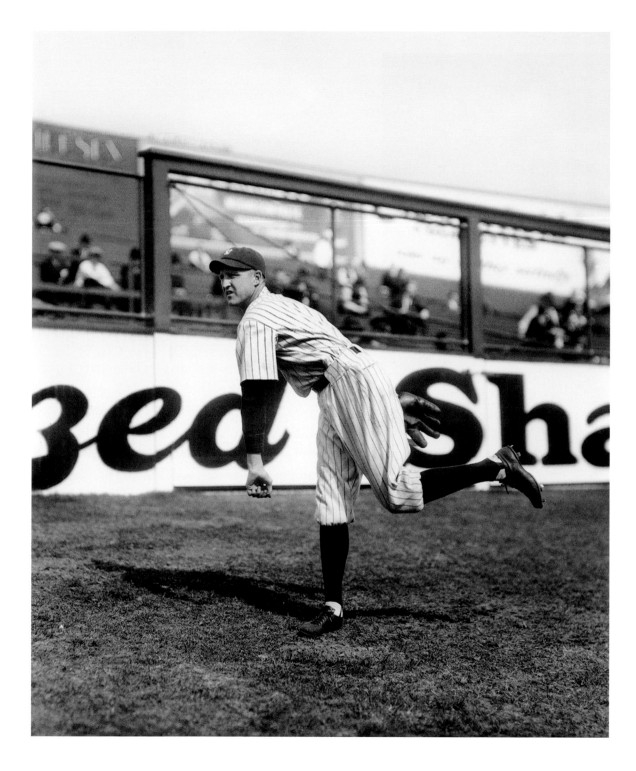

HERB PENNOCK
1923 New York Yankees

"A pitcher is just a thrower until he gets smart," declared Washington owner Clark Griffith. "Pitchers like Walter Johnson and Bob Feller, who made good right away, are the exception. They had so durn much stuff they couldn't miss. But it took Herb Pennock years to be a good pitcher. You don't get to be a good pitcher until you get to be smart." Pennock needed to be extremely smart, because he didn't have too durn much stuff on the ball, as Tiger outfielder Gee Walker observed: "The only comforting thing about hitting against that old bird is that you don't have to be afraid of getting hurt. Even if he hit you in the head with his fastball he couldn't knock your cap off." Pennock admitted as much, but added: "Why, some days I was actually fast, and Wally Schang would have to use two sponges in his mitt. I remember one day Wally Pipp said to me, 'You're as fast as Johnson.' That night I bought him a steak dinner and a hat for his wife."

"Lefthanders are milk on the cat's saucer for me," boasted Bob Fothergill, who was incredulous when a certain crafty southpaw held him hitless one day: "Imagine a lefthander doing that to me," sniveled Fothergill. "He's done it to me, too, Bob," said his teammate, Harry Heilmann. "That wasn't just another lefthander, that was Herb Pennock."

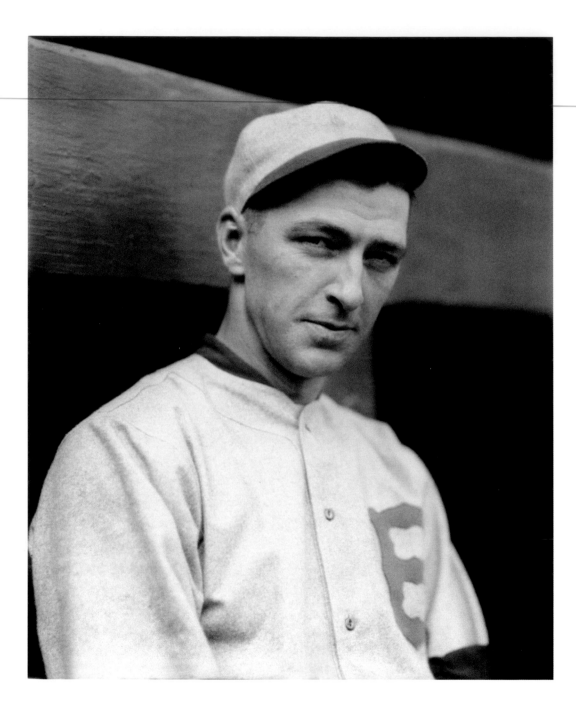

JOE GENEWICH
1924 Boston Braves

Joe wanted to pitch for his high school team, but the other boys wouldn't let him play: "I had a hard time at the start because I had a hard name to spell or to pronounce. It is pure Polish and the American boys up around Elmira, New York had a way of poking fun at the Poles. Even when they did say 'Jen-e-wich,' which is correct, the boys insisted on putting an 'h' on the end instead of a 'z' and I have had to use it that way ever since. The correct spelling is Genevicz."

In 1923, Joe was the Braves' best pitcher with a record of 13-14. In 1924, he went 10-19, but even that dreadful record wasn't enough to lead the Braves in losses, because that year his teammate Jesse Barnes led the major leagues by losing twenty games for the worst ball club in baseball.

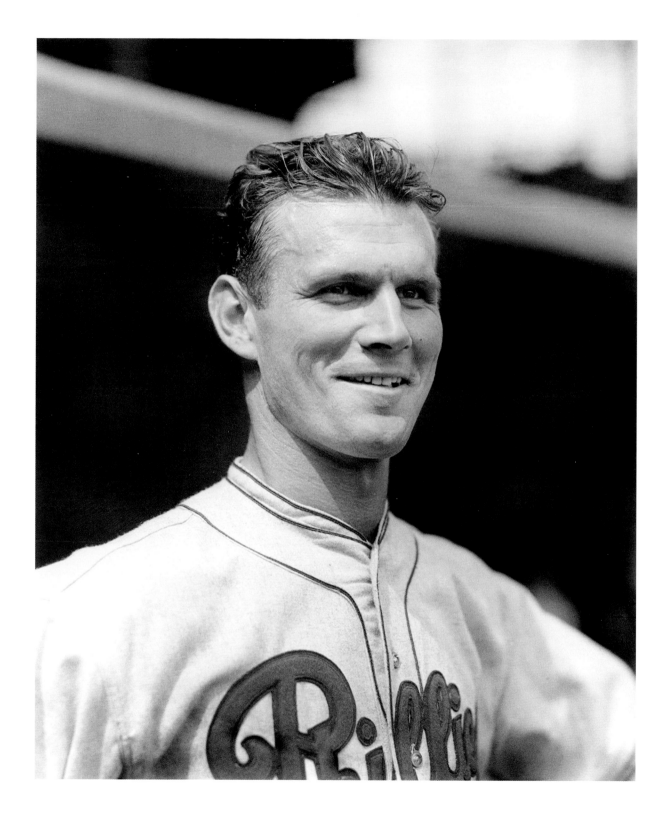

PETE SIVESS
1937 Philadelphia Phillies

This easygoing fellow won seven games and lost eleven during a forgettable three-year career spent pitching for a team that finished last in the league, next-to-last in the league, and, finally, dead last in the majors. The unflappable Sivess whistled as he pitched, remaining relaxed in the face of adversity: "I always thought I was every bit as good as the players I was facing. But I honestly wasn't enamored with baseball. That's just the way I am." Sivess, who grew up with parents who spoke only Russian, found his true calling as a naval officer in World War II, when he served as a bilingual liaison between American and Soviet forces. Then—quite unlike the self-mythologizing Moe Berg— this brilliant ex-ballplayer quietly became a genuine, full-time spy. Pete worked for the CIA from 1948 until 1972, debriefing Cold War defectors, political refugees, and former prisoners, including U-2 pilot Gary Powers.

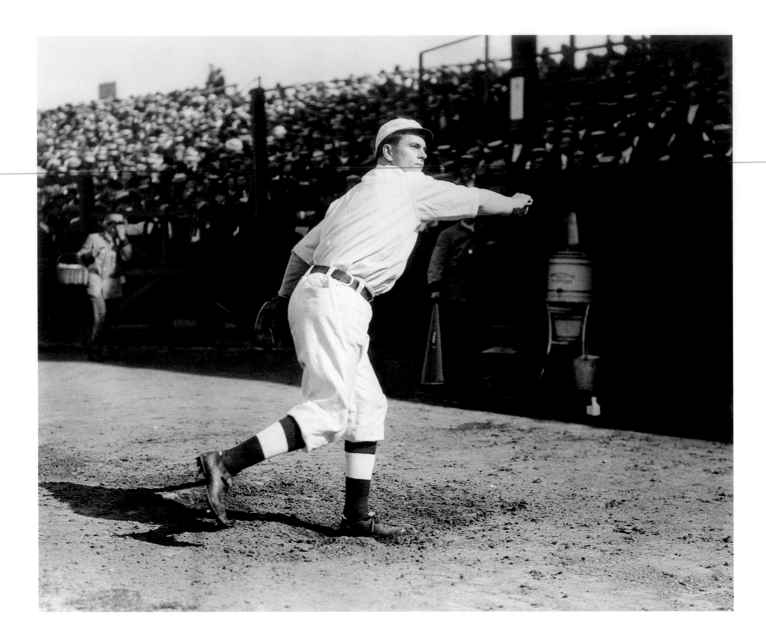

RUSSELL FORD *1911 New York Highlanders*

In 1910, Russell Ford won twenty-six games, setting the American League rookie record. He won twelve consecutive games, and his eight shutouts set a team record that stood for sixty-eight years. There was only one small problem: Ford was cheating. His co-conspirator, catcher Ed Sweeney, later revealed Ford's ingenious system: "Russ showed me a leather ring that he slipped over a finger on his left hand. Like most players' gloves, his mitt had a big hole in it. All he had to do was scratch the ball with the emery which was pasted on the leather ring. The bigger the scratch the greater the freak jumps the ball would take. He would fake a spitter, and

nobody ever got wise. When Russ threw the ball, no batter in the world could hit it. Once in a while somebody did, but it was an accident. I've seen batter after batter miss the ball a foot."

"Pitching the emery ball was not unlike handling a stick of dynamite," Ford recalled. "I used it only when I felt that I was in deep water, and it was necessary. It was a lifesaver to me." And the miscreant remained unrepentant: "I've been called a cheater, but I wasn't. A lot of pitchers roughed up the ball more than I did. There was no rule against doing it. Some pitchers even used files to rough the ball. Others used potato graters."

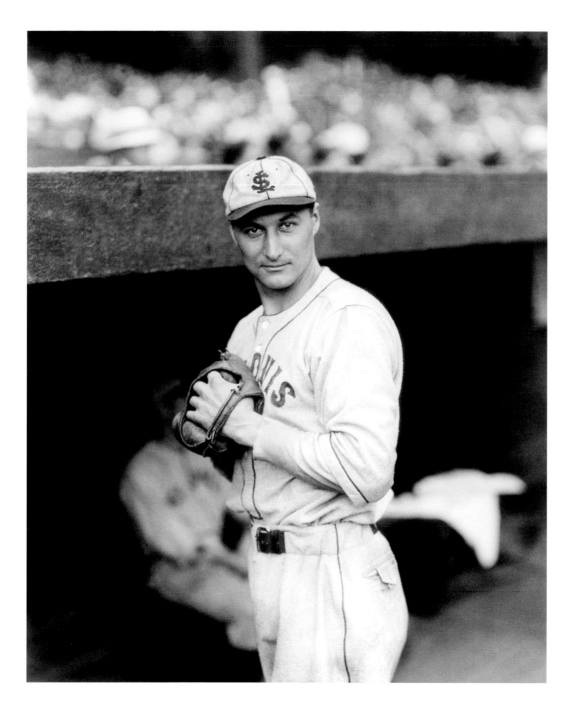

GEORGE BLAEHOLDER
1929 St. Louis Browns

Here is the first prominent exponent of the "slider," a pitch best described by Charlie Dressen as "either a fastball with a very small slow break or a curveball with a very small fast break." After facing Blaeholder, bewildered batters would return to the bench muttering: "Every fastball the guy throws is a curve." Heinie Manush was still muttering thirty years later: "He was one of the toughest for me—and remember Joe Sewell, who only struck out half a dozen times a season? Well, Blaeholder was the one pitcher who could fan little Joe—and Joe couldn't figure it out."

Blaeholder was discovered by Jimmy Austin of the St. Louis Browns in 1923 while pitching in his native Orange County, California, and his success in baseball helped the family expand their citrus groves. Blaeholder's brother Henry, better known as "Hank Skillet," played fiddle for the original Beverly Hill Billies, a group of country musicians allegedly discovered in the hills above Malibu in the spring of 1930. Their radio and movie appearances inspired the Sons of the Pioneers, whose lead singer, a young truck driver named Leonard Slye, later became better known as "Roy Rogers."

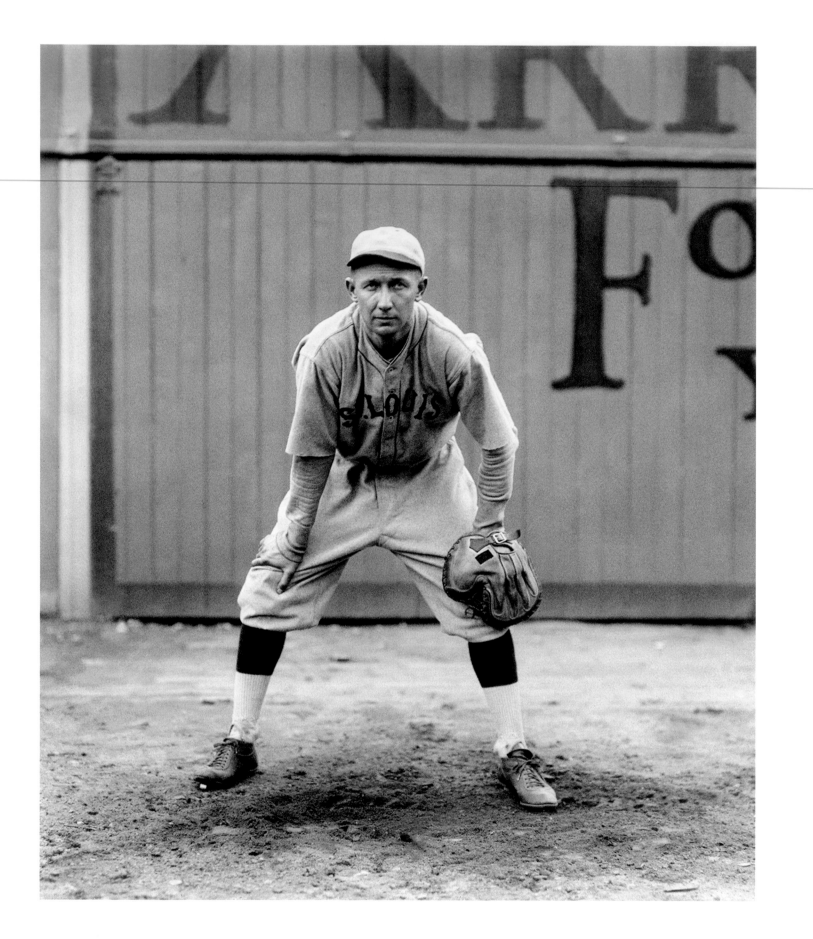

KEN SILVESTRI ➤

1941 New York Yankees

"Every year when I go home, the neighbors wonder what I do for a living all summer. They hear that I'm a baseball player but they never see my name in a box score; they never hear about me on the radio. Some of them think I'm a peanut peddler or a hot dog hustler." This happily invisible bullpen catcher, nicknamed "Hawk," played in only seventeen games in 1941, and he spent the next four years serving in World War II. During 1946 and 1947, Ken played in a total of sixteen games for the Yankees, and between 1949 and 1951, he played in only nineteen games for the Phillies: "You'll rust out before you'll wear out," Philadelphia general manager Herb Pennock assured Silvestri, whose enthusiasm and catching experience—such as it was—helped youngsters Robin Roberts and Curt Simmons as they pitched the "Whiz Kids" into the 1950 World Series.

◐ JOSH BILLINGS

1922 St. Louis Browns

In 1922, this man hit .429—but no one noticed. As the Browns' third-string catcher, Josh was barely a member of the team, and he came to the plate only seven times all season. Conlon encountered the stoic Billings in his natural habitat, the bullpen. In 1943, Josh became the first manager of the Kenosha Comets, one of the four founding teams of the All-American Girls Professional Baseball League.

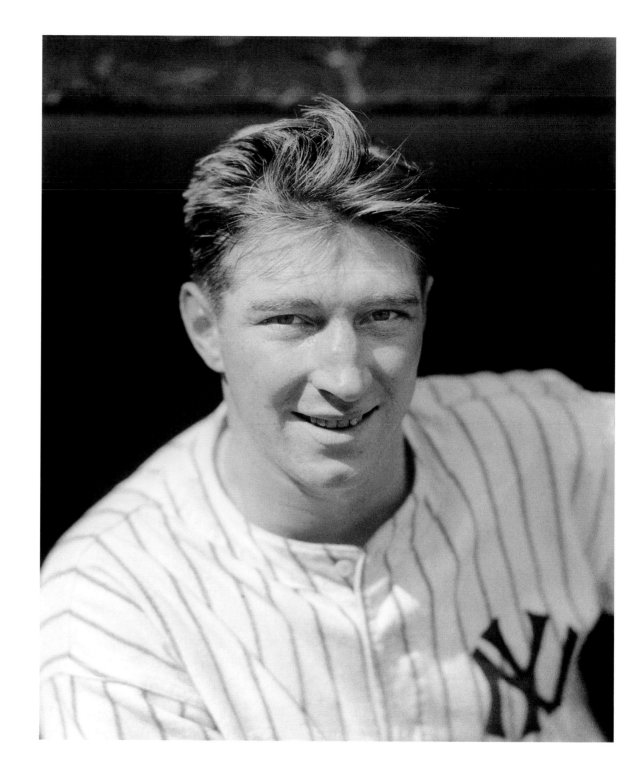

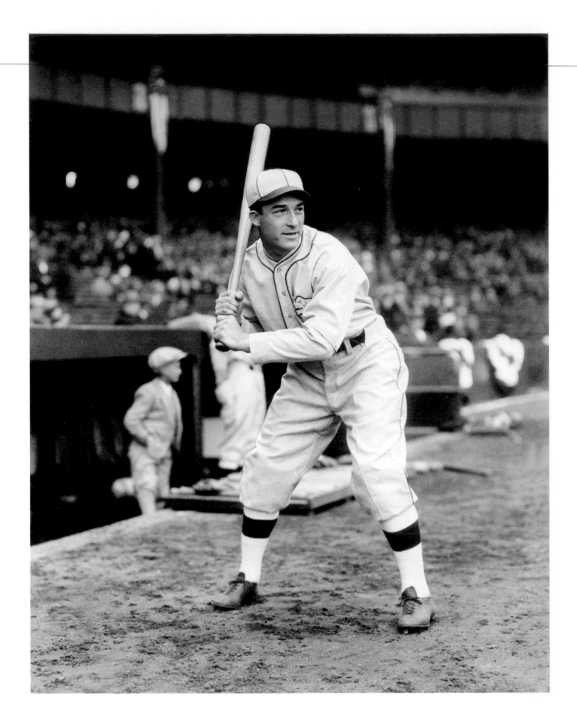

AL SIMMONS
1927 Philadelphia Athletics

"He had that famous swagger as a kid; he had it when he quit," said A's catcher Cy Perkins. "It was a swagger of confidence, of defiance."

"The way I always regarded it was that the pitchers were trying to take your living away from you," said Al Simmons. "It's just the same as if he'd walk into the dining room and take the bread out of your mouth when you were hungry. You wouldn't smile back at him, would you? Exactly! The only thing you've got to beat a pitcher with is your bat." And Simmons didn't take any chances: His Louisville Slugger was nearly thirty-nine inches long—the longest in baseball history. "They give you that herky-jerky motion and stall around and try to get you off stride and play you for a chump. There's no reason to be friendly with a pitcher who's trying to take your bread and butter away from you. I never had any sympathy for a pitcher."

"Al always sort of scared me," admitted pitcher Herb Pennock—but only after he had spent a decade playing Simmons for a chump by using all the dirty tricks the batter detested.

CONNIE MACK

1926 Philadelphia Athletics

"I've always been grateful to Connie Mack for not trying to change my batting style," said Al Simmons. "They said I hit with my foot in the bucket, and maybe I was unorthodox. But, when I swung, I was stepping directly into the ball— only the dopes never noticed that. There were even some dopes on our club when I came up with the A's in 1924. They looked at me without seeing what I was doing and some of them wanted me to change my stance. They kind of had me worried, because I was only a busher and they were big leaguers, but Mr. Mack heard them and he gave them the devil. He said to them, 'Let that young man alone, his stance suits me all right.' After that, they let me alone and I showed them I could hit up here better than any of them could."

The insufferably egotistical Simmons was inducted into the Baseball Hall of Fame in 1953, but he seemed to strike a note of genuine humility when he thanked his mentor: "Without a man like Mr. Mack guiding me, I never would have been able to gain this honor."

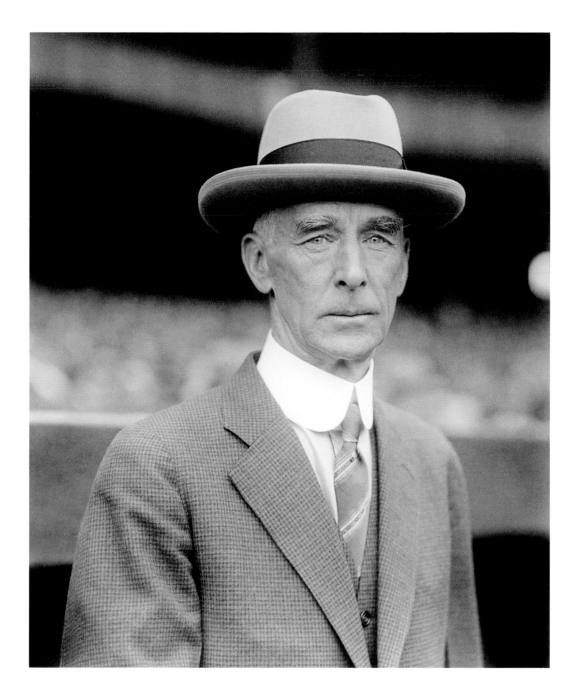

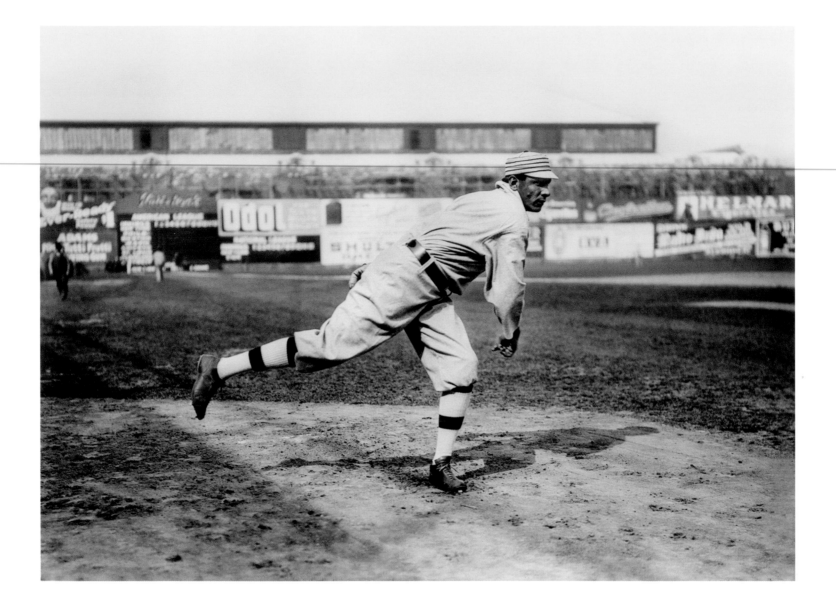

CHIEF BENDER *1911 Philadelphia Athletics*

Bender lost Game One of the 1911 World Series to Christy Mathewson of the New York Giants by a score of 2–1, but he went on to beat Matty in Game Four, and the Chief clinched the World Series with a victory in Game Six. "On Broadway they rave about Mathewson being the greatest 'money' pitcher in baseball—but only on Broadway, the home of gunmen, etc.," reported the *Philadelphia Evening Bulletin*. "Right here in this town, where we boast of the greatest ball club of all time, we boast of the greatest 'money' pitcher—the greatest of all. That hurler is Charles Albert Bender."

Philadelphia manager Connie Mack concurred: "If there was one game I simply had to win, I'd want the Chief to pitch it for me.

Bender was my smartest pitcher—the smartest, I think, that ever threw a baseball." But Bender revealed that it wasn't nearly as easy as it looked: "Mr. Mack thought I was the coolest pitcher he ever had. I *was* cool—on the outside. On the inside, I burned up. I couldn't eat for three hours after a game."

"Mr. Mack always matched Bender against the toughest pitchers in the league," explained Ty Cobb. "There were no soft spots for him. If the White Sox pitched their big wheel, Ed Walsh, Bender went in to oppose him. If Walter Johnson was Washington's starting pitcher, Bender would be in there for the Athletics. That went on for years."

CHIEF BENDER
1926 Chicago White Sox

"I don't know why they called me a 'money' pitcher. I never got any. I signed up for $1,800 in 1903 and in my last year, 1914, got $5,000. And it was like pulling teeth to get Connie to give me that. I guess I was born too soon." In 1918, Connie Mack declared: "No ball player who ever lived is worth more than $5,000 for a season's work. There is no other work in the world where a man receives greater compensation for less effort than he does in baseball."

In 1953, the year before his death, Bender was elected to the Baseball Hall of Fame: "I was sure I'd make the Hall of Fame sometime, because I figured, sooner or later, the white man would have to give something back to the Indians."

JIMMY ARCHER
1917 Chicago Cubs

In 1903, Archer scalded his right arm and leg when he fell into a vat of boiling soap. His horrible scars meant that he could never fully extend his throwing arm, but in 1917, *Baseball Magazine* nevertheless proclaimed him "The Greatest of All Catchers." In 1914, the *New York Sun* declared: "Archer is the fastest, the most deadly of throwers to the bases. He is the nonpareil of all catching wizards." In 1913, the *New York Evening Telegram* called Jimmy "the perfector of the snap throw from a squatting position behind the plate." Archer also threw the ball while sitting or kneeling, which infuriated the manager of the Detroit Tigers in 1907: "Hughie Jennings asserted that a catcher could never be of major league material as long as he persisted in throwing from a squatting position," Archer recalled. "He wanted me to stand up before throwing to the bases. I knew that I could save time by throwing from that squatting position. The object is to throw out the runner. What difference does it make how you throw the ball just so you get it there?"

JIMMY ARCHER
1916 Chicago Cubs

"Jimmy Archer wasn't a good hitter, but he used to murder me," moaned Hall of Fame pitcher Grover Cleveland Alexander, who considered Archer his special jinx: "He could have hit me with a broom. I remember he used to say, 'Well, I hit .228, and I guess .200 of that was off Alexander.'"

"Jimmy Archer hit one on the nose at the west side park [*sic*] Tuesday," wrote Ring Lardner after a game in 1914. Startled spectators saw Archer "swing his strong right fist on the jaw of a tall, well-dressed spectator," reported the *Chicago Tribune*. "It seems that during the game the well-dressed fellow took occasion to address Mrs. Archer and her friends." When the game ended Mrs. Archer pointed out the masher to her husband: "The leap into the box and the blow on the jaw followed. In a jiffy blue-coated officers had the fellow in charge. While he mopped the blood off his mouth, Archer went to the clubhouse and Mrs. Archer and her friends made a hurried exit." Archer was charged with assaulting the well-dressed fellow, who "decided that as a Cub fan he did not wish to prosecute Archer," and the case was dismissed.

BOB FOTHERGILL
1923 Detroit Tigers

"Fothergill is one of the few genuine showmen left in the so-called national pastime," declared Bud Shaver of the *Detroit Times*. "Roly Poly Robert is a past master of the art of extracting the last atom of drama out of any given situation. He puts an artistic fillip to every achievement." Fothergill's greatest dramatic achievement came one day when he faced pitcher George Earnshaw of the Philadelphia Athletics: "George pitched one in close," recalled A's catcher Mickey Cochrane, "and Bob got the idea it was aimed at his head. He was very sore. He took a terrific swipe at the next pitch, and hit perhaps the longest homer of his career. As he went around the bases he was yelling at Earnshaw, and just before he reached the plate, he turned a complete somersault in the air without using his hands, landing on the plate on his feet." Fothergill's teammate Charlie Gehringer was equally amazed: "He's rounding the bases nice and easy—and then when he gets to third base he comes running like a freight train and does a complete flip in the air and lands on home plate! Never saw him do that before. Man, he brought the house down!"

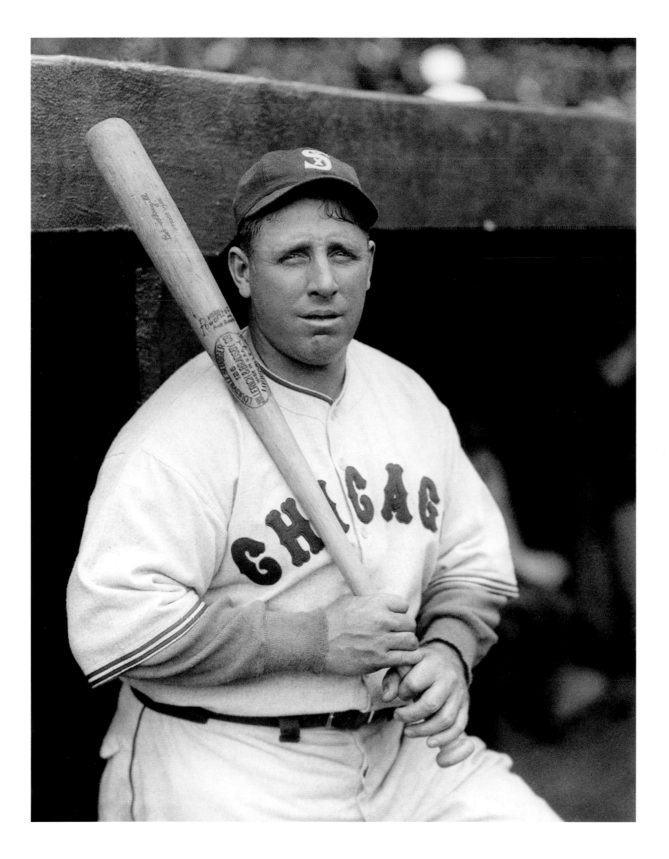

BOB FOTHERGILL
1932 Chicago White Sox

In 1932, the *Sporting News* noted that "Bob Fothergill, the White Sox outfielder, who lives on hunches and superstitions, has no fear of No. 13. He wears it on the back of his uniform. He says it is no heavier than 14 or 12." But this Conlon photograph makes it painfully obvious that the thirty-five-year-old Fothergill—now heavier than ever—was having no luck in his battle with obesity. His once phenomenal athletic abilities were rapidly eroding, and Bob would end his career in a limited pinch-hitting role with the Red Sox in 1933. He eventually returned to Detroit as a security guard for the Ford Motor Company.

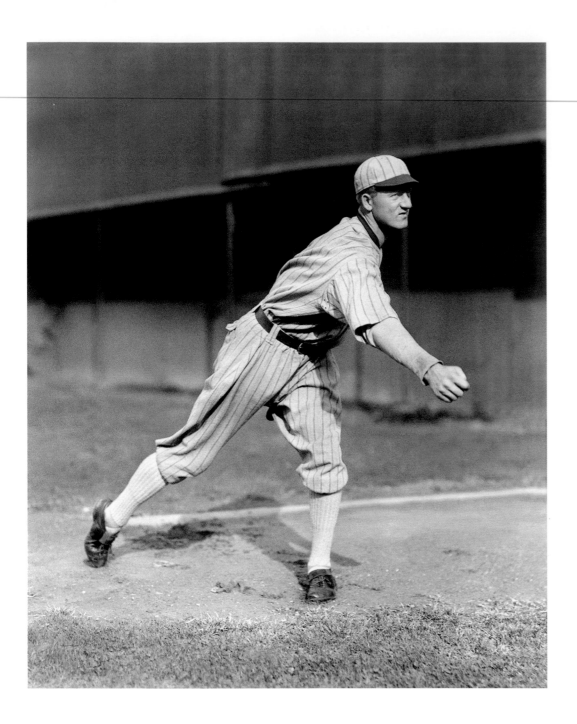

◐ RED FABER

1917 Chicago White Sox

Red Faber was the pitching hero of the 1917 World Series, winning three games, including the sixth and deciding contest played at the Polo Grounds. He also stole a base in the fourth inning of Game Two, but there was a complicating factor: His White Sox teammate Buck Weaver was already standing on the bag. "Where the hell are you going?" inquired the astonished Weaver. Faber, who had just made the third out with his base-running blunder, replied matter-of-factly: "I'm going out to pitch."

RED FABER ◑

1932 Chicago White Sox

Like all spitballers, this Hall of Famer would go through the motions of "loading one up" before every pitch, but he never tipped off his spitter by moving his jaw muscles—unlike his teammate Ed Walsh, whose cap jiggled whenever he readied a wet one. "There was no reason for ever outlawing the pitch that I could see," said Faber. "I suppose a lot of people thought it was more unsanitary than dangerous. I would just wet two fingers. I didn't wet them much, just enough so the fingers would slip off. Some fellas used a lot of spit, especially those who chewed slippery elm. When they threw, you could see moisture flying all over the place. I tried slippery elm, but it made the ball too hard to grip. Just ordinary spit wasn't good, you know. Finally I found my own ideal mixture. On one side of my mouth I'd have a chaw of tobacco and on the other I'd have gum. Never got 'em mixed up either." That ideal mixture is visible on the sleeve Red wore in 1917 (see left).

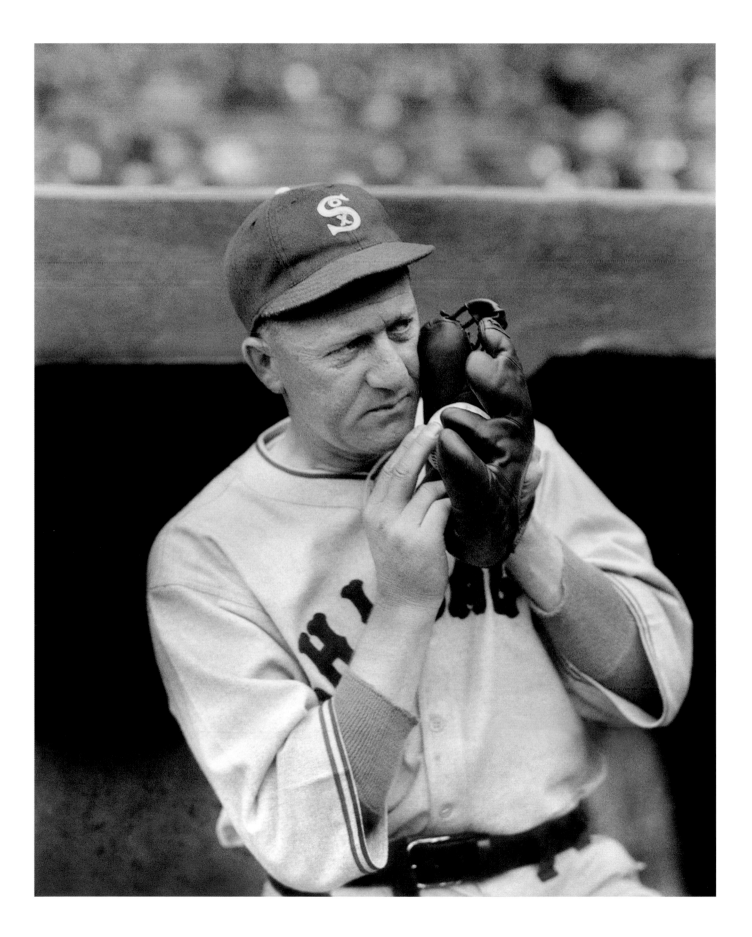

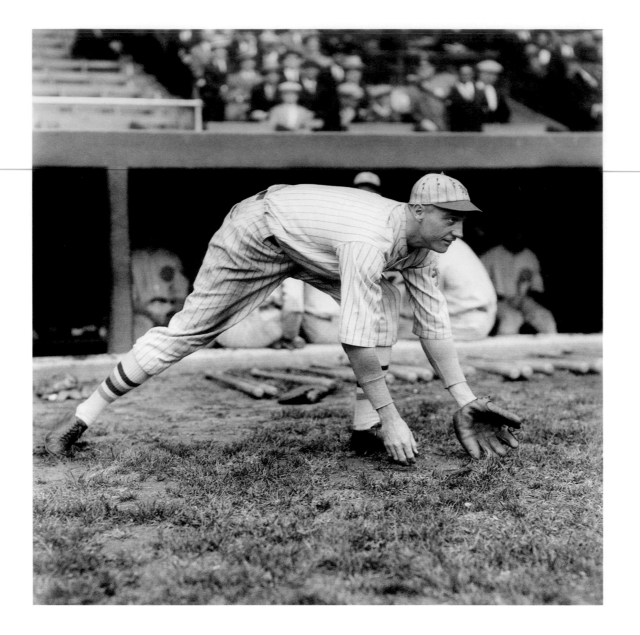

GEORGE KELLY *1925 New York Giants*

"Kelly's phenomenal reach pulls in many a throw that with a shorter man would go as an error," reported the *Pittsburgh Post-Gazette* in 1924. "He's an ideal target, and when he's on first the infielders know they don't have to be quite so careful about their aim." But Kelly's tiny first-baseman's mitt was less than ideal—particularly when judged by the standards of later generations: "You didn't use that thing, did you?" asked an incredulous major leaguer in 1949. "Sure," replied Kelly. "You guys are sissies today." Kelly's glove remained his favorite conversation piece: "Look at it. My boy wouldn't use it. Too small. But that's the glove I used

throughout my career. I brought it out to Candlestick Park and showed it to Willie McCovey. He could take it and put it *inside* his own glove."

In a 1927 editorial titled "Bizarre Decorations," the *Sporting News* deplored the gratuitous use of red, white, and blue in baseball uniforms: "The national colors were not meant for stockings," fulminated the Bible of Baseball, citing as damning evidence the unsettling vision of "Long George" Kelly's legs in a Giants uniform: "When he came on the field he looked like twin light houses escaped from anchorage."

GEORGE KELLY

1929 Cincinnati Reds

Kelly was eventually supplanted as the Giants' first baseman by future Hall of Famer Bill Terry, but he didn't leave voluntarily: "I used to kid Terry to beat all hell while he sat on the bench, waiting to take my place. I wouldn't go out of the lineup. I didn't make the mistake that Wally Pipp did." When Kelly was finally traded to the Reds in 1927, Will Wedge of the *New York Sun* paid him a farewell tribute: "The Giants probably never had a better all-around player than 'High Pockets' Kelly of the chattering voice and gum-chewing jaws. Yet Kelly, in his early days breaking in with the Giants, took an unmerciful course of razzing from the fans before he made a firm place in their affections. He had a habit of striking out frequently when he was green at the game. But he never lost confidence in himself, and never lost his smile, and before long he learned to smite the horsehide as few men can smite it except Ruth and Hornsby." In 1973, Kelly joined them in the Hall of Fame.

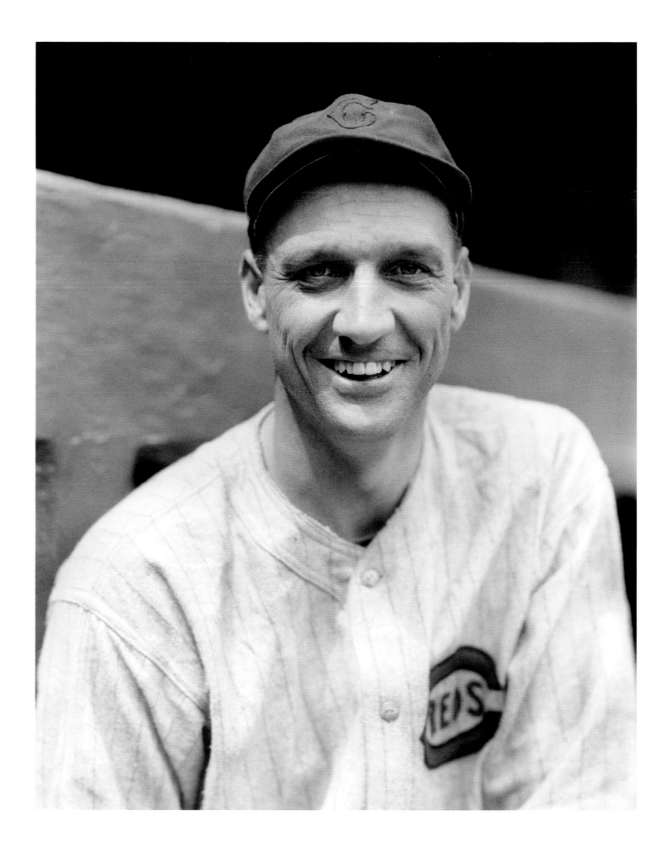

HARRY COVELESKI
1917 Detroit Tigers

The pitching Coveleski brothers were born in Shamokin, Pennsylvania: "I was just a kid from the slag dumps around the mines," recalled Harry. "They called me 'Donkey Boy' because I drove the mine mules." With the Phillies in 1908, Harry became "The Giant Killer" when he beat the New York Giants three times in the last week of the season to force them into a playoff with the Chicago Cubs: "When I get in the clubhouse, there's [Philadelphia manager] Billy Murray holding out his arms. He almost kisses me, then hands me a brand new $50 note. From that minute on I made up my mind I'd never look at another mine mule." After three consecutive twenty-game-winning seasons with the Tigers, Harry hurt his arm and eventually ended up tending bar at The Giant Killer, his tavern back in Shamokin: "My biggest regret is I missed the big dough they're passing out today," he said wistfully. "If I had received some of that important coin, I wouldn't be here."

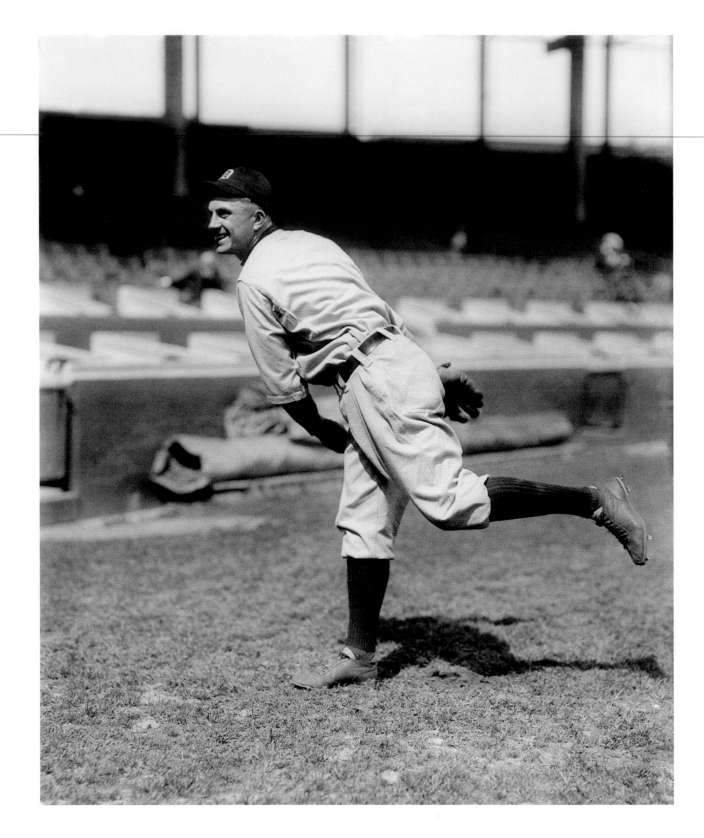

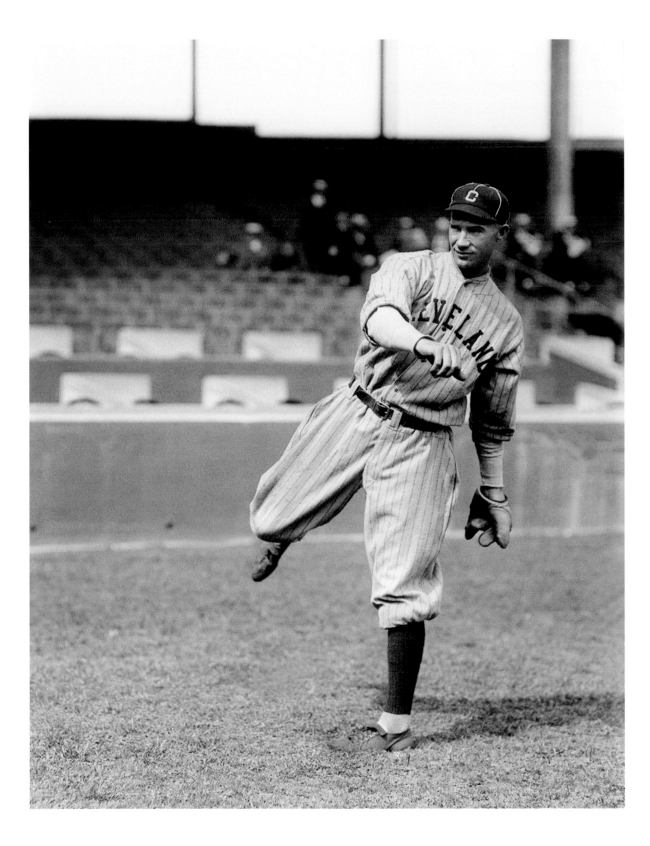

STAN COVELESKI
1917 Cleveland Indians

"There wasn't any fun with him," said catcher Luke Sewell. "It was a grim business." But Stan Coveleski *had* to take his job seriously: "There was an art to throwing a good spitter. If you couldn't control it, you were just a menace. You could hurt a batter because a spitball takes off." Coveleski's spitter could also get the batter very wet: "Darn thing came up there looking like a moving shower bath—it'd splash all over you," claimed Babe Ruth. "That's not true," protested Stan. "You didn't load up a spitter—at least I didn't. My spitter wasn't a lot of guck. It was hardly damp—just a fast ball that didn't tumble. But one thing you need is a jawful of slippery elm. You don't use much of it, but just plain sweat is no substitute for slippery elm. Elm would make the ball as slippery as a piece of ice." Stan was the pitching hero of the 1920 World Series, winning three games for the Indians, and he had five twenty-game-winning seasons before retiring to run a gas station in South Bend, Indiana. He was elected to the Baseball Hall of Fame in 1969.

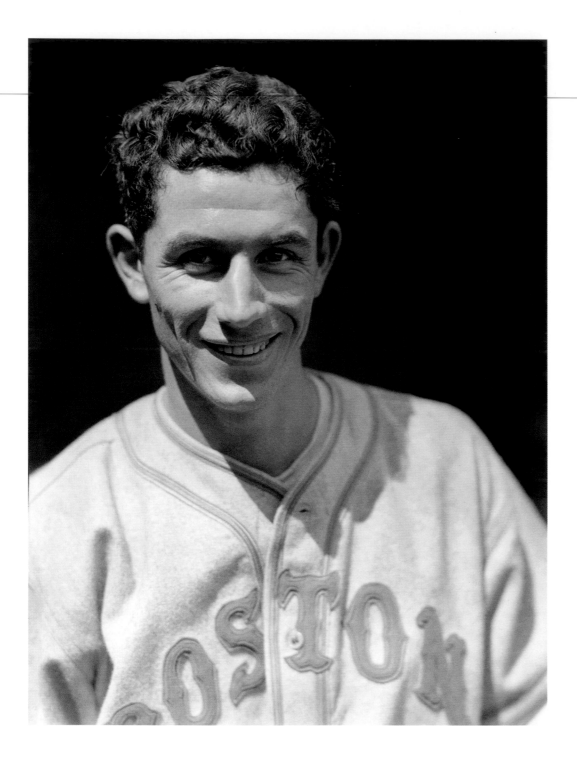

VINCE DiMAGGIO
1937 Boston Bees

In 1937, this rookie outfielder led the National League in strikeouts—a feat he would accomplish six times in his ten-year career—but he was philosophical about this unfortunate proclivity: "After all, if you strike out, you don't hit into a double play," he explained in all seriousness. "Vince is the only player I ever saw who could strike out three times in a game and not be embarrassed," recalled former Bees manager Casey Stengel. "He'd walk into the clubhouse whistling." Vince was the National League batting hero in the 1943 All-Star Game with a single, a triple, and a home run, but his greatest contribution to baseball was arranging a professional tryout for his shy kid brother, who hardly ever struck out: "If it hadn't been for my brother Vince, I never would have been a ball player at all," said Joe DiMaggio.

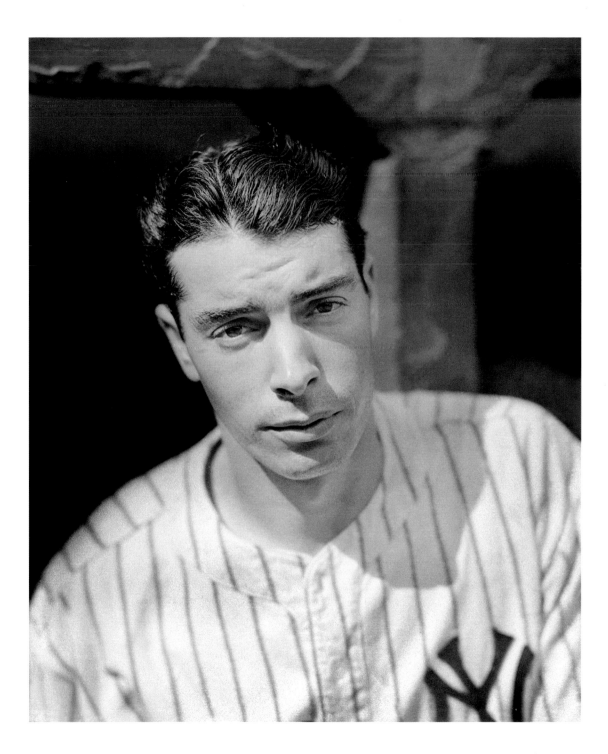

JOE DiMAGGIO
c. 1937 New York Yankees

With just three games left in the 1932 season, shortstop Augie Galan of the San Francisco Seals asked his manager for permission to go on a trip to Hawaii. Permission was denied because Galan's absence would leave the team one in-fielder short—until Seals outfielder Vince DiMaggio resolved the dilemma: "What's the matter with my brother Joe? He's a shortstop and a good one." Joe wasn't much of a shortstop, but he hit a triple in his first professional at-bat, and in 1933 he batted safely in sixty-one consecutive Pacific Coast League games. Joe became a start-ing outfielder for the Seals, making his big brother expendable, and Vince was soon playing for the Hollywood Stars.

Joe went on to become an American sports hero, a strange and lonely legend who eventually amassed a fortune through product endorsements and personal ap-pearances, but by the 1970s, while the Yankee Clipper was selling Mr. Coffee on television, his brother Vince was selling Fuller Brushes door to door.

LENA BLACKBURNE
1918 Cincinnati Reds

One day around 1937, umpire Harry Geisel complained to Philadelphia A's coach Lena Blackburne that new baseballs were so slick that they tended to slip out of the pitcher's hand. Nothing that the umpires rubbed on the ball—tobacco juice, shoe polish, dirt—had satisfactorily solved the problem . . . until Blackburne had a brainstorm. He returned to the ballpark with a mysterious substance that he had serendipitously discovered at a secret location near his home in Palmyra, New Jersey. The proud purveyor of "Lena Blackburne's Baseball Rubbing Mud" declared cryptically: "Nobody will ever know the exact spot where I get my goo." It was officially adopted by the American League in 1938, and by the National League in 1955.

MRS. GRACE C. BLACKBURNE
1934

By 1944, Blackburne was charging the American League $50 for a year's supply of his goo. Each of the eight teams paid $6.25 for a one-pound coffee can full of semi-dehydrated mud— enough to last for an entire season: "Hell, this is no business," admitted Lena. "It's just a hobby. Besides, what I get I share with my wife."

"I take my girl friends to lunch every year with my share," gushed Grace. "It's my mud money." Tragically, neither of the Blackburnes lived to see the really big mud money: By 2000, a year's supply of mud was going for an astronomical $40 dollars a can, which—coupled with massive major-league expansion—meant that the Lena Blackburne Rubbing Mud Co. now had a gross annual income in excess of $1,200.

HARRY GEISEL

1926 American League umpire

When Joe DiMaggio arrived in the big leagues in 1936, one thing impressed him immediately: "The umpiring is different. Comparing the work of Harry Geisel with the type of umpiring I saw in the Pacific Coast League is like putting Gehrig alongside that kid who plays first base for the Bees."

"What makes a major league umpire? I'd put appearance first," said Geisel, who was described as "the Beau Brummel of the guessing party" by a Chicago sportswriter. "Harry Geisel sat in the grandstand in all his sartorial splendor," reported the *Boston Herald* in the spring of 1931. "He was a symphony in brown, with chamois gloves to match."

"It has been many years since I have enjoyed a game and then I was in the grandstand," said Geisel in 1937. "The task assigned to the umpire is a serious one. When I leave the dressing room five minutes before playing time, I have no reason to feel enthusiastic or excited; rather, I tighten up, wash my mind of everything else and concentrate on calling 'em." But after calling his last game in 1942, Harry finally confessed: "For 33 years I had the most thankless job God ever created, but I enjoyed it."

TRAFFIC CONTROL OFFICER

1940, outside Yankee Stadium

Taking a break from the second most thankless job God ever created, this NYPD sergeant poses solemnly—and a little stiffly—for a Conlon portrait reminiscent of the work of August Sander, the famous German photographer whose greatest achievement was a vast documentary project titled *People of the Twentieth Century*. The didactic Sander viewed his subjects as types, not individuals; the meticulous Conlon was careful to identify the people in his photographs by name, but—uncharacteristically—he described this policeman only as "Stadium cop." By 1940, his thirty-seventh year as an obscure American photographer, Conlon's own vast documentary project was winding down, and it is highly unlikely that he took this picture with publication in mind—but he was still quietly and unpretentiously recording every facet of major league baseball.

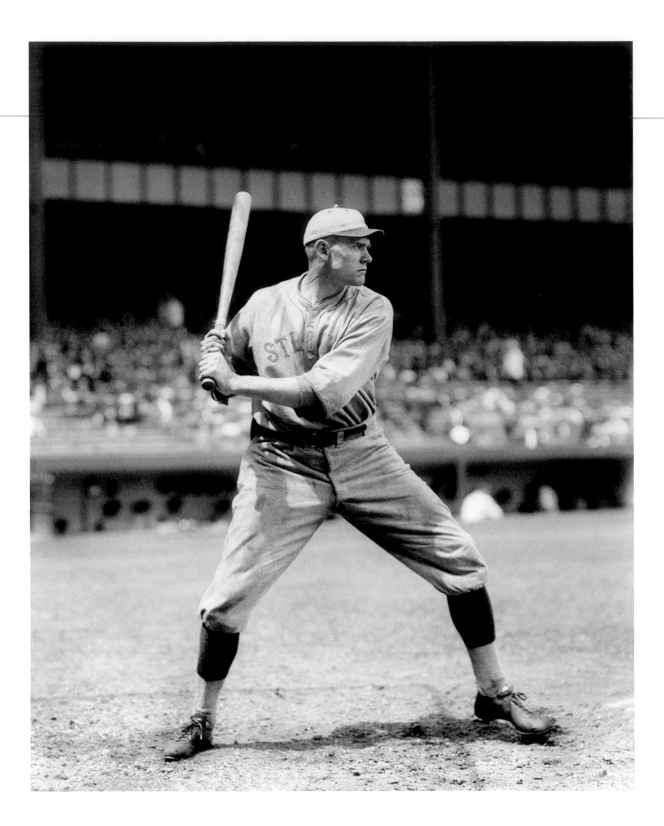

BABY DOLL JACOBSON
1923 St. Louis Browns

During the spring of 1912, Bill Jacobson appeared in an exhibition game in Mobile, Alabama: "They had a band playing on the field, and just before the first pitch they played 'Oh, You Beautiful Doll.' Just a couple of minutes later, I led off and hit the first pitch over the fence. A lady behind home plate stood up just as I finished circling the bases and yelled, 'That must be that beautiful baby doll they were just talking about.' Well, from that day to this, I've been Baby Doll. If I didn't have that nickname, my name would be mud."

"I might not have been the greatest centerfielder in history, but in my time I was the biggest," said the six-foot-three Baby Doll. "When he starts after a fly ball the earth trembles," reported the *Sporting News* in 1924. "He had the longest step I have ever seen a man take," recalled his former Browns teammate Marty McManus.

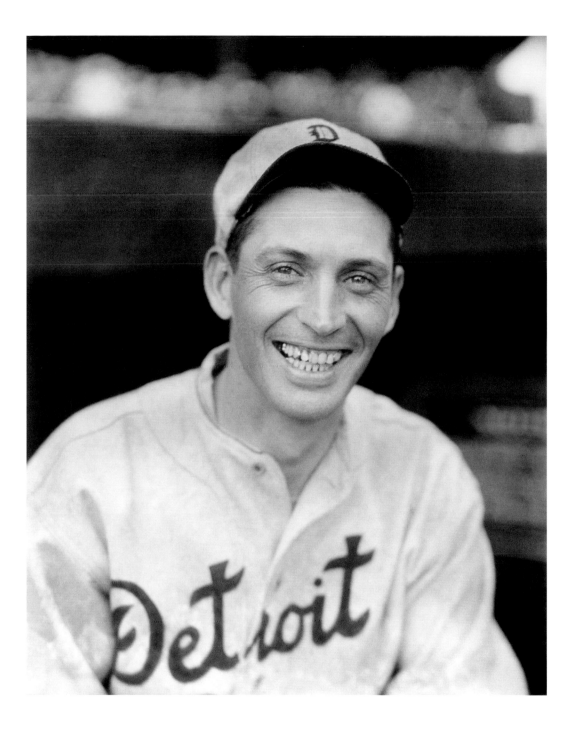

MARTY McMANUS
1930 Detroit Tigers

In 1922, the St. Louis Browns were the power-house of the American League, although they finished second to the Yankees by one game. Only five American League players knocked in one hundred runs or more that season, and four of them were on the Browns: outfielders Baby Doll Jacobson and Ken Williams, and infielders Marty McManus and George Sisler.

In 1930, McManus led the league in stolen bases with the Tigers, who reluctantly traded him to the Red Sox in 1931: "In the departure of McManus, Detroit loses a player who has been its most aggressive unit since he joined the club in 1927," reported the *Detroit News*. "Those who know him hope that he will remain for many more seasons to inflame with his competitive zeal a game that is becoming drab for lack of players of his temperament." McManus managed the Boston Red Sox in 1932 and 1933, and in the 1940s, he managed the South Bend Blue Sox of the All-American Girls Professional Baseball League.

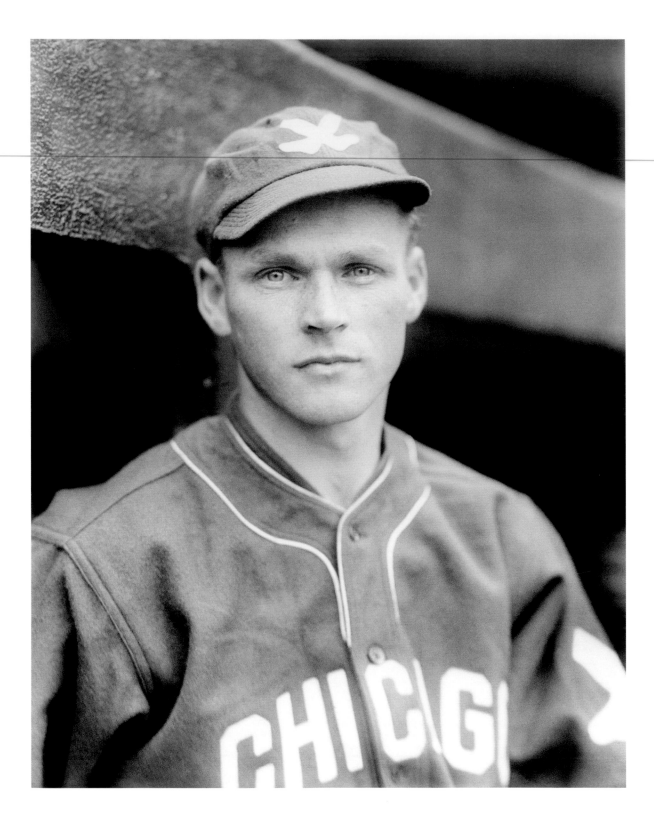

BILL HUNNEFIELD
1926 Chicago White Sox

HONEY TURNS INTO A PEACH was the headline when this Conlon photograph was first published in August of 1926. The *Sporting News* was teasing the Cincinnati scout who had "put the lemon stamp on what in reality was a peach" when he passed on young Bill Hunnefield after deciding that the prospect "didn't know beans as a shortstop." The White Sox took a gamble on Hunnefield, however, and the rookie became their starting shortstop in 1926. But things turned sour for "Honey Boy" in 1928, when the notoriously impecunious White Sox owner Charles Comiskey benched Hunnefield at the end of the best season of his career—allegedly to deprive him of a $1,000 bonus: "I had played in 92 games when we were to make our last Eastern trip. I had been going well, but I was left behind. Didn't even make the trip. What should I figure but they were doing it to keep me from playing in the 100 games that would get me the bonus?" asked Hunnefield, who worked as an accountant in the off-season. "So long as he was on the payroll of the club he believed had not used him fairly, he was unable to perform at his best," reported the *Sporting News*. "Hunnefield's usefulness to Chicago was at an end."

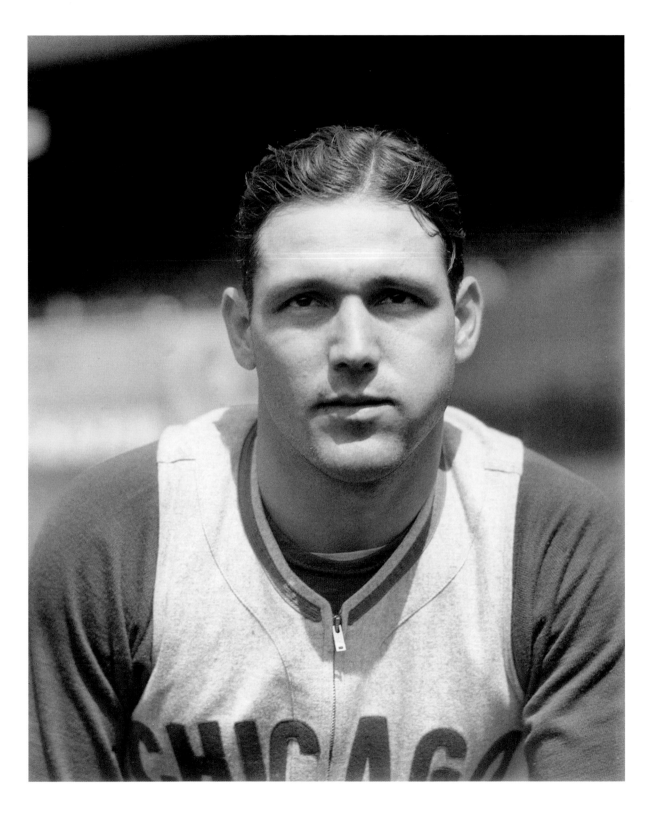

BILL NICHOLSON
1940 Chicago Cubs

One day at Ebbets Field in Brooklyn, while this slugger was taking a practice swing, a taunting fan yelled: "Swish!" Soon the entire crowd was chanting "swish" with every swing he took. "That was it," said Bill. "From then on I was 'Swish.' The crowds in the Polo Grounds took it up, and before the season was over I got it everywhere, even in Wrigley Field." But pitcher Schoolboy Rowe wasn't laughing: "Honest, that guy frightens a pitcher, the way he stands and swings."

Nicholson led the National League in home runs and RBIs in both 1943 and 1944, missing the 1944 MVP Award by only one point, and he hit home runs in four consecutive at-bats at the Polo Grounds on July 22–23, 1944—the weekend when Giants manager Mel Ott famously decided to walk Nicholson with the bases loaded. At Forbes Field on July 19, 1950, Bill famously hit an infield fly so incredibly high that by the time it landed, he had a triple. Actually, it was a routine pop fly, but the Pirate infielders collided near home plate while attempting to catch it, and by the time the ball was retrieved, Nicholson was standing on third base. One Pittsburgh writer dismissed it as a "fluke triple," while another disparaged it as "cheesy."

ART FLETCHER

1916 New York Giants

When this shortstop joined the Giants in 1909, the team was already wearing modern collarless uniforms, but Art Fletcher—sensitive to taunts from fans and opponents mocking his long neck and "chisel chin"—fashioned his own collar from a strip of cloth. The Giants finally ordered a set of uniforms customized just for him, and Fletcher wore this anachronistic high collar until he was traded to the Phillies in 1920: "Since Arthur Fletcher and his Adam's apple passed out, there are no collars on shirts in the big leagues," noted sportswriter Damon Runyon in 1921. Art later managed the Phillies, but turned down the chance to succeed Miller Huggins as manager of the Yankees. "I'm not the type to be a manager," he explained. "I don't believe I have the sweet disposition to go with the job." He much preferred being a Yankees coach, the job he held from 1927 until 1945, and whenever the team won the World Series, Fletcher led the victors in singing "The Sidewalks of New York." But even the Yankee third base coach's job had its vicissitudes: "Sometimes the runners ignore me and keep on going for the plate. When they get thrown out, they say they didn't see my stop sign. When they score, I feel very unscientific."

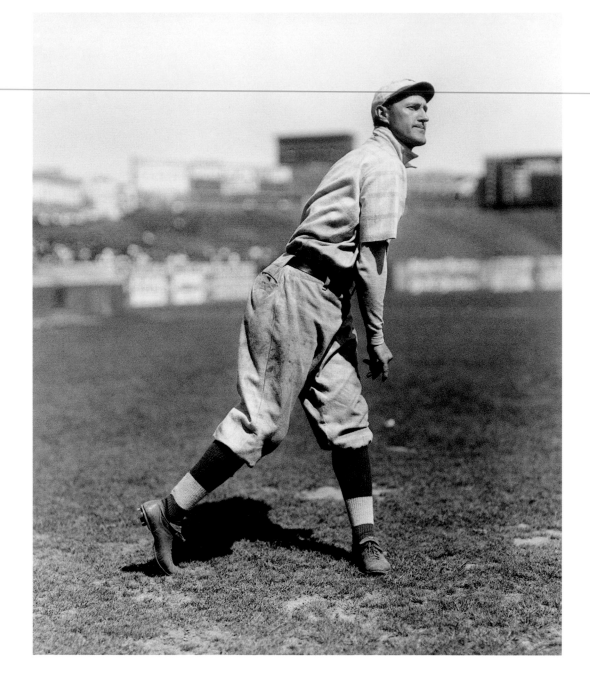

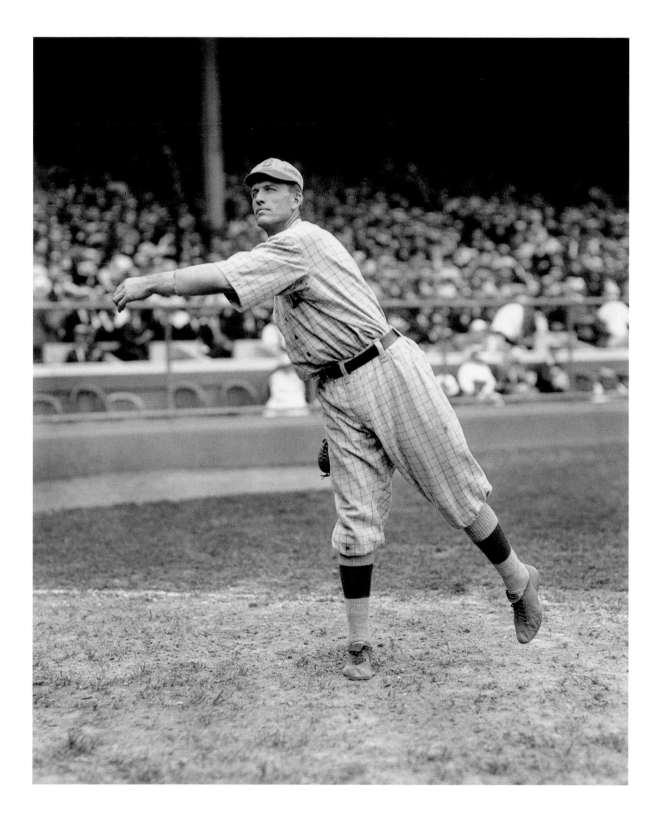

JAKE DAUBERT
1916 Brooklyn Robins

Here Jake Daubert, first baseman and captain of the Robins, models the 1916 Brooklyn road uniform, with its peculiar but not unattractive design of blue crosshatched stripes. The wacky design of the 1916 New York Giants uniform, however, was a proto-psychedelic bad trip. Trimmed in violet, with purple stripes crosshatched to produce a truly disturbing plaid effect, the new uniforms immediately provoked scorn and derision: "Probably the only uniforms that ever approached them in sheer hideousness were those formerly worn by the Athletics," ranted Walter Trumbull of the *New York World* in the spring of 1916. "The suits appear to be constructed from the material still in vogue at prisons which never came under reform influence, and what the caps look like cannot be stated in this family newspaper. Suffice it to say that they are perfect 'pep' extinguishers." William B. Hanna of the *New York Sun* knew a straight line when he saw one: "It is said that the new road uniforms of the Giants have a prison stripe effect, but then the playing of the Giants lately has been a crime."

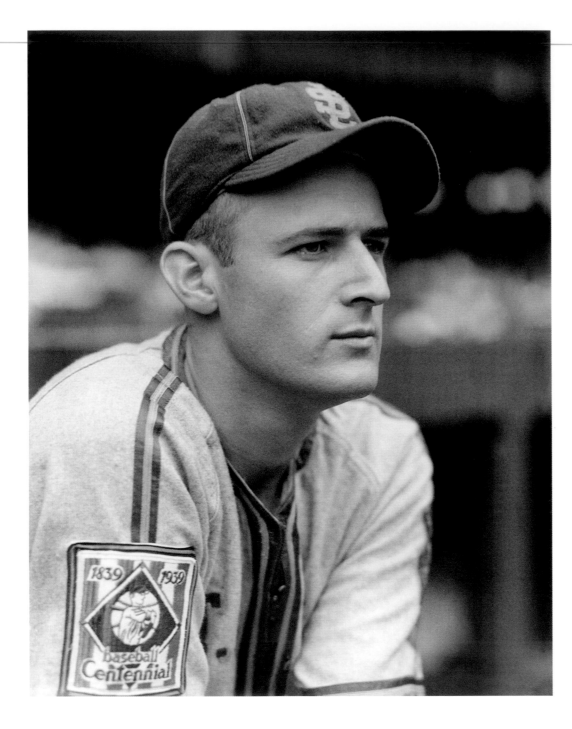

JOE GRACE
1939 St. Louis Browns

Here is the magnificent Roman profile of outfielder Joe Grace, who is wearing a 1939 Baseball Centennial patch on his sleeve. In commemoration of Abner Doubleday's mythical invention of the game in 1839, the potentates of baseball organized a spectacular celebration culminating in the dedication of the Baseball Hall of Fame at Cooperstown. The competition to design the centennial emblem was won by artist Marjori Bennett of Manhattan. She placed a red batter on a blue diamond; the three white stripes symbolized three strikes, and the four red stripes represented four balls. "Vicariously," said Ms. Bennett, "I'm getting around an awful lot these days, in the best kind of company."

In 1941, Joe Grace batted a career-high .309. He celebrated by marrying his sweetheart, who gave him an ominous warning on their wedding day: "Keep up that .300 average or it's going to be just too bad for you." Joe never batted .300 again, and he eventually became a meat salesman.

RANDY MOORE
1930 Boston Braves

This long, tall Texan was a steady outfielder on some very shaky teams. He had his best luck on other fields—oil fields, to be precise. Moore struck oil in 1930, but he told reporters in the spring of 1931: "That oil wasn't enough to make me a wealthy man at all, at all. I've got a little bitty interest in it, but not enough to be able give up the old pastime. They're now drilling on my land, and if a few wells come in on that land, well, that may be a different story." In time, well, it was a different story: "Finally we got a well started in Talco, about 30 miles north of Omaha, Texas. Watson Clark, Al Lopez, Johnny Cooney, and Casey Stengel all invested, Casey more than the others. Every time I'd mention a new lease, Casey would say, 'I want a fourth of that.' We struck oil and the thing is still paying." Moore eventually became the president and owner of the State Bank of Omaha.

In 1930, the Braves wore a bright red Pilgrim hat on their sleeves to commemorate the tercentenary of the original Massachusetts charter granted to the Puritans by King Charles I of England.

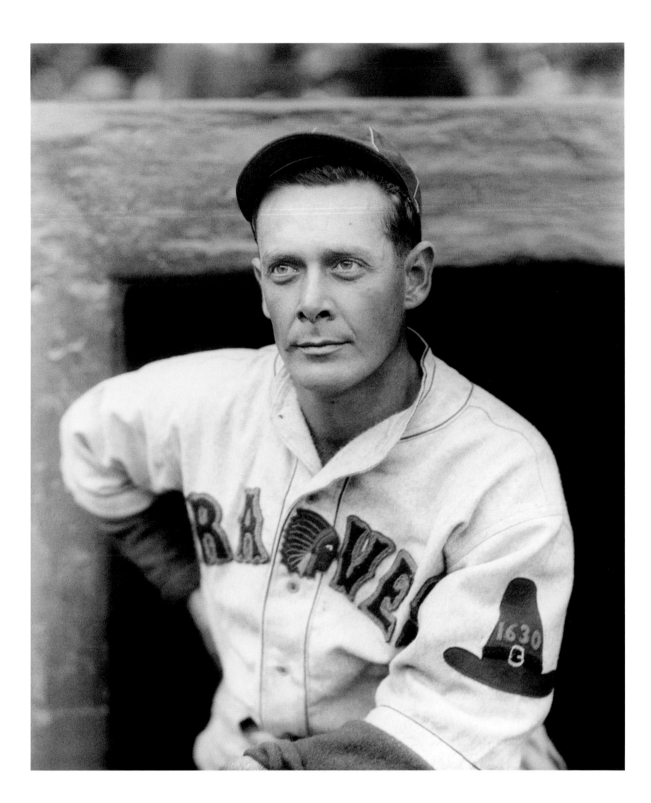

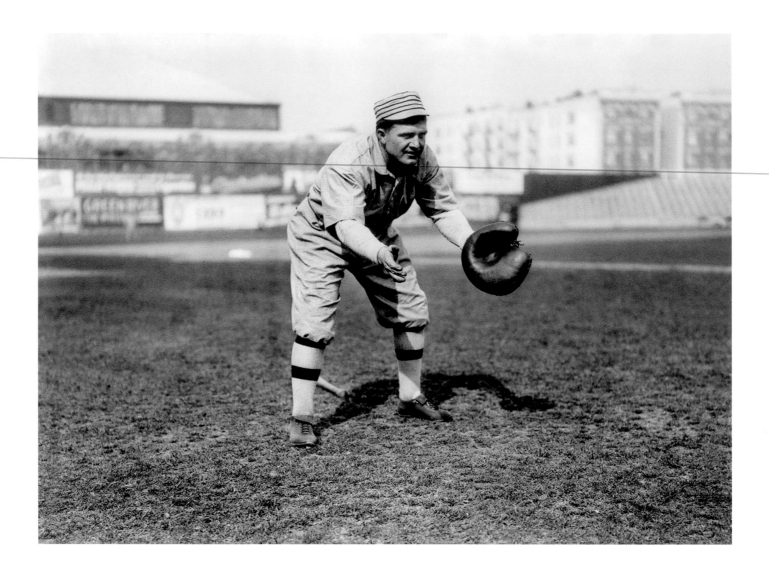

PADDY LIVINGSTON *1911 Philadelphia Athletics*

In 1901, Livingston played in his first major-league game. Unfortunately, the first pitcher he batted against was named Cy Young: "He hit me square in the ribs with a fast ball. I was blue and yellow from my hip to my shoulder. Boys, he threw hard." When his father saw that ghastly bruise, Paddy's baseball career was over after only one game, and he went to work in the shipyards. In 1906, Livingston returned to the majors, spending most of his career in the bullpen—although he was the backup catcher on the 1911 American League All-Star team: "Gabby Street picked me to handle the spitballers. He caught Walter Johnson, who was so fast he didn't need any trick pitches."

The grandstand of the Polo Grounds burned down on April 14, 1911, and the New York Giants temporarily relocated to Hilltop Park, the home field of the Highlanders. In order to accommodate the more numerous Giant fans, the tiny park's seating capacity had to be increased immediately. Here we see the hastily constructed wooden bleachers in center field, ready just in time for the Highlanders' first home game with the world champion Athletics on April 29—although the sellout crowd of eighteen thousand fans would still spill out onto the playing field. Tris Speaker of the Red Sox socked a home run at Hilltop Park on May 5: "It hit into the new bleachers which were erected for the benefit of the Giants, and which have since been to the great disadvantage of the Yanks," moaned Damon Runyon in the *New York American*.

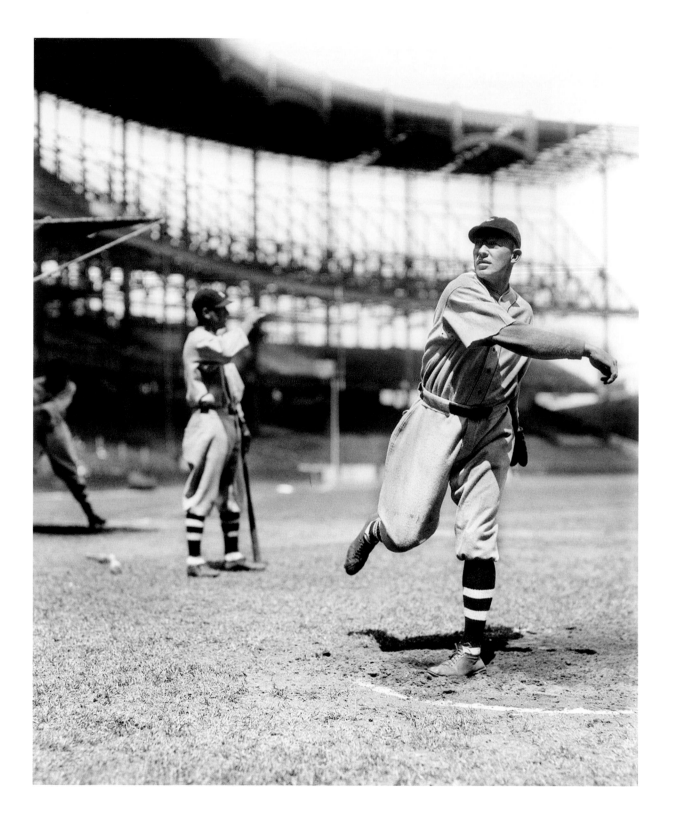

GEORGE UHLE
1928 Cleveland Indians

"The hardest guy for me to hit over the years was George Uhle," said Babe Ruth, but off the field there were no hard feelings: "I invited Ruth to our house for dinner," recalled Uhle. "I knew about his appetite. I got a keg of beer and about a barrel of pig's knuckles and sauerkraut, his favorite food. He ate 'em so fast he was throwing pieces of bone over his shoulder. I didn't find out until later that my daughter was charging the kids in the neighborhood ten cents apiece to look through the window to watch the Babe."

Because of record crowds in 1927, the Yankees decided to enlarge the House That Ruth Built. During the spring and summer of 1928, the grandstand was extended into fair territory, making "upper-deck" home runs a possibility for the first time: "The erection of the new left field stand has changed the 'sky' for outfielders," reported the *Sporting News* in May. "Left field is now shaded, while the sun rests on center field. The result is that Earle Combs has been considerably bothered by the new angle of light, as have center fielders of visiting teams." On September 9, the Yankees swept the Athletics in a doubleheader played before 85,265 fans—still the largest crowd in Yankee Stadium history.

JOE GORDON

1938 New York Yankees

This acrobatic second baseman fielded his posi-
tion with extraordinary grace—but only after
years of training as a gymnast and dancer at
the University of Oregon: "There's nothing like
that tumbling and stuff to keep you nice and
slick. You develop a sense of rhythm and timing
which you unconsciously use in making plays.
It's just natural for me to jump around out there
and not even notice any movement at all." Even
his glove was well trained: After every game
he put a ball inside it and wrapped it up with
a fat rubber band in order to maintain a large,
well-rounded pocket.

"I'd just as soon make a whale of a fielding
play as get a base hit," said "Flash" Gordon in
1942, the year he was named the American
League MVP. "Hitting—what is there to it? You
swing, and, if you hit the ball, there it goes. Ah,
but fielding—there's rhythm, finesse, teamwork
and balance. I love it!"

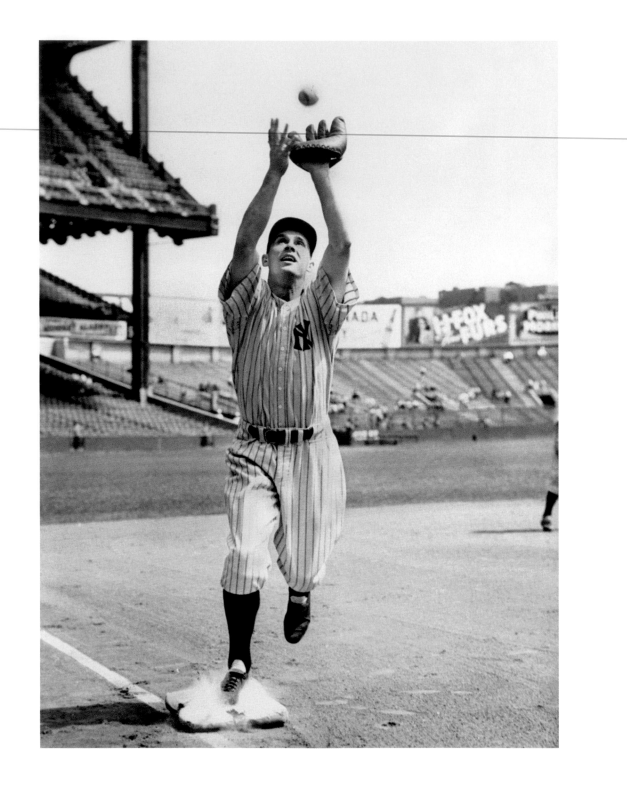

JUDGE KENESAW MOUNTAIN LANDIS

c. 1932, Commissioner of Baseball

"As we'd come out of the dugout he'd be settin' right there," remembered Cubs pitcher Sheriff Blake. "He expected you to look at him . . . and that's about all. He didn't speak to nobody, and he never smiled either. He wore a Piccadilly collar. He had kinda long hair and a slouch hat and he was the most impressive man I ever saw. He weighed about 145 pounds, but he was dynamite."

Judge Kenesaw Mountain Landis was hired as the commissioner of baseball in the wake of the 1919 Black Sox scandal: "The game needed a touch of class and distinction at the moment," observed humorist Will Rogers, "and somebody said, 'Get that old guy who sits behind first base all the time. He's out here every day, anyhow.' So they offered him a season's pass and he jumped at it."

"I certainly have a tough job," admitted Judge Landis. "I play golf in the morning and have to watch a baseball game in the afternoon."

BENNY KAUFF
1919 New York Giants

"Benny has vast confidence in his baseball ability, and says so," wrote Damon Runyon in 1917. "He is an aggressive, chattery little chap, with a powerful punch in his bat, and he does not believe in hiding his light under a bushel. He is always swinging with his whole soul in every swing, and with his right cheek bulked out under the influence of the largest 'chaw' of tobacco ever worn by any man in baseball." Kauff, who had been the best hitter in the outlaw Federal League, hit two homers in Game Four of the 1917 World Series, but his career ended abruptly when he was indicted for auto theft in 1920. Although he was acquitted of that charge in 1921, Kauff was barred from organized baseball for life by Judge Kenesaw Mountain Landis, the commissioner of baseball, and his subsequent petitions for reinstatement were denied by the New York Supreme Court.

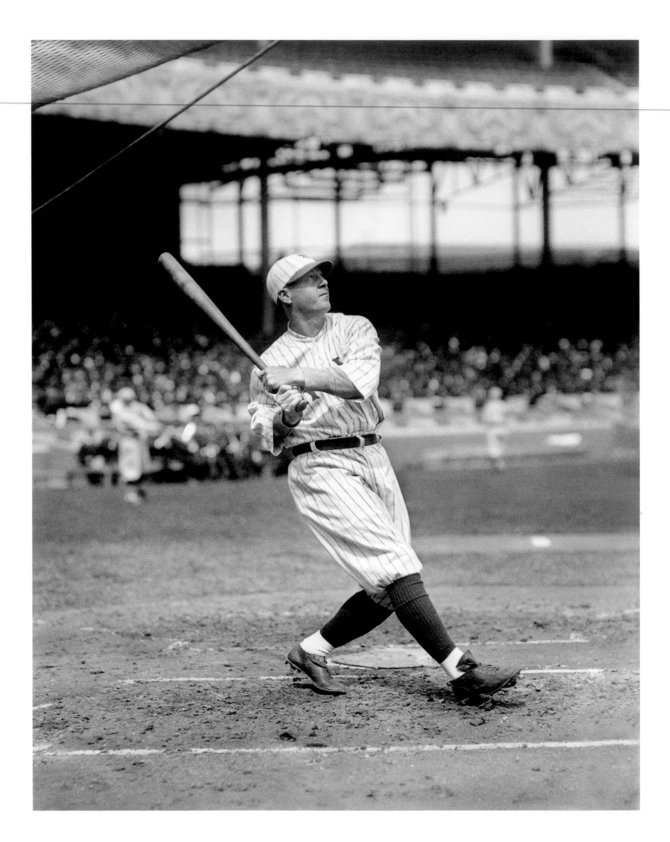

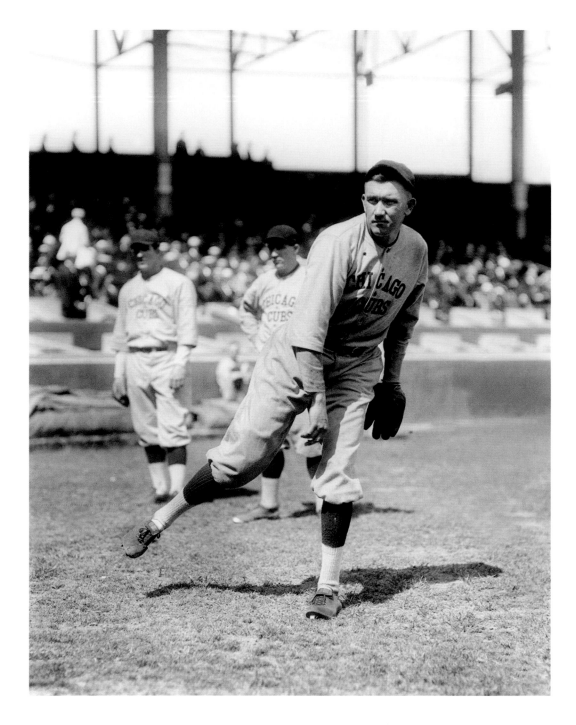

SHUFFLIN' PHIL DOUGLAS
1917 Chicago Cubs

After he was traded to the Giants in 1919, this six-foot-four spitballer nursed a grievance against manager John McGraw, who had hired a keeper for Douglas in a failed attempt to slow the pitcher's alcoholic self-destruction. In August 1922, Douglas threatened to desert the Giants in a semi-coherent letter: "I want to leave here but I want some inducement. I don't want this guy to win the pennant and I feel if I stay here I will win it for him." The pathetic document was turned over to McGraw and Judge Landis, and Shufflin' Phil was banned for life: "He is the victim of his own folly," declared Landis. "He is the dirtiest ball player I have ever seen," said McGraw. The devastated pitcher retreated to Tennessee, where he contemplated a sinister, extralegal remedy: "I thought I got a rough deal, but it is all over with, and I have forgiven the two men who did me wrong. As I look back I am glad I didn't do something I was going to do. One of the men was in a little town visiting and I was going to see him. I am happy today I never got to see him."

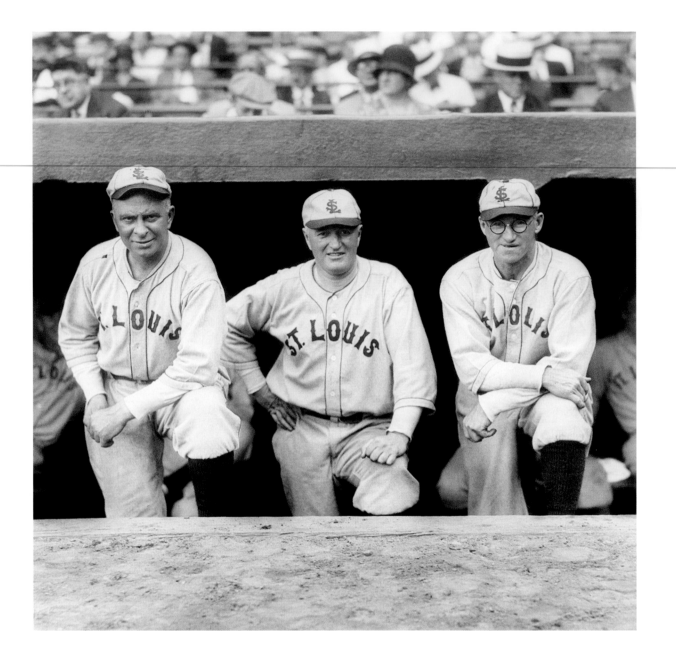

BILL KILLEFER, DAN HOWLEY, JIMMY AUSTIN (LEFT TO RIGHT)
1929 St. Louis Browns

"I wrote my mother a letter every day for eight years, and she wrote to me daily, too," said Browns manager Dan Howley. "I promised her that I would never touch liquor, and—odd as it may seem—I haven't the slightest idea of what whisky, or any other intoxicant, tastes like. My training rules? Not so rigid. I have a few players who like a drink or two, and, insofar as I'm concerned, that is their business. They are not afraid to drink in front of me. In fact, I encourage them to do so. If a player is going to drink, he'll drink, regardless of the manager. But I haven't a drunkard on my team. I demand but little of my players. I ask them to go to bed not later than 12 midnight, and to crawl out not later than 9 A.M. I have no trouble with them."

Coach Bill Killefer was such a slow runner in his playing days that he was nicknamed "Reindeer," but he was also Hall of Fame pitcher Grover Cleveland Alexander's favorite catcher. Killefer succeeded Howley as Browns manager in 1930. Coach Jimmy Austin later became the mayor of Newport Beach, California.

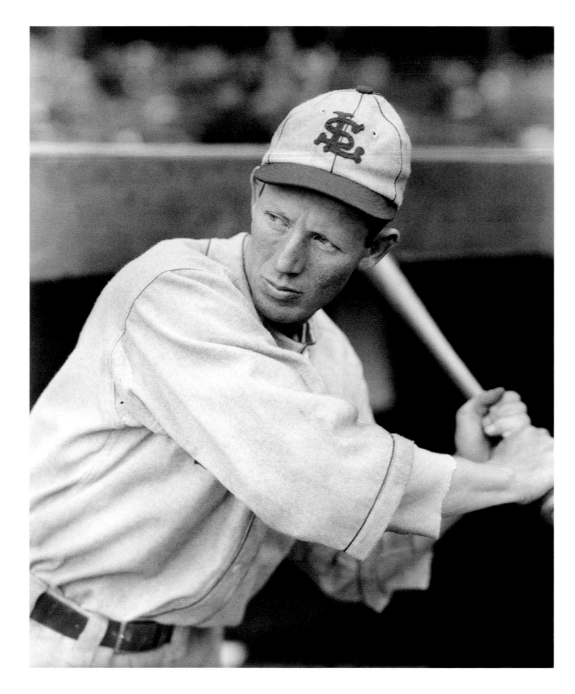

JIM LEVEY
1932 St. Louis Browns

During spring training in 1932, Browns manager Bill Killefer grumbled that he was "getting a little too old to sit up all night waiting for sailor boys to come home." He was referring specifically to Jim Levey, a former marine with a bad attitude. But Levey's attitude improved immeasurably after a simple batting adjustment: "It's the greatest thing that ever happened to me. Here I'd been going along for years thinking I couldn't hit, being just an ordinary ball player. Then Mr. Killefer told me to bat left-handed, and look what happened. Boy, I can sock that ball!" Levey's batting average soared from .209 in 1931 to .280 in 1932, thanks largely to the new switch-hitting stance he so earnestly demonstrated for Conlon. Unfortunately, Levey didn't sock that ball for long, and in 1933 his average plummeted to .195—despite batting tips from his new manager, Rogers Hornsby. Jim's big-league baseball career was over, but from 1934 to 1936 he was a running back for his hometown Pittsburgh Steelers.

"Those football players can't be good baseball players," claimed Washington owner Clark Griffith. "They're overdeveloped in the shoulders and arms. Strength up there is great stuff for football, where they have to tug and haul, but it ruins 'em for baseball."

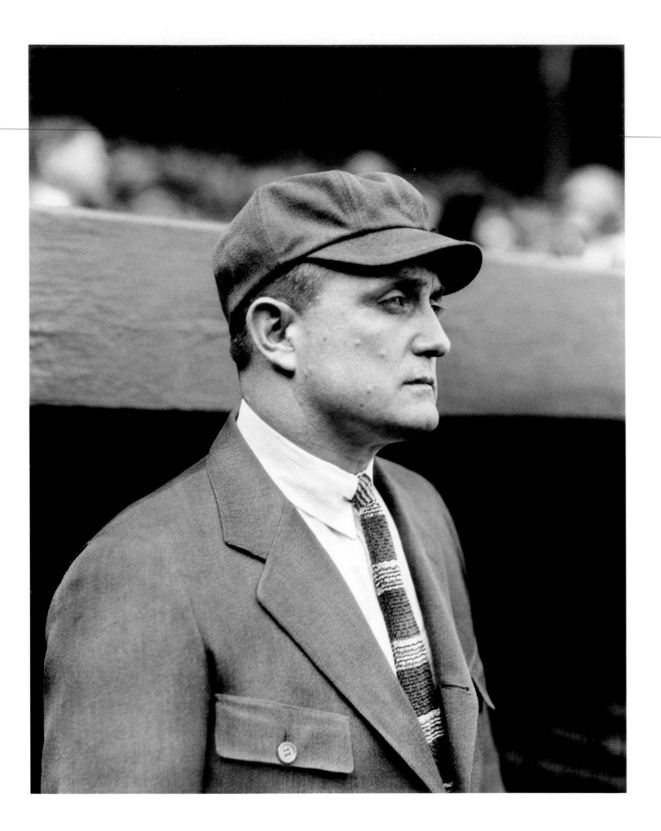

BILLY EVANS
1927 American League umpire

In 1906, twenty-two-year-old Billy Evans became the youngest major-league umpire ever. A year later he became the youngest major-league umpire ever to have his skull fractured when a fan in St. Louis beaned him with a full twenty-three-ounce glass bottle of soda pop. Evans was a professional sportswriter throughout his Hall of Fame career, and he even had a very brief boxing career in 1921, when a ballplayer challenged him under the grandstand after a game. The umpire opted for the Marquess of Queensberry rules, but Evans' opponent, Ty Cobb, chose to fight with no rules whatsoever: "It seemed he was working me over with a dozen fists," recalled Evans, who somehow survived the beating with his movie-star profile intact. After his retirement as an umpire in 1927, Billy served as general manager of the Cleveland Indians, the Detroit Tigers, and the Cleveland Rams of the NFL.

"Always make it a point to see that your uniform is presentable," wrote Billy Evans in his book *Umpiring from the Inside* (1947). "Nothing is more important than the cap. A bad looking cap can spoil the entire effect of a good looking uniform."

PID PURDY
1928 Cincinnati Reds

In March of 1928, a sportswriter for the *Cincinnati Commercial Tribune* didn't quite catch the name of the obscure football team for whom Pid Purdy played blocking back in the off-season: "Pid had a great professional gridiron season with the Green Bay Packards [*sic*], but has promised the Red Club to henceforth refrain from the dangerous pastime." Little did the writer know that—for Purdy, at least—baseball was by far the more dangerous pastime: "The famous Pid Purdy of the Reds did little damage while visiting at the Polo Grounds last week except to his own team," observed *New York Times* columnist John Kieran in June. "He played left field like a duck on roller skates." Pid finally did serious damage to himself in August, when he crashed into the concrete wall at Braves Field in Boston while chasing a long drive off the bat of George Sisler. He was carried off the field unconscious and placed under observation. His head was fine, but the knee injury he suffered on the play kept him out for the rest of the season.

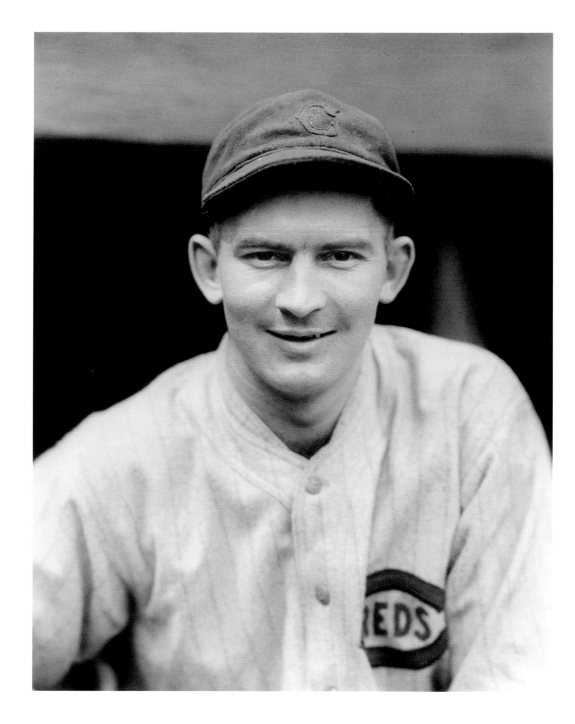

SLIM CALDWELL
1915 New York Yankees

Ray Caldwell's unique physique inspired some vintage prose from sportswriter Damon Runyon, who described him variously as "the most slender pitcher in captivity," "the human splinter," and "String" Caldwell, "whose physical lines are similar to a stick of macaroni." In his first game as a Cleveland Indian on August 24, 1919, Slim was preparing to face the final batter of the game when he was suddenly struck by a bolt of lightning: "Every player felt the electrical current through his body, the spiked shoes they wore attracting the juice," reported the *Cleveland Plain Dealer.* "It was just as if somebody had hit me on the top of the head with a sandbag," said Slim. "I tingled all over and just naturally sunk to the ground. My first thought was that I was through for all time—living as well as pitching. But when I looked up and saw I was still on the diamond and that the fans were there in the stands just as they were before I was hit, I had to laugh with joy. I never was so glad to be living in all my life." After a minute or so, Caldwell rose without assistance and retired the last batter on a ground ball to win the game. Two weeks later he returned here to the Polo Grounds to face his old teammates. He pitched a no-hitter.

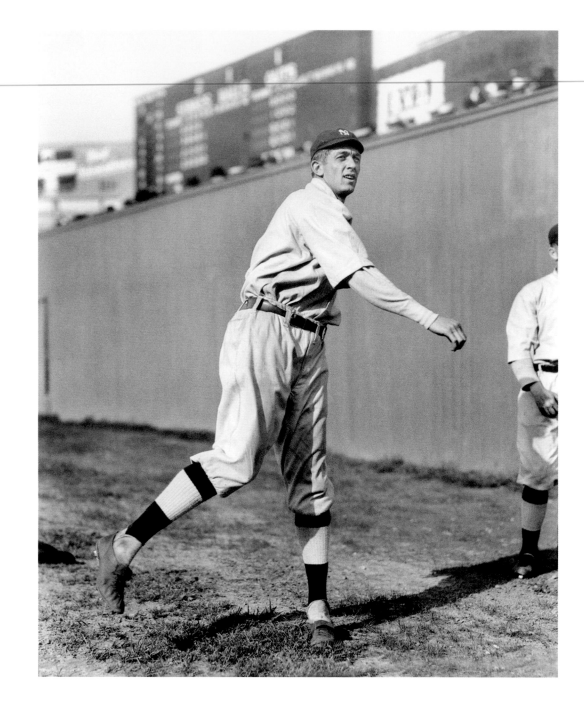

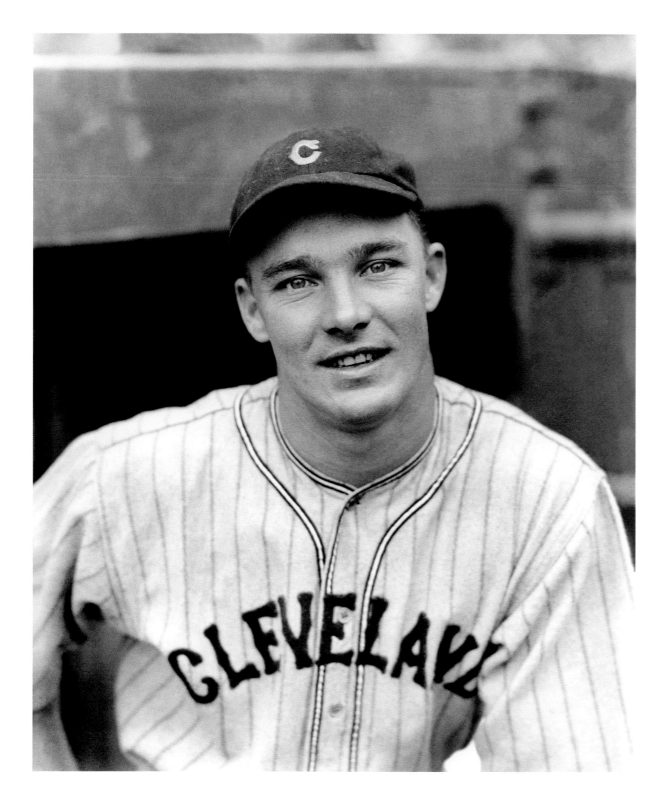

ROY WEATHERLY
1936 Cleveland Indians

"If Roy Weatherly quits sassin' the umpires he will receive a $500 bonus at the end of the season," reported the *Associated Press* in 1940. "Sent to the showers twice this season, Weatherly has been threatened with indefinite suspension by the league if banished from another game." Nicknamed "Stormy" Weatherly because of his frequent run-ins with umpires, Roy calmed down just long enough to claim the $500, but he also claimed that the umpires had underestimated him: "I guess they just didn't respect my intelligence," he pouted, but his manager Ossie Vitt knew better: "It's not what he says, it's the way he says it."

In 1936, this rookie had two triples and a single in his first major-league game, and the Cleveland broadcasters dubbed the five-foot-six outfielder "Little Thunder." Weatherly roomed in Cleveland with fellow rookie Bob Feller, at a dormitory-style hotel where the food was absolutely delicious—or at least Roy thought so, since he eventually married the hotel dietician.

PAUL SCHREIBER

1942 New York Yankees

"They don't know me from Adam's goat," this man admitted. "They see me in a Yankee uniform and think I'm a real ballplayer. At first I tried to explain, but it didn't make any difference, and finally I found it was quicker to sign my name than give an explanation. There must be thousands of fans around the circuit who look at their autograph books and say, 'Who the hell is this Schreiber?'"

Paul Schreiber was a minor-league pitcher who had a couple cups of coffee with the Dodgers in 1922 and 1923. A sore arm ended his undistinguished professional baseball career in 1931, and he became an insurance salesman. But while pitching for a semi-pro team on Sundays in 1937, he was discovered by Yankee scout Paul Krichell, who hired him as the team's batting-practice pitcher: "I guess more home runs have been made off me than off any other pitcher in the history of baseball," joked Schreiber. "I just put the ball across the plate nice and straight and let the guys have fun. Just nice straight stuff—the home run speed, you know. That's my specialty."

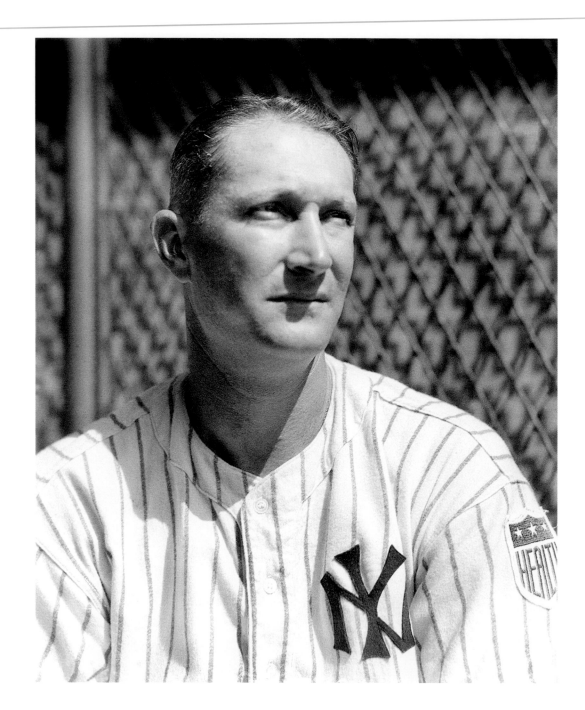

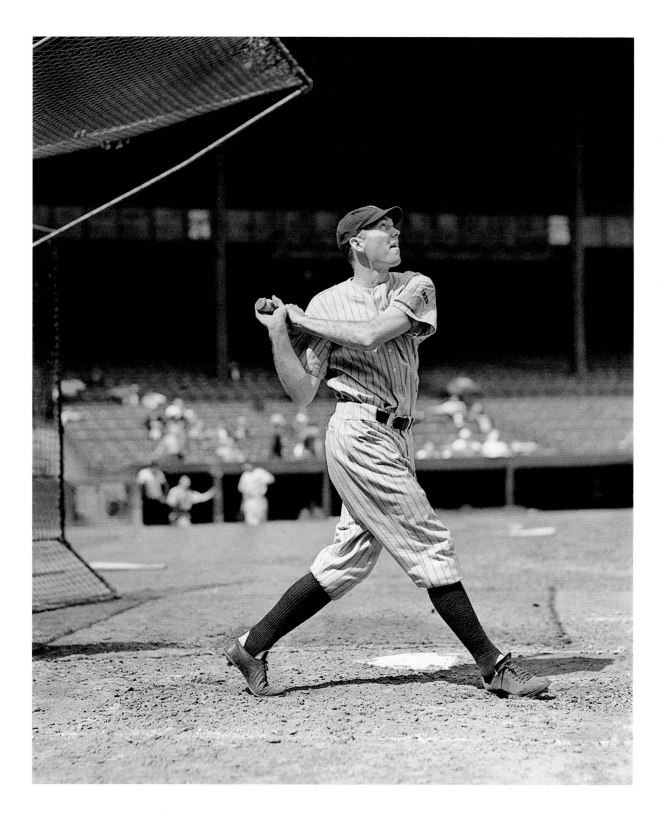

BILL DICKEY
1938 New York Yankees

"The pitching mound during batting practice isn't the safest place in the world," said Paul Schreiber. "Bill Dickey always worried me the most because he hit through the middle a lot." A Dickey line drive eventually tagged Schreiber just above the knee: "I carried the lump past Christmas. I guess that was as hard as I've ever been hit. In that respect, Joe DiMaggio was one of the most considerate fellows I ever pitched to. He was such a great pull hitter, he easily could have taken my head off, but rather than take a chance on crippling me for life, he'd hold back his swing."

"Schreiber isn't even under contract to the Yankees," reported Joe Williams in the *New York World-Telegram* during the 1938 World Series. "He's just a day laborer. In the general scheme of things he doesn't rate much above the groundskeeper. But when the Yankees met to divvy the swag they voted this man a *full* share." Schreiber received six World Series shares with the Yankees, and in 1945, he even pitched in two regular season Yankee games without embarrassing himself. In 1946, he joined the Red Sox and picked up one last slice of Series swag.

DICK BARTELL
1929 Pittsburgh Pirates

"I'm not looking for any trouble, but if any comes up, you can bet I'm going to protect myself," declared "Rowdy Richard." "Belligerent Bartell is probably the most hated gent in the National League," wrote Stanley Frank of the *New York Post* in 1935. "The boys don't like his flip tongue, his overweening arrogance or the manner in which he throws his spikes into people's faces." In retirement, Bartell made no apologies: "I was a fiery, competitive, hard-running, hard-working player. I was never a good loser. I was in quite a few fights. Someone would slide into me or I'd slide into them and it would start. I didn't win too many either. When things happen fast, you don't stop to pick size." Carl Hubbell of the New York Giants compared Bartell to a bantam rooster standing at the plate, daring the pitcher to hit him: "And if you came too close to him he'd act like he was going to come out after you!" During the 1940 World Series, this shortstop's high-pitched chatter was reminiscent of another barnyard fowl: "Richard's strident strains drift up from the infield like those of a guinea hen calling her young," reported the *New York Herald Tribune*.

GABBO GABLER

1937 Boston Bees

"I got gabby this way riding the buses in the bush leagues," explained Frank Gabler. "The roads were so rough that we couldn't sleep, so we just had to talk." New York sportswriters were so impressed with the good-natured Gabler's gift of gab that they dubbed him "The Great Gabbo"—a nickname derived from the title of Erich von Stroheim's first talkie, in which the actor portrayed a demented ventriloquist. In 1932, Gabler suffered a skull fracture when he was struck by a line drive while pitching for Kansas City. He was left blinded and partially paralyzed, but after a slow recovery he miraculously made it to the big leagues with the New York Giants in 1935. "Fewer are abler than Hubbell and Gabler," boasted the versifying Gabbo, and indeed, he helped the Giants win the 1936 pennant. But he was ineffective in the 1936 World Series, and in June of 1937 Gabler was sent to the so-so Boston Bees, for whom his record was 4-7. But the Great Gabbo was clearly unaffected by his sudden change of fortune: "Anybody that don't like this diamond life is batty," he exulted.

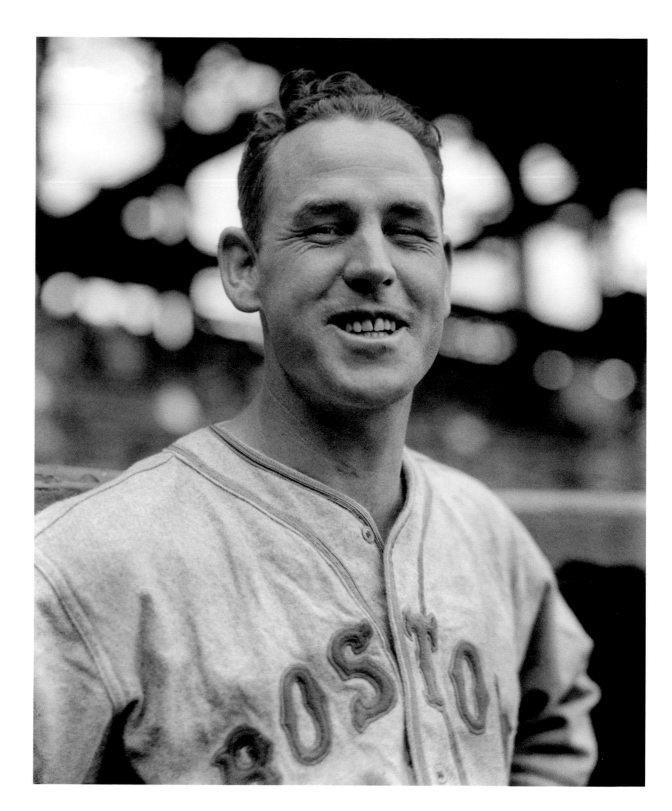

BOB BOWMAN
1940 St. Louis Cardinals

Bob Bowman began working in West Virginia coal mines at the age of sixteen, and he was still working there as a rookie with the Cardinals in 1939: "My baseball earnings aren't what you'd call juicy just yet," he explained. "If I can be a winner for five or six years with the Cardinals, I ought to save enough money to say goodbye to the coal mines forever." But after Bob's fine 13-5 season in 1939, tragedy struck: During a pre-game elevator ride with Dodger manager Leo Durocher and ex–Cardinals teammate Joe Medwick on June 18, 1940, Bowman allegedly threatened to "take care" of them, and the first time he faced Medwick that day, Bowman beaned him. The unconscious Medwick was carried off the field with a severe concussion, and the New York district attorney briefly considered pressing criminal charges against Bowman. "It was an accident," pleaded Bowman, and Medwick agreed that the pitcher was not at fault: "I froze," he admitted. Neither player ever fully recovered from the incident— and Bob's dream of a juicy payday soon crumbled into coal dust.

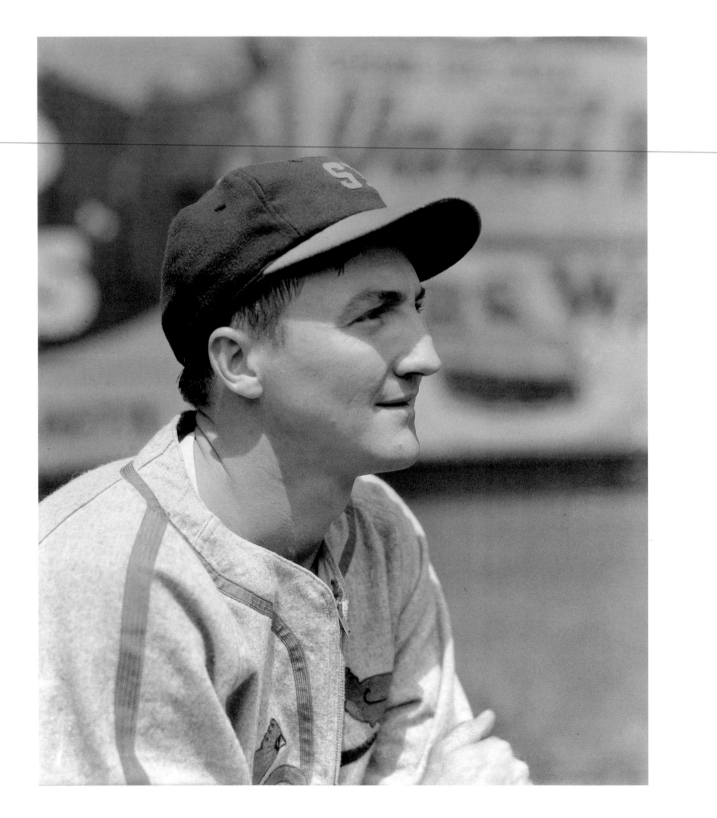

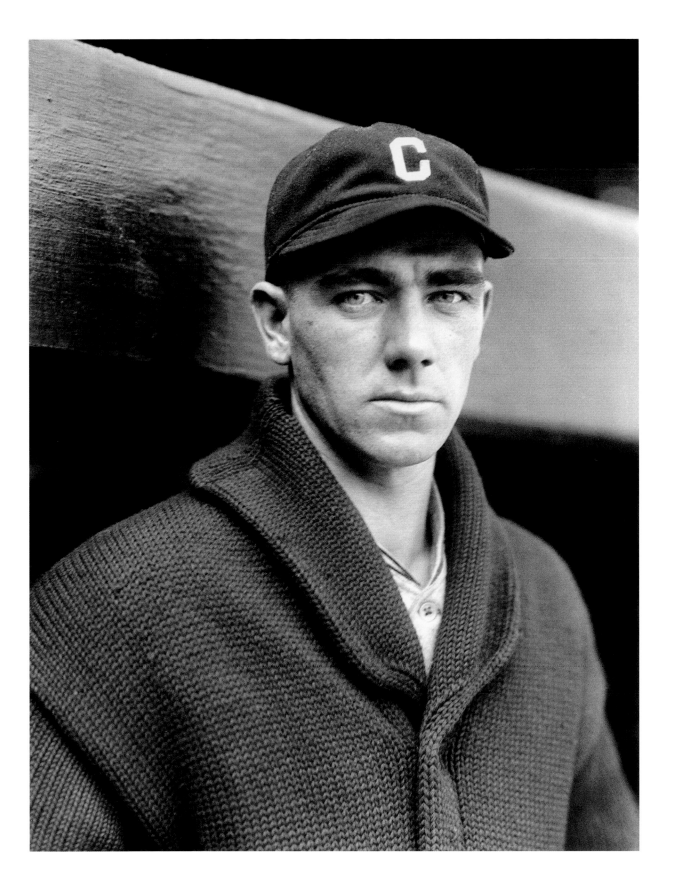

SHERIFF BLAKE
1926 Chicago Cubs

In Game Three of the 1929 World Series, the Chicago Cubs had a seemingly insurmountable 8–0 lead after six and a half innings, but the Philadelphia Athletics proceeded to score ten runs in the bottom of the seventh. Five Cub pitchers were battered during this nightmare inning, but Fred Blake was the one who took the loss: "I lost that one pitchin' to two men," he recalled half a century later. "I'm tryin' to figure out yet what happened." A coal miner's son from West Virginia, Blake got his nickname from George Stallings, his manager in the minor leagues: "He went to call me sump'n and he couldn't think of it and he called me a moonshinin' sheriff and it went through all of my life. I've had to explain that a hundred times. 'Was you a sheriff?' 'No, I wasn't a sheriff.'" When Blake's pitching career was over, it was back to the mines, where he toiled for thirty years.

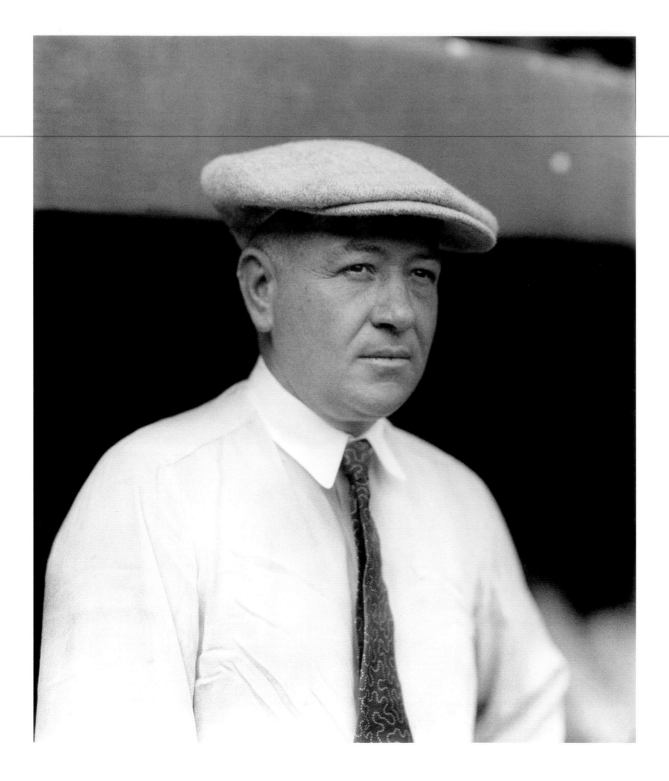

MIKE MARTIN

c. 1927 Washington Senators trainer

After training six-day bicycle racers as a teenager in the late 1890s, Martin became the assistant trainer at Columbia University in 1900. Manager Clark Griffith hired him as the New York Highlanders' trainer in 1904: "Switching from the role of training college athletes to major league ball players was quite a change," Mike acknowledged. "I was as much of a novelty to those hard-boiled babies as they were to me." Moving to Washington with Griffith in 1912, Martin soon had a new golf partner named Woodrow Wilson, the recipient of four Martin massages a week: "I worked on the President in his bedroom—on a plain, old iron bed—and many a time he went to sleep before I finished." Mike concocted a miracle potion endorsed by baseball's greatest stars, including Ty Cobb and Walter Johnson: "I use Mike Martin's Liniment after each game and it works wonders for me in keeping all soreness and stiffness out of my arm," testified aging pitcher Herb Pennock. After retiring as trainer in 1946, Mike served as a Senators scout until he died in a car crash while driving to the ballpark in 1952. Clark Griffith eulogized him as "the best friend I ever had."

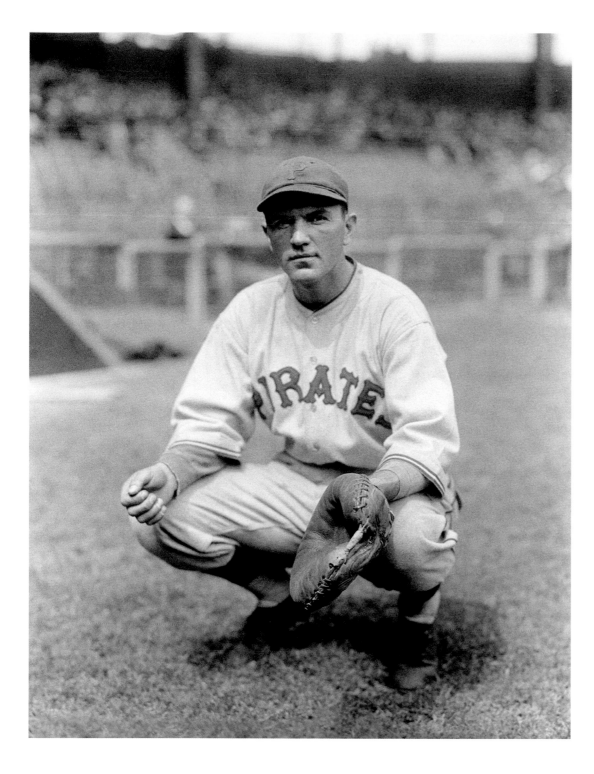

HAL FINNEY
1933 Pittsburgh Pirates

In his first game of the 1932 season, shortly after a hurricane had wrecked his father's home, Hal Finney's left elbow was fractured by a pitched ball. In 1934, just after he had passed out cigars to his Albany teammates to celebrate his son's birth, Finney was hit on the head by a fastball and taken unconscious to the hospital. After the 1934 season, Hal was working as a tractor salesman: "While showing how one of those powerful machines could crush its way through a Mississippi swamp, he came near losing his life," reported the *Sporting News*. "The great caterpillar ploughed up a tree, and a piece of the trunk hurtled through the air and struck Finney full in the face. He was 40 miles from medical attention, and when he reached a doctor was faint from loss of blood. He sustained a fractured skull, and 15 stitches were necessary to close cuts around his right eye. For a time it was feared that the sight had been destroyed." His injuries prevented him from playing at all in 1935, and when he valiantly returned to the Pirates in 1936, Hal went 0 for 35. His playing days over; he went on to a long career as an Alabama county commissioner in charge of building bridges and paving roads.

ART VELTMAN
1926 Chicago White Sox

When the New York Giants went to San Antonio, Texas, for spring training in 1920, fourteen-year-old Art Veltman was their bat boy. "He was a lanky kid with a sad-looking phiz," reported the *Sporting News*, "and the players took delight in calling him Gloomy Gus. He announced that he was going to be a ball player. Secretly he built the ambition to be a player with the Giants." Veltman played in one game for the Giants in 1928, and in two games in 1929, but he was quixotically competing for the outfield job already held by a youngster named Mel Ott, and manager John McGraw advised him to become a catcher.

Art's big chance finally came in 1934 when he started the season as the regular catcher for the Pittsburgh Pirates, but his .107 batting average put him out of the majors for good. Veltman had developed arthritis, which would end his professional career at the age of thirty, and eventually cripple him. But Art never lost his love for the game, and when his playing days were over he became the founder and coach of the Veltman Kids Baseball Team in San Antonio. Until his death in 1980, he usually served as either manager or coach in the annual South Texas All-Star Amateur Baseball Game.

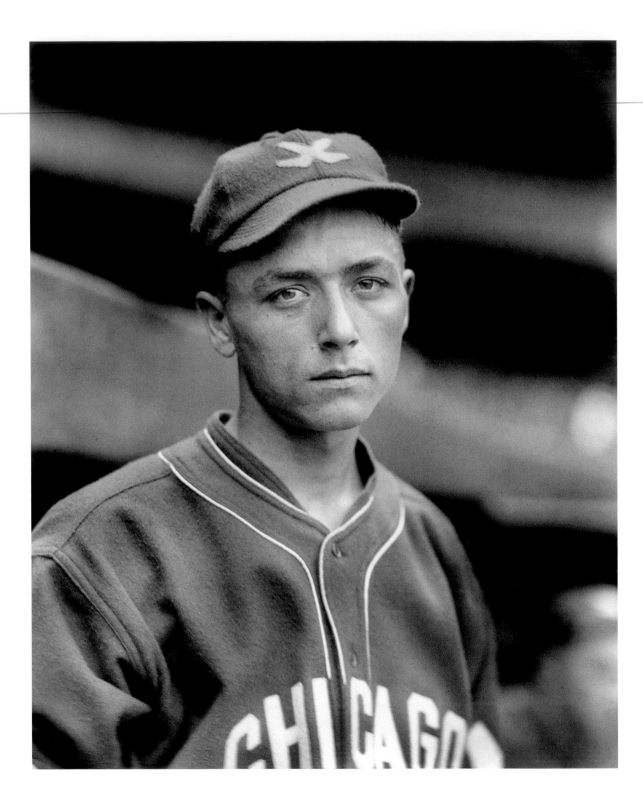

JACKIE HAYES
1928 Washington Senators

When rookie Jackie Hayes stepped into the Washington Senators' clubhouse in 1927, he liked what he saw: "Man, this Big League is for *me!*" The amiable Hayes was a utility man for the Senators, and in 1932 he became the regular second baseman for the Chicago White Sox. In the spring of 1940, however, Hayes experienced blurred vision and a burning sensation in his eyes. By Opening Day, he was blind in his right eye. The White Sox valued Jackie's services so highly that they fitted him with a batting helmet—the only one in the major leagues—and he played in eighteen games before it was determined that his disability was permanent. Glaucoma left him totally blind shortly after Christmas of 1943, but it didn't slow him down. Hayes was elected county tax commissioner in his hometown of Clanton, Alabama, and he never stopped going to the ballpark: "I like to 'see' a few ball games in the spring, to visit with old pals, to hear the diamond lingo again. That sure is living, man."

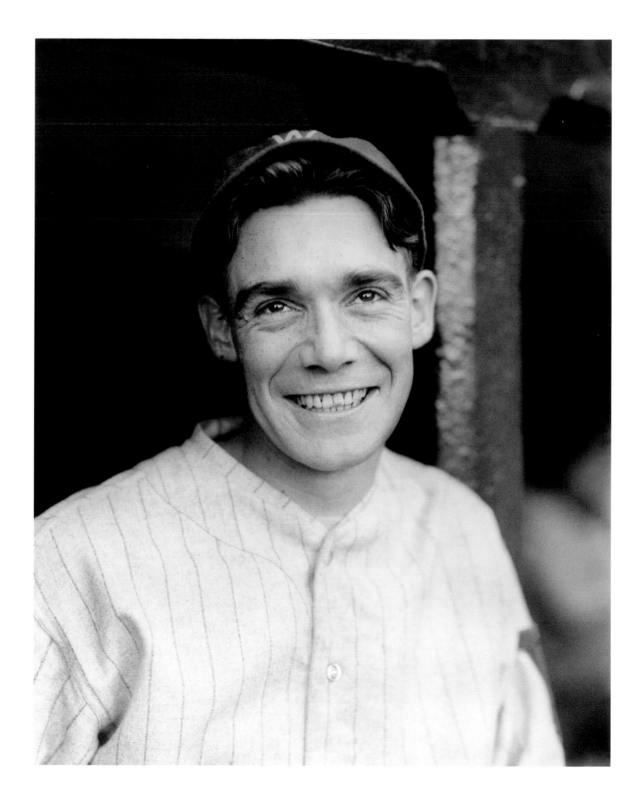

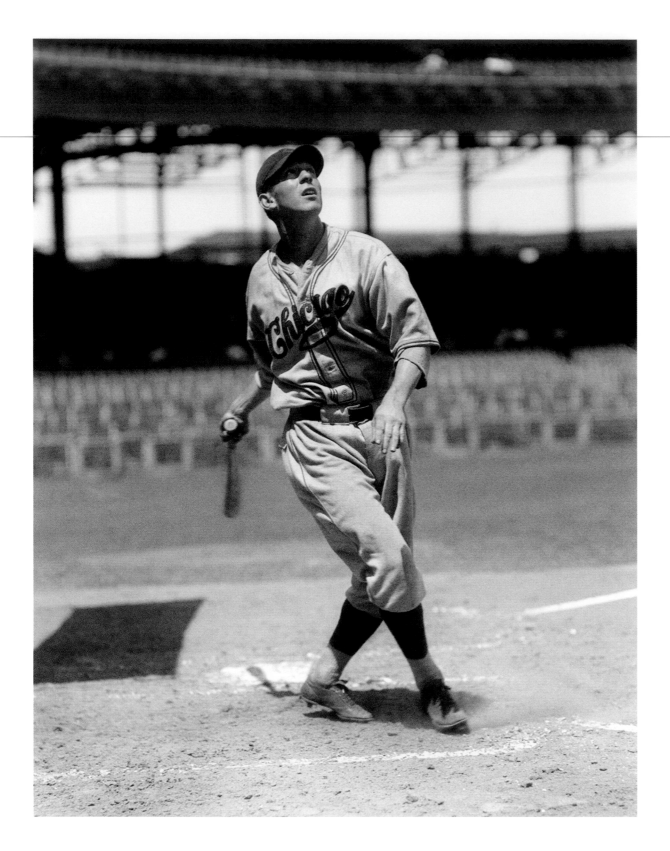

AUGIE GALAN
1934 Chicago Cubs

Galan's immigrant parents operated a French laundry in Berkeley, California, where young Augie became an expert at ironing the delicate frills and ruffles on women's dresses and neckwear. In 1922, on the day before his tenth birthday, Augie fell out of a tall tree in his backyard and broke his right elbow. He was afraid to tell his parents about the accident, so his injury was never treated, and for the rest of his life he couldn't fully extend his right arm—quite a handicap for a right-handed outfielder: "When I threw the ball into the infield I'd jump straight up into the air the pain was so bad," recalled the gutsy Galan. In 1937, the switch-hitting Augie became the first National League batter to homer from both sides of the plate in the same game. By 1943, however, his elbow would swell to twice its normal size whenever he batted from the right side, so for the last six years of his career he batted from the left side exclusively.

TRIS SPEAKER
1917 Cleveland Indians

Tris Speaker threw out more base runners than any other outfielder in major-league history—this despite the fact that he was using the wrong arm: "When but 10 years old I was thrown from a bronco and had my collarbone and right arm broken. I was naturally a right-handed thrower, but was forced to use my left hand after the accident, and finally used my left hand for throwing altogether." Speaker's range as an outfielder was so extraordinary that he was able to play a very shallow center field, as Ring Lardner noted in the *Chicago Tribune* during the 1915 World Series: "Speaker plays assistant short-stop for the Red Sox and deceives the opposing team into thinking Boston has no center fielder. The deception is kept up until a fly ball is hit to center field."

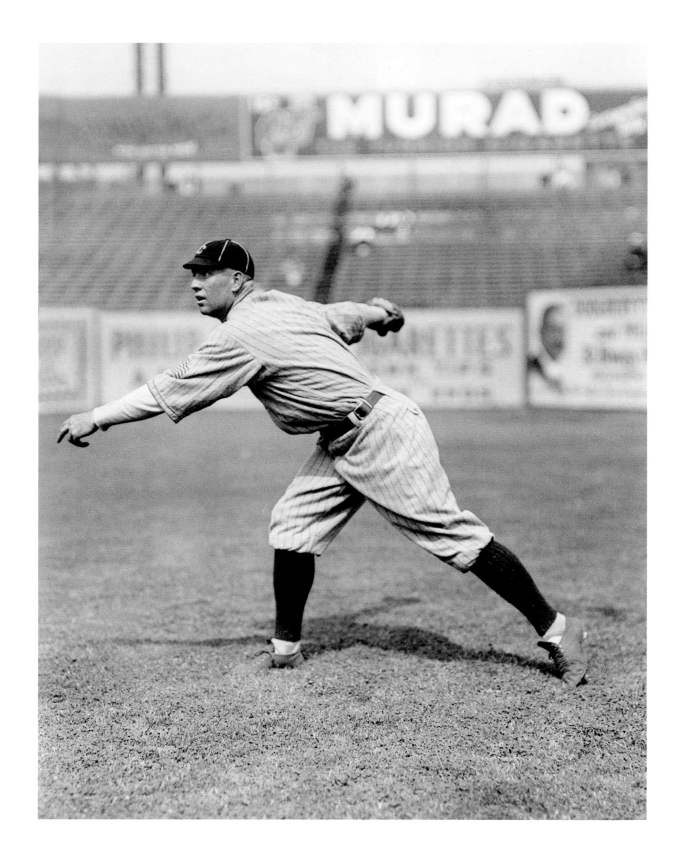

CECIL TRAVIS

1935 Washington Senators

This soft-spoken rookie from Georgia made quite an impression in 1934: "He's one of those old-fashioned boys who always wanted to play ball, rare in these days of mad speed, when baseball has become too slow for Young America in search of a thrill," observed an anonymous sportswriter. In 1941, when Ted Williams hit .406, and Joe DiMaggio batted safely in fifty-six consecutive games, Cecil Travis led the league in hits. But the All-Star shortstop spent the next three and a half years as an infantryman in World War II, and his feet were frozen during the Battle of the Bulge. When Travis returned to baseball late in 1945, the spring was gone from his step—and the merciless Washington fans booed him. By way of apology, Cecil said sadly: 'I ain't got no 'cat' in me no more."

"He's the favorite ballplayer of the umpires," said umpire Bill McGowan as Travis neared retirement in 1947. "He hasn't squawked yet on a called strike or any decision against him anywhere. He's the only ballplayer I ever felt sorry about calling out."

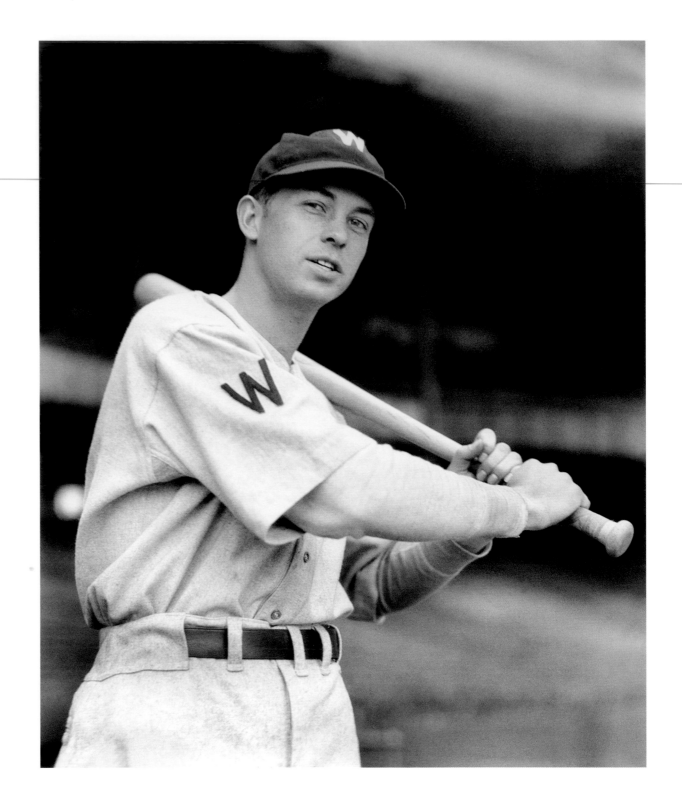

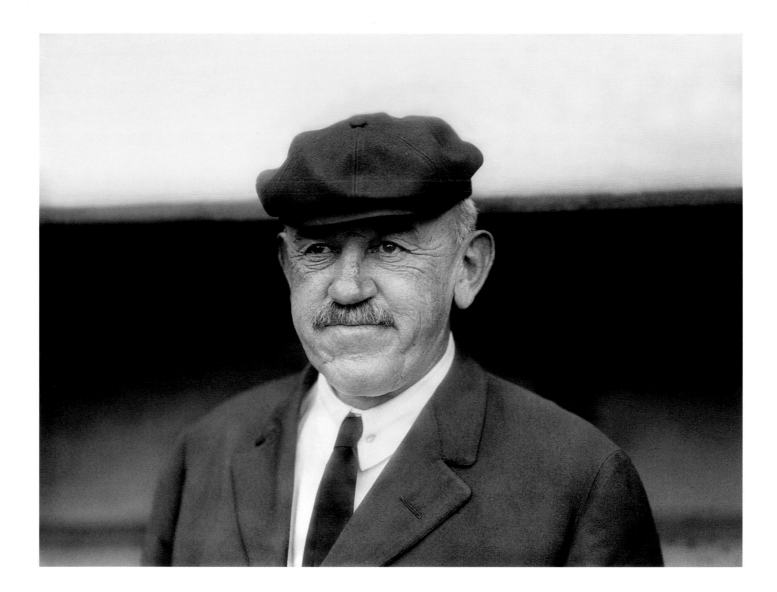

JACK SHERIDAN *c. 1914 American League umpire*

When a Washington player squawked too vociferously in Detroit on July 30, 1914, umpire Jack Sheridan slugged him, provoking a brawl: "No more disgraceful and totally uncalled for riot has been seen on the diamond since baseball was raised from the plane of a 'roughneck' amusement," railed E. A. Batchelor in the *Detroit Free Press*. Washington manager Clark Griffith had seen it coming: "Sheridan has been acting queerly all season, insulting and cursing ball-players and threatening to 'get' them. A man must be crazy to talk like that."

Sheridan, an undertaker in the off-season, had punched players before: In 1897, he took a poke at pitcher Pink Hawley, provoking a shower of rotten eggs. But now age and alcoholism were taking

their toll: "He very seldom moves during a ball game," grumbled the *Washington Post* in 1914. The *New York Journal* defended him after the riot in Detroit, declaring: "A ball player is merely a ball player but Jack Sheridan is an Institution." But the umpire suffered sunstroke late in the 1914 season, and he died in November. "Until his eyes began to fail him, no more wonderful judge of the balls and strikes ever stood behind the catcher," wrote umpire Billy Evans in a eulogy to his mentor. "Jack made only one mistake—he tarried a bit too long in the strenuous pastime."

"Old Jack Sheridan is dead," reported the *Chicago Daily News*. "Gone to join a wife and a baby he mourned all those years." He was fifty-two.

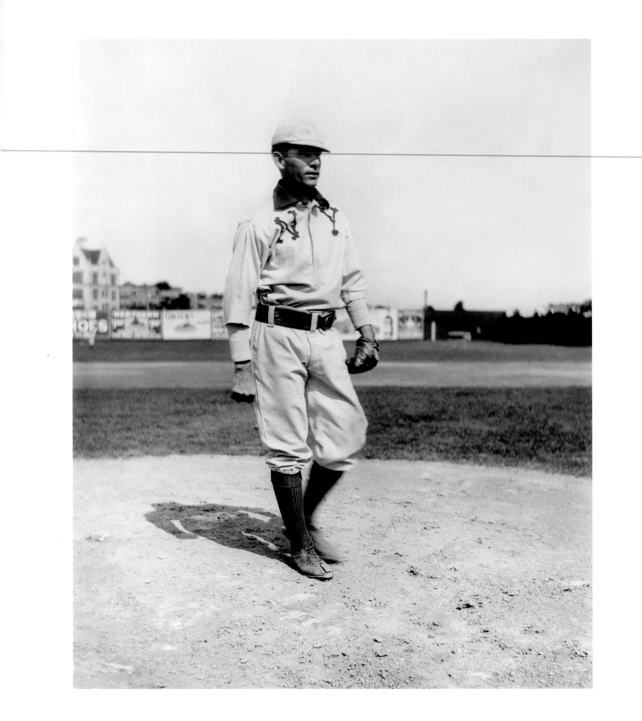

CLARK GRIFFITH
1904 New York Highlanders

"We never thought of pitching off a mound in the earlier years of the century, and we had some pretty good pitchers in those days," recalled Clark Griffith. "I'd like to see some of our old-timers working off one of these high mounds. They would blow the ball right past the hitter." Griffith never blew the ball past anybody, but he managed to win 240 games in a twenty-year pitching career, which began in 1891. "What kind of pitcher was Clark Griffith? Well, he was what I'd have to call a dinky-dinky pitcher," explained Cy Young. "He didn't have anything, but he had a lot of nothing, if you get what I mean."

"He used to throw the shine ball and the emery ball and anything else he could get away with," said Nick Altrock. "Griffith would stand on the rubber and step off before the pitch. He would be two feet closer to the batter before he threw the ball. Two feet can mean a lot. They called him the Old Fox because he could get away with it."

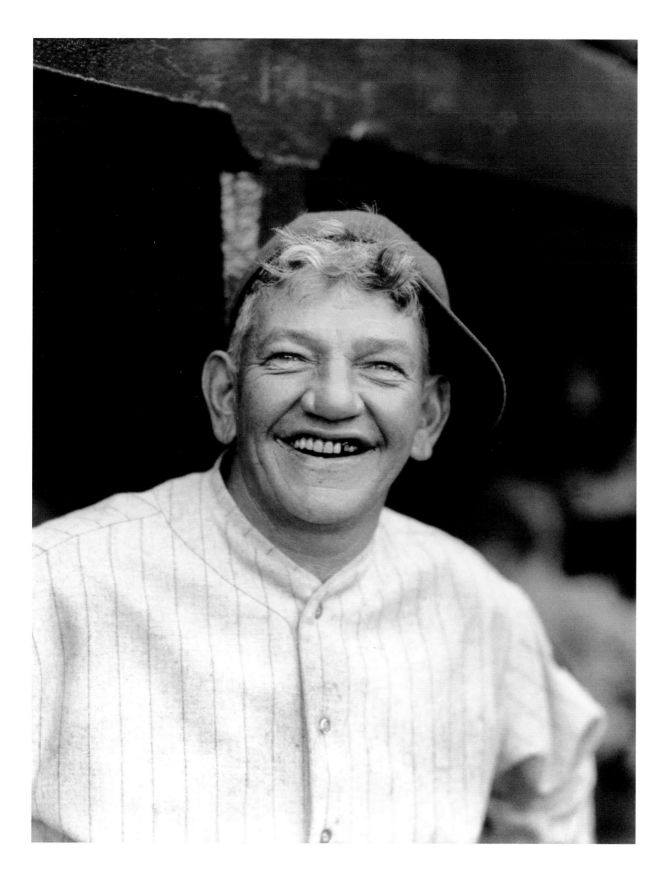

NICK ALTROCK
1928 Washington Senators

One day in 1912, Washington manager Clark Griffith ordered Nick Altrock, a newly arrived albeit washed-up pitcher, to put on his comedy act in the coach's box: "Liven these players up; they're the worst bunch of dead heads I've ever seen." The opposing pitcher was soon laughing so hard that the Senators went on to win the game, and Altrock had a job for life. He was a Washington coach for the next forty years: "We might just as well go on the road without our pitchers and catchers as without Nick," said Clark Griffith, his appreciative boss.

This "human gargoyle" was the progenitor of hip-hop head-gear, and one of baseball's first and finest clowns: "My wrestling stunt, which has proved a popular one, was my own idea. If I can get a good half Nelson on myself, I can generally put myself on my back after a desperate struggle with myself." The *Cleveland News* described one of Altrock's boxing matches with himself: "At the end of the first round Altrock was getting groggy from Altrock's terrible jabs and blows when Altrock shot a terrific left to Altrock's jaw and Altrock went down."

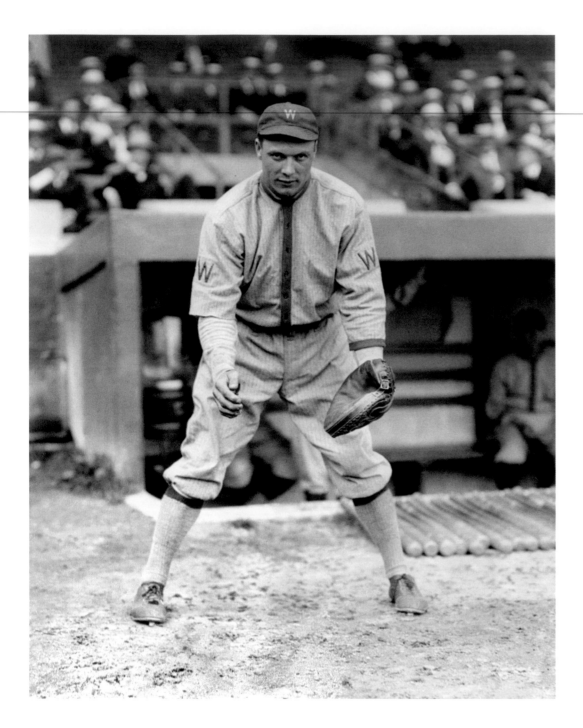

EDDIE AINSMITH
1916 Washington Senators

"Ainsmith has the reputation of being a man of ungovernable temper once he is roused, though he is usually careful to curb himself. It is said of him that he does not argue with umpires at all for fear that he will lose control of himself and punch them," reported E. A. Batchelor in 1914, shortly after Ainsmith had sucker-punched umpire Jack Sheridan. In 1915, Eddie received a suspended thirty-day jail sentence after he decked a streetcar motorman on Opening Day.

His hair-trigger temper did not affect his catching ability, however. "Walter Johnson had all the speed, but his ball came in light as a feather," recalled Ainsmith. "You could catch him without a glove. I once did, in fact. I mean it. During World War I they had an Englishman out at the ball park one day. He was a hand grenade expert and he was interested in the technique of throwing any object, so they had Johnson warm up for him. The Englishman was amazed that anyone could catch a ball that fast, and wouldn't believe it when Clark Griffith said I could catch Walter's best stuff bare-handed. So I had to show him. I took off my glove and caught four or five pitches as hard as Johnson could throw them. Nothing to it."

GABBY STREET
1930 St. Louis Cardinals

The hard-bitten Street earned the nickname "Sarge" while serving in World War I, during which he was strafed and wounded by a German pilot while fighting in the Battle of the Argonne. "I joined the army to fight," explained Gabby, who had faced friendly fire during his years as Walter Johnson's catcher: "All the catchers in those days had their gloves made special. The leather was hard, yet pliable, and once you got the glove broke in and the center pocket deep enough, you could bring off some mighty good noises. I made Johnson's pitch pop extra loud. I think sometimes the people who sat right back of the plate got scared."

"Gabby had a great arm, and he was pretty proud of it," said Walter Johnson. "I'd be tossing to first to try to keep a man close to the bag, and you could hear Gabby chattering all over the park, 'Let 'em run; Gabby'll get 'em.' He would too. He'd throw anyone out at second. I've seen him make Ty Cobb quit many a time. Ty would get a lead, Gabby would throw, and Ty would be glad to scramble back to first. What a receiver he was—a perfect target, a great arm, spry as a cat."

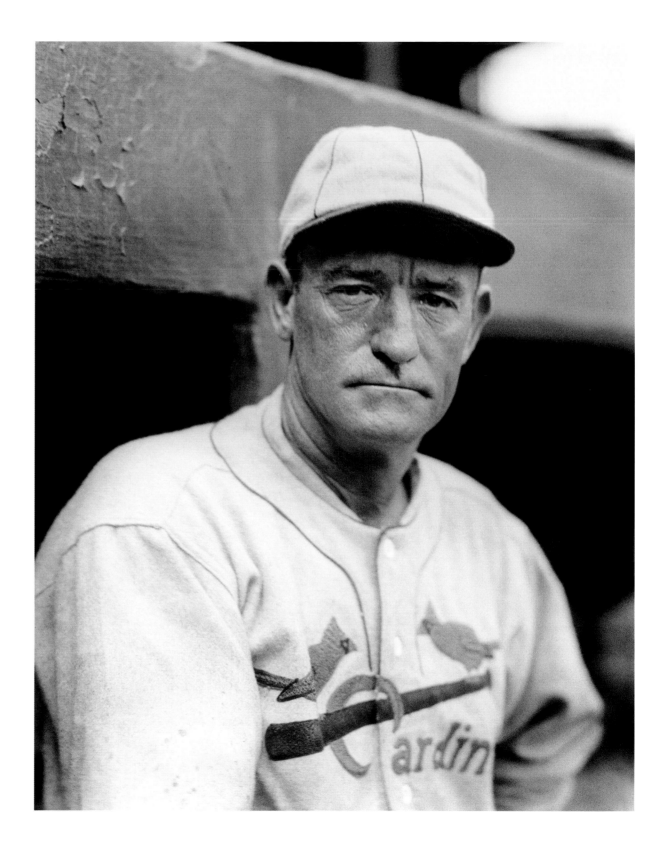

HAL TROSKY

1933 Cleveland Indians

Hal Trosky had been in the major leagues for less than a week when he posed for this Conlon portrait at Yankee Stadium. As the week ended, his batting average stood at .091 after a humiliating day facing Yankee pitching ace Lefty Gomez on September 17, 1933: "I swung at the first eleven pitches that Gomez threw and never touched one. When I ticked the twelfth, the crowd cheered. Four strikeouts! Maybe you don't think I was low. That night our manager, Walter Johnson, put his arm around me and said, 'You're going to be my first baseman for a long time.'"

The next day, a relieved Trosky paid his first visit to Fenway Park, and in the first inning he hit his first major-league home run, a game-winning three-run blast. Johnson's confidence in the young slugger really paid off in 1934, when Trosky had one of the greatest rookie seasons ever, batting .330, hitting thirty-five home runs, and knocking in 142 runs. Trosky's newfound fame was a mixed blessing, however. He didn't mind when sportswriters called him "Lenin," but his mother, listening to Cleveland games at the family farm in Iowa, objected to another nickname: "Don't call me Tarzan," Trosky told the radio announcers. "Ma don't like that name. Call me Hal."

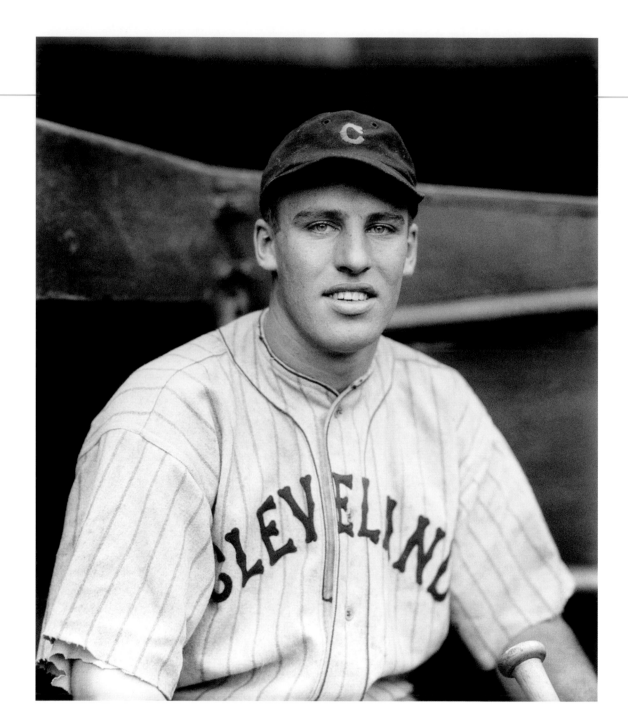

WALTER JOHNSON
1913 Washington Senators

The "Big Train" had always been especially kind to rookies: "He always liked to see a young fellow get a hit off him the first time," recalled catcher Eddie Ainsmith. "He would just blow one up there and beam all over when the kid got a hit. But after that the kid was on his own. One kid tripled the first time up against him—and never got another hit off him."

"Walter—God bless him—was the most trusting fellow I ever knew," said Clyde Milan, Johnson's longtime roommate. "He was so good himself that he thought everybody else was the same way." Walter never locked their hotel room door—despite Clyde's repeated warnings—and one day a twenty-dollar bill left on the dresser went missing: "I guess I lost it," said Walter. "Nobody would take it." At this point, the normally mild-mannered Milan lost it: "People steal, Walter! People steal! How many times have I gotta tell you—everybody ain't like you!"

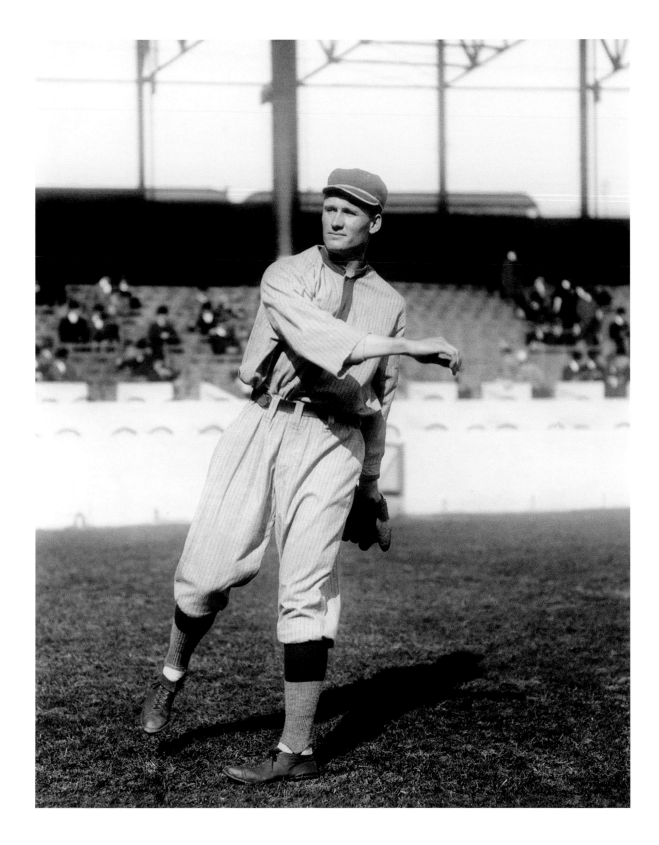

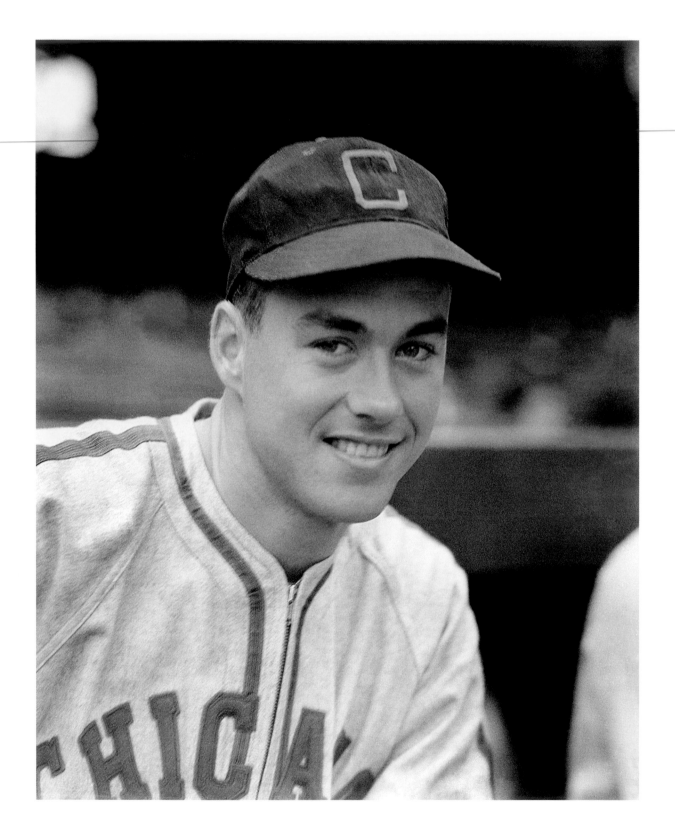

BOB KENNEDY
1940 Chicago White Sox

"I was born and raised on Chicago's South Side, a White Sox fan to the bone," said Bob Kennedy. In 1937, he worked out with the team at Comiskey Park, where he also worked as a peanut vendor. Red Sox farm director Herb Pennock was so impressed that he tried to sign the sixteen-year-old to a contract, but Kennedy elected to sign with his hometown team, and—after the forced retirement of Jackie Hayes in the spring of 1940 opened up a spot in the infield—Bob became their regular third baseman at age nineteen, playing in all 154 White Sox games during his rookie season. A natural right-handed thrower, he made himself an ambidextrous fielder: "I developed my left arm, just in case," he explained. As a young man, Bob's hobbies were playing the xylophone and ice-skating, but after serving as a Marine fighter pilot in World War II and the Korean War—during which he gave flying lessons to a fellow jet pilot named Ted Williams—Kennedy turned to hot rods and expensive Italian racing cars for his off-the-field kicks. He later defected to the Chicago Cubs, serving as both their manager and general manager.

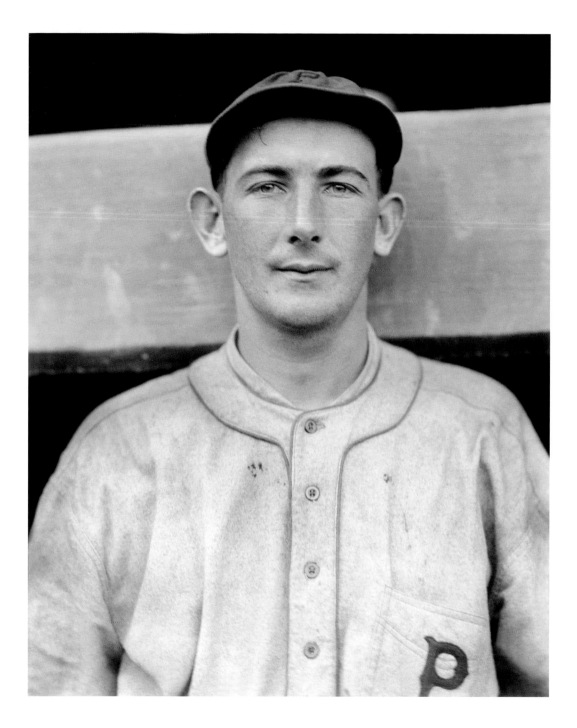

JACK SCOTT
1916 Pittsburgh Pirates

"I never expected to be a professional," said Jack Scott. "I didn't think I was good enough, but just drifted into it and kept plodding along. I have been plodding ever since." When asked about the population of his hometown of Ridgeway, North Carolina, Scott replied impassively: "It ain't got any."

Conlon took this rookie's picture only two weeks into his plodding big-league career, during which Scott would pitch a brilliant four-hit shutout for the Giants in the 1922 World Series, and lose twenty-one games in a season . . . twice. Jack's inconsistency can be traced to the fact that he "had difficulty observing training rules," as the *Sporting News* euphemistically reported in 1925. Scott later became the police chief of Warrenton, North Carolina.

"Prince Hal Schumacher isn't the first Giant who went into the bat business," recalled his former teammate Mel Ott. "Jack Scott was a timber scout, and he used to get out in the woods in North Carolina and chop down trees, and saw 'em up in short lengths, to be shipped away to that bat-making company in Louisville. One time the spring rains came unusually early and flooded his land and washed away all the piles of timber he was readying to sell, and he was madder'n a wet hen, and I don't blame him."

PHIL RIZZUTO

1941 New York Yankees

In the summer of 1936, eighteen-year-old Phil Rizzuto tried out with the Brooklyn Dodgers, who told him that he was too small at five-foot-six and 135 pounds. "My experience with the Giants was even briefer," he recalled. "Pancho Snyder took one look at me, refused me a uniform and a tryout, and said, 'Kid, you are too frail for baseball. Stay and watch the Giants play the Reds if you like, but we can't use you.'" The compassionate Snyder advised Phil to become a shoeshine boy, but Paul Krichell, the Yankees' head scout, liked what he saw: "Riz-zuto," he said, "I think you might have it." And the kid did: In 1941, Rizzuto replaced Frank Crosetti as the Yankees' regular shortstop, and he won the American League MVP Award in 1950. "The Scooter" retired as a player in 1956, but his Yankee career had only just begun: "The year after I collected my last World Series check, I became a rookie all over again—a broadcasting rookie." After fifty-six years with the Yankees—on the field and in the booth— Hall of Famer Rizzuto finally retired in 1996 at the age of seventy-nine.

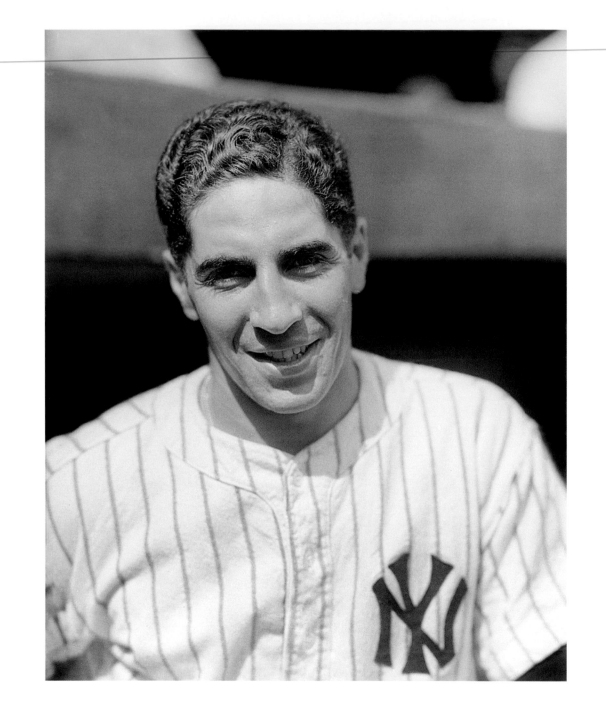

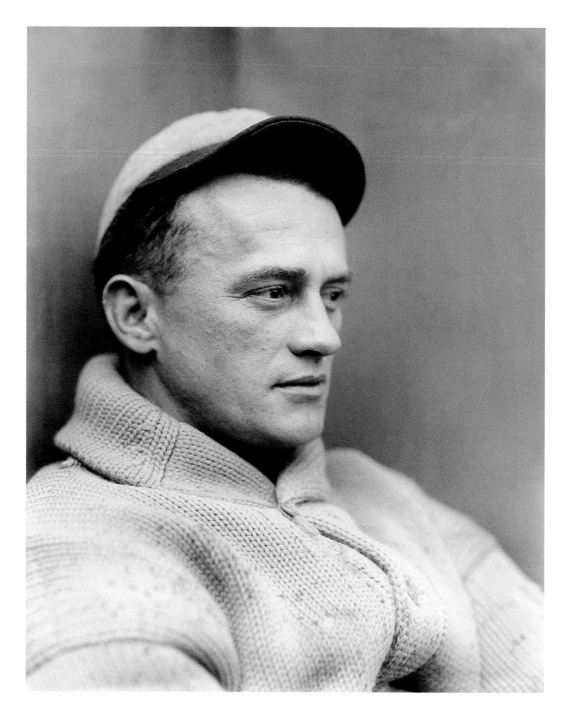

URBAN SHOCKER
1918 St. Louis Browns

In 1924, the *Sporting News* cautiously assessed this moody spitballer: "Shocker is a trifle temperamental—headstrong, it might more aptly be called. Like all stars he wants his way. A Bolshevik? Well, no, it's not that bad." But all was forgiven once Urban took the mound: "When he is right, he can knock the opposition as dead as a kosher pickle." Shocker began his major-league career in 1916 with the New York Yankees, but they unwisely sent him to the St. Louis Browns in 1918: "From the day he was traded by the Yankees, Shocker has been sore and revengeful against the New York club," noted sportswriter Damon Runyon. "He has hated 'em violently ever since. If ever a ball player was anxious to beat another club, it is Shocker." In this haunting image, Conlon captured the brooding Yankee Killer, ready to do battle with the enemy.

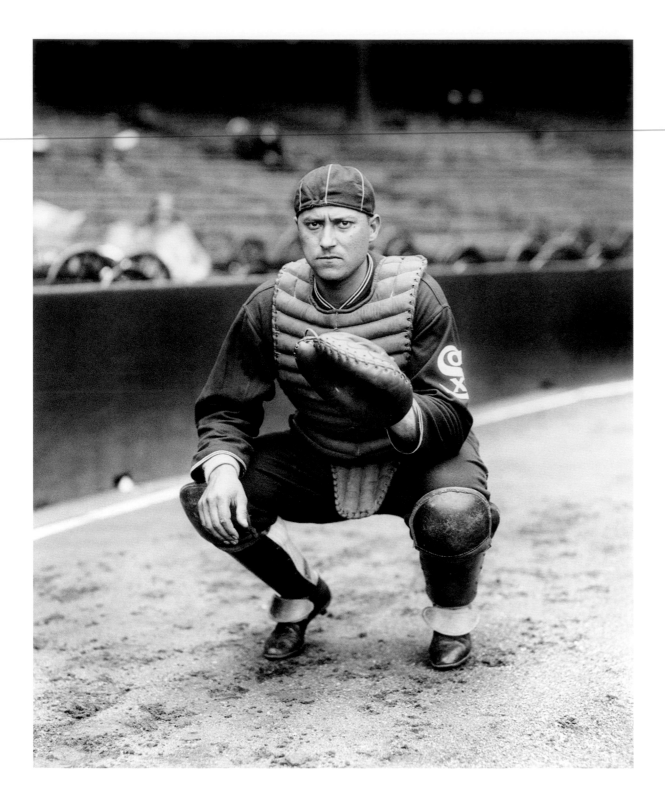

JOE KLINGER
1930 Chicago White Sox

This anxious, indecisive young man had a lifetime major-league batting average of .385—but he batted only thirteen times in his entire career. He had a fleeting tryout as an outfielder with the Giants at the end of the 1927 season, and in January of 1930 the *Sporting News* reported that "just before the 1929 season closed," Joe Klinger of the Little Rock Travelers "forgot his ambition to be a pitcher, and relinquished his position in the outfield, and on first base, and became a catcher."

On April 5, 1930, the Travelers played the White Sox in the first of two exhibition games, and Little Rock's new catcher-in-training went 3 for 3, including two inside-the-park home runs. On April 6, Klinger pinch-hit safely in the ninth inning. On April 7, the Travelers' "hard-hitting handy-man" was purchased by the highly impressed White Sox. On Opening Day in Chicago, he entered the game as a late-inning defensive replacement, but by the time Conlon took his picture at Yankee Stadium a few weeks later, third-stringer Klinger's big-league lucky streak was over, and it looks like poor Joe knew it. By 1931, he was the backup catcher for the Des Moines Demons.

JOHNNY BASSLER
1923 Detroit Tigers

At the end of the 1924 season, former pitcher Christy Mathewson picked this man as the best catcher in the American League: "There is ample justification for the selection of Bassler," commented the *Sporting News*. "He is the hardest hitting catcher in the two major leagues. His 1924 batting average of .346 also is the highest among the Detroit regulars. In addition to his worth on the attack, Bassler is a first-class backstop, possessed of a capable throwing arm and of the ability to handle pitchers. What more could one ask?" One could have asked for a little more power from a catcher: In 1924, Bassler's best big-league season, he hit exactly one home run—the only home run of his nine-year big-league career. Johnny spent fourteen years catching in the Pacific Coast League, where his hobby was growing dahlias in his Santa Monica garden.

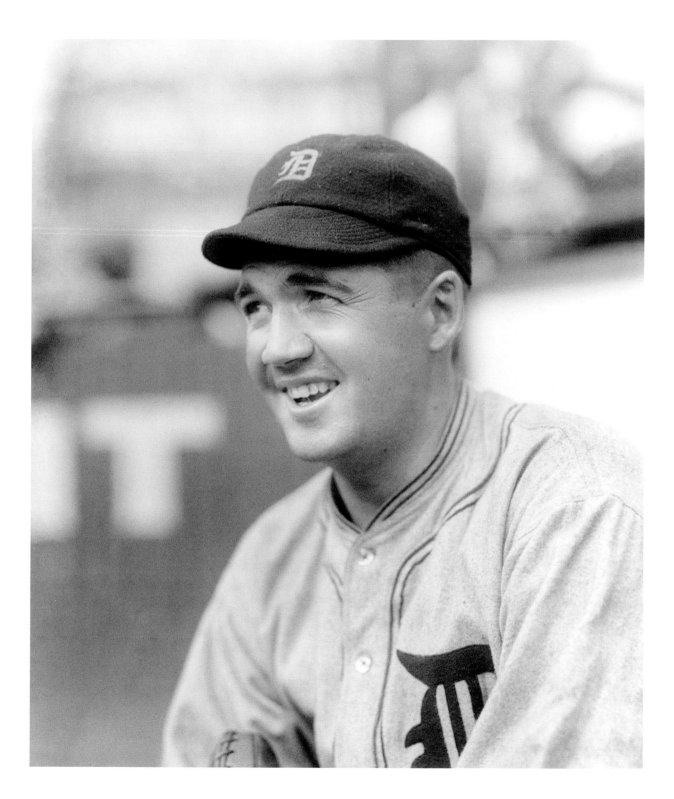

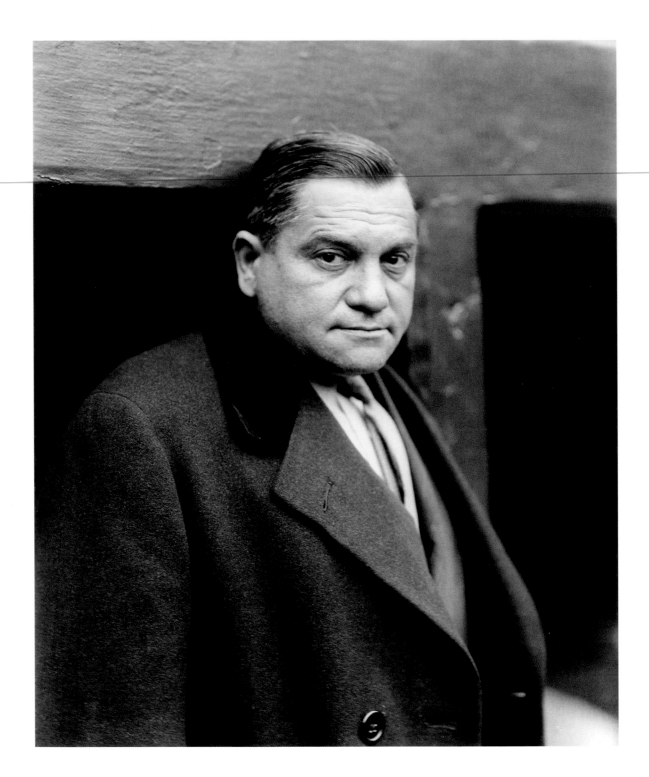

JUDGE EMIL FUCHS
1929 Boston Braves

"The time has gone when a manager has to chew tobacco and talk from the side of his mouth," declared Braves owner Judge Emil Fuchs in the spring of 1929. "I don't think our club can do any worse with me as manager." But Fuchs managed the Braves right into the cellar in 1929—their worst performance in five years. He had acquired the team in 1923, naming his bridge partner, Christy Mathewson, as president, but the inept Fuchs could never make the Braves a success: "Though Judge Fuchs, one of the most lovable characters in the game and the most popular club owner Boston ever had, has won thousands of adherents to his cause and made the Braves more popular than any National League club has been here since 1914, it is winning baseball and not personality that makes the turnstiles click," observed Boston sportswriter Paul Shannon in 1934. After failing to make the turnstiles click with dog races at Braves Field—a wacky idea vetoed by Judge Landis— the desperate Judge Fuchs lured Babe Ruth to Boston with vague promises of a managerial job: "I never should have fallen for that guy's baloney," grumbled the Bambino. Fuchs was forced to sell the Braves after Ruth quit the team in disgust, and the Judge became chairman of the Massachusetts Unemployment Compensation Commission.

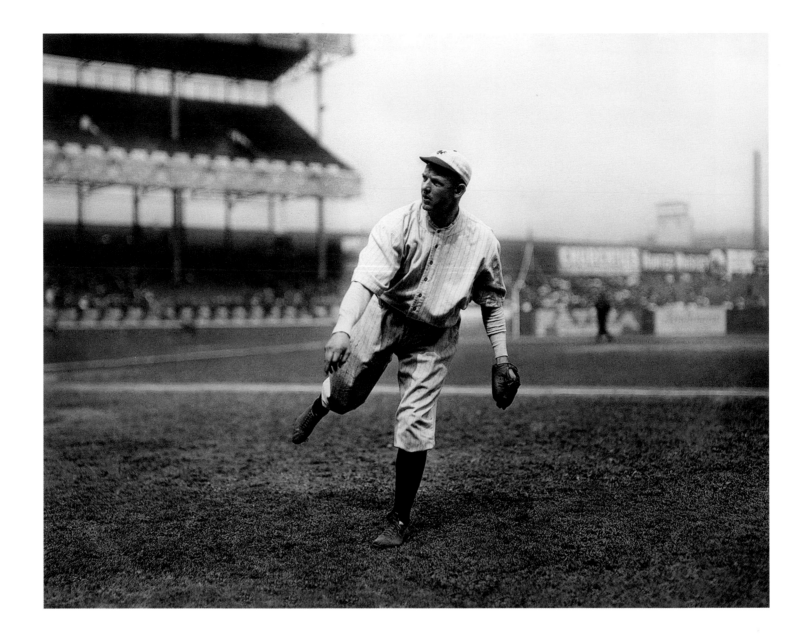

CHRISTY MATHEWSON *1915 New York Giants*

"The first sight of him was something," recalled teammate Larry Doyle. "My heart stopped for a moment. Just looking at him, he affected you that way. He looked so big and sure and, well, sort of *good*. Like he meant well toward the whole world. We were a rough lot, we Giants in those days. All except Matty. He was no namby-pamby. He'd gamble at cards and take a drink now and then, but he was always quiet and had a lot of dignity. I remember how baseball bugs would rush up to him and pester him with questions. Matty hated it. But he was always courteous. I never saw a man who could shake off those bugs so slick, without hurting their feelings."

"Crowds rather annoyed Mathewson," wrote Damon Runyon. "He was cold, and distant. To know him was to marvel that he was the baseball idol of the New York crowds."

"I used to get a laugh out of the way the fellows loved to go up to that plate and hit against Christy," recalled pitcher Grover Cleveland Alexander: "He seemed to throw so smooth and easy. They would hit one on the nose and come back saying 'Lucky son-of-a-gun, that Mathewson—did you see me hit that ball right to an outfielder?'"

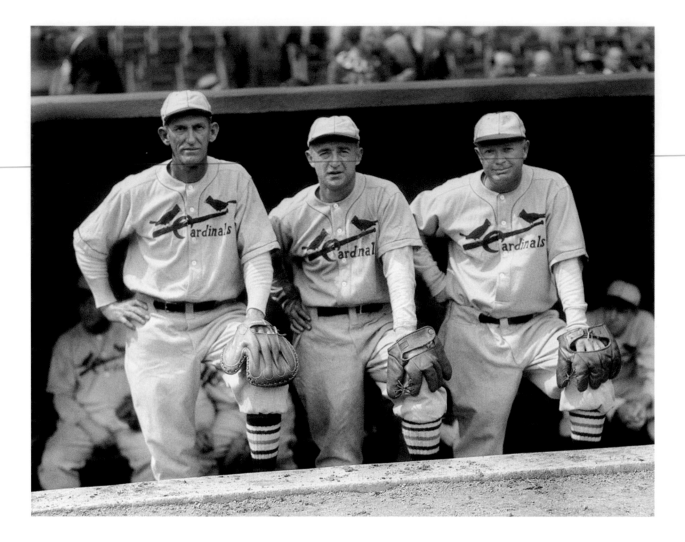

MIKE GONZALEZ, FRANK FRISCH, BUZZY WARES (LEFT TO RIGHT)
1934 St. Louis Cardinals

"I think managing shortened my career," complained Hall of Fame second baseman Frank Frisch. He led the Cardinals to a World Series victory over the Tigers in 1934 as their player-manager, but handling the Gas House Gang proved to be hazardous to his mental health: "I enjoy driving that Dutchman nuts," laughed pitcher Dizzy Dean. "A guy is crazy to take a job as manager of a big league ball club," groaned Frisch. "It brings him nothing but grief, heart-aches, sleepless nights and—well, he's nuts to do it. But I dunno, there's something about managing a big league ball club that gets to you."

Miguel Angel González, a St. Louis coach from 1934 to 1946, managed the team briefly in 1938 and 1940. He retired immediately after the 1946 World Series to become the owner-manager of his hometown team, the Havana Lions. He was inducted into the Cuban Baseball Hall of Fame in 1956.

Wares, nicknamed "Buzzy" because of his incessant chatter, was a Cardinal coach from 1930 to 1952, serving under seven managers. It was his job to keep track of the baseballs, and the *Sporting News* reported that Wares "cried" over foul balls hit into the grandstand. The players kidded him about his excessive vigilance, but Buzzy was unapologetic: "We use about $15,000 worth of baseballs a year, a pretty big item," he explained. "Everybody, it seems, wants baseballs, autographed or otherwise, and it's my duty to see that not too many of those balls get away. Players who need baseballs simply ask for and receive them, but when I find someone swiping a ball, that's where my retrieving comes in."

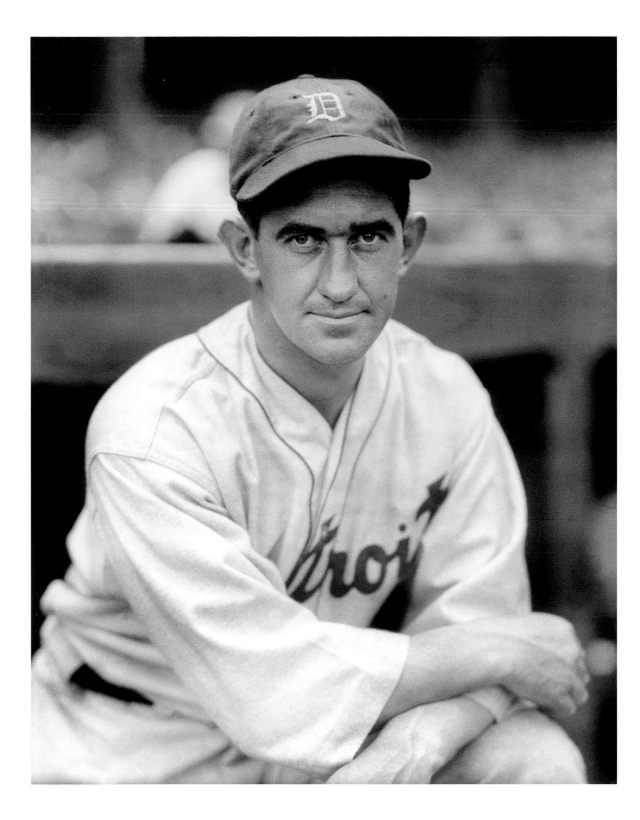

MICKEY COCHRANE
1934 Detroit Tigers

"Mickey Cochrane is taking baseball too seriously," warned Philadelphia Athletics manager Connie Mack in 1934. Ten years into his Hall of Fame catching career, Cochrane had taken on the additional task of managing the Tigers: "When I was a player I only worried about myself," he confessed. "Good money and easy work. Now I have to worry about everybody. I have to see that they're in shape and stay in shape. If one of them eats something that makes him sick, it makes me sick too." He responded to the pressure in 1934 by winning the MVP Award and leading the Tigers into the World Series; the next year he scored the winning run in the 1935 World Series. But Mickey suffered a nervous breakdown in 1936, a skull fracture in 1937, and in 1938, the Tigers fired him. Cochrane never managed again: "It seems that once you get into the Hall of Fame, nobody wants to hire you," he said bitterly. "Mike had the thought that the game turned its back on him," said former teammate Hank Greenberg. "He never got over the hurt. And this wasn't getting hit on the head by Bump Hadley. Mike's hurt was in the heart, not the head."

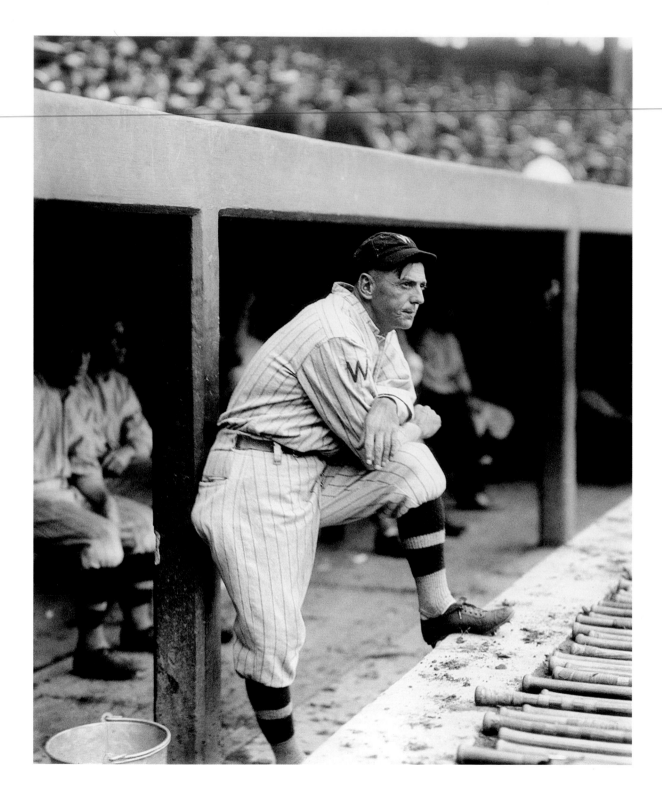

CLYDE MILAN

1922 Washington Senators

On March 10, 1922, rookie outfielder Goose Goslin was indefinitely suspended by the new Washington manager, Clyde Milan: "I care not whether he be the rankest busher or one of the most dependable men, unless a player follows the rules laid down by the club he will suffer suspension." The very next day, however, Milan relented: "I am thoroughly convinced that he did not really realize what he was doing, and I am positive he will never repeat his action while a member of the Washington club." But hard-partying players like Goslin knew exactly what they were doing: "The fellows took advantage of his good nature and that hurt," said Clyde's best friend, Walter Johnson. "He was too good a fellow to manage a ball club." Job stress aggravated Milan's preexisting stomach ailments, and he retired after guiding Washington to a sixth-place finish in 1922—his one and only season as a big-league manager. Here, Conlon caught the miserable Milan watching his club play at Yankee Stadium, where the Senators lost ten of eleven decisions that year.

BILL TERRY

1937 New York Giants

"If you go near the Giants' dressing room, Bill Terry is liable to snap your head off, and the boys who make a living writing about baseball say he is the most unpopular manager in the big leagues," reported the *United Press* in 1936. "They say he is an unfriendly, surly citizen." In this revealing Conlon photo, Terry gazes forlornly at first base, his former place of refuge, as hostile sportswriters besiege him in the dugout: "Their attitude was such that it might have warped me a little," admitted Bill, although he acknowledged that his ongoing feud with the writers made for good box office: "After a run-in with the press the fans would come storming out to the Polo Grounds to see just how much of a heel this Bill Terry really was." A lifetime .341 hitter, Terry was elected to the Hall of Fame in 1954—but only after an eighteen-year wait: "I don't know what kept me out," he mused during his induction speech. "Maybe it was the baseball writers. Anyway, I finally made it and I thank God for it."

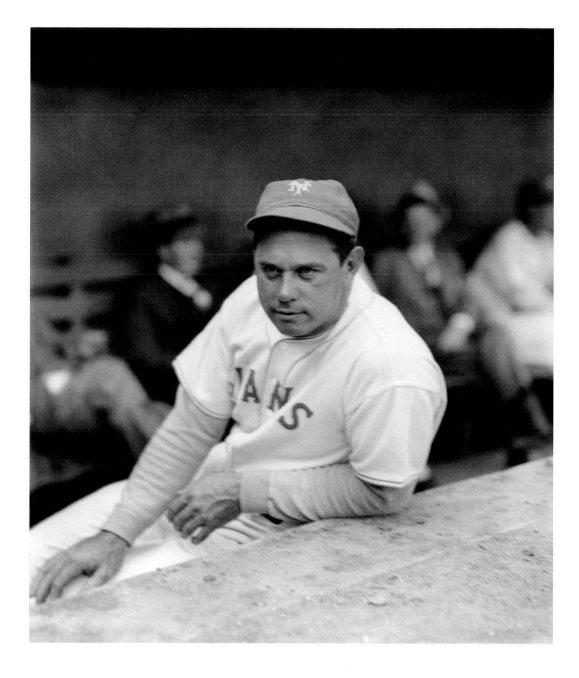

CHARLIE DRESSEN
1925 Cincinnati Reds

Charlie Dressen's languid reverie recalls the pre-Raphaelite images of nineteenth-century photographer Julia Margaret Cameron, whose subjects were the leading poets, artists, and philosophers of the Victorian Age—but the young man in this portrait quit school at the age of fourteen, and he was not quite the literary type: "I've never read a book in my life," he boasted. Charlie nevertheless made a lasting contribution to the English language during the 1953 season, when he said, aphoristically and prophetically: "The Giants is dead." He may have been virtually illiterate, but Dressen had a brilliant mind for baseball, and he was a born leader, having been the original quarterback for his hometown Decatur Staleys (the predecessors of the Chicago Bears). He managed the Brooklyn Dodgers to pennants in 1952 and 1953, and he was considerably more enlightened than many of his more "educated" contemporaries on the subject of racial equality: When Jackie Robinson retired in 1957, he called Charlie Dressen "the greatest manager I have ever known."

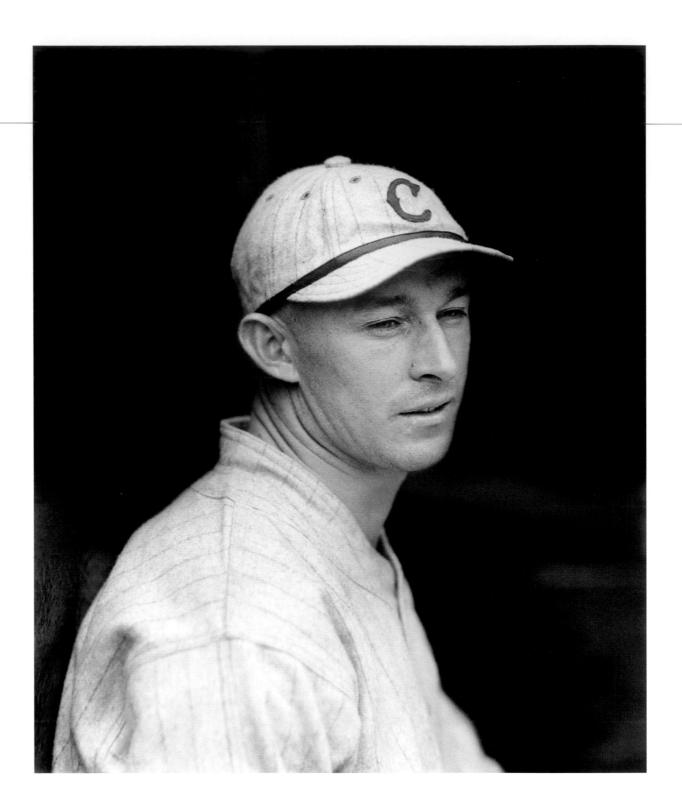

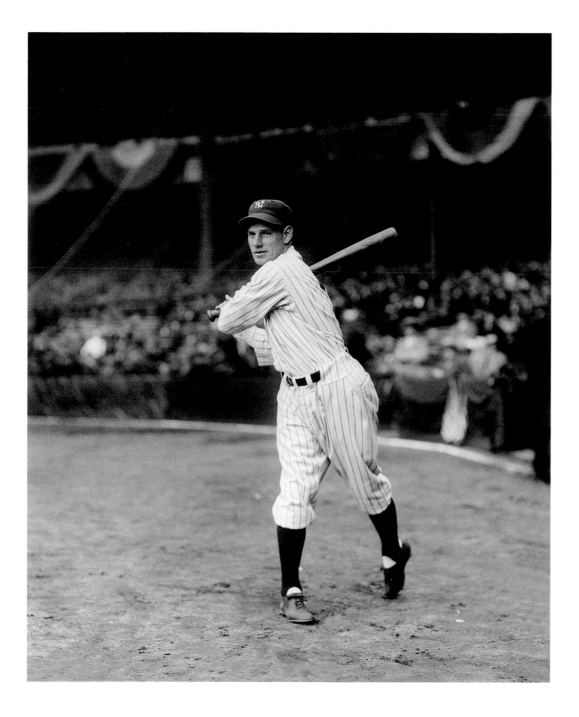

LEO DUROCHER
1929 New York Yankees

"Who's the little gink in the monkey suit?" inquired Babe Ruth during the first evening of spring training in 1928. The "little gink" in question turned out to be none other than Leo Durocher, who offered a very reasonable explanation for his tuxedo: "They make 'em to wear, don't they?" In 1929, the Yankees became the first major-league team to wear numbers on the back of their uniforms: Babe Ruth's number was 3, and Lou Gehrig's number was 4, but number 7—later immortalized by Mickey Mantle—was first worn by none other than "The All-American Out" himself, Leo Durocher. With this photograph, taken on Opening Day in 1929, Charles M. Conlon inadvertently recorded a sliver of a baseball milestone.

In 1951, Durocher was managing the New York Giants when a nervous rookie joined the team: "I just love that man," said Willie Mays. "He gave me confidence when I needed it most. I don't know what I would have done without him."

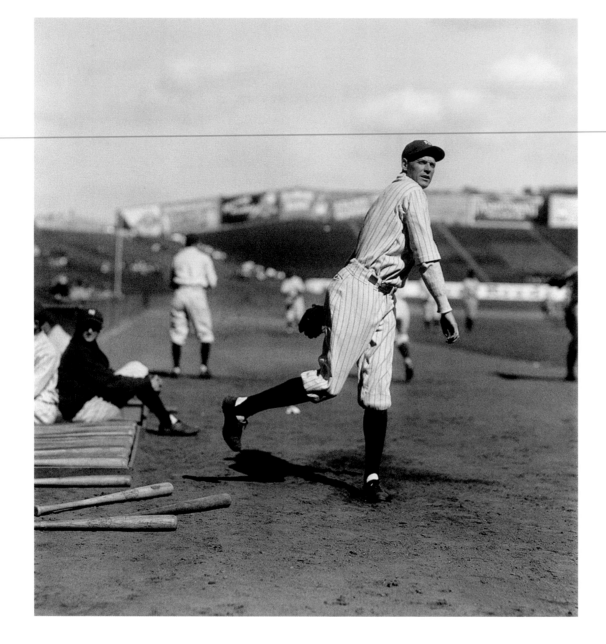

BOB MEUSEL
1927 New York Yankees

Bob Meusel was a "cold fish," recalled sportswriter Paul Gallico: "You never knew whether he liked baseball or didn't, whether he liked his teammates or not, or even whether he liked himself. No one ever got close enough to find out. He was uncommunicative to the point of surliness sometimes, a loner, and there was no heat in him. Nothing ever seemed to ruffle, disturb or excite him, including the ball games." American League umpire Billy Evans concurred: "He is the only player in all the history of baseball who never once doffed his cap to the crowd in acknowledgment of applause." But it turned out that Meusel had been enjoying himself all along: "Things couldn't have worked out better for me in life," he said during the celebration of Yankee Stadium's twenty-fifth anniversary in 1948, and Meusel was voted the greatest left fielder in Yankee history on the team's fiftieth anniversary in 1952. In this luminous Conlon photograph, "Long Bob" looms large over left field at Yankee Stadium, his untroubled head in the clouds.

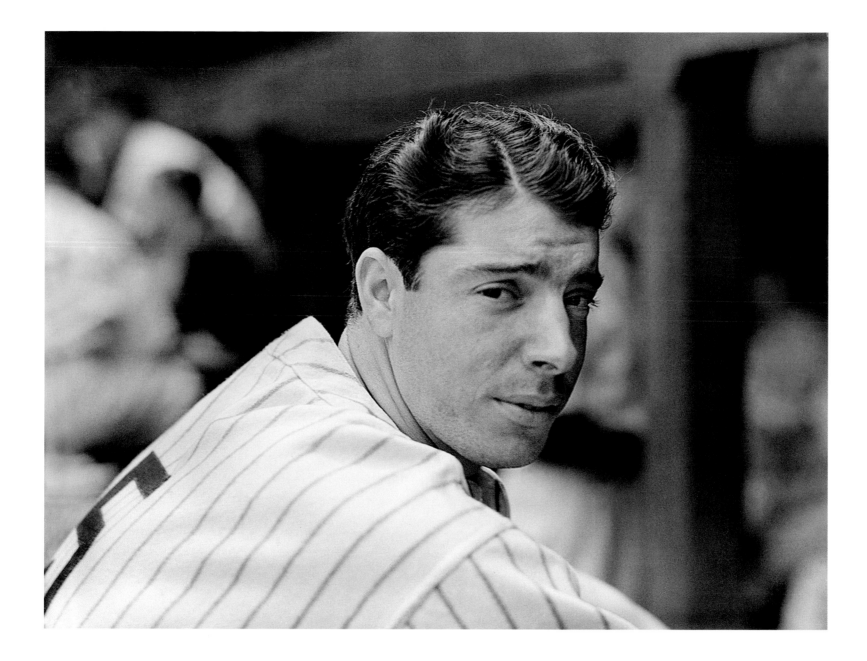

JOE DiMAGGIO *c. 1941 New York Yankees*

When Joe DiMaggio arrived at Yankee Stadium in 1936, the sportswriters' comparisons were instantaneous: "In build Joe is another Bob Meusel. . . . ," "DiMaggio has the strongest and most accurate arm since Long Bob Meusel. . . . ," "He has an arm which ranks with the best ever seen in baseball, which will remind old Yankee followers of Bob Meusel and Babe Ruth when they were at the top of their form. . . . ," "Joe yesterday cut loose with his arm and made one of the most remarkable throws seen in the Stadium

since the Bob Meusel heyday." DiMaggio inherited the number 5 from Meusel—the first Yankee to wear the number in 1929—and even shared Bob's glacial temperament: "Joe's one of the loneliest guys I ever knew," said teammate Ed Lopat. "And he leads the league in room service." In 1952, DiMaggio was voted the greatest Yankee center fielder of all time, with Babe Ruth inevitably earning the right field spot.

SUNNY JIM BOTTOMLEY
1923 St. Louis Cardinals

"I was scared to death when I reported for big league service," said Jim Bottomley. "If I stopped to figure out a pitcher, he'd fan me while I was figuring. I just hit at what I think I can get ahold of." The *Washington Star* elaborated on Bottomley's batting success: "He just naturally hits, he don't know why. He has a strong face and a quiet, pleasant, kindly, serene way about him that just naturally wins friendliness." Tommy Holmes of the *Brooklyn Daily Eagle* offered this perfect description of Sunny Jim: "He goes about his work with all the pepper of a schoolboy and the jauntiness of a mediaeval cavalier, always with his cap on the side of his skull, always with his lips parted in a smile."

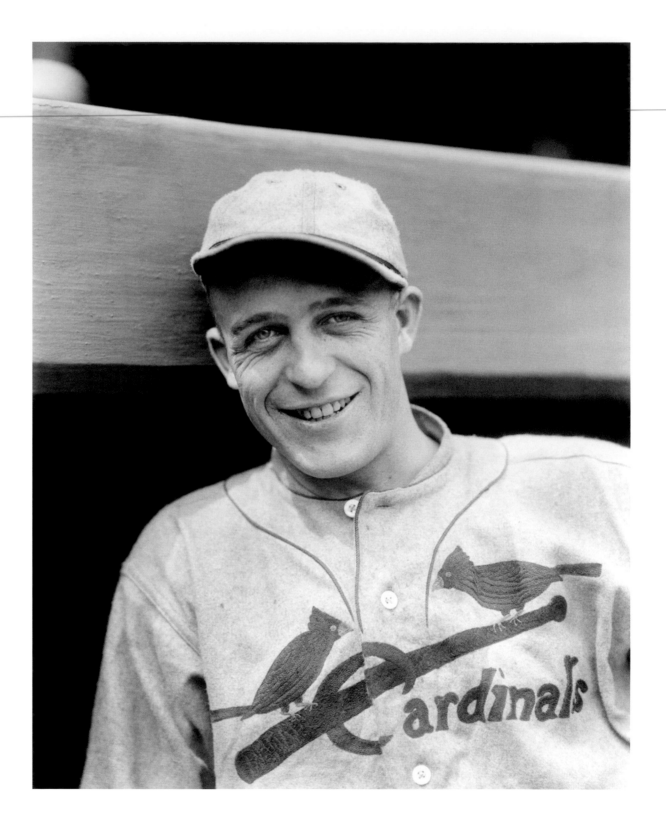

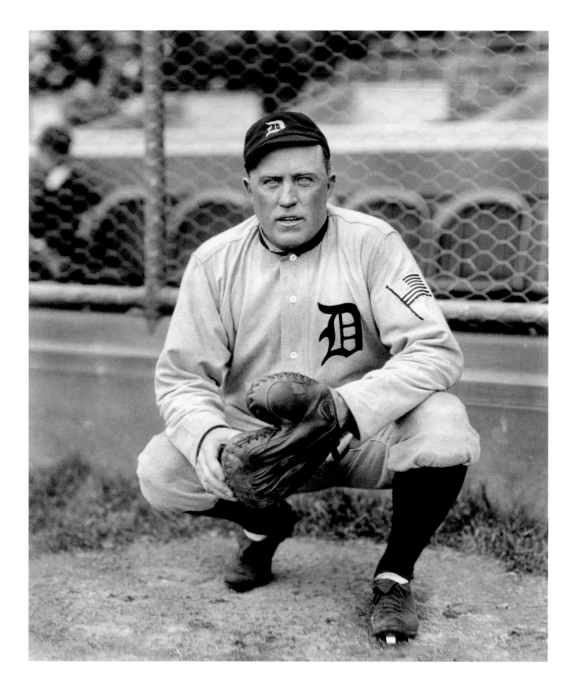

SUNSET JIMMY BURKE
1917 Detroit Tigers

"His full-blooded face flames like a sunset," observed sportswriter Will Wedge. "His digits look like the wings of a windmill that had been hit by a cyclone." Burke explained: "I guess I must have played on fifteen different clubs in the majors and minors, and I'm beginning to think my hands show it. We were batting against a croquet ball in the old days. That ball was harder than an umpire's heart, and what those pitchers was allowed to do with it was a shame."

Burke was a vociferous coach, whose baseball etiquette (as recorded by reporter Ring Lardner) was not particularly complicated: "If a man gets in your way, peg at his bean. Knock him down. You fellas is too polite. That's the trouble with you fellas. You don't see no other club bein' polite. If they're tryin' to make a play, bump into 'em. That's the way to play ball. Bump into 'em and knock 'em down. Then they can't make no play. And when they bump into you, peg at their bean. You fellas is too polite."

STAN HACK
1934 Chicago Cubs

This brilliant third baseman, "his famous built-in smile flashing as naturally as ever," was called "the best-liked player in the National League" by the *Chicago Tribune*: "He's got more friends than Durocher has enemies," confided an unnamed St. Louis Cardinal. "I enjoyed playing ball," said "Smiling Stan" Hack, "and the grin was my way of showing it." In 1935, the Cubs offered "Smile with Stan Hack" mirrors to fans at Wrigley Field—until the bleacher bums started using them to blind opposing batters. A tall and skinny lead-off man, Stan was a singles-hitter who twice led the league in stolen bases. He batted .348 in four World Series with the Cubs, and .400 in four All-Star Games. Before the 1934 season, the Cubs promised Hack a $500 bonus—but only if he could gain ten pounds: "I faithfully tried for the added bulk," said Stan, "but could boost my weight only eight pounds."

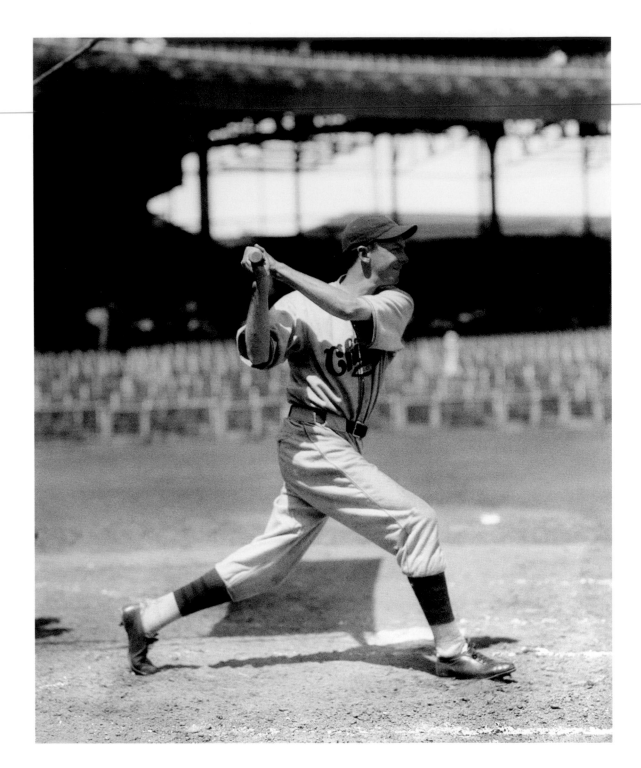

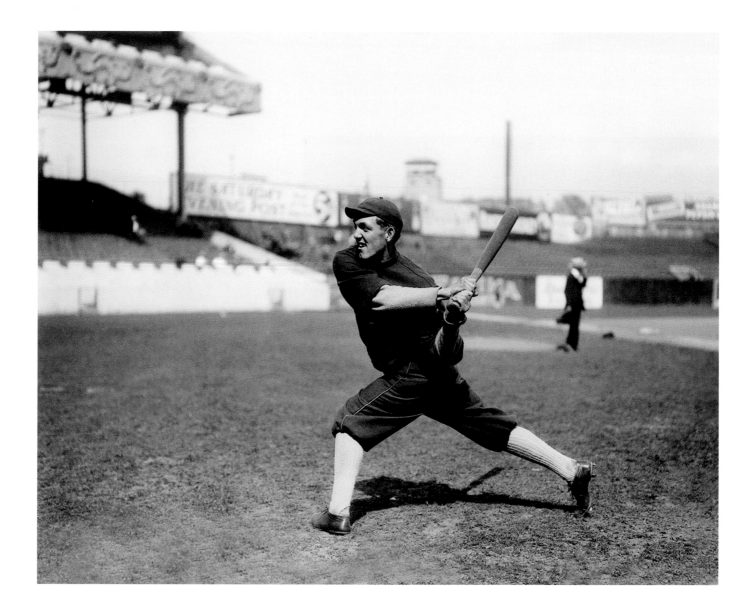

BUCK WEAVER *1913 Chicago White Sox*

"Buck Weaver is the White Sox shortstop / And naught can make this little sport stop / Smiling even for a day / His countenance is built that way."

When Ring Lardner penned these lines in 1914, the ebullient Weaver had just led the American League in errors—for the third straight year. But Buck steadily improved on the field, and he played a crucial role in winning White Sox pennants in 1917 and 1919. After a brilliant 1920 season, during which he batted a career-high .331, Buck was banned from baseball at the age of twenty-nine because his fellow Black Sox had fixed the 1919 World Series—although Weaver's role in the affair remains controversial

to this day: "He apparently had knowledge of what was going on but kept it to himself," said former White Sox manager Pants Rowland. "So he was guilty as an accessory. I'm not saying he shouldn't have been punished, but squealing in those days was considered almost a crime in itself. And Buck, who never got beyond the third or fourth grade, simply didn't know how to cope with such a situation or the slick operators. I saw all eight from time to time afterward, but Weaver was the only one who stepped right up and protested his innocence. 'Skip,' he'd add, 'even murderers serve their time and go free. But I got a life sentence with no parole. I'm the same as dead.'"

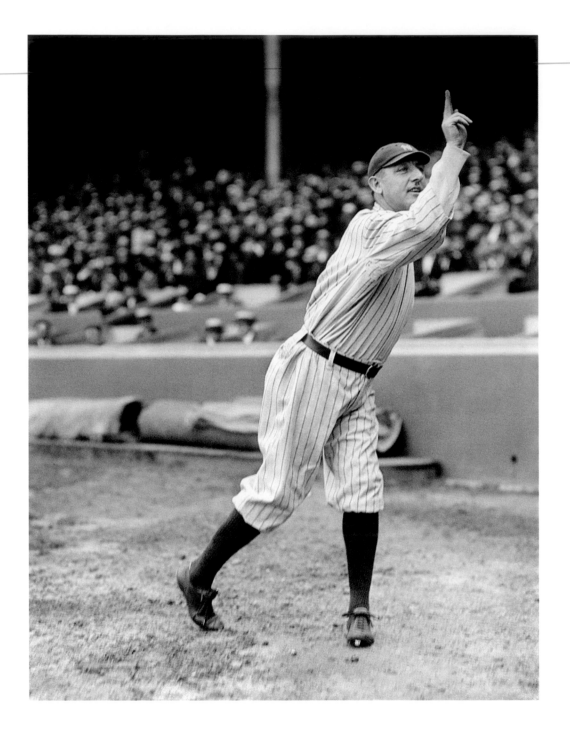

WILD BILL DONOVAN
1917 New York Yankees

"Bill Donovan carried his smile all through the game, even in the face of defeat," noted a puzzled Chicago sportswriter one day in 1915. "No one ever did find out what Bill is smiling at all the time." In 1917, Donovan was in his third and last year as Yankee manager, and the *Sporting News* blamed the team's failure on his sunny disposition: "He created the impression of a good club fellow instead of a baseball leader, and he lost caste with the players. They would not take Bill seriously and Bill, having created the impression that he did by his genial conduct, could not enter a serious role."

Wild Bill earned his nickname in 1897, when he threw a pitch that bounced into the grandstand and knocked a spectator out cold. He was still wild in 1901, when he led the National League in walks, but he also led the league with twenty-five victories, and in 1907 he pitched the Detroit Tigers to their first World Series with a brilliant 25-4 record. The baseball world was shocked in 1923, when the universally beloved Donovan was killed in a train wreck at the age of forty-seven.

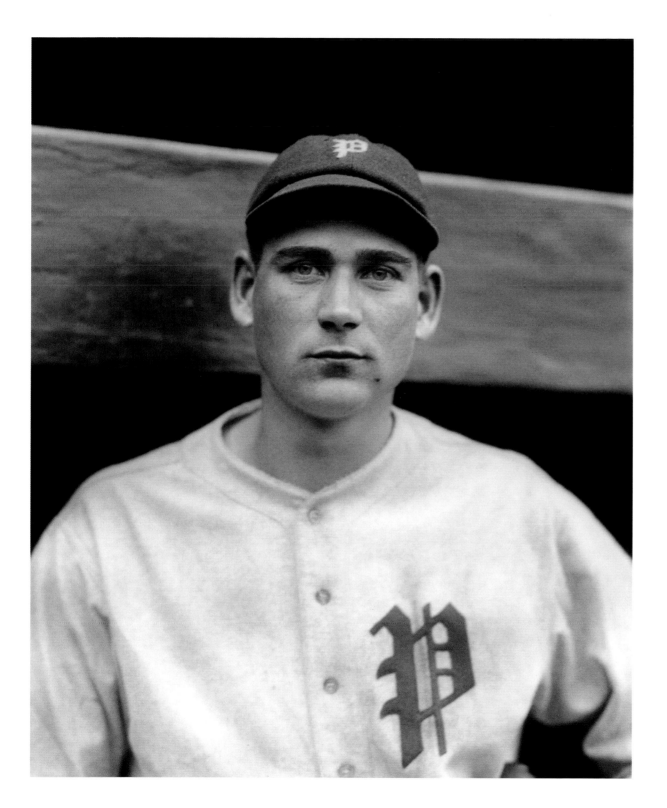

WAYLAND DEAN
1926 Philadelphia Phillies

"Pitchers are queer," observed sportswriter John Kieran in 1928. "There was Wayland Dean, for instance. He came to the Giants with a great minor league record. He had speed and a select assortment of hooks and sinkers. He could throw overhand, sidearm and underhand. He 'had everything,' as the boys say. But where is Wayland now? With everything in his favor, he refused to take his job seriously and he hit the chute that took him out of the big league [*sic*] into complete obscurity."

Dean was a sharp-dressed man from West Virginia who played a mean steel guitar, but his promising pitching career was ended by tuberculosis. As he lay dying, Wayland attempted to brighten the spirits of a visiting friend: "I have one of those dime-a-dozen sets of lungs, Duke, and I am liable to call it a day most any time." He passed away in 1930 at the age of twenty-seven.

CHARLIE HOLLOCHER
1918 Chicago Cubs

His sensational rookie season carried the Cubs to the 1918 World Series, but a few years later something went terribly wrong: After the 1922 season, during which he was the best fielding shortstop in the major leagues, Charlie Hollocher suddenly complained of a mysterious stomach ailment that no doctor could diagnose. He deserted the team in 1923, leaving his manager Bill Killefer this note: "Feeling pretty rotten, so made up my mind to go home and take a rest and forget baseball for the rest of this year. No hard feelings, just didn't feel like playing any more. Good luck. As ever, HOLLY." After a halfhearted comeback attempt in 1924, the troubled Hollocher retired permanently at the age of twenty-eight, and for the rest of his life he worked at odd jobs such as drive-in theater watchman, tavern manager, and newspaper delivery man. In 1940, still complaining of severe abdominal pains, he committed suicide by shooting himself in the neck. He was forty-four.

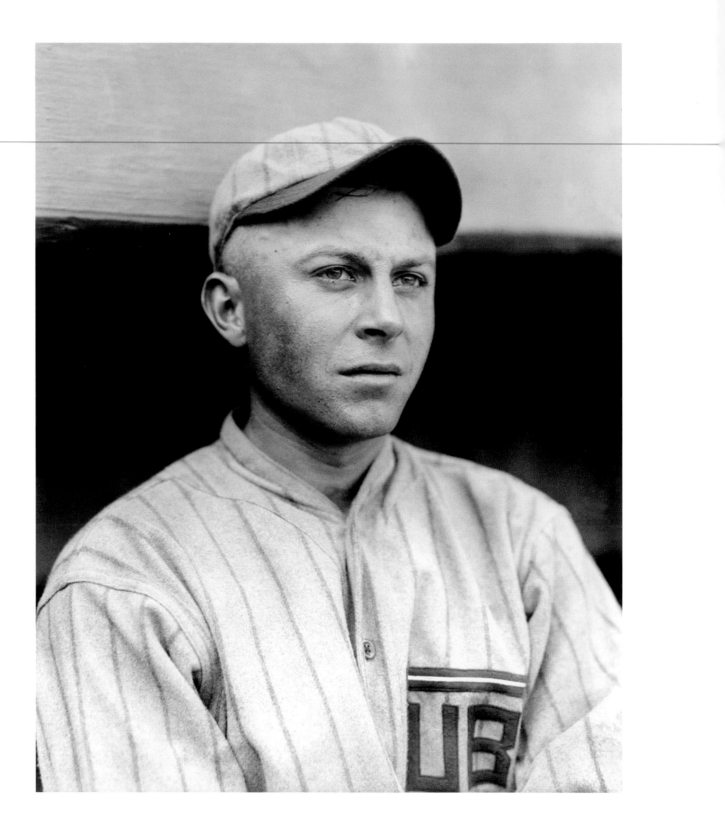

JAKE POWELL
1936 New York Yankees

This man was a twisted racist thug, despised by fans and fellow players alike. He was the Yankees' hero in the 1936 World Series, leading all batters with a .455 average, but earlier in the year he had intentionally collided with Hank Greenberg, breaking the Detroit first baseman's wrist. Jake Powell never apologized, and after intentionally colliding with Washington first baseman Joe Kuhel in 1937, he went out to his position in left field and—in the words of sportswriter Shirley Povich— "placed his thumb to his nose and agitated his fingers vigorously." The disgusted Washington fans showered the former Senator with soda bottles.

"Powell has more players laying for him than there are tax collectors," reported the *Sporting News* in June 1938. When Powell, a policeman in the off-season, made racist remarks during a radio interview in July, he was suspended for ten days by Commissioner Landis. After his playing career fizzled, Jake became a drifter and a grifter, and in 1948, after he was arrested for passing phony checks, he committed suicide in a Washington, D.C., police station by shooting himself in the chest and right temple. He was forty.

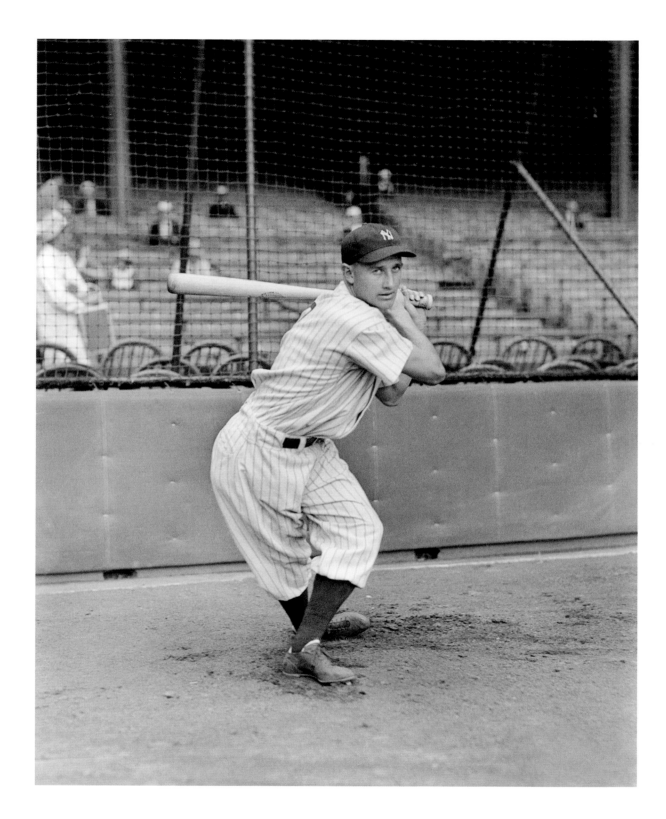

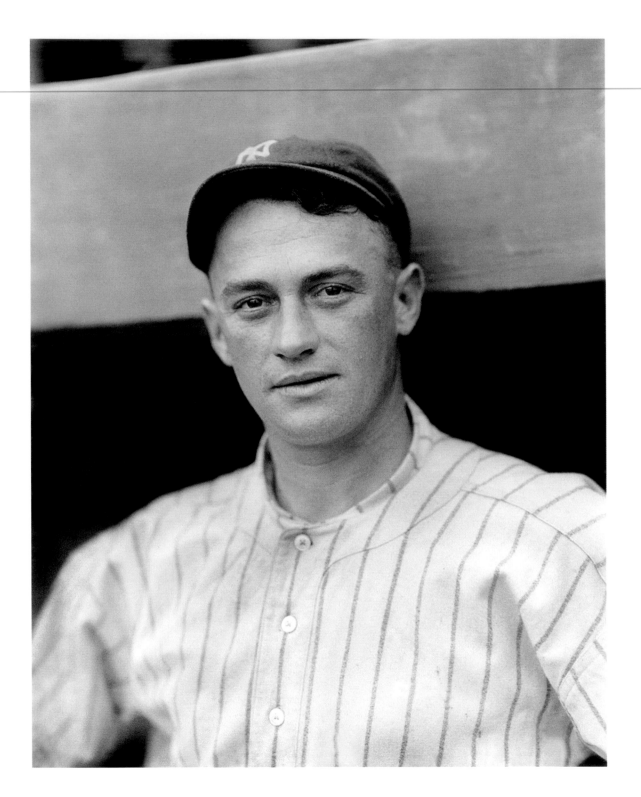

URBAN SHOCKER
1916 New York Yankees

This Yankee rookie, purchased for $750, spent most of the 1916 season pitching for the Toronto Maple Leafs, with whom his record was a dazzling 15-3. His fifty-four consecutive scoreless innings and 1.31 ERA that year are still International League records, yet the Yankees sent the promising Shocker to the St. Louis Browns after the 1917 season: "Every time the Yankee owners think of Shocker these days they sadden and get an attack akin to nausea," reported the *Sporting News* in 1921. "For they see in Shocker what everyone else sees—one of the greatest flingers in the game. And the sadness comes when they recall that in 1918 they passed along Shocker to the Browns as the 'to boot' part of a baseball bargain. The Yankees didn't think Shocker was worth his keep, and they gave him up in preference to $2,500. Now Shocker is worth $50,000 on the hoof." Urban won twenty-seven games in 1921, the second of his four consecutive twenty-game-winning seasons for the Browns. The mortified Yankees finally reacquired him in a trade after the 1924 season.

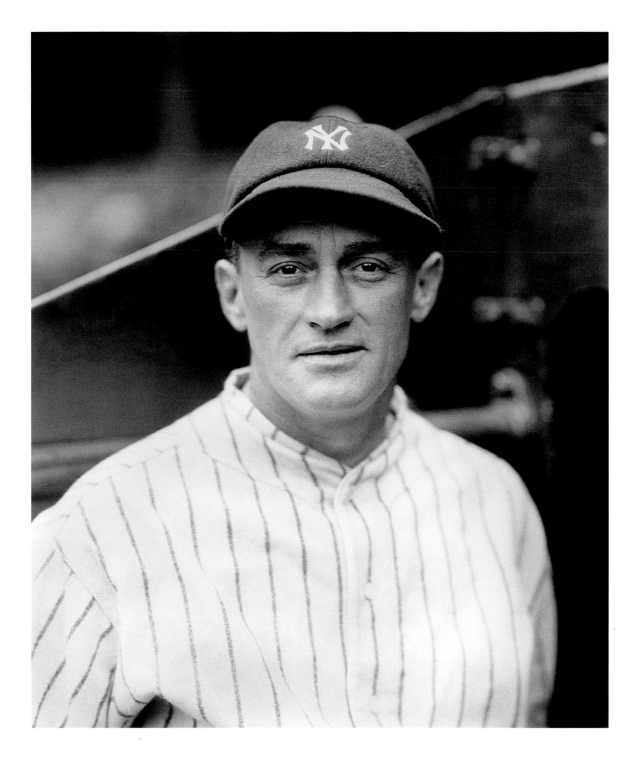

URBAN SHOCKER
1928 New York Yankees

This sick old man made a single mean-ingless mop-up appearance in May of 1928 before the Yankees released him early in July. Suffering from heart dis-ease and pneumonia, Shocker entered a Denver hospital in August: "Although 1,500 miles away, in spirit he was with his former teammates constantly," said his wife. "He felt their defeats keenly, and he gloried in their victories. He wanted to read every detail of every game." While anxiously awaiting the results of a crucial Yankees-Athletics doubleheader, Urban Shocker uttered his last words: "I'll be better today. I want to see the Yankees win those two games." He died on September 9, 1928, at the age of thirty-eight, and was buried in St. Louis five days later. His pallbearers—all Yankee teammates—included Lou Gehrig and Earle Combs.

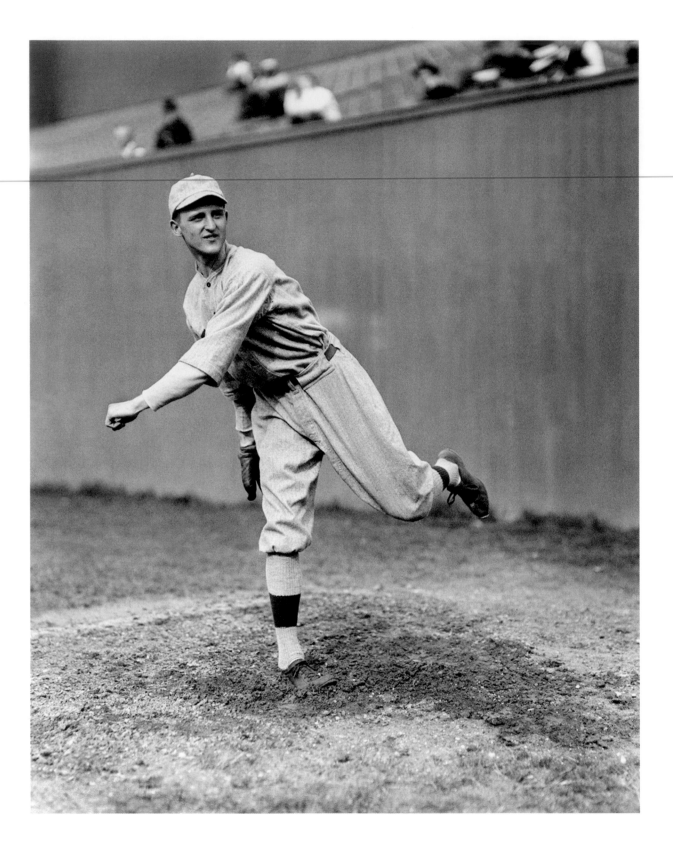

HERB PENNOCK
1916 Boston Red Sox

"I am not repeating a mistake I made in 1915," said Philadelphia Athletics manager Connie Mack. "I sold Herb Pennock to the Boston Red Sox—the biggest blunder of my managing career. I was too impatient with the boy. I started him against Detroit one day, and Herb did not obey instructions. I said, 'Young man, so far as I am concerned, you can sit on that bench all season and never pitch another ball.' Pennock replied, 'If you don't care for my pitching, why not trade me, or sell me?' I got sore and did sell him. Boston eventually sold him to the Yankees in 1923, and Herb became one of the marvelous left handers of all time."

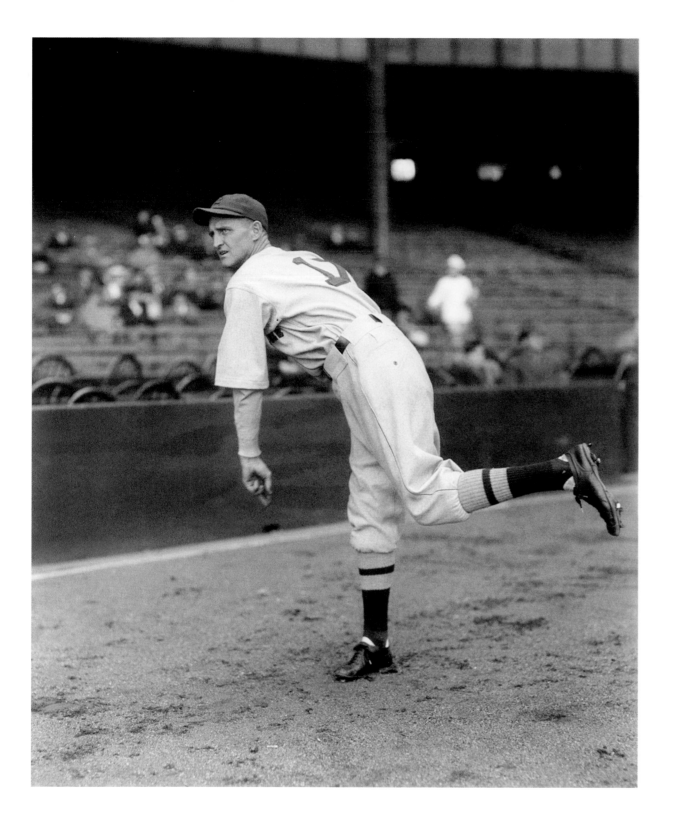

HERB PENNOCK
1934 Boston Red Sox

"The spring has long since gone from Pennock's arm," observed sportswriter Joe Williams in 1931. "His fast one no longer buzzes across the plate, and he won't throw a curve unless he has to, but his head is as cunning as ever. He pitches to each batter as if the game depended on it, working smoothly and slowly. And when the game is over one wonders how Herbie managed to weather the storm." In 1934, Pennock returned to the Red Sox, ending his Hall of Fame career as an occasional relief pitcher. He later became director of the Red Sox farm system, and as general manager of the Philadelphia Phillies in the late 1940s he put together the team that would win the 1950 National League pennant.

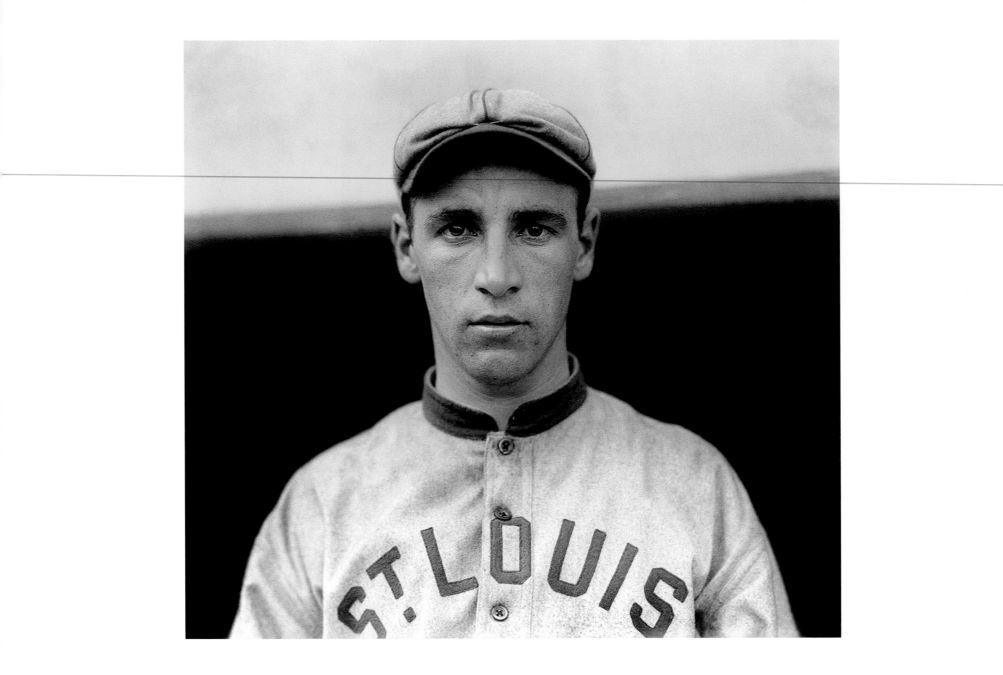

DOC LAVAN *c. 1914 St. Louis Browns*

"As a kid in Grand Rapids, I used to drive our family doctor on his horse-and-buggy rounds," recalled Dr. John Lavan. "I decided then and there that I would be a doctor, too. I didn't go to college to play baseball. I went to learn medicine. I got to know [baseball coach] Branch Rickey at the University of Michigan and he showed me how I could play ball seriously and study medicine at the same time. So I went out for the University team and made it." When Rickey became the Browns' manager in 1913, he signed the former medical student as his St. Louis shortstop—although he briefly loaned Lavan to the Philadelphia A's as a temporary replacement for their injured shortstop, Jack Barry: "I'm the only one who remembers it—well, no, Connie Mack does—but I was with the Athletics in 1913," joked Lavan. "Not long—but for enough of the season to get a share of the World Series money when the A's beat the Giants that fall. That was very important to me because with that money I paid off the last of the debts I had accumulated as a medical student. The next Spring, I was back in St. Louis. Don't ask me how it was all done. A gentleman's agreement I guess."

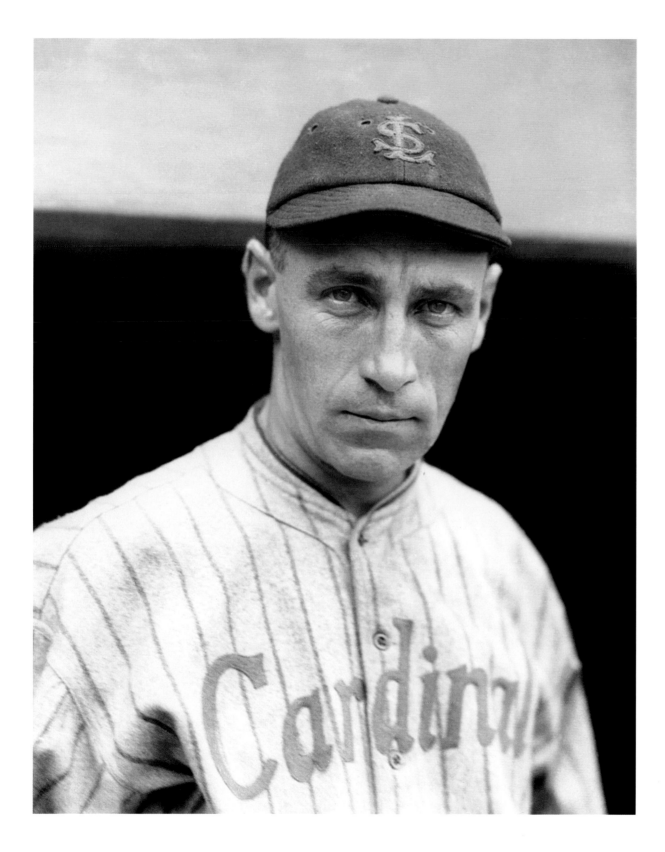

DOC LAVAN
c. 1922 St. Louis Cardinals

It was a good thing that Lavan had other career options, because he was a weak hitter and a poor fielder. He struck out twenty-two times in his first forty major-league at-bats, and in 1915, his first full season as the Browns' starting shortstop, he led the league in strikeouts and errors. He led the American League in errors with Washington in 1918, and—after his mentor Branch Rickey brought him to the St. Louis Cardinals in 1919—Lavan led the National League in errors in both 1920 and 1921. Married to a graduate of the University of Michigan School of Nursing, Lavan served as a medical officer in both world wars, retiring as a commander in the navy. He served as health commissioner in Grand Rapids, Michigan, and Toledo, Ohio, and at the time of his death was director of social hygiene for the Wayne County, Michigan, Health Department. He is buried in Arlington Cemetery.

JIMMIE WILSON

1923 Philadelphia Phillies

"Soccer was the sport I loved as a boy," said Wilson. "When I was 16 or 17 years old, baseball was just a sideline sport with me. We looked on American football as a 'sissy' game and laughed at the kids who lugged those egg-shaped balls around with them." But the strong legs he developed playing soccer made him a natural catcher, and Wilson began playing baseball semiprofessionally in his native Philadelphia in 1919. Jimmie joined the big leagues in 1923, but he continued to spend his off-seasons working as a knitter and machinist in a hosiery factory until he collected his third World Series paycheck in 1931 as catcher for the victorious St. Louis Cardinals.

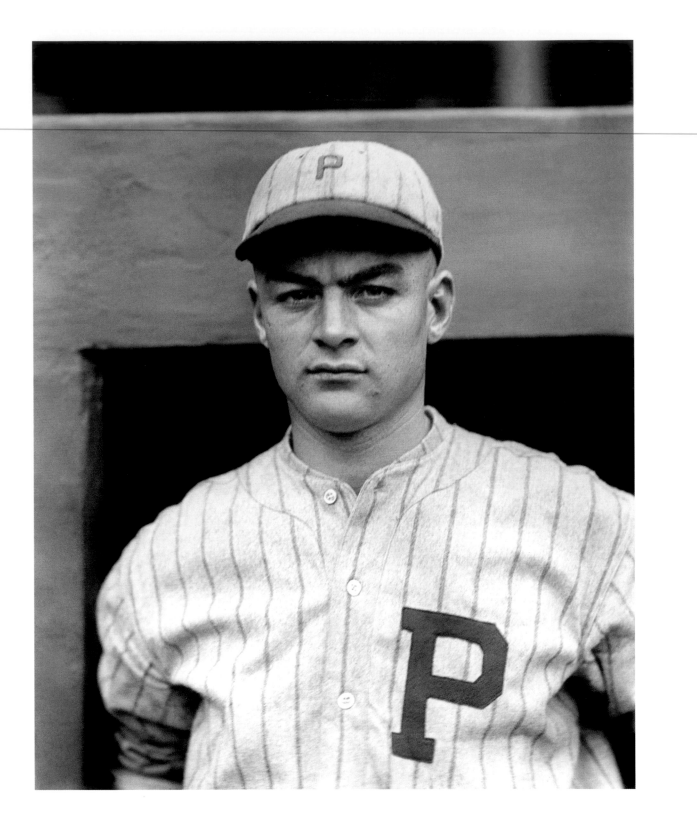

JIMMIE WILSON
1938 Philadelphia Phillies

In 1938, thirty-eight-year-old Jimmie Wilson was in his fifth and last year as the Phillies' player-manager. The team never finished higher than seventh place during his reign, and after batting only twice in 1938, Wilson called it quits. The next year he became a coach for the National League champion Cincinnati Reds, but in the fall of 1940, after the suicide of catcher Willard Hershberger and a serious injury to catcher Ernie Lombardi, the Reds had no choice but to reactivate their ancient coach as their catcher. Jimmie proceeded to perform like a prodigy, helping Cincinnati win both the pennant and the World Series, whereupon he announced his permanent retirement as a player: "You got your last look at me in catching harness—the old master is through," he declared.

"Singing his swan song in the final contest, Wilson had a perfect day at bat, getting two singles and a sacrifice and making his famous steal of second," reported the *Sporting News*. "What a trouper! After the game, he was congratulated by [seventy-three-year-old] Commissioner Landis, who said: 'You did our generation proud, Jim.'"

FRED MERKLE *1912 New York Giants*

The New York Giants were just two outs away from winning the 1912 World Series when Tris Speaker of the Red Sox came to bat against Christy Mathewson with men on first and second: "Speaker raised a high foul toward first base which Merkle, who seemed to be in a trance, made scarcely a try for, especially as catcher Chief Meyers was making a desperate effort to get under the ball," reported *Sporting Life.* "He could not quite reach it and so the ball, for which Merkle had ceased trying, dropped safely into the coacher's box [*sic*], thus giving the most dangerous batter of the Red Sox a life which proved fatal to the Giants."

"The ball was drifting toward first and would have been an easy catch for Merkle," recalled Speaker. "I was going to yell for Meyers to make the catch for I didn't think he could, but before I could open my mouth I heard Matty calling, 'Meyers, Meyers.' Meyers chased the ball, but it was going away from him and finally Merkle charged in, but he was too late and couldn't hold the ball. Fred was blamed for not making the catch, and the term 'bonehead' was thrown at him again, recalling his failure to touch second base in 1908. I never thought Merkle deserved any blame at all. It was Matty who made the blunder in calling for Meyers to try for the catch." Speaker then knocked in the tying run, and the Red Sox won the Series on a sacrifice fly.

FRED MERKLE
1925 New York Yankees

In 1925, this thirty-six-year-old coach played in five games as the Yankees' first baseman before Lou Gehrig won the job. After the 1926 season, the quiet and withdrawn Merkle lost his coaching job to the more aggressive Art Fletcher, who was better suited to the task of keeping Babe Ruth and the rest of Murderers' Row in line: "Merkle isn't tough enough," complained Yankee manager Miller Huggins. "I gotta do something." Merkle soon slipped into a reclusive retirement in Florida, where he could finally escape the constant abuse from boneheaded New York fans: "As a player I became callused to it after awhile. But it was tough on my wife, and worse as my three daughters grew up. It finally got on my nerves." In 1950, an apprehensive Merkle reluctantly returned to New York for an old-timers' game: "When I quit baseball, I said I was through with it forever. But it's strange how things work out. I never had such a good time. If there's another shindig like this, I know I wouldn't hesitate to accept. It makes a man feel good to hear such cheers after all those years. I expected so much worse."

EARLE COMBS

1926 New York Yankees

In 1926, Yankee center fielder Combs played in his first World Series, batting a team-high .357: "There will never be another thrill like that for me in baseball," he said. Altogether, he appeared in eleven World Series as either player or coach: "There's something about a World Series that you can't get out of your system. I picked up somewhere around $72,000 in those Series, and you know something? I've still got most of it."

In 1934, Combs crashed into the left-field wall in St. Louis, breaking his collarbone and fracturing his skull: "Funny thing about that. I never did have a headache from the fractured skull." Earle was able to return in 1935 as a part-time center fielder, but after the season, he retired to become the Yankees' first base coach.

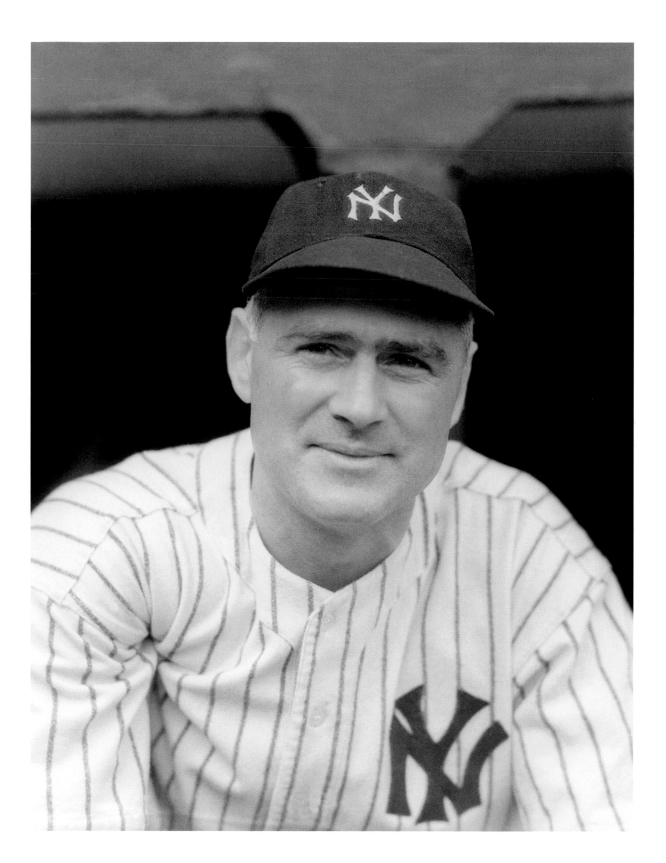

EARLE COMBS
1940 New York Yankees

Before the 1936 season, Yankee general manager Ed Barrow told Combs about the rookie who would be his successor in center field: "Ed asked me to take this young fellow under my wing. 'If this boy does as well as you did,' Barrow said, 'I'll be satisfied.' The young fellow was Joe DiMaggio. He took my place and I guess you know what he did. And while I did sort of take him under my wing, don't give me any credit for what he did. He didn't need any help." DiMaggio, however, gave Combs credit for helping him become one of the most graceful outfielders in baseball history: "I practiced hard," said DiMaggio decades later. "I was a complete player because I worked at it. I remember how good a fungo hitter Earle Combs was. He could put the ball just inches beyond your glove."

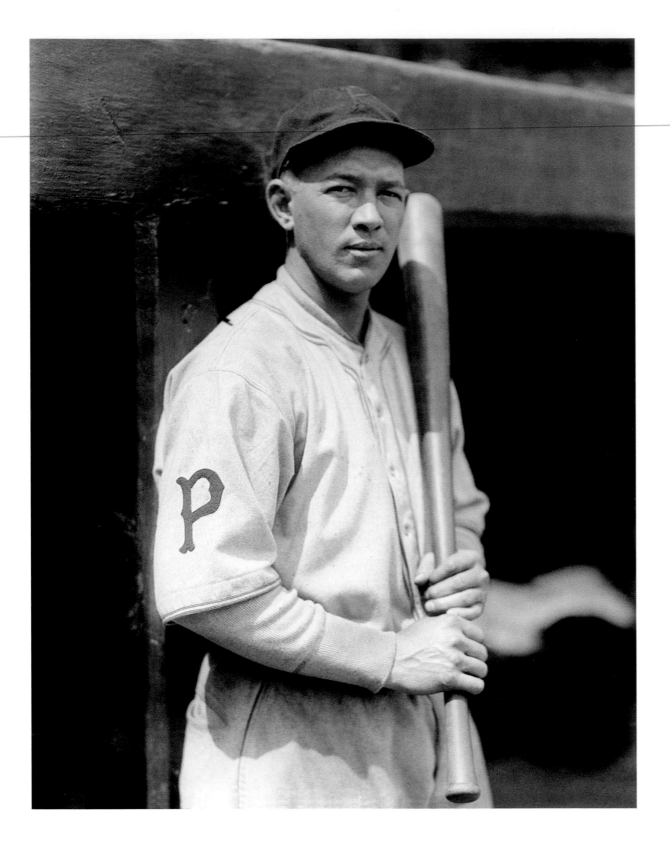

GEORGE GRANTHAM
1929 Pittsburgh Pirates

"Grantham often gave off the impression that he was indifferent about his work," observed Havey J. Boyle in the *Pittsburgh Post-Gazette*. "It was because he was a phlegmatic type, outwardly at least, that he seemed at times lackadaisical, but underneath he burned up at his own failures and took them to heart."

George Grantham had a lifetime batting average of .302, and he led the National League in stolen bases twice, but this seemingly phlegmatic fellow had plenty of failures to take to heart. As a rookie second baseman with the Chicago Cubs in 1923, Grantham set a modern National League record with fifty-five errors, earning the nickname "Boots." In 1924, Grantham again led the league with forty-four errors. In 1930, when he became the Pirates' regular second baseman, Grantham led the league with thirty-six errors. "His fleetness of foot fascinated Pirate supporters," reported the *Pittsburgh Press* after Grantham was traded to the Reds in the spring of 1932: "Failure to field consistently was the reason for his being let go."

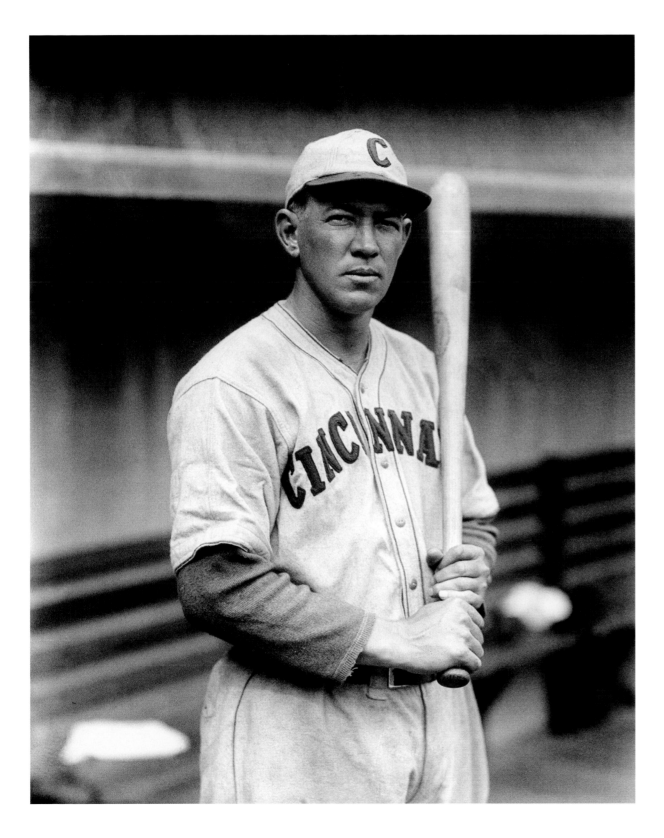

GEORGE GRANTHAM
1932 Cincinnati Reds

This pair of photographs demonstrates the strangely obsessive aspect of Conlon's working method. He tried to take every player's picture every year, no matter how many similar pictures he had on file, and the players naturally repeated characteristic poses for Conlon, who rarely "directed" his subjects. There was little demand for timeliness or novelty at *Spalding's Guide,* the *Sporting News,* or *Baseball Magazine*—publications that routinely reprinted familiar Conlon photos year after year, regardless of a player's current team—yet Conlon persisted in taking these seemingly redundant photographs. Today, of course, when baseball historians are fascinated by the slightest changes in any aspect of the game, Conlon's eccentric and seemingly excessive documentary zeal turns out to have been visionary, and when virtually identical pictures are placed side by side, the effect can be amusing, or hallucinatory— or both.

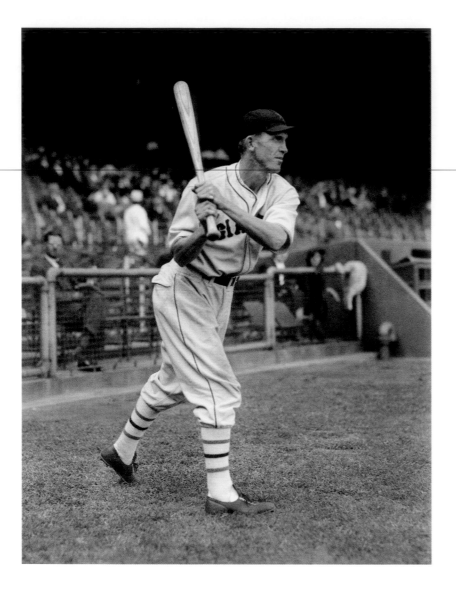

JOE MOORE ⬆

1935 New York Giants

This five-foot-eleven, 155-pound native of Gause, Texas, was called "The Gause Ghost" and "The Thin Man"—for obvious reasons: "He looks like he might fall apart any day," observed sportswriter Dan Daniel in 1934. "He's just a bundle of bones stuck together with adhesive tape," wrote the *Sporting News* in 1935. "Frail in appearance, Moore is apparently made of India-rubber," wrote the *Sporting News* in 1937.

JOE MOORE ⬇

1936 New York Giants

Despite Joe's downright cadaverous physique, Giants manager Bill Terry declared: "I would rather have Moore than any other outfielder in the league. He can hit and run—and, boy! how he can throw. He is the best leadoff man in either league." Joe had the last laugh by outliving nearly all of his seemingly more robust teammates: On Christmas Day in 2000, he celebrated his ninety-second birthday.

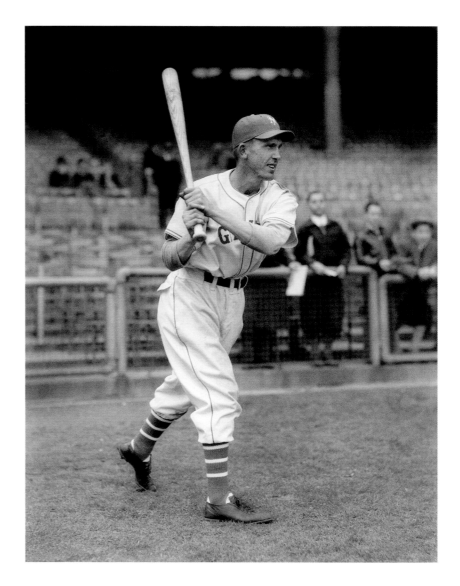

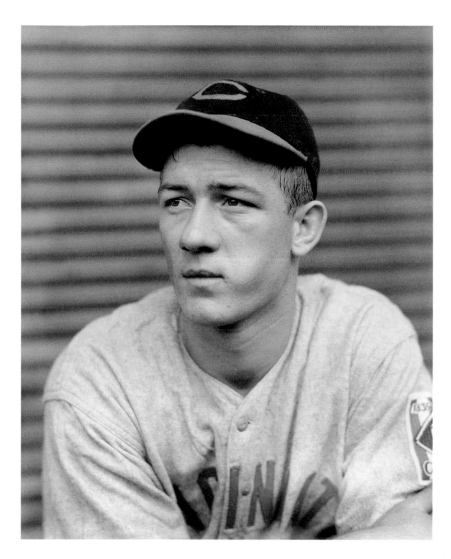

JUNIOR THOMPSON ⊙

1939 Cincinnati Reds

Junior had a great rookie season in 1939, going 13-5 for the pennant-winning Reds, and he started Game Three of the World Series. He allowed the Yankees only five hits, but, unfortunately, four of them were home runs. The Bronx Bombers knocked Junior out of the box after four and two-thirds innings, and they went on to sweep the Series.

JUNIOR THOMPSON ⊙

1940 Cincinnati Reds

Junior had a great sophomore season in 1940, going 16-9 for the pennant-winning Reds, and he started Game Five of the World Series. He allowed just one home run, but this time he lasted only three and one-third innings: "The Tigers were not quite so spectacular [as the Yanks in '39]," noted one sportswriter, "but they were equally unmerciful." When the Reds finally won the seventh game of the Series, Thompson's wife, Dorothy, was so relieved that she immediately fainted in the grandstand. Nearby fans revived her by fanning her face with their scorecards.

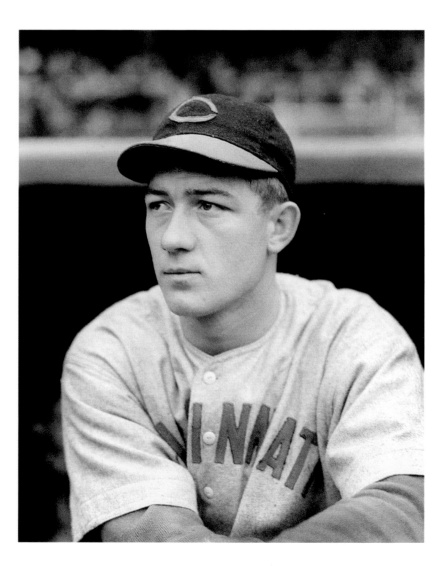

MELO ALMADA ⊙
1936 Boston Red Sox

In 1914, Melo Almada's father was appointed governor of Baja California. Unfortunately, the Mexican Revolution was raging at the time, and the previous incumbent refused to step down: "He had a large well-equipped army," recalled Almada, "while my dad's army consisted of my mother and eight children. Lord only knows what would have happened to all of us had we moved into Baja California. My father always wanted us children to have an American education, so when the opportunity came along for him to become Mexican consul at Los Angeles, he turned over most of his property to relatives and moved us all to this country. I was then only a year and a half old, so you see I am very much an American." Melo grew up speaking English, but he noted: "I took Spanish in school and talk it fairly well." When Almada joined the Red Sox in 1933, he became the first Mexican to play in the major leagues, although the Mexican Baseball Hall of Fame is careful to point out that Melo wasn't really *Hecho en México* ("Made in Mexico"). Nevertheless, the Melo Almada Trophy is now awarded annually to the Mexican League Rookie of the Year.

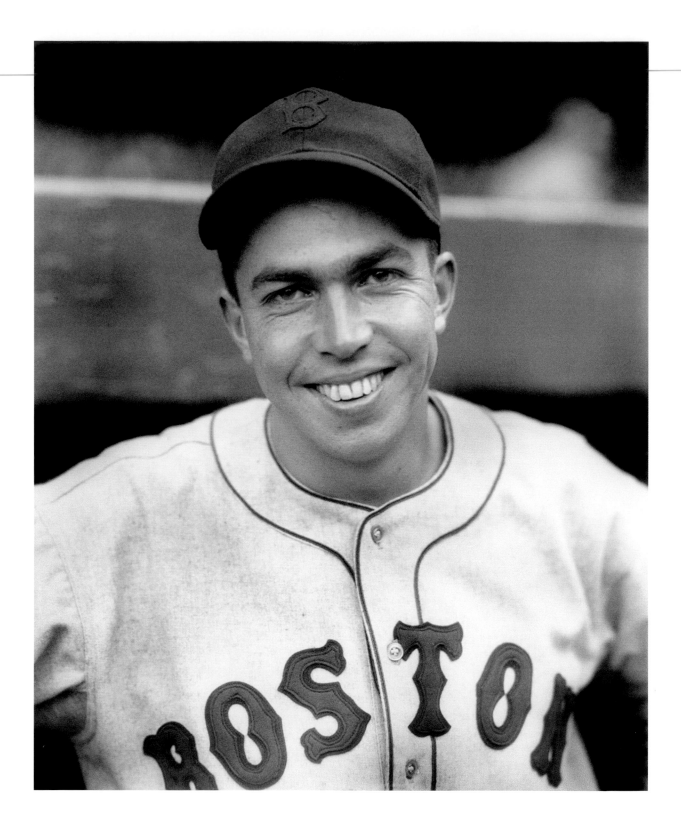

● MELO ALMADA
1937 Washington Senators

Melo was traded to Washington in June of 1937, and Shirley Povich of the *Washington Post* noted that in Almada's debut with the Senators (or Nationals, as the team was also known in that era), he "covered centerfield like the morning dew." On July 24, in St. Louis, he tied a major-league record by scoring five runs in the first game of a doubleheader. He scored four more runs in the second game, setting the record for total runs in a doubleheader. By 1938, the *Post* was reporting that Almada had "captured the fancy of the local fans with his sensational catches and hit-robbing tactics."

MELO ALMADA ●
1938 St. Louis Browns

"There was genuine sympathy among the hard-boiled Nats this morning as Melo Almada said his good-byes, took leave of the club and dashed for the train to St. Louis," reported Shirley Povich in June 1938. "St. Louis is big league baseball's Black Hole of Calcutta. Big leaguers shudder at the thought of a trade that would send them to the Browns. There, an atmosphere of defeatism prevails. There's the matter of low salaries, too. In St. Louis, the lowest big league wages prevail. No wearer of a Brownie uniform can hope for the big dough." On his first day in a Brownie uniform, Almada got five hits in a doubleheader: "The Nats traded him because he couldn't hit," wrote Povich in August. "But there must have been some mistake about that, because the other day he just concluded a streak in which he hit safely in 29 games. At the time he was traded by the Nats, he was a colossal joke as a hitter. Even his superb fielding could not offset his batting deficiencies. But at St. Louis, the Mexican is a man transformed." Melo finished with a .311 average in 1938—his best season in the big leagues.

○ KIKI CUYLER

1932 Chicago Cubs

On August 31, 1932, at Wrigley Field, the Cubs were trailing the Giants by a run in the bottom of the ninth when Kiki Cuyler hit a single to tie the game, sending it into extra innings. The Giants scored four runs in the top of the tenth, but the Cubs rallied, and Cuyler's dramatic three-run home run in the bottom of the tenth won the game: "Cuyler was mobbed by a crowd of admirers," reported the *Chicago Tribune*, "and he was rescued by ushers with some difficulty." Among Kiki's admirers that day was his son, Harold: "I remember as I rounded third base, I looked over, back of the dugout, and there was my boy. He was ten years old then, but he was standing up at least five inches taller than he was when the game started. I caught his eye as they carried me off on their shoulders, and I'll never forget how he looked at me."

Conlon took this pre-game picture at Yankee Stadium during the 1932 World Series, which was inevitably anticlimactic for Kiki—particularly since the Yankees beat the Cubs in four games.

KIKI CUYLER ○

1934 Chicago Cubs

"Trim of figure, Cuyler is an exponent of diamond neatness," reported the *Sporting News* in a story describing his insistence on a well-tailored uniform. Kiki was fastidious in all respects: "Cuyler not only doesn't cuss, but he reproves other ball tossers who use vile language in his presence." *Who's Who in Baseball* noted that "Kiki is a total abstainer from both intoxicants and tobacco. He is a truly graceful dancer and frequently has won the 'prize waltz' staged annually by the merchants of Catalina Island during the Cubs' spring training routine." But his artistic temperament had a downside: "Kiki Cuyler is said to be one of the most sensitive players in the business," confided a Pittsburgh writer. "When he's not hitting, he is given to excess worry."

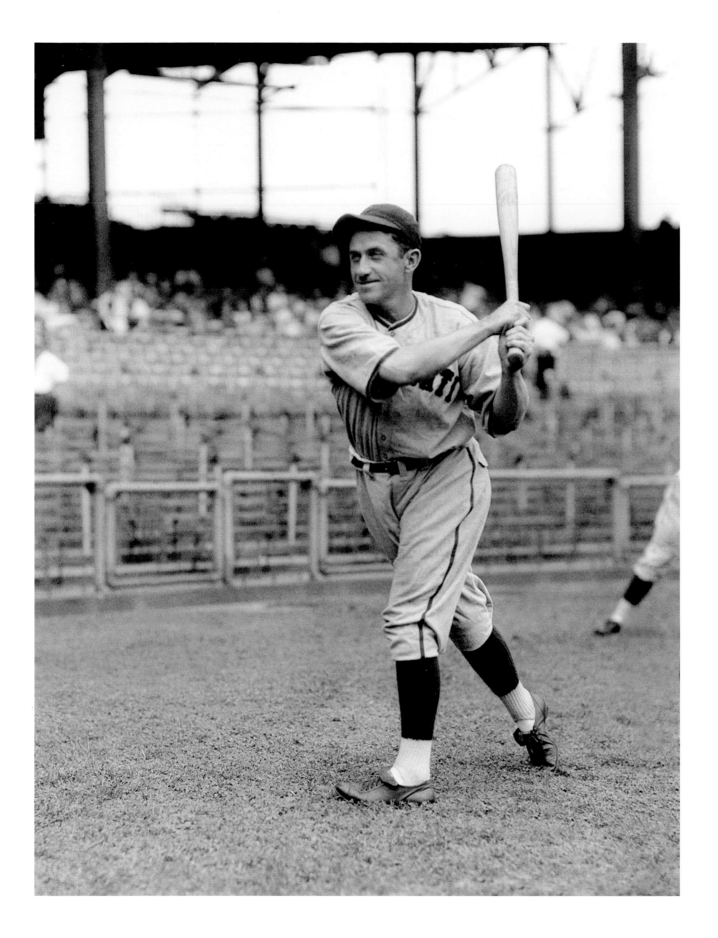

⊙ KIKI CUYLER
1937 Cincinnati Reds

"Back in the days of my childhood I was called 'Cuy,' and I was 'Cuy' when I went to the Southern League. Some sportswriter changed this to 'Ki.' In those days, when I would come in from center for a short fly ball, the second baseman would shout 'Ki,' then the shortstop would yell 'Ki.' Fans and players took this up, and very soon I became 'Kiki.'" Besides having one of the most unusual—and most often mispronounced—nicknames in baseball history, Cuyler led the National League in stolen bases four times, and had a lifetime batting average of .321. He was elected to the Baseball Hall of Fame in 1968.

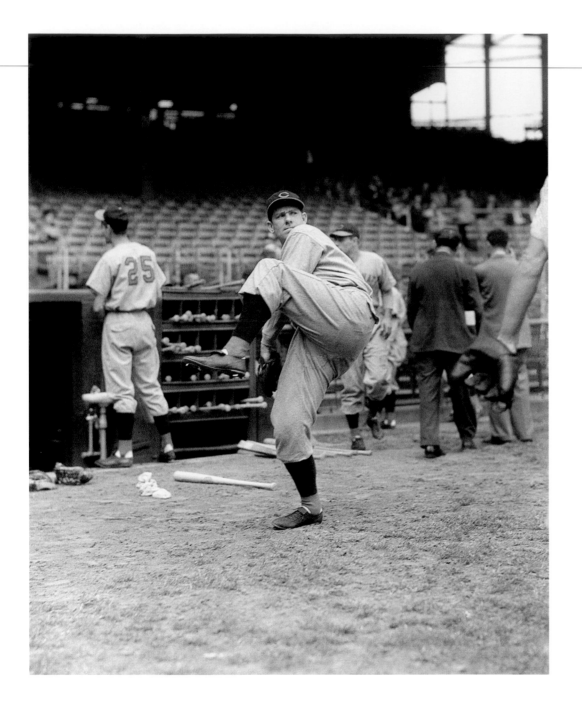

PAUL DERRINGER
1940 Cincinnati Reds

Rookie pitcher Paul Derringer started Game One of the 1931 World Series for the Cardinals, facing Lefty Grove of the A's: "I was going along great until Al Simmons ruined my dream. He blasted a home run with two on and that was the end of me." Paul also lost Game Six of the 1931 Series, and he lost Game One of the 1939 World Series as the Yankees swept the Reds. He lost Game One of the 1940 World Series to the Tigers, but Derringer's dream finally came true as he went on to win Games Four and Seven—and the 1940 Series.

Conlon's best baseball portraits are notable for their beauty and calm, so it is somewhat jarring to be reminded of the chaotic environment in which he worked. In this failed, albeit fascinating, photograph, Conlon has asked the Reds' star pitcher to pose for him in the midst of a crowd. Here—as players and civilians wander about, and teammate Lee Gamble chats with someone behind the dugout—Big Paul demonstrates his famous high leg kick.

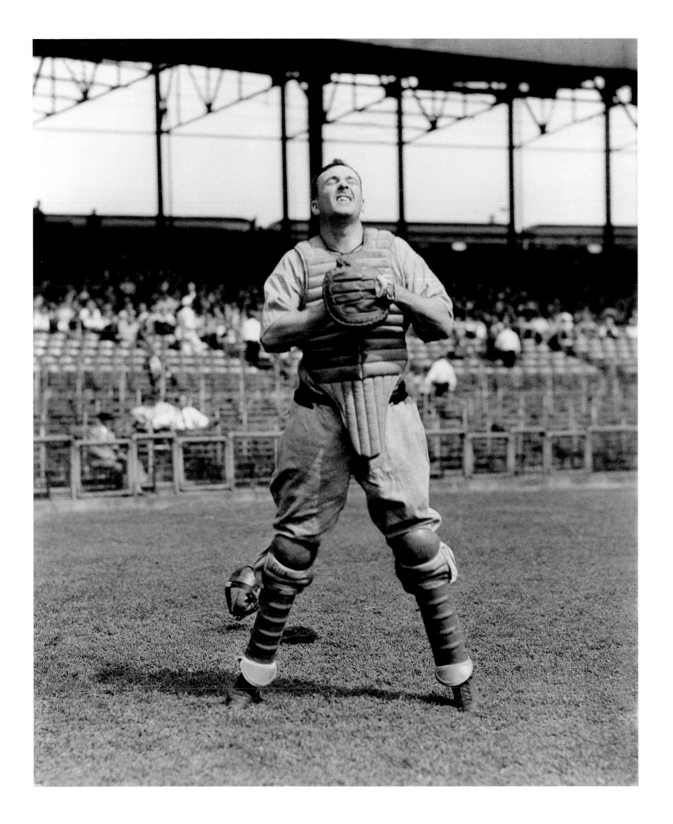

AL TODD
1938 Pittsburgh Pirates

When asked who was most responsible for his success, this man replied: "Dizzy Dean. He challenged me to fight and I received more publicity by licking him than anything I had ever done." Regrettably, Al Todd also threatened to lick his own teammates: "Todd, aside from his catching deficiencies, presented a problem at times by his firm opinions," wrote Havey J. Boyle of the *Pittsburgh Post-Gazette* in 1938, immediately after the Pirates had traded Todd. "He was not always one who could yield when a difference of opinion arose. The big catcher was firmly set in his views and there were times when this attitude did not sit well with the rest of the cast. However, under the hand of Pie Traynor there was no outbreak at any time, although there were moments when trouble loomed on the horizon. Todd must get 100 percent for effort—for he was a willing fellow—but around the circuit he was considered subnormal in handling pitchers."

Trouble struck in this amusing Conlon misfire—a subnormal simulation of a catcher about to handle a pop foul—as the willing but deficient Todd stands frozen, blinded by the midday sun.

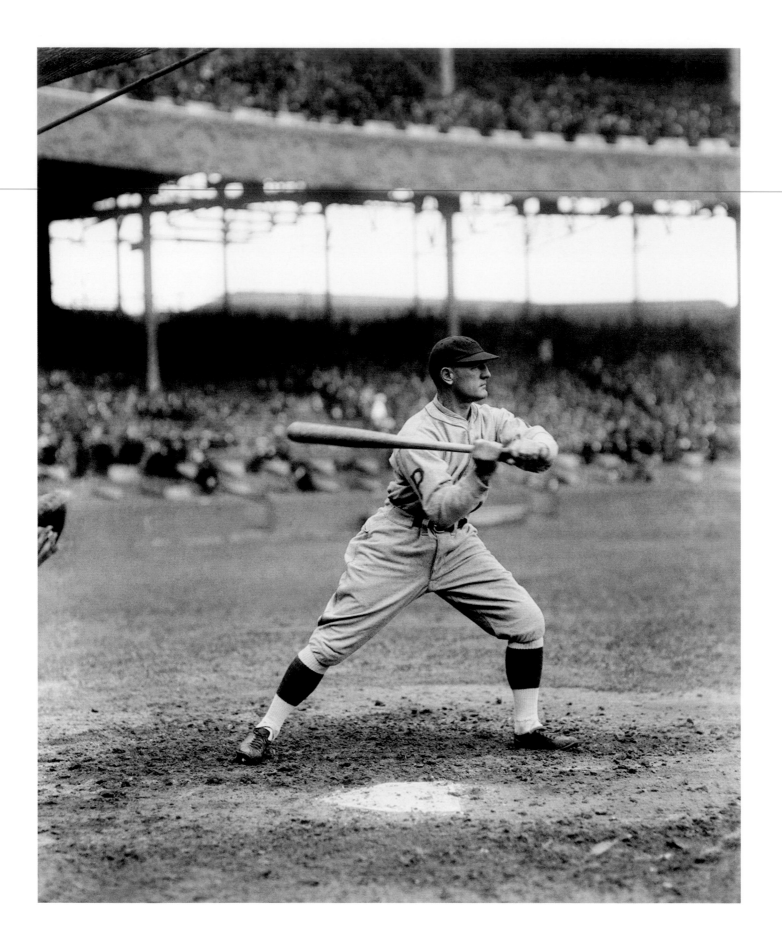

◉ WALTER SCHMIDT
1923 Pittsburgh Pirates

In 1923, the *Sporting News* gave its readers this inside dope: "Common report has it that when Pittsburg [*sic*] put Walter Schmidt on the market, no major league club stepped in to make a bid, and yet Schmidt is considered one of the most capable backstops in the game and is still in his prime. There is a reason. Schmidt has given his club trouble over signing contracts in the past, but that is not all. The Pittsburg opinion is that his temperament as displayed is not conducive to harmony on a ball club, and managers and magnates in general seem to have become of the same opinion."

WALTER SCHMIDT ◉
1921 Pittsburgh Pirates

In 1921, sportswriter Damon Runyon called him "the best catcher in the National League," and in 1938, more than a decade after his retirement, he was still the standard by which all Pittsburgh catchers were measured: "Walter Schmidt would be rated the slickest catcher the Pirates had, smart in handling pitchers, deft in tagging base runners, and faster than most of his contemporaries," wrote Havey J. Boyle in the *Pittsburgh Post-Gazette*.

Since Conlon's presence at the ballpark was almost as immutable as home plate, his batting practice photographs can often be surreally juxtaposed. Here Schmidt prepares to swing at the ball in 1923, and makes contact in 1921.

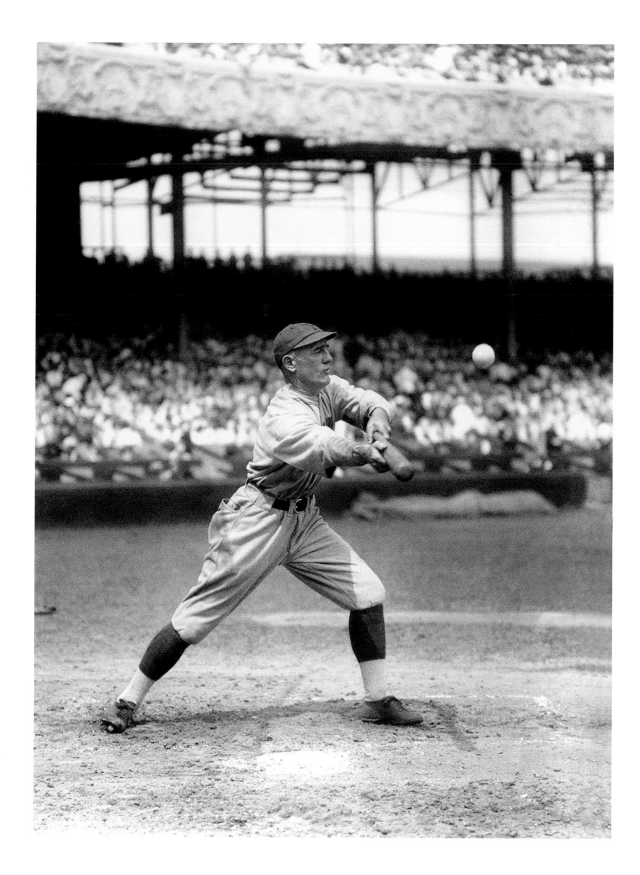

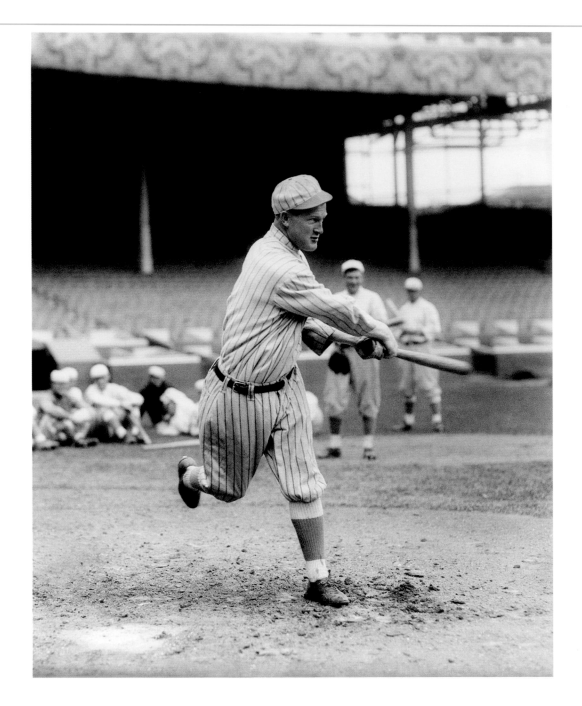

RED MURRAY
1915 New York Giants

John McGraw called it "probably the most dramatic thing I ever saw on a ball field." Honus Wagner declared it "the greatest play I ever saw." On August 16, 1909, Christy Mathewson was pitching in the eighth inning of a tie game in Pittsburgh: "Thunder roared, lightning flashed, clouds of dust arose in whirlwinds beyond the park, and it commenced growing dark," reported a local writer. With base runners on second and third and two out, a Pirate batter blasted the ball to deep right center, whereupon Red Murray made a spectacular leaping catch with his *bare hand* as a lightning bolt lit the sky and a sudden downpour ended the game. MURRAY'S CATCH GREATEST EVER MADE ON BALL FIELD read the headline in the next day's *Pittsburgh Leader*, and—for once—this was probably not hyperbole.

"Murray is a peculiar hitter," noted sportswriter Ring Lardner in 1909. "He strikes at bad balls continually and sometimes misses them three or four feet. At other times he smashes right into them." The teammate laughing as Murray lunges is, appropriately enough, "Laughing Larry" Doyle, the man who famously exclaimed: "It's great to be young and a Giant!"

CLAY BRYANT
1936 Chicago Cubs

Why did this wild young fastballer decide to sign with Cubs scout Pants Rowland in 1934? "No particular reason," answered Clay Bryant, "except that I liked the name 'Cubs.'" In 1938, he led the National League in both strikeouts and walks, and his nineteen victories helped put the Cubs in the World Series, where their opponents were the mighty Bronx Bombers led by Lou Gehrig and Joe DiMaggio. Before the 1938 World Series opened, Chicago White Sox catcher Luke Sewell offered this prescient analysis: "Bryant has enough swift, but he doesn't pitch to spots. He just powers the ball through there. I don't believe that kind of pitching can stop the Yankees." One thing is for sure: that kind of pitching couldn't stop the Yankees' rookie second baseman Joe Gordon, who battered Bryant with a solo home run and a two-run single in Game Three, leading the Yanks to a Series sweep.

PIE TRAYNOR

1937 Pittsburgh Pirates

When Pie Traynor was hired as manager of the Pirates in 1934, his wife, Eve, was worried: "I'll worry more than ever now, because Pie is a worrier. He worried so much as a player, think what he'll do as a manager." Pie was worried, too: "I always worried a lot when I was a player. But now I'm worse than ever, and I can't shake myself of that habit of worrying, worrying, worrying."

So why isn't this manager worried? In the spring of 1935, outfielder Babe Herman gave the Traynors a baby bird, and their worries were over: "When you are married to a baseball player, you sometimes get very lonely, for one cannot always travel with one's husband," Eve explained. "When my hubby is absent I find excellent company in my pet parakeet named Pete. It flies about the room and amuses us by doing numerous tricks which really are amazing. It will roll a marble all around the floor, will sit on my shoulder for hours and loves to perch on a book or magazine while Pie is reading."

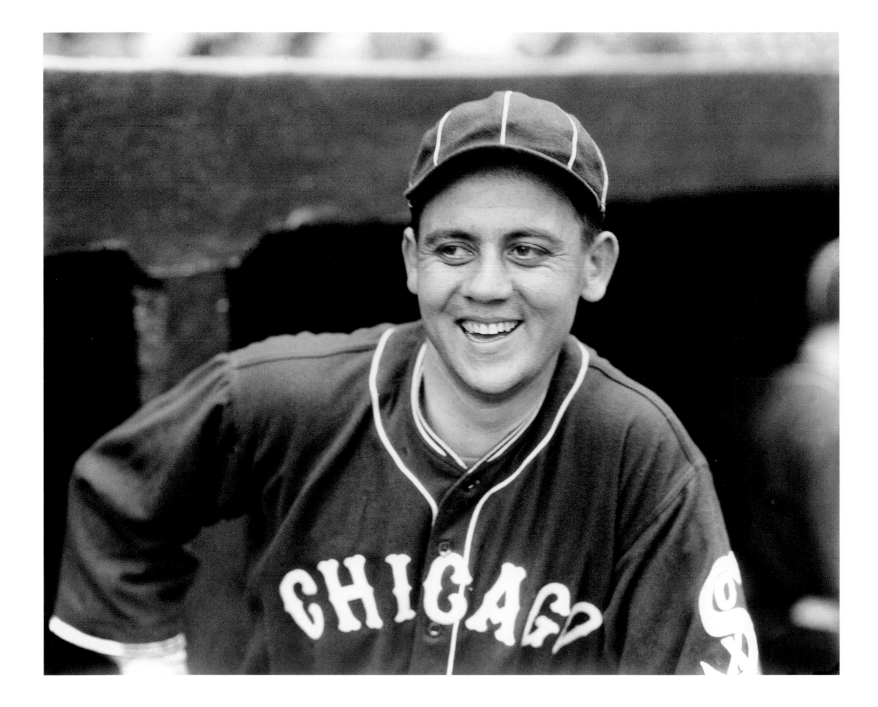

HAL McKAIN *1930 Chicago White Sox*

In 1930, this relief pitcher led the major leagues with a .419 batting average, outhitting even Bill Terry, who led the National League with a measly .401. True, McKain batted only thirty-one times, but *Spalding's Guide* still put his name at the top of the 1930 batting leaders. Hal rested his bat over the winter, and proceeded to have even better luck with his birds: "Harold McKain, Chicago White Sox hurler, is gaining new laurels as a breeder of mallard ducks in the Middle West," reported the *Sporting News* in February of 1931. "His flock recently took blue ribbons in Nebraska and Iowa exhibitions, in addition to the National Western Poultry Show at Denver." During the 1931 season, Hal batted only .119, and his record as a relief pitcher was 0-6. In November of 1931, however, Hal returned to championship form when he won a rod and reel after catching a fourteen-pound pike.

PEPPER MARTIN
1935 St. Louis Cardinals

"When I was an active player, I was cat-like in actions," said Pepper Martin. "This is not ego. The good Lord gave me certain physical qualities and I tried to make the most of them. I could fly around the bases in those days, even if I do say it myself. You've got to be bold. You have to picture yourself in your subconscious mind the night before as a hero doing tremendous things. Doggonit, you can't just be a plodding guy. Have some animation about you. And you'll be surprised how often it becomes reality the next day."

This base-stealing third baseman was indeed catlike in actions—trying to catch Martin in a rundown was "like being in a cage with a tiger," recalled one infielder—but he was hardly feline in fastidiousness: "Pepper was superstitious," explained a teammate. "He never changed his underwear. Not until he came home from a road trip. Then his wife wouldn't let him in the house until he did."

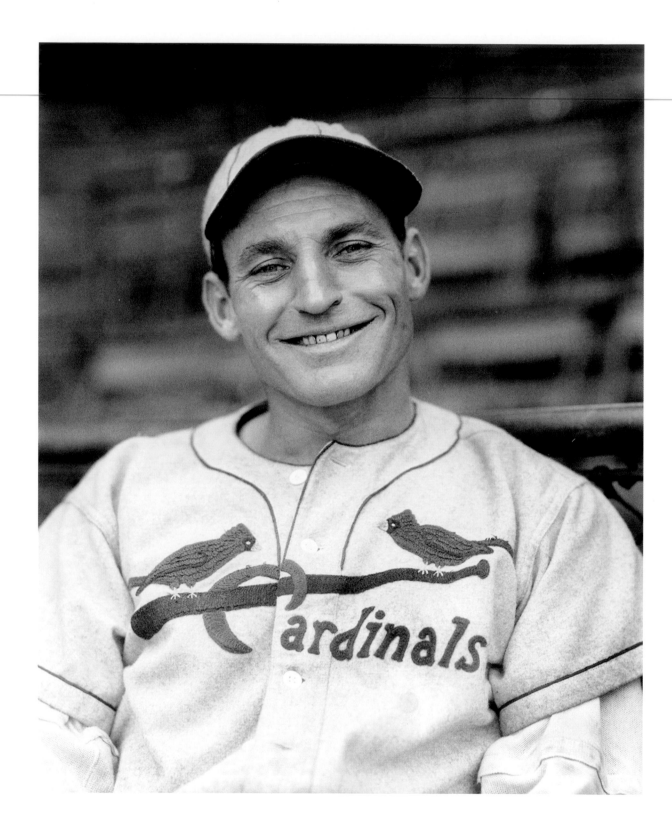

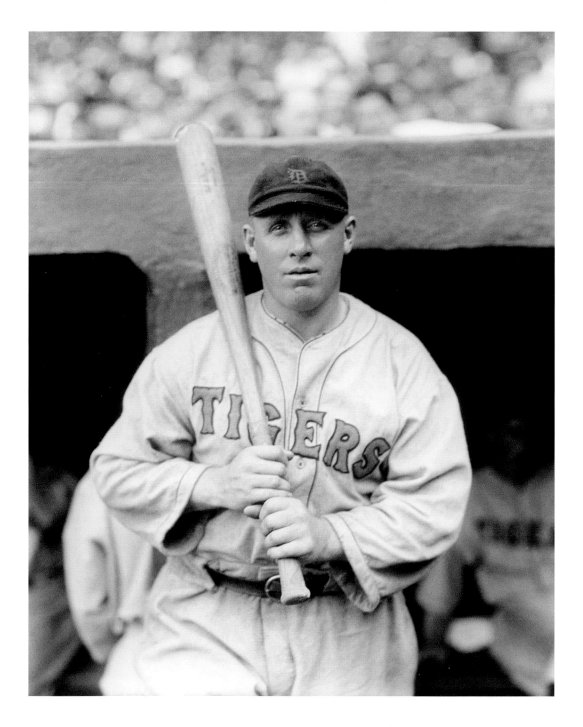

BOB FOTHERGILL
1928 Detroit Tigers

"Fothergill is probably the most deceptive man in his league," observed H. G. Salsinger of the *Detroit News* in 1926. "That is because he is the fattest. Neither speed nor punch is expected of him, but he carries both. He is much faster than the cash customers credit him with being and he is a much better batsman than pitchers believe him to be." In 1926, he batted a career-high .367, and in 1927 he hit .359.

"I inherit my tendency to take on weight," said Fothergill. "My father was a big man, and my mother was far above average size. In the summer my weight does not vary much." At the beginning of spring training in 1928, Bob weighed 229 pounds: "I got two rubber shirts and three woolen sweat shirts with me. It won't be no hard job at all to get down." By Opening Day, Bob's weight was down to 210: "I'm weaker than a cat," he gasped. He went into a batting slump at the beginning of the season, and quickly abandoned his crash diet: "Bob Fothergill seems to be slowly but surely disappearing in his own fat," observed Harold Burr in the *Brooklyn Daily Eagle* at the end of April, but Fothergill's system never recovered from his close brush with svelteness, and he finally slumped to .317. The next year he hit .354.

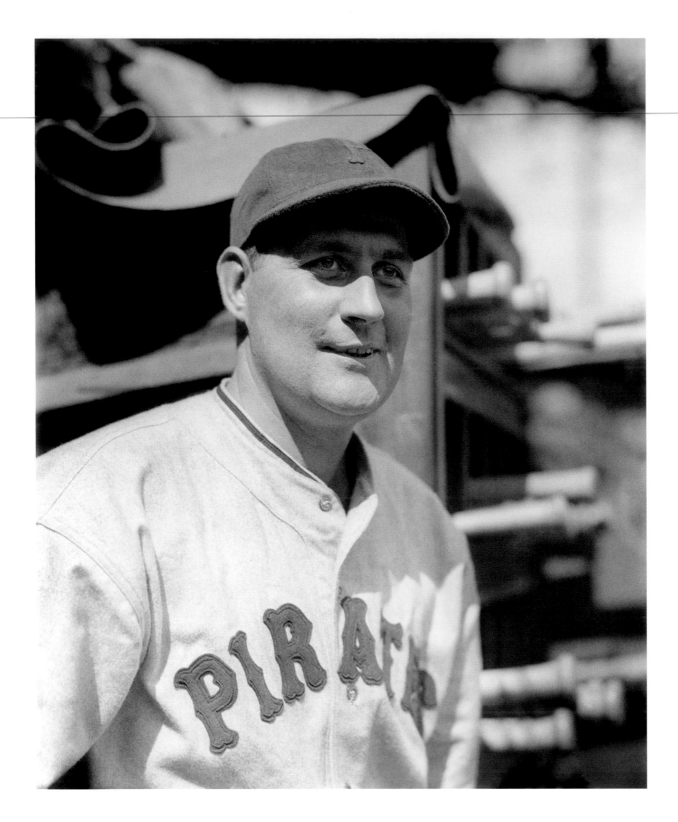

RALPH BIRKOFER
1935 Pittsburgh Pirates

During spring training in 1934, the *Pittsburgh Press* informed its readers that Pirate pitcher Ralph Birkofer was "inclined to swell into the size of a balloon overnight." But Pirate pitching coach Doc Crandall, whose job it was to supervise Ralph's diet, was unconcerned: "I am not worried about the fact that he is overweight or sporting a big bay window. It seems to me it is natural for him to be fat." Birkofer tried eating only two meals a day in an attempt to get down to two hundred pounds, but that regime was short-lived.

During spring training in 1935, the *Sporting News* informed its readers that Birkofer "reported overweight, and Traynor ordered him to the cave reducing baths at San Bernardino, where natural hot water produces a vapor which is credited with being excellent for reducing purposes." The Arrowhead Hot Springs Hotel and Spa boasted that its natural steam caves were "filled with invigorating vapors," which provided a "thrilling source of exuberant vitality," but while Ralph is clearly invigorated, thrilled, and exuberant in this Conlon portrait, the hot air appears to have kept him well inflated.

MEL HARDER
1935 Cleveland Indians

When Mel Harder reported to the Indians in 1928, he weighed only 145 pounds, so they told the skinny eighteen-year-old rookie to drink a quart of milk a day and eat plenty of spinach. By 1935, the six-foot-one pitcher still weighed only 170 pounds, and the *Sporting News* reported that the slender Harder would "turn himself into a pretzel shape to oblige photographers."

The 1934 All-Star Game is famous for Carl Hubbell's pitching performance, but the game was actually won by Mel Harder, who pitched five scoreless innings for the American League. Between 1934 and 1937, he set the all-time All-Star Game record by pitching thirteen consecutive scoreless innings. "You ask DiMaggio about him," said Bob Feller. "Joe could never figure Mel out. He'd make Joe look like a hacker." But Harder was characteristically humble about his domination of DiMaggio: "Joe was the kind of hitter who kept you awake nights worrying. He was never easy for me. I had to work like a dog to get him out. I guess I'll be famous in years to come as the pitcher who held DiMaggio to a .180 average." After twenty years as a Cleveland pitcher, Harder became the team's pitching coach: "Mel taught me everything I know about pitching," said Bob Lemon, a third baseman converted by Harder into a Hall of Fame pitcher.

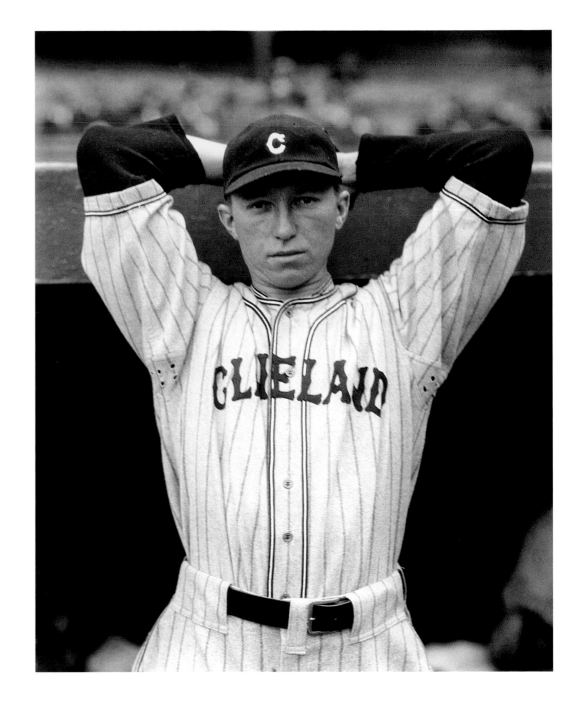

FLEA CLIFTON
1935 Detroit Tigers

"When I am out there on the field, I experience no nervous reaction to developments," said Flea Clifton in September of 1935. "Concentrating on the job at hand, I feel no sensation. What I do is largely routine. The execution comes from long practice and is more or less mechanical. The plays in which I have participated gave me no thrill whatsoever." Clifton's placid temperament came in handy when first baseman Hank Greenberg broke his wrist in Game Two of the 1935 World Series and—after some hasty lineup-juggling—Flea suddenly became Detroit's starting third baseman. The rarely used utility man went hitless in the remaining four games, but he was steady on the field as the Tigers won the Series: "You know, I wasn't the least bit nervous about going into a spot like that until I began thinking about it the next February," said Clifton. "That's when I was getting ready to go to spring training, to meet my teammates again. I began to think how much money I could have cost them with my play—and, brother, you should have seen me sweat."

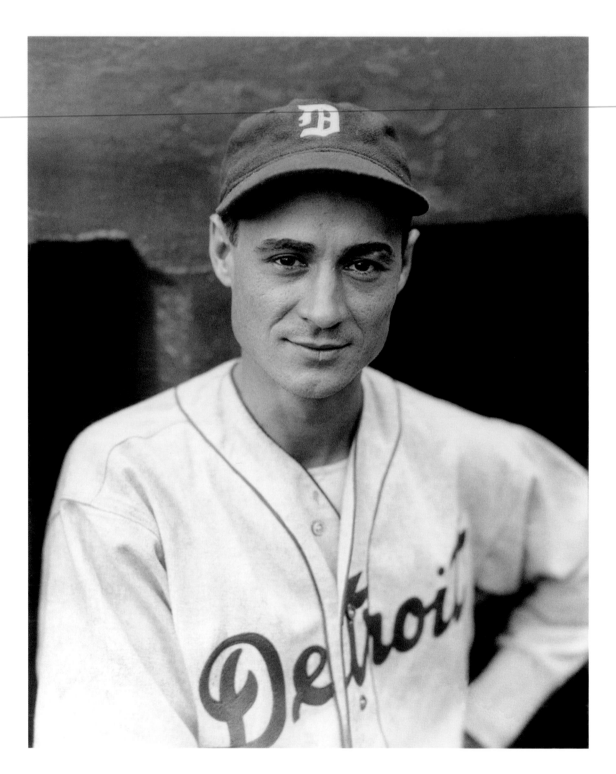

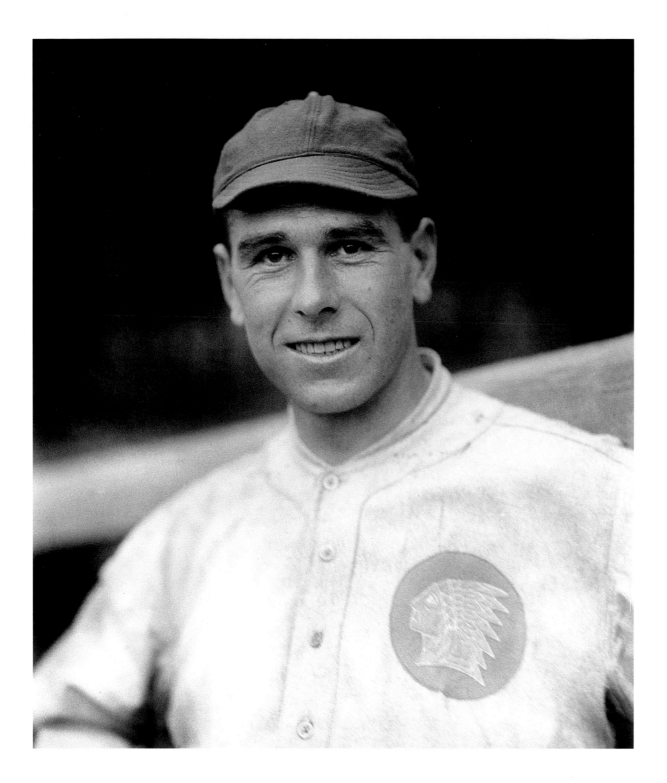

FRED SNODGRASS
1916 Boston Braves

"Fred Snodgrass seems to be the Dr. Jekyll and Mr. Hyde of base ball [*sic*]," reported the *New York Tribune* in 1914. "Off the diamond he is one of the most gentlemanly and cultured of fellows; on the diamond he has the faculty of quickly antagonizing opponents and fans." It all began when Snodgrass, the Giants' center fielder, faced pitcher Lefty Tyler in Boston on Labor Day 1914: "The first ball sizzed [*sic*] by close to his head, whereupon he placed his thumb to his nose and wriggled his fingers at Tyler," reported *Sporting Life*. "The pitcher answered by tossing the ball in the air and muffing it as it came down, this pantomime being an imitation of Snodgrass' muff in the World's [*sic*] Series of 1912." Tyler then hit him with a pitch, and Snodgrass charged the mound: "The fans hooted and I did something inelegant," he recalled. "I thumbed my nose at the customers, and they responded with bottles, cushions, and anything else that was loose." Boston's mayor tried to have him ejected from the game for inciting a riot, but after Dr. Jekyll was traded to the Braves in 1915, Mr. Hyde was granted clemency.

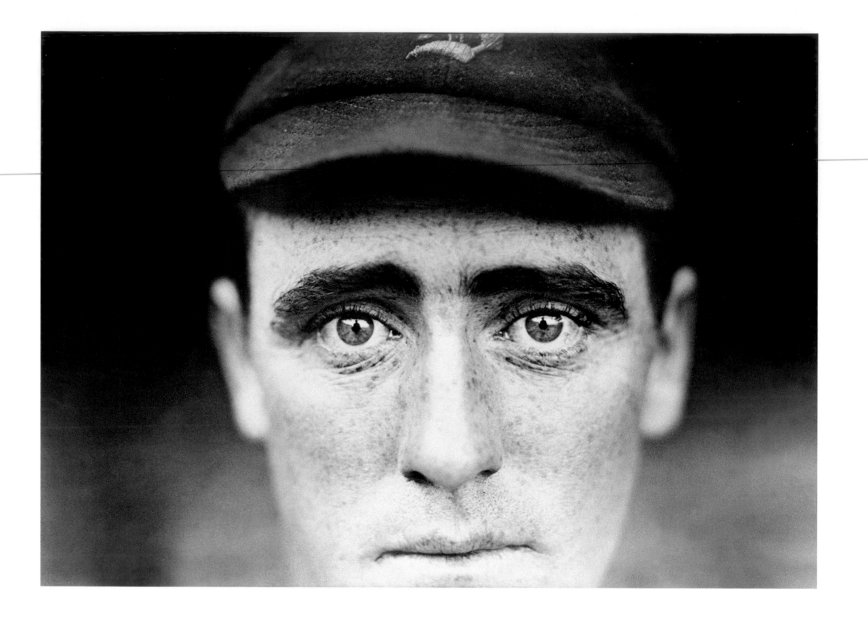

DONIE BUSH *1912 Detroit Tigers*

"Bush covers more territory than any shortstop in the league," observed the *Washington Post* in 1914, "but fielding, unlike hitting, does not cause the same thrill when put down in cold type."

"I was a switch-hitter," said Donie Bush, "and if you look at my batting average, you'll see I wasn't too hot either way." Bush found another way to get on base—between 1910 and 1914 he led the American League in walks five times—but this created another problem: "I had to run. That Cobb was always running over me and I had to get out of his way. I batted ahead of him in the lineup, and we never saw the day when Ty caught up with me on the base paths. I'd argue with Cobb, but I never was afraid of him, because although

everybody bragged about how fast Ty was, I could outrun him. Cobb never could catch me."

Bush led the Pirates to the 1927 World Series as a proactive manager. He once grabbed a bat and offered a "certain mouthy pitcher" this fatherly advice: "Listen, you big heel, another crack and I'll bend this on your lousy skull." Bush almost bent a bat on the skull of a certain talkative space cadet who drove him crazy in 1938—but the kid loved the old grouch anyway: "I've tried to pattern myself after him as a person," said Ted Williams, calling Bush "as fiery as a man could be, a man who tried to be tough but was as soft as a grape."

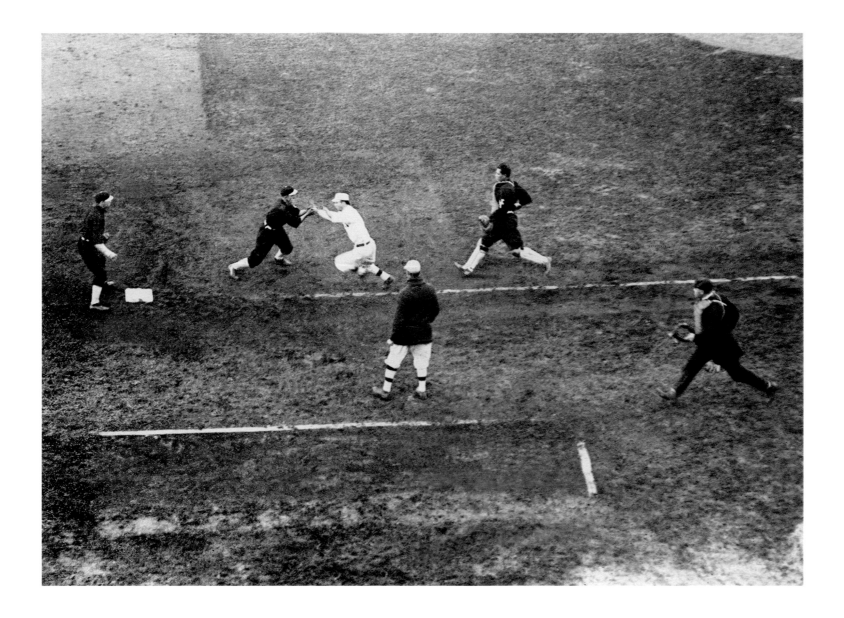

NEW YORK GIANTS VS. PHILADELPHIA ATHLETICS
October 24, 1911, Shibe Park, Philadelphia

It is the bottom of the eighth inning in Game Four of the 1911 World Series, and Jack Barry of the A's has just been tagged out in a rundown by Buck Herzog, the Giants' third baseman. Shortstop Art Fletcher backs up the play, as catcher Chief Meyers and plate umpire Bill Dinneen rush into position. Chief Bender beat Christy Mathewson of the Giants by a score of 4–2 this day, and the Athletics went on to win the World Series in six games.

"Ty Cobb and I were good friends off the field but we were enemies during a game," said Barry. "Can't forget that guy. Look! I've got his trademark on my shin, even cut to the bone. And that

was in 1909. Years later I was attending an old-timers reunion. Cobb walked over and said, 'Gentlemen, here is the only man I ever was sorry I injured.'" During an exhibition game in the spring of 1917, Ty Cobb intentionally spiked Buck Herzog. After the game, Herzog went to Cobb's hotel room and challenged him to a fight. Cobb accepted the challenge, and Eddie Ainsmith refereed the impromptu bout. "I was Herzog's roommate," recalled Art Fletcher. "I found him in the dark, sitting in a chair, his lip cut, both eyes just about closed. 'I got hell kicked out of me,' he smiled, 'but I knocked the bum down—and you know that swellhead, he'll never get over the fact that a little guy like me had him on the floor.'"

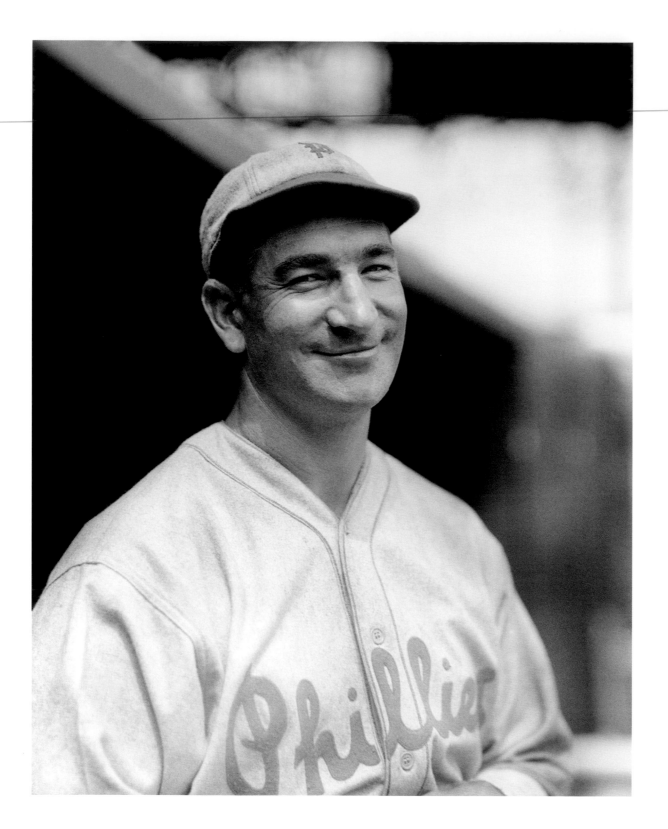

WES SCHULMERICH
1933 Philadelphia Phillies

The versatile Schulmerich turned down a chance to play for Knute Rockne at Notre Dame in the 1920s, electing to stay at home and play fullback for Oregon State, and he chose big-league baseball over a professional wrestling career in 1931. Those anticipating the arrival of a menacing brute were pleasantly surprised when this 210-pound teddy bear showed up for spring training: "It is always worth the price of admission to be in Wes's company," wrote a delighted Boston sportswriter. "He's good nature itself." Wes was especially good-natured in 1933, when he finished fifth in the National League batting race with a career-high .318 average.

In 1936, a cocky seventeen-year-old made his pitching debut in the Pacific Coast League. Wes Schulmerich welcomed the rookie with a 450-foot home run, ending the kid's pitching career on the spot. Undaunted, the kid moved to the outfield, and eventually to Boston, where he, too, knocked a few out of the park. His name was Ted Williams.

JULIE WERA
1927 New York Yankees

"I didn't play very much," recalled Wera, "but I can always say that I was a part—even though a very small one—of the greatest ball team of all time." Julie was the lowest-paid player on the '27 Yankees, and he didn't get to play at all in the 1927 World Series, but now and then they let him warm up on the sidelines, which is where Conlon spotted the delighted rookie on Opening Day. Wera hit his only big-league home run on July 4, 1927, but his contribution to the Yankee fireworks was a very small one, as Murderers' Row swept the holiday doubleheader with Washington by a combined score of 33–2.

In 1932, a nervous seventeen-year-old shortstop, just beginning his professional career in the Pacific Coast League, lobbed a tentative throw to first base. "You dumb busher. Throw that ball!" advised the veteran third baseman, Julie Wera. "I thought he was going to take my head off and I was really scared," recalled the shortstop, "so the next time the ball was hit to me I threw it as hard as I could and it landed in about the seventeenth row of the grandstand." The flustered shortstop moved to the outfield, and eventually to New York, where he, too, felt lucky to be a Yankee. His name was Joe DiMaggio.

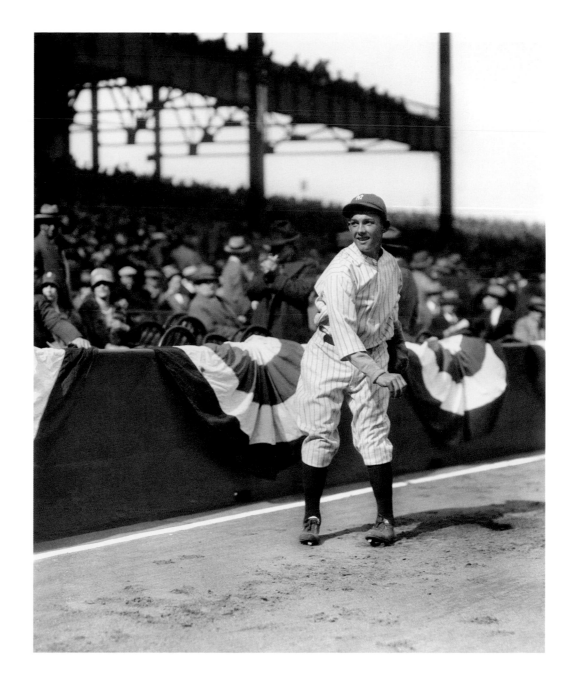

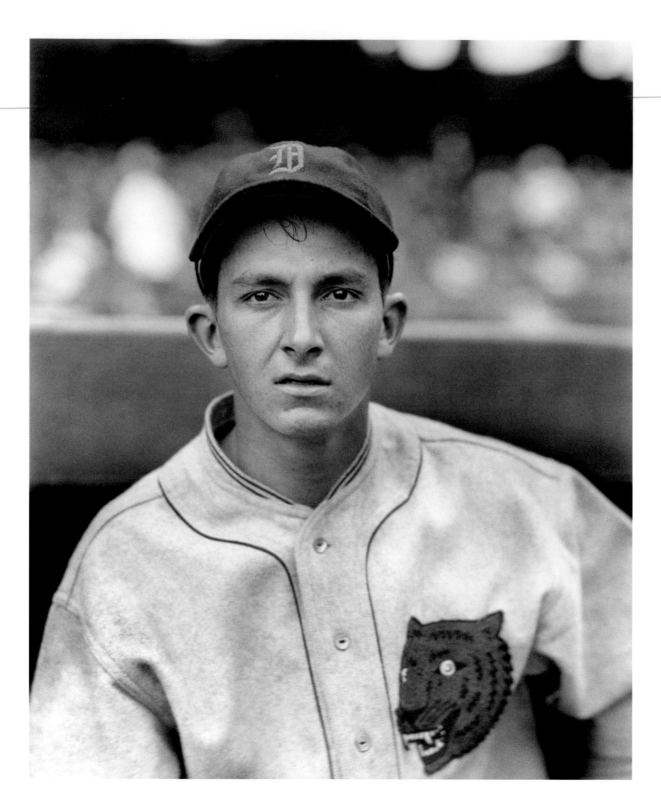

RUFUS SMITH
1927 Detroit Tigers

On September 17, 1927, Rufus Smith pitched for Providence against Bridgeport in the Eastern League. On September 19, he joined the Tigers in Boston. On September 21, the dazed twenty-two-year-old arrived at Yankee Stadium, where he was waylaid by the watchful Charles M. Conlon. On October 2, Smith's major-league career officially began when he started the last game of the season in Detroit. The Tigers rallied to beat the Cleveland Indians in the bottom of the ninth inning, but, alas, Rufus had been removed for a pinch hitter in the bottom of the eighth, and, with a record of no wins and no losses, his major-league career was over—exactly one hour and forty minutes after it had begun.

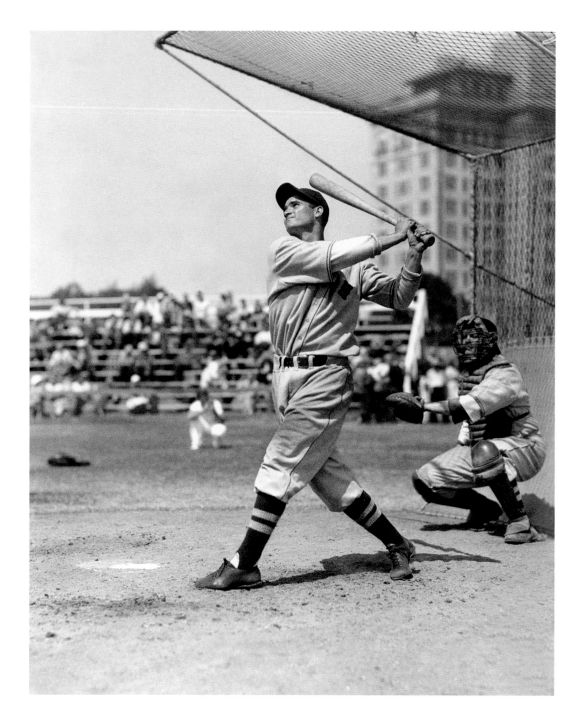

BOBBY DOERR

1937 Boston Red Sox

"I do not think the fact that I'm only 18 will interfere with my chance to make good with the Red Sox," declared Bobby Doerr during spring training in 1937. "My dad had me playing ball ever since I was 9 and I feel a lot older than I am when I'm on the diamond." While playing ball for the San Diego Padres in 1936, the second baseman had been scouted and signed by Red Sox general manager Eddie Collins, who also spotted a lanky Padres outfielder named Ted Williams—although the latter would have to wait two more years before he could join Bobby on the big club. During a brilliant fourteen-year career spent entirely with the Red Sox, Doerr had six 100–RBI seasons, played in nine All-Star Games, and batted .409 in the 1946 World Series. "How lucky can a person's career be?" said Bobby in wonderment. Forty-nine years after Conlon photographed the promising rookie in Florida, Doerr was inducted into the Baseball Hall of Fame—with his ninety-year-old mother at his side. She no doubt agreed with Ted Williams, who said at the ceremony: "If I had a son, I would want him to be like Bobby Doerr."

219

JIM TURNER

1942 New York Yankees

After pitching in the minor leagues for twelve
long years, Turner finally caught on as a thirty-
three-year-old rookie with the Boston Bees in
1937. He won twenty games that year, and his
2.38 ERA led the National League. But Turner
was back in the minors by the summer of '42,
his playing career nearly over . . . when he was
suddenly acquired by the best team in baseball
at the end of August. Here, in one of Conlon's
last photographs, we see a man whose baseball
career has just been given new life—and quite
a life it was: Turner was the pitching coach for
Casey Stengel's Yankees from 1949 to 1959, for
the Reds from 1961 to 1965, and for the Yankees
again from 1966 until his retirement in 1973.
"If I live to be 100, I would never be able to
repay baseball for what it has done for me," said
Turner. "I just loved the game. I wouldn't trade
my career with the President of the United
States." Turner spent fifty-one consecutive
seasons in professional baseball, and he lived to
be ninety-five.

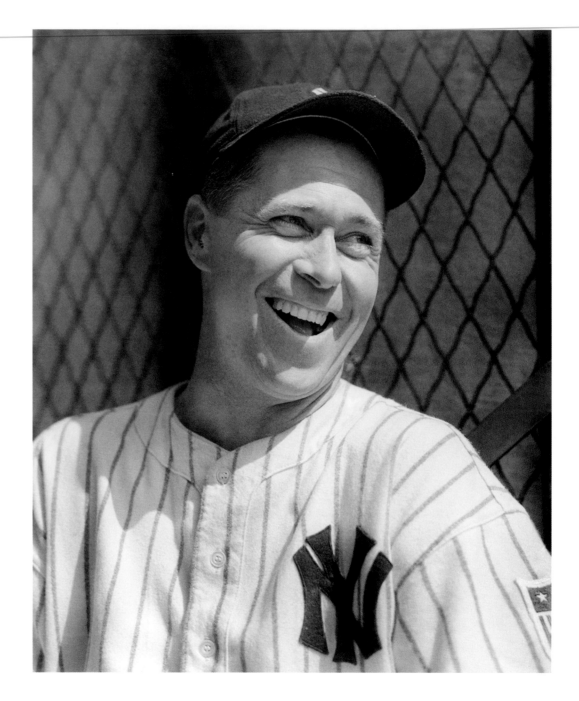

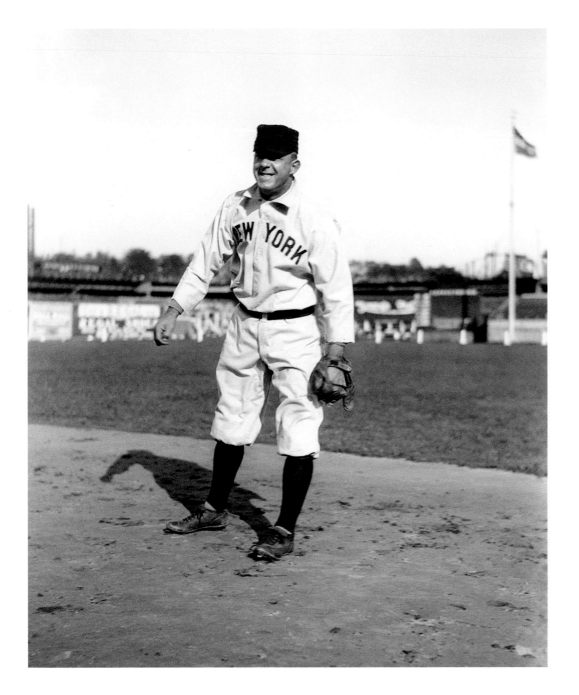

BILLY GILBERT
1904 New York Giants

GILBERT A SECOND BASE GENIUS was the headline of Billy's 1927 obituary in the *New York Sun*: "His baseball came to fruition in 1904, when he started with his usual speed, but became faster and faster and more and more accurate. He often made such astounding stops and pickups that he startled the spectators."

In 1906, *Sporting Life* described Billy Gilbert as "a perfect little gentleman" who "has a reputation of having the most even disposition of any player on the New York team, and every one he meets falls a victim to his charming personality. It is a well-known fact that if anybody in New York ventures the opinion that Billy Gilbert is not the slickest second baseman in the world, the person who makes the assertion takes his own life in his hands."

In 1904, Charles M. Conlon first took his camera onto the field at the Polo Grounds, where he fell victim to the charm of the slickest second baseman in the world, a genius preparing to startle the spectators.

Index to the Plates

Acknowledgments

It's always a matter of opinion, of course, but sometimes the sequel turns out to be even better than the original. Certain works come to mind immediately: Shakespeare's *Henry IV, Part 2*, Francis Ford Coppola's *The Godfather, Part II*, and *Shut Down, Volume 2* by the Beach Boys. This second Conlon collection is, in my opinion, a lot better than the first book, which was admittedly a promising rookie effort. The quality of the photos in this volume is just as high, if not higher, but this time around I actually had some idea of what I was doing, and I also benefited from the generous assistance and moral support of the many people who had faith that this book would eventually be published.

First of all, I must thank my sister, Constance McCabe, who introduced me to Conlon's work and printed the photographs from the original negatives. Andrew Robb provided invaluable assistance in preparing the image files. Steve Gietschier, former managing editor and archivist at the *Sporting News*, gave the Conlon project its start, and Shawn Schrager, director of programming and product development at the *Sporting News*, gave the sequel the go-ahead. Eric Himmel, Steve Tager, and Lindley Boegehold welcomed Conlon back to Abrams, where Laura Dozier has been my wise and sympathetic editor.

Hank Thomas, Chuck Carey, Tom Simon, Fred Schuld, Sarah Greenough, Harold Bronson, Art Fein, Paul and Nancy Body, Gene Sculatti, Todd Everett, Skip Heller, Andrew Sandoval, Bob Veltman, Larry Gremp, Nicole Montalbano, Jonathan Richman, Oliver Trager, Tim Thornton, Gaye Lowenstein, Dori Friedman, Raiford Rogers, Anne Trelease, Jan Clubb, Jill Shively, and Diana Chin offered important advice and encouragement. Claude Moine and Jean-Philippe Smet provided invaluable inspiration. Constance McCabe is particularly grateful to Karin Fangman for her support and patience.

The following people championed an orphaned project when its prospects seemed more than a little bleak, and they made this book possible: Carolyn Thomas, Fred R. Conrad, Dave Anderson, Dave Frishberg, Dan Ross, David Davis, and the late Lawrence S. Ritter.

Finally, my sister and I dedicate this book to the memory of the avid fan who first took us out to the ballgame:

Hi Mom

THE SHARED HEART